D1452645

Marvelous Encounters

Marvelous Encounters

Surrealist Responses
to Film, Art, Poetry,
and Architecture

Willard Bohn

Lewisburg
Bucknell University Press

Associated University Presses
2010 Eastpark Boulevard
Cranbury, NJ 08512

The paper used in this publication meets the requirements of the American National Standard for Permanence of Paper for Printed Library Materials Z39.48-1984.

Library of Congress Cataloging-in-Publication Data

Bohn, Willard, 1939–
 Marvelous encounters : surrealist responses to film, art, poetry, and architecture / Willard Bohn.
 p. cm.
 Includes bibliographical references and index.
 ISBN 0-8387-5611-5 (alk. paper)
 1. Romance poetry—20th century—History and criticism. 2. Surrealism (Literature) 3. Art and literature. I. Title.
 PN814.B65 2005
 809.1′91163—dc22 2005000366

PRINTED IN THE UNITED STATES OF AMERICA

Contents

Illustrations

Acknowledgments

THE FOLLOWING WORK WAS SUPPORTED IN PART BY THE PROGRAM FOR Cultural Cooperation Between Spain's Ministry of Culture and United States' Universities, which awarded me grants on two separate occasions. The first enabled me to study surrealist poets writing in Catalan and the second to conduct research on the Canary Island surrealists. In addition, a University Research Grant from Illinois State University allowed me to analyze critical poetry by Philippe Soupault. Further research was carried out at Christ Church College, Oxford University, where I spent six delightful months as Fowler Hamilton Visiting Research Fellow. Much of the book itself was written during my stay in Oxford. As always, I am indebted to Joan Winters and the staff in the Circulation Department of Milner Library at Illinois State University who, like their counterparts in Interlibrary Loan, were consistently helpful as the project progressed.

Preliminary versions of several selections appeared in the following publications and are reprinted with their kind permission: "Louis Aragon and the Critical Muse," *Romanic Review* 89, no. 3 (May 1998): 367–79, copyright by the Trustees of Columbia University in the City of New York; "Where Dream Becomes Reality," *L'Esprit Créateur* 36, no. 4 (winter 1996): 43–51; "Heading West With Rafael Alberti and Buster Keaton," in *Agítese bien!: A New Look at the Hispanic Avant-Garde*, ed. Maria Pao and Rafael Hernández-Rodriguez (Newark, Delaware: Juan de la Cuesta Hispanic Monographs, 2002): 119–29; "Lorca, Buster Keaton, and the Surrealist Muse," *Revista Hispánica Moderna* 53, no. 2 (December 2000): 413–24; and "Marvelous Encounters: J. V. Foix and Salvador Dalí," *CiberLetras*, no. 8 (January 2003), n.p.

Every effort has been made to trace all copyright holders, but if any have been inadvertently overlooked, the author will be pleased to make the necessary arrangements at the first opportunity.

* * *

For better or worse, all translations are my own.

Marvelous Encounters

1
Critical Poetry

THE CONCEPT OF *POÉSIE CRITIQUE*—POETRY THAT POSSESSES BOTH A poetic and a critical function—has an extensive history in modern literature, especially in France where it has flourished since the turn of the century. Written in response to another work of art, be it a painting, a film, a poem, or a piece of music, the critical poem comments on the latter in various ways but refuses to abandon its poetic mission. Curiously, despite the crucial role the genre has played in the development of modern poetry, it has attracted relatively little attention from scholars. As Robert W. Greene notes in a recent study of Pierre Jean Jouve, critical poetry is "still [a] largely neglected phenomenon."[1] The situation is complicated, moreover, by the emergence of a rival tradition exemplifying a radically different principle. "Recently," Thorpe Running remarks in an excellent study of eight Latin American poets entitled *The Critical Poem*, "a poetry has emerged that expresses utter despair at not being able to say anything at all."[2] Exhibiting a skeptical attitude toward language, he explains in the introduction, critical poetry questions its own construction and its ability to convey meaning. As such, it is concerned not with other works of art but with its own failings. To be sure, this tradition is well documented in Latin America and elsewhere, for example in North American $L=A=N=G=U=A=G=E$ poetry.[3] However, the appropriation of the term "critical poetry"—by the Mexican poet Octavio Paz in 1971—stems from a serious misunderstanding.

Since Paz's error sheds a certain amount of light on the origin of critical poetry, which the passage of time has increasingly obscured, it is worth examining. The concept of critical poetry appears to have been formulated originally by Charles Baudelaire who, reviewing the paintings at the Salon of 1846, argued that criticism should be amusing, committed, passionate, and poetic. "Le meilleur compte rendu d'un tableau," he declared, "pourra être un sonnet ou une

13

élégie" (The best criticism of a painting might be a sonnet or an elegy).[4] The publication of "Les Phares" ("The Beacons") eleven years later, in which the names of famous painters were paired with evocative images, provided a model for future poets to follow. The term "poème critique" was first employed by Stéphane Mallarmé in an obscure passage in *Divagations* (1897), which attracted Paz's attention seventy-five years later. "La novedad de *Un Coup de dés*," he claimed, "consiste en ser un *poema crítico*. Poema crítico: si no me equivoco, la union de estas dos palabras contradictorias quiere decir: aquel poema que contiene su propria negación" (The novelty of *A Throw of the Dice* consists in being a critical poem. A critical poem: if I am not mistaken, the union of these two contradictory words means: a poem that contains its own negation).[5] Unfortunately, Paz *was* mistaken. Mallarmé himself described the genre as follows:

> Les cassures du texte, on se tranquillisera, observent de concorder, avec sens et n'inscrivent d'espace nu que jusqu'à leurs points d'illumination: une forme, peut-être, en sort, actuelle, permettant, à ce qui fut longtemps le poème en prose et notre recherche, d'aboutir, en tant, si l'on joint mieux les mots, que poème critique. Mobiliser, autour d'une ideé, les lueurs diverses de l'esprit, à distance voulue, par phrases. . . .

> [The breaks in the text, setting one's mind at ease, take pains to agree, with sense and only inscribe naked space at their points of illumination: a form, perhaps, emerges, present, permitting, what was long the poem in prose and our research, to culminate, joining improved words together, in a critical poem. Mobilizing, around a single idea, the diverse glimmers of the mind, at a certain distance, by phrases. . . .][6]

Rather than an exercise in self-negation, Mallarmé's sibylline pronouncement reveals the critical poem was conceived as a modified prose poem that exploited certain visual effects. The second sentence, among others, leads Gordon Millan to conclude that the passage announces "a new hybrid prose form situated somewhere between the traditional prose poem and the review article."[7] While Mallarmé composed a number of texts that conform to this description, he never again referred to "le poème critique" in print. Buried in the obscure bibliographical notes to a collection of miscellaneous poems and articles, the reference attracted far less attention than the concept attached to it. Upon Mallarmé's death, the torch was passed to another poet who not only popularized critical poetry but

inspired his colleagues, and later his disciples, to try their hand at the new genre: Guillaume Apollinaire.

Like visual poetry, *poésie critique* was regarded as little more than a curiosity at the beginning of the twentieth century, as an amusing experiment and nothing else. Apollinaire was among the very first to recognize the potential of these and other hybrid genres, which promised to revolutionize modern aesthetics, and to exploit them to their full extent.[8] Convinced the modern age demanded new modes of expression, he developed visual poetry and critical poetry into major art forms, even going so far as to combine them in 1917.[9] Whereas the *calligramme* represented a radically new departure for Apollinaire, the critical poems were a logical continuation of previous poetic efforts. They reflect not only his lyric vision, which transformed everything he encountered into subject matter for poetry, but his poetic temperament as well, which is imprinted on most of his criticism. For, as André Salmon once remarked, "son génie de critique était inséparable de son génie de poète" (his genius as a critic was inseparable from his poetic genius).[10] Indeed, signs of Apollinaire's commitment to lyric poetry emerge at every turn in his criticism, for example in his choice of stylistic devices. Instead of rigorous intellectual analysis, LeRoy Breunig points out, he generally preferred the lyric statement.[11]

Although Apollinaire experimented with critical poetry as early as 1905, in an article devoted to Picasso, his greatest achievement was the publication of *Méditations esthétiques: les peintres cubistes* eight years later. Since the title appeared in smaller letters than the subtitle, generations of critics have mistakenly treated the volume as a study of Cubist painting. However, as Breunig and Jean-Claude Chevalier observe, Apollinaire's originality lies not in his analysis of Cubism but "d'avoir étendu le domaine de la poésie moderne à la prose de la critique d'art en unissant ce que Baudelaire . . . avait maintenu nettement distinct" (in having expanded poetry's domain to encompass art criticism written in prose by combining elements that Baudelaire, in his own works, had insisted on keeping separate).[12] Conceived as a critical poem divided into seven movements, they add, the volume's subtle harmony emanates from a complex network of metaphors, analogies, contrasts, and stylistic echoes. Elsewhere, discussing Apollinaire's critical poetry in general, Breunig perceives an intriguing parallel between his practice and that of Baudelaire.[13] Like the author of "Les Phares" ("The Beacons"), who likened Rembrandt to a hospital and Goya to a nightmare, he

employed a series of correspondences to evoke the style of various painters. Juxtaposing each artist's name with a corresponding image, he compared Matisse to an orange, Marie Laurencin to a dancer, Picabia to a machine, and so forth. In addition, hoping to gain greater acceptance for his or her art, he often paired an artist's name with that of a famous author such as Molière or Pascal.

The following pages are devoted not to Apollinaire—whose experiments with critical poetry merit a book-length study of their own—but to surrealist poets writing in French, Spanish, and Catalan who, either consciously or unconsciously, followed the trail he had blazed. As we will discover, many writers were inspired by Apollinaire's example and were conscious of belonging to the same tradition. Other writers added a few wrinkles of their own or struck out boldly in new directions. The first three chapters are concerned with the surrealists in France, who began to cultivate critical poetry toward the end of World War I, during a period when they were associated with the Dada movement. This is not the place to review the differences and similarities between Dada and surrealism, which have elicited heated debates in the past. For even as they championed Dadaist principles, André Breton and his colleagues experimented with a number of procedures that would form the cornerstone of the later movement. "Le *Premier Manifeste* de 1924," he declared in 1934, "ne fait qu'apporter la somme des conclusions tirées par nous lors de ce qu'on pourrait appeler *l'époque héroique* du surréalisme, et qui s'étend de 1919 à 1923" (In 1924, the *First Manifesto* simply summarized conclusions drawn during what might be called the *heroic period* of surrealism, extending from 1919 to 1923).[14] Chapter 2 considers how Louis Aragon and Philippe Soupault appropriated the critical poem, as they reviewed books of poetry and films starring Charlie Chaplin. Chapter 3, which examines how Benjamin Péret and Paul Eluard conceived of critical poetry, analyzes their response to poems by Tristan Tzara and paintings by Giorgio de Chirico and Joan Miró. Chapter 4 is devoted entirely to Breton, who experimented with the genre in both his poetry and his art criticism.

Not surprisingly, perhaps, the French experiments attracted the attention of the Spanish and the Catalan avant-gardes before long, inciting numerous poets to try their hand at the exciting new genre. Chapter 5 focuses on texts by J. V. Foix, widely considered to have been the most important poet writing in Catalan, and by Salvador Dalí, who played an important role among the Catalan surrealists

before moving to Paris. Unlike Foix, who devoted several texts to
modern artists, Dalí does not appear to have written poetry about
another individual's works. Instead his poems are interwoven with
his painting, providing an intriguing commentary on his experi-
ments with surrealist art. The next two chapters consider critical
poetry by Spanish-speakers living in Spain. Chapter 6 is concerned
with a fascinating film script by Federico García Lorca and with an
equally fascinating poem by Rafael Alberti, both of which feature
Buster Keaton as their protagonist. Among other things, they pres-
ent an instructive contrast to Soupault's texts on Charlie Chaplin,
examined in the second chapter. Chapter 7 examines critical poetry
by four individuals residing in the Canary Islands: Domingo López
Torres, Emeterio Gutiérrez Albelo, José María de la Rosa, and Pedro
García Cabrera. While three of the compositions are about Pablo
Picasso, the fourth resumes Soupault's dialogue with Chaplin.

The final two chapters follow the progress of critical poetry to
Latin America, where the surrealist movement had numerous ad-
herents. The combined influence of the French and Iberian writers
convinced Hispanic American poets to experiment with this genre
as well. Chapter 8 analyzes a critical poem by the Argentine surreal-
ist Aldo Pellegrini and three compositions by César Moro and Emilo
Adolfo Westphalen, who headed the surrealist movement in Peru.
In contrast to many of the preceding examples, which were engen-
dered by paintings or films, all four texts are devoted to poetry. Re-
turning to visual art with a vengeance, the last chapter examines
critical poems by surrealists residing in Chile and Mexico. In con-
trast to Enrique Gómez-Correa, who concentrates on a single paint-
ing by René Magritte, Jorge Cáceres considers the art of Max Ernst,
Paul Klee, and the Douanier Rousseau. Authored by the Nobel Prize
winner Octavio Paz, the final composition comments on the art of
Robert Rauschenberg.

Surveying surrealist practice in general, Renée Riese Hubert con-
cludes that poetry provided Breton and his friends with both a foun-
dation and a justification for their art criticism.[15] By definition,
Roger Navarri points out, critical poetry in particular posits "la supé-
riorité du langage poétique sur le métalangage le plus rigoureux"
(the superiority of poetic language over the most rigorous metalan-
guage).[16] In experimenting with critical poetry, the surrealists were
following in the footsteps not only of Apollinaire but of many other
poets, who had been inspired by art and artists for centuries. Much
has been written about ekphrastic poetry, for instance, which ap-

pealed to the ancient Greeks and Romans. The classic example is Homer's description of Achilles' magnificent shield in the *Iliad*. More recently scholars such as Marjorie Perloff, W. J. T. Mitchell, and Mary Ann Caws have examined modern attempts to revive this ancient genre, which have been surprisingly numerous.[17] Despite occasional attempts to broaden its scope, ekphrasis is normally defined as the verbal representation of visual art. Like the *Bildgedicht*, with which it is usually equated, the ekphrastic poem attempts to supplant the work of art it evokes.[18] As James Heffernan notes, it "stages a contest between rival modes of representation: between the driving force of the narrating word and the stubborn resistance of the fixed image."[19] While it strives to supersede art, Shimon Sandbank adds, initially it needs the art it wants to supersede.[20]

While this describes critical poetry as well, the latter differs from ekphrastic poetry in several important ways. This difference is exacerbated in the texts we will be examining, which demonstrate what happens when critical poetry is pushed to the limit. Each poem represents a *cas limite*, an extreme case, in which the principles that govern the genre must contend with those that govern surrealism. In the first place, critical poetry possesses a much broader focus than ekphrasis, since it encompasses all forms of artistic expression. In addition to painting and sculpture—the traditional subjects of the ekphrastic poets—it may be inspired by poems, novels, films, music, dance, or even architectural monuments. We will see that the surrealists explored most, if not all, of these areas. In the second place, critical poetry responds to a much broader spectrum of aesthetic stances. It does not necessarily single out beautiful objects, for example. In contrast to Keats's "Ode on a Grecian Urn," surrealist poetry eschews traditional beauty in favor of other, distinctly modern, aesthetic criteria. The works that elicit admiration are far from harmonious and frequently appear incoherent. In the pursuit of what the surrealists called "convulsive beauty," they tend to privilege concepts such as surprise and revelation. Finally, critical poetry employs a greater selection of rhetorical strategies than ekphrastic compositions. Despite certain obvious similarities, the surrealist response to aesthetic objects was radically different.

The surrealist poets strove not to reflect the original work of art, as the ekphrastic poets did (and still do today), but to refract it in such a way that it was barely recognizable. Instead of incorporating the work into their texts, they sought to give it a brand new identity. In contrast to previous poets, they desired neither to possess it nor

to capture it for posterity, but to transmute it into something entirely different. The following chapters attempt to demonstrate how various poets achieved this goal and to shed additional light on the concept of critical poetry. Unfortunately, the term itself fails to describe what actually transpires, and is essentially a misnomer. Critical poets neither analyze a particular work nor strive to elucidate its meaning. They almost never comment adversely on the work of art they have chosen to write about. Discussing Breton's *Le Surréalisme et la peinture*, Anna Balakian declares "there is actually no 'criticism' but rather a series of approbations."[21] Parodying the last line of *Nadja* in 1941, Breton himself exclaimed: "La critique sera amour ou ne sera pas" (Criticism will be love or will not be).[22] Here and elsewhere critical poetry is portrayed as an act of textual intercourse, one that assumes a bewildering variety of forms.

Like ekphrastic poetry, critical poetry is by definition an intersemiotic genre. Like the former, it is situated at the intersection of two different sign systems that interact with each other to varying degrees. Claus Clüver likens the exchange of information that takes place to literary translation.[23] He speaks of "intersemiotic transposition" in describing how this information is transferred from one semiotic code to another and discerns a metatextual dimension. "Intersemiotic transpositions read as such," he asserts, "are always read also as texts about text making that show us possibilities and limitations inherent in the two sign systems."[24] This does not seem to be true of *intra*semiotic transposition, which involves an exchange between works belonging to the same semiotic system—for example, between two different poems. Whereas ekphrastic poets are restricted to the first operation, critical poets perform either procedure at will. In contrast to ekphrastic poetry, which tends to be highly mimetic, critical poetry does not seek to present a truthful picture of the work of art in question. Unlike the former genre, therefore, it refuses to imitate, to critique, or to interpret an aesthetic object. At least this describes the texts examined in the present volume, authored by surrealists writing in three languages and living on three continents—which assume other roles. In probing the realm of "interartifactuality," as Balakian calls it, they take the form of meditations, commentaries, or independent creations.[25] As often as not they treat the text, in Hubert's words, "as a suggestive and challenging invitation to reinvent their own worlds."[26] While some critical poems are tightly bound to the work they have chosen

to "criticize," weaving elaborate patterns of references and counter-references, others simply use it as a springboard.

Although the present investigation fills a gap in the historical record, it is not really concerned with literary history but with the theory and practice associated with the surrealist experiments. More precisely, it strives to expose the foundations of each poet's inspiration, to analyze how the various components in each poem function, and to relate the poems to each other. It seeks to discover what each work means, how it achieves that meaning, and its theoretical implications. For this reason I attempt to interpret the poetry and to investigate the function of various poetic devices at the same time. While it is hard enough to analyze the average surrealist text, the fact that the poems tend to comment on other surrealist works makes this project doubly difficult. For that matter, although some of the poetry considers works by nonsurrealists, the same kind of double analysis is required. Since critical poetry recreates the original work of art by transposing it into a different medium or a different idiom, it also becomes necessary to analyze the work that serves as its point of departure. Therein lies the challenge—and the fascination—for someone like myself, whose entire career has been devoted to studying the relationship between literature and the other arts. By analyzing critical poetry systematically and in detail, I hope to provide a basic understanding of how the surrealists adapted it to their own programmatic needs. And by studying the various components of the texts in question, as well as their relation to the works of art that engendered them, I hope to discover the underlying mechanisms that govern the critical poem itself. Finally, by reconstructing these poems from their creators' point of view, I hope to provide valuable insight into the working of the surrealist imagination.

2
Synthetic Criticism

WHILE A NUMBER OF CRITICS HAVE ANALYZED APOLLINAIRE'S INFLUENCE on André Breton, which was extensive, his impact on the other surrealists has received relatively little attention.[1] And yet, as J. H. Matthews observes, "l'attitude et l'oeuvre des surréalistes de la première heure doit beaucoup à l'exemple d'Apollinaire" (the attitude and the works of the first surrealists owe much to Apollinaire's example).[2] One of the areas in which this debt is readily apparent, although it has been consistently overlooked, is that of surrealist criticism. For if Breton and his colleagues eventually developed their own distinctive styles, they patterned their initial efforts on Apollinaire's experiments with *poésie critique*. From the latter they learned that criticism should be creative, that it should rival the beauty and intensity of the work in question, in short that it should be a work of art itself. Like Apollinaire, they celebrated the creative vision of the artist or writer. Like Apollinaire, they made no attempt to be systematic but simply alluded to characteristics that appealed to them. Whether these were taken from the composition itself or from the larger corpus was often immaterial. "Répudiant toute analyse de l'oeuvre," Marguerite Bonnet notes, "[ils cherchaient] à suggèrer l'impression reçue au moyen d'une equivalence poétique" (Rejecting any attempt to analyze the work, [they tried] to suggest the impression it made on them by establishing a poetic equivalence).[3] Since they sought to recreate the work rather than to dissect it, they baptized their newfound method *poésie synthétique*.

LOUIS ARAGON

The first one of the surrealists to employ the method was Louis Aragon who, in homage to Apollinaire, chose to review his latest book. According to Bonnet, Breton introduced him to the poet ini-

tially in May or June 1918.[4] Either during this encounter or shortly
thereafter, Apollinaire asked the young poet to write a review of *Cal-
ligrammes*, which had just been published.[5] In fact, Aragon eventually
wrote two reviews of this important collection of poetry, one of
which appeared a few months later, the other not until 1920.[6] Pub-
lished in *L'Esprit Nouveau*, the second review followed the conven-
tional format. Nobody loved imagery as much as Apollinaire, Aragon
proclaimed. By rehabilitating poetic language, which had grown
hopelessly stale, he inaugurated a new era of sensuality. By contrast,
the first review was written in a style that quickly came to be associ-
ated with *critique synthétique*. According to Jacqueline Chénieux-Gen-
dron, Synthetic Criticism took the form of a prose poem or a
pastiche utilizing metaphorical allusions, lyrical praise, and (occa-
sionally) coded reservations.[7] Aragon himself described the genre as
follows:

> C'étaient des espèces de poèmes en prose fort courts, à propos d'un
> livre qui venait de paraître, ce qui me permettait à la fois la désinvolture,
> ou aussi bien un certain éloge poétique des choses que je n'aurais peut-
> être pas pleinement approuvées si j'en avais écrit sur le ton à propre-
> ment parler critique.

> [It was a kind of brief prose poem about a book that had just been
> published, which allowed me at the same time to employ an offhand
> manner or else a certain poetic praise of things I might not have fully
> approved if I had been truly critical].[8]

Published in *SIC* in October, Aragon's first experiment with Syn-
thetic Criticism was in many ways his most successful. Interestingly,
the term *critique synthétique* seems to have been invented by the edi-
tor, Pierre Albert-Birot, who employed it as a heading here and in
subsequent issues. At any rate, it is absent from the original manu-
script.[9] Since a detailed comparison reveals additional discrepancies
between the handwritten and printed versions, the former is repro-
duced below.

> Rue Gît-le-Coeur, tu te promènes: n'oublie pas les dessins sur les
> murs, coeurs empennés, coeurs en peine.
> DEFENSE D'AFFICHER SOUS PEINE D'AMENDE
> La mandarine des Hôtels précède l'obus trivial. De quelle couleur les
> mains de ces bougres dans l'estaminet? Sur la nappe, ce chapeau haut-

de-forme prend de l'importance, devient une colline. Elle croule ou s'ef-
feuille: simple tour de forain sans bouche qui parle par son ventre.
Tiens, la guerre.
Le poète menteur a la franchise militaire. La Maison loge à pied et à
cheval, artilleur. Puis, *puits des magies*, l'Argonne t'égare. Au carrefour:
voici le chemin de Damas, les damas de Madame Rosemond.
Votre voiture est avancée.
Mais en avant, l'autre route, l'autre roue et l'autre amour. Le soleil fait
le paon que regarde l'aveugle. Se peut-il que le canon ait ressuscité le
grand Pan? Pan! sa tête s'ouvre, c'est une fleur.
 Les CALLIGRAMMES sont des ROSES.

[You walk along the Rue Gît-le-Coeur: don't forget the drawings on
the walls, feathered hearts, afflicted hearts.
 POST NO BILLS OR PAY A FINE
The Hotels' tangerine precedes the trivial artillery shell. What color are
the hands of those fellows in the cafe? On the tablecloth that high silk
hat increases in importance, becomes a hill. The hill collapses or sheds
its leaves: the simple trick of a sideshow performer with no mouth who
talks through his stomach.
Comes the war.
The lying poet has a military frankness. The House provides accommo-
dation for man and beast, artilleryman. Then, *a magic well*, the Argonne
leads you astray. At the crossroad: here is the road to Damascus, the dam-
ask of Madam Rosemonde.
Your automobile is advanced.
But stretching before it the other road, the other wheel, and the other
love. The sun spreads its peacock tail, while the blindman watches.
Can the cannon have revived the great Pan? Bang! his head opens, it is
a flower.
 The CALLIGRAMS are ROSES].

At first glance the text seems to make very little sense. Although it
is certainly entertaining, it is hard to believe it embodies a coherent
approach. Not only are the individual phrases puzzling, but there
appears to be no continuity from one statement to the next. That
the author indulges in a series of gratuitous puns increases the con-
fusion even more. Not surprisingly, at least one critic is persuaded
that the kaleidoscopic imagery and enigmatic pronouncements are
hallucinatory. Thus Etienne-Alain Hubert insists that they derive di-
rectly from Rimbaud's *Illuminations*.[10] However, there is no need to
look so far afield when a more likely source lies nearby. Aragon's
style resulted not from a long, immense, and deliberate disordering

of the senses but from imitating Apollinaire. If the latter's collage aesthetic was well developed by 1913, causing Georges Duhamel to compare him to a proprietor of a secondhand store, by the time *Calligrammes* appeared it had become even more pronounced.[11] While Aragon's text anticipates his mature style in several respects, at this stage he and his friends were heavily influenced by literary cubism. Although Breton and Soupault would experiment with psychic automatism the following spring, leading to the creation of *Les Champs magnétiques* (*Magnetic Fields*), the surrealists had not yet begun to explore the unconscious.

At this period of his life, Matthews writes, Aragon appeared to be a highly gifted writer who took pleasure in abusing talents that many others would have liked to possess.[12] Since he and his colleagues were increasingly attracted to the Dada movement, which sought to dismantle a long list of bourgeois institutions, this stance is understandable. And yet the text is much more than a defiant gesture. A close reading soon demonstrates that it is a serious attempt to create a new discursive model. Above all, as Roger Navarri points out, Synthetic Criticism was designed to appeal to a select group of readers: those who possessed the necessary knowledge to decipher it.[13] For the readers of *SIC* and, later, *Littérature*, the new genre was relatively accessible. According to Bonnet, Aragon's review of *Calligrammes* evokes the volume's formal diversity and its principal themes "d'une manière imagée, tendre et charmante" (in a charming, tender, and vivid manner).[14] As she remarks, the themes of love and war traverse both works, and play a prominent role in their economies. Nevertheless, the attempt at intrasemiotic transposition is situated not at the thematic level so much as at the level of the individual images. Despite the transfer of certain themes from the first work to the second, their duplication is largely incidental. Or rather, since they are anchored to specific images that are repeated, it is unavoidable. "Voici l'article demandé," Aragon wrote in a note accompanying the original text.

Ce ne sont que quelques images evoquées à la lecture des *Calligrammes* et qui rendent compte des divers aspects du livre tout en s'enchaînant suivant une certaine logique littéraire. Toutes supposent un mot inexprimé, celui qui se trouve en capitales à la dernière ligne en conclusion et qui est a lui seul la synthèse de l'article, l'article même.

J'ai cru ne pouvoir plus restreindre l'article par déférence pour le Poète. Une autrefois si j'avais à parler de plusieurs livres, je me voudrais

borner à deux ou trois lignes pour chacun, de façon à plus brièvement amener le mot terminal et seul utile, à mon sens.

[Here is the article requested. It consists of a few images evoked in reading *Calligrammes* that account for various aspects of the book and are linked together according to a certain literary logic. They are all predicated on a single implicit word, printed in capitals in the last line, which synthesizes the article, which constitutes the article itself.

I didn't believe I should reduce the article any more out of deference for the Poet. Another time, if I were to review several books, I would like to limit myself to two or three lines apiece so as to arrive at the final word all the more quickly, the only useful word in my estimation.]

Among other things, this precious document sheds additional light on Aragon's debt to Apollinaire. From the beginning, Synthetic Criticism appropriated not only the theoretical assumptions underlying his *poésie critique* but its two main strategies. Like Apollinaire, Aragon incorporated a number of images from the work he was reviewing that expressed its primary concerns. Like his predecessor, he chose a single monumental image, a single *image-clef*, to serve as a metaphorical emblem. Whereas Apollinaire juxtaposed this image with a particular individual, as we saw in chapter 1, Aragon usually established an equation between the metaphor and a particular work. In contrast to the former author, who focused on the creative artist, he preferred to concentrate on the composition itself. Reserved until the last moment, the final (typographically enhanced) term sought, in Navarri's words, to "fixer dans l'esprit du lecteur une représentation quasi visuelle de l'ouvrage considéré" (imprint upon the reader's mind an almost visual representation of the work in question).[15]

As Navarri also points out, Aragon's text obeys the same chronological order as *Calligrammes*.[16] Like the latter work, which covers the years 1913–1918, it chronicles Apollinaire's existence during this period. Following the artistic experiments preceding the war, we glimpse the poet as he progresses from boot camp to the artillery to the front lines where he is wounded, hospitalized, and evacuated to Paris. The composition itself incorporates not just a few but nearly two dozen images borrowed from *Calligrammes*. In addition, it contains various images and stylistic effects that conjure up *Alcools* (1913). This describes the first two lines, for example, in which allusions to both volumes of poetry are closely intertwined. On the one hand, the admonition to post no bills—whose enormous letters de-

face the very wall they are supposed to protect—evokes the typo-graphical experiments in *Calligrammes*. The same thing is true of the graffiti covering the wall, which recall Apollinaire's experiments with visual poetry. The multiple references to hearts, including the name of the street, allude to the cardioid shape in "Coeur couronne et miroir" ("Heart Crown and Mirror").[17] That they are "empennés" indicates that each heart is traversed by an arrow. On the other hand, these lines evoke a corresponding passage in "Zone," which introduces the reader to *Alcools*. Like Aragon, Apollinaire is intrigued by a variety of messages as he strolls along a city street. Like Aragon he relates what takes place not from a retrospective vantage point but as it actually happens. "Tu lis les prospectus les catalogues les affiches" (You read the handbills the catalogues the posters), he declares in the second person, as if he were describing someone else (*OP*, p. 39). Like Aragon he also examines inscriptions printed on the walls.

The first few lines of Aragon's text introduce a second stylistic trait that recurs regularly thereafter: persistent wordplay. Most often, as in the progression from "coeurs empennés" to "coeurs en peine" it involves paronomasia. Although the constant punning seems gratuitous initially, it has a double function. In the first place, by creating an exuberant mood it conveys the reviewer's enthusiasm for Apollinaire's poetry. In the second place, it alludes to the poetry itself in which punning constitutes an important rhetorical device.[18] Except for the artillery shell, which appears in subsequent portions of *Calligrammes*, the initial images are taken from the first section. If Aragon finds much of the war poetry to be "trivial," he clearly admires the revolutionary aesthetics introduced by the earlier poems. The image of the tangerine, for example, evokes the *poème simultané* "Les Fenêtres" ("The Windows"), which concludes with a breath-taking simile: "La fenêtre s'ouvre comme une orange / Le beau fruit de la lumière" (The window opens like an orange / That lovely fruit of light) (*OP*, p. 169). Similarly, the fellows seated in the café seem to refer to "Lundi rue Christine" ("Sunday Christine Street") (OP, pp. 180–82), which introduced the conversation poem.

To these examples should be added the high silk hat resting on the tablecloth and the hill into which it is transformed. Both images are borrowed from "Les Collines" ("The Hills") (*OP*, pp. 171–77), where they are associated with Marc Chagall's painting and with the prophetic vocation respectively. The mouthless sideshow performer may refer to the acrobats in "Un Fantôme de nuées" ("A Cloud

Phantom") (*OP*, pp. 193–96), as Navarri suggests, or to the strange individual in "Les Collines" who is able to swallow himself. He also resembles the protagonist of "Le Musicien de Saint-Merry" (*OP*, pp. 188–91) who, although he possesses a mouth, has no eyes, no nose, and no ears. The fact that Aragon's character speaks "par son ventre" links him to the *pétomane* as well—to that incredible exhibitionist who entertained crowds with his flatulence at the beginning of the century.

With the outbreak of the war the wordplay suddenly intensifies: "Le poète menteur a la franchise militaire." Lurking behind this paradoxical statement, a metaphor and a pun allow us to resolve the apparent contradiction. Apollinaire is presumably a liar because he manages to pass off his illusions of reality for reality itself. In a similar vein, Jean Cocteau defined the work of art as "un mensonge qui dit toujours la vérité" (a lie that always tells the truth).[19] That Apollinaire also speaks with a military frankness is explained by the fact that he was an indefatigable correspondent during the war. Like everyone who was serving in the armed forces, he benefited from a military exemption or *franchise militaire* that dispensed him from having to pay postage. The House in the following line comes from "Paysage" ("Landscape") (*OP*, p. 170), where it is juxtaposed with a tree and a man smoking a cigar. Reserved for stars and divinities before the war, it is occupied by foot soldiers and others who, together with Apollinaire, have arrived on horseback.

Like the opposition "puis" / "puits," which harks back to "La Tzigane" ("The Gypsy Woman") (*OP*, p. 99), the pairing of "Damas" and "damas" conjures up a poem from *Alcools*. Lamenting the loss of Annie Playden in "La Chanson du mal-aimé" ("The Song of the Jilted Lover"), Apollinaire exclaims at one point: "Et moi j'ai le coeur aussi gros / Qu'un cul de dame damascène" (And my heart is as swollen / As a Damascus lady's behind") (*OP*, p. 55). The same thing is true of the reference to Rosemonde, which evokes a poem by the same name that also belongs to *Alcools* (*OP*, p. 107). Although the allusion to a magic well (in italics) is puzzling, Aragon may be thinking of a proclamation in "Les Collines": "Voici le temps de la magie" (Behold the era of magic) (*OP*, p. 172). Or since the well and the Argonne battlefield are placed in apposition, the latter may be the source of the magic, which in that case would be aesthetic. In "Merveille de la guerre," for instance, Apollinaire exclaimed "Que c'est beau ces fusées qui illuminent la nuit" (How beautiful these flares are that illuminate the night) (*OP*, p. 271). This interpretation

is strengthened by the reference to the road to Damascus in the next line, where St. Paul experienced divine illumination. If this reading is correct, the spoonerism "l'Argonne t'égare" would suggest that Apollinaire was misled initially by the war's apparent splendor. True beauty is the province of the female sex—personified here by Madame Rosemonde.

The automobile that appears at this juncture evokes the vehicle in "La Petite Auto" (*OP*, pp. 207–08), which symbolizes the transition from one historical period to another. As Apollinaire soon realized, the war marked the end of the Belle Epoque and the beginning of a whole new era. Coupled with the injunction "en avant," the fact that his vehicle is advanced transforms it into an aesthetic symbol as well. Not only was Apollinaire a progressive poet himself, but he was the acknowledged leader of the avant-garde. Whereas he persisted in writing war poetry, Aragon urged him to return to a subject at which he truly excelled: love. On the one hand, "l'autre amour" evokes his previous involvement with Madeleine and possibly with Lou, both of whom appear in *Calligrammes*. On the other, it suggests that more love affairs await him in the future. As Navarri points out, the final images were inspired by several lines from "Chant de l'horizon en Champagne": "moi l'horizon je fais la roue comme un grand Paon / Ecoutez renaitre les oracles qui avaient cessé / Le grand Pan est ressuscité" (I the horizon I spread my tail like a great Peacock / Listen to the oracles resume that had fallen silent / Great Pan is reborn) (*OP*, p. 266).

Madeleine Boisson argues convincingly that Pan is identified with Argus in these verses, whose emblem is the peacock, and that they describe the starry sky overhead.[20] By contrast Aragon's drama takes place in broad daylight and involves the sun rather than the stars. The image of the blindman staring at the solar disc seems to have been suggested by two other lines: "Je l'adore comme un Parsi / Ce tout petit soleil d'automne" (Like a Parsi I adore / This tiny autumn sun). Thus Aragon's *aveugle* would seem to be an Indian disciple of Zoroaster who, either deliberately or accidentally has been blinded by gazing directly at the sun. Although the punning juxtaposition of Pan and peacock is taken from the earlier poem, Aragon complicates the equation by introducing a third homonym: *paon / Pan / pan!* The sound of the exploding shell that wounded Apollinaire in the head announces the final theme. Paradoxically this terrible experience, which nearly cost the poet his life, may have been a blessing in disguise.

Apollinaire raised this possibility himself in "Tristesse d'une étoile" ("Sorrow of a Star") (*OP*, p. 308), where he envisioned Minerva springing fully armed from his brow in a reenactment of the Greco-Roman myth. Thus his own role paralleled that of Jupiter and conferred a divine status on the creative impulse. However, Aragon selected another mythological character to symbolize the poet's renewed inspiration: the great god Pan. Rather than the goddess of wisdom, whose famous chastity clashed with the theme of love, he preferred a deity whose sensuality (like Apollinaire's?) was notorious. Rather than mighty Jupiter, he chose a deity who was intimately associated with lyric poetry. For while Pan assumed a number of different guises, he was above all the inventor of the *syrinx* or shepherd's flute. The story of his death and resurrection was invented by later authors, who equated Pan with ancient paganism. Just as his death symbolized the defeat of pagan forces by Christianity, his miraculous rebirth centuries later would herald the dawn of a marvelous new era. Apollinaire applied the myth to the twentieth century which, he predicted, would rise like a phoenix from its ashes. Aragon related the myth to Apollinaire himself who, refined in the war's crucible, would reincarnate "le grand Pan." In point of fact, each of these developments was predicated upon the other.

Despite repeated attempts to explain the final line, which in theory summarizes the preceding images, Navarri is ultimately unsuccessful. Adopting a shotgun approach, he declares that the glorious roses evoke 1) scattered references to the flower (and the color) in *Calligrammes*, 2) Apollinaire's tendency to view the war through rose-colored glasses, and 3) Aragon's attempt to surprise the reader. However, there is no need to go to such unconvincing lengths to justify the final equation. On the one hand, the fact that the cannon causes Apollinaire's head to burst into flower refers to similar events in *Calligrammes*. Rather than actual flowers, it recalls frequent descriptions of signal flares whose "rose éclatement" (rosy burst) transforms them into "fleurs de feu" (flowers of fire) (*OP*, pp. 238 and 289). Indeed, the same collocation of cannon and floral explosion occurs in "Chevaux de frise" ("Barbed-Wire Barriers"): "La fusée s'épanouit fleur nocturne" (The flare blossoms nocturnal flower) (*OP*, p. 303). On the other hand, the terminal formula alludes to a manifesto entitled *L'Antitradition futuriste*, which Apollinaire composed in 1913.[21] Briefly allying himself with the Italian Futurists, the poet showered roses on various avant-garde figures and bombarded their reactionary counterparts with excre-

ment. Inspired by Apollinaire's example, Aragon bestowed the first accolade on *Calligrammes* while reserving the second for future occasions.

Thereafter Aragon pursued the plan he had outlined in his letter to Albert-Birot. Reducing the text to a fraction of its former size, he emphasized the basic metaphoric equation by printing it in boldface capitals. In November he compared a book on Cubism by Roland Chavenon, who had nothing new to say, to a process-server's affidavit. By contrast he found Paul Claudel's play *Le Pain dur* to be as rewarding as cashing in a large bond. In December Aragon equated a book by Léon Bloy, who droned on and on, to a bumblebee, and assorted poems by Walt Whitman, whose fresh visions and original inflections appealed to him, to a professor of modern languages. Blaise Cendrars' *Le Panama ou les aventures de mes sept oncles,* he confided, reminded him of a flashy parrot. Whereas a savory book by Emile Dermeghem resembled an olive, he continued, Fernand Divoire's latest collection of poetry was the work of a sorcerer. Following Apollinaire's death the same month, Aragon published a moving tribute to the poet in February 1919 and two more reviews in March. While the November texts had averaged six lines apiece, the latest reviews were twice as long. Claiming to perceive a resemblance between Max Jacob's novel *Le Phanérogame* and La Bruyère's *Les Caractères,* he playfully accused the author of plagiarism. Similarly, the hero of Jean Giraudoux's *Simon le pathétique,* despite his constant womanizing, reminded him of Jean-Jacques Rousseau's *Rêveries d'un promeneur solitaire* (*Reveries of a Solitary Walker*).

Although *SIC* continued to be published until the end of the year, Aragon transferred his allegiance at this point to *Littérature,* which he founded the same month with Breton and Soupault. The first issue contained two examples of Synthetic Criticism that, with one exception, conformed to the model inaugurated six months before. While Aragon continued to juxtapose each work with a single, monolithic image, he no longer printed the latter in capital letters. Although the final impact was somewhat diminished, at the same time the text acquired an added subtlety. The terminal metaphor no longer jumped out at readers but snuck up on them instead. The first text was devoted to a collection of Dada poetry by Tristan Tzara entitled *Vingt-cinq poèmes*:

> On ne sait jamais si c'est une fleur ou une bête, ni son sexe, et cet homme qui porte une veste à brandebourgs prend trop de libertés avec

les sexes. Mais le vent l'emporte; il n'y a que du vent et l'on vend au rabais toute la quincaillerie du bazar: solde avant inventaire. Le livre ne touche que les marchands d'images. Ils font des étoiles et marquent les prix d'achat devant les numéros. Vous voyez bien que c'est un catalogue.

[One never knows if it is a flower or an animal, nor its sex, and that man wearing a jacket with frogs and loops takes too many liberties with the sexes. But the wind triumphs; there is nothing but wind, and all the hardware in the bazaar has been marked down: a pre-inventory sale. The book only appeals to picture sellers. They record the price before each number and add an asterisk here and there. You can see from this that it's a catalogue).

The story of Tzara's triumphal arrival in the French capital the following year has often been told. Assessing the *Vingt-cinq poèmes* for Jacques Doucet in 1922, Aragon recalled: "Nous fûmes quelques-uns qui l'attendîmes à Paris comme s'il eût été . . . Rimbaud" (We waited eagerly for him to come to Paris as if he had been . . . Rimbaud).[22] Tzara's poetry broke so completely with tradition, he explained, that it filled him and his colleagues with boundless excitement. Like Rimbaud's *Illuminations* and Lautréamont's *Chants de Maldoror*, it amounted to a declaration of war. At the same time, Aragon confessed he had failed to appreciate the poetry's full worth initially because the encounter was so traumatic. This somewhat sheepish admission is confirmed by the present text, which is frankly critical. Instead of praising the volume's anarchic spirit and endless diversity, the author concentrates on what he considers to be its shortcomings. Whereas the companion review expresses his admiration, as we will see shortly, the present one is filled with reservations. Not surprisingly, perhaps, the second text is more than twice as long as the first.

Detailed comparison of Aragon's text with the volume he was reviewing turns up an interesting fact. Without exception, none of the images is taken from Tzara's poetry. On the one hand, according to Mary Ann Caws, the twenty-five poems are characterized by vivid color, movement, light, direction, and geometrical figures.[23] On the other, these traits are conspicuously absent from the comparison text. Since his readers were familiar with Apollinaire, Aragon was free to refer to his poetry as much as he liked. However, since few people in Paris had ever heard of Tzara, he was obliged to adopt a different strategy. Instead of reproducing Tzara's imagery, he began by evoking the volume's unusual illustrations, which were as star-

tling as the poetry (see figure 1). Executed by Hans (Jean) Arp, the ten woodcuts exemplified the artist's lifelong preoccupation with abstract biomorphic forms. As Aragon noted, it was impossible to tell whether the designs depicted flora or fauna and, assuming the latter, whether the figures were male or female. Convinced they represented crabs and squid, another critic detected human forms as well.[24]

The next reference is undoubtedly to Tzara himself who presides over the images that follow. While Aragon could conceivably have seen a photograph of him wearing a "veste à brandebourgs," he probably chose the jacket himself. Since Tzara had published a number of texts in German, Aragon seems to have been under the impression that this was his native tongue. The expression alludes not only to Brandenburg province in Prussia, therefore, where the garment originated, but to the poet's supposedly Teutonic origins. The remainder of the initial sentence is tantalizing and rather puzzling at the same time. What kind of liberties, one wonders, has Tzara taken with members of both sexes? After considerable effort, one perceives that the statement refers not to wanton behavior on Tzara's part but to persistent gender confusion. The latter is not genetic or psychological in nature, moreover, but grammatical. Since the artist's command of French was far from perfect, he occasionally mistook a masculine noun for a feminine one and vice versa.

Turning to the poems themselves, Aragon utilized three distinctive metaphors to describe the endless cascade of images. That he found the works disconcerting, even overwhelming, is apparent at first glance. The trouble with Tzara's poetry, the first metaphor implies, is that it lacks substance. Like the wind it is hopelessly diffuse, totally unstructured, and thus devoid of meaning. Although the second metaphor is preceded by some lighthearted wordplay, opposing "vent" to "vend," it is equally demeaning. For one thing, *quincaillerie* is used in a pejorative sense to describe jewelry that is false or in bad taste. For another thing, the comparison is obviously meant to be unflattering. Like a pile of pots and pans in some dingy marketplace, Tzara's poems are flashy, cheap, and vaguely disreputable. Instead of a few carefully chosen images, he fills them with all the mental hardware he can find. The text culminates with a third metaphor, drawn from the art world, that confirms this assessment. Like paintings at the annual Salon des Indépendants, where anyone could exhibit who wanted to, Tzara's images were amazingly varied. Since they appeared to be selected at random, Aragon compared

tristan tzara

vingt-cinq poèmes

h arp

dix gravures sur bois

collection dada zurich

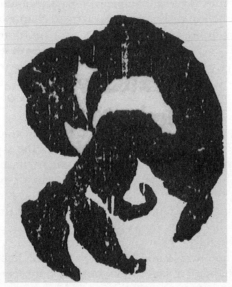

Figure 1. Hans (Jean) Arp, woodcut from *Vingt-cinq poèmes* by Tristan Tzara, 1918.

the volume to the Indépendants' catalogue, which listed the pictures in the order in which they were submitted. The "marchands d'images" making notes in the margins of their catalogues are art dealers who have been invited to the *vernissage*, where they can view the paintings in advance.

The second text was devoted to a book by Pierre Reverdy entitled *Les Jockeys camouflés et Période hors-texte* (*The Camouflaged Jockeys and Illustrative Period*). Consisting of three poems and a short story, it featured five drawings by Henri Matisse.[25] Whereas Aragon had been intrigued by Arp's illustrations previously, Matisse's contributions apparently failed to impress him. Ignoring the drawings altogether, he began by describing the appearance of the book itself.

> Poser mes doigts sur ce livre si blanc, couleur des fantômes. Je l'avais déjà lu, chaque fois que mes regards heurtèrent le ciel, la glace, le mur, des yeux stupides, toutes les surfaces unies. Il y a des heures trop tristes, d'autres trop exaltantes: tour à tour, les nuits gris perle où l'on marche sur les routes en confiant sa vie à des inconnus, les noires qu'on traverse sans voir la fatigue, les matins clairs, sans raison, par simple tournure d'esprit, les jours froids et vifs comme des joues au grand air, il y a la lumière toute nue. Il y a un homme comme une boule dans un corridor qui roule et rebondit de l'ombre à la clarté. Il chante un air qu'on n'entend pas, sans doute un air de danse. Dans le sommeil, la fièvre ou l'ivresse, il sait écarquiller les paupières au moment que les autres perdent conscience. Sa lucidité à de pareilles profondeurs m'effraie. Il me fixe avec des yeux d'épouvantail. Ses bras s'agitent dans le vent, et sa voix, et lui-même, se perdent dans le murmure des arbres.

> [Placing my fingers on this book, so white, the color of phantoms. I had already read it each time my glance struck the sky, the mirror, the wall, stupid eyes, every smooth surface. Some hours are too sad, others too exalting: by turns the pearl grey nights when one walks along the paths trusting one's life to strangers, the dark nights that one traverses without noticing one's fatigue, the clear mornings for no reason, by a simple mental operation, the cold days like cheeks glowing in the brisk air; there is the naked light. There is a man like a ball rolling down a corridor and bouncing from the shadow into the light. He is singing a silent song, doubtless a dance tune. Immersed in sleep, fever, or drunkenness, he knows how to open his eyes when the others begin to lose consciousness. His lucidity at such depths frightens me. He stares at me with scarecrow eyes. His arms flail in the wind, and his voice—like he himself—is lost in the trees' murmurs].

Although phantoms figure prominently in the initial poem, enti-
tled "Les Jockeys mécaniques," Aragon's ghosts differ markedly
from those envisioned by Reverdy. Unlike the former, who spur
their fiery steeds across the night sky, they seem to be dressed more
conventionally in white sheets. What links them to the "livre si
blanc," therefore, is primarily their color. Stationed at the begin-
ning of the text, Aragon's ghosts serve as enigmatic emblems as well.
As such they refer to Reverdy's poetry in general which features
anonymous individuals engaged in mysterious missions amid equally
mysterious surroundings. Like Aragon's ghosts, the camouflaged
jockeys and their cohorts lead an enigmatic existence. The images
in the second sentence continue this theme and emphasize the
poetry's opacity. Trying to decipher Reverdy's poems, the author
claims, is like trying to glimpse heaven or like interrogating some-
one who is unconscious. Like a mirror or a wall or for that matter
any solid surface, the compositions are basically impenetrable. To be
sure, Reverdy's poetry contains frequent references to the sky and to
walls, which constitute an important thematic resource. Rather than
cataloguing the poet's motifs, however, Aragon strives to recreate
the eerie atmosphere that had become his trademark.

As the text proclaims, Reverdy's poetry tends to alternate between
despair and elation as day fades into night and vice versa. Like a rub-
ber ball rolling in and out of the shadow, Aragon jokes, the poet
bounces back and forth between light and darkness. Adding to the
air of mystery, the song Reverdy is singing falls invariably on deaf
ears. The dance of his creative intellect is simply too subtle for
human intelligence to apprehend. The text concludes with a eulogy
of Reverdy's amazing ability to penetrate the realm of the uncon-
scious, which can be glimpsed in dreams, in moments of delirium,
and in drunken behavior. Like his surrealist colleagues, Aragon was
fascinated—and frightened—by the irrational impulses that perme-
ated the poet's work. Whereas Tzara was portrayed as a cataloguer,
Reverdy is ultimately depicted as a scarecrow. At first glance, this
image appears to have been suggested by the second poem in the
series in which a mysterious drunkard is buffeted by the wind. In
retrospect one perceives that the metaphor continues the theme of
fright introduced in the previous sentence. Reverdy is transformed
into an *épouvantail* because he is associated with *épouvante*. What
makes him so remarkable, Aragon concludes, is the uncanny skill
with which he exploits our unconscious fears.[26]

Philippe Soupault

Inspired by Aragon's example, many other poets began to experiment with Synthetic Criticism as well. Although the genre appealed mainly to his surrealist colleagues, who would explore its possibilities during the next decade, it attracted the attention of several additional poets who were committed to different goals. These included Reverdy himself and the Italian poet Giuseppe Ungaretti, both of whom published examples in *Littérature* the same year. In general, as Navarri observes, "la critique synthétique reste une critique du premier contact, écrite à chaud, d'une manière presque automatique" (Synthetic Criticism remains a criticism of first impressions, written in the heat of the moment, in a virtually automatic manner).[27] Its spontaneous nature, he adds, is more apparent in Soupault's compositions than in those authored by Aragon. Indeed, since they were composed during the same period, some of the texts resemble passages in *Les Champs magnétiques*.

Like Aragon, who was preoccupied with literary works, Soupault contributed a monthly column to *Littérature*. Entitled "Les Spectacles," it concentrated on various types of entertainment and reflected the surrealists' eclectic taste. While some columns were concerned with sophisticated genres such as plays and the ballet, others were devoted to more lowly art forms. Besides boxing matches, these included dance competitions, ice skating, and the movies, which were commonly regarded as a popular amusement. Soupault was particularly excited by the cinema which, although still in its infancy, offered endless creative possibilities. While he enjoyed an occasional western or melodrama, he loved a good comedy more than anything. Published in June 1919, his first attempt at Synthetic Criticism focused on a film by Charlie Chaplin. Soupault seems to have found his comic genius irresistible, for "Charlot" was to reappear in his column again and again.

Considered by many critics to be Chaplin's first masterpiece, *A Dog's Life* (1918) (figure 2) is an extraordinary achievement by any standard. Indeed, Dan Kamin argues that its organic unity makes it his most perfect work.[28] For the first time, Chaplin later confided, he began "to think of comedy in a structural sense, and to become conscious of its architectural form. Each sequence implied the next sequence, all of them relating to the whole."[29] Chaplin himself played the familiar role of the little tramp, who had already become

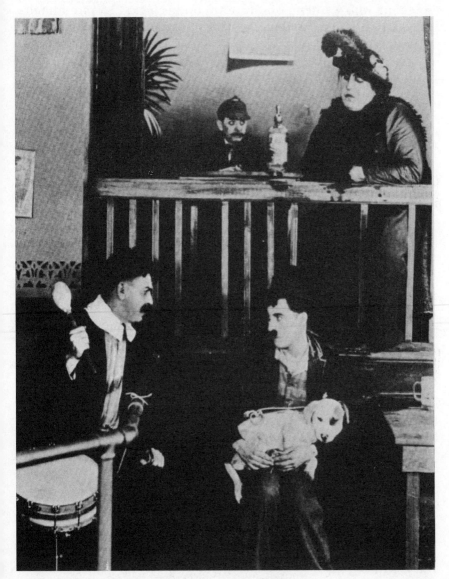

Figure 2. Charles Chaplin, frame from *A Dog's Life*, 1918.

his trademark by that date. According to Georges Sadoul, *A Dog's Life* established the character once and for all.[30] Dapperly dressed and carrying a cane, he was not a professional hobo but merely someone who was temporarily down on his luck. "La pire humiliation d'un homme," Sadoul explains, "est d'être sans travail et sans amour" (the worst humiliation for a man is to be out of work with no one to love him). In *A Dog's Life,* the tramp succeeds in solving both these problems with the help of his canine companion.

Despite its frequent reversals, the plot, which is dominated by sight gags, is relatively simple. Outmaneuvered by a mob of applicants, Charlie fails to obtain a job but rescues a stray dog vying with a pack of vicious hounds for a bone. Man and beast turn out to have quite a bit in common. Both are relegated to the margins of society without a home to call their own. Both are permanent underdogs in the daily fight for survival. Somehow they eke out a precarious existence in what is clearly a dog-eat-dog world. When Charlie meets an unhappy singer in a dive called The Green Lantern, he contrives to rescue her as well. His dog conveniently digs up a fat wallet, he himself outwits the thugs who buried it, and the three of them retire to a little farm. Completing their domestic bliss, the dog presents her master and mistress with a litter of puppies in the last scene. While Soupault's review follows the story's general outline, the picture it paints seems impersonal and hence abstract. Although Soupault evokes actions and objects that figure in the film, he insists on using the passive voice. Not only are the human actors difficult to discern, but there is no trace of the dog whatsoever.

> A cinq heures du matin ou du soir, la fumée qui gonfle les bars vous prend à la gorge: on dort à la belle étoile.
>
> Mais le temps passe. Il n'y a plus une seconde à perdre. **Tabac.** Au coin des rues on croise l'ombre; les marchands établis aux carrefours sont à leur poste. Il s'agit bien de courir: les mains dans les poches on regarde. **Café-Bar.**
>
> A la porte on écoute le piano mécanique. L'odeur de l'alcool fait valser les couples.
>
> **Ils sont là.**
>
> Au bord des tables, au bord des lèvres les cigarettes se consument: *une nouvelle étoile chante une ancienne et triste chanson.*
>
> On peut tourner la tête.
>
> Le soleil se pose sur un arbre et les reflets dans les vitres sont les éclats de rire. Une histoire gaie comme la boutique d'un marchand de couleurs.

[Five o'clock in the morning or at night, the smoke swelling the bars seizes you by the throat; sleeping in the open air.

But time passes. Not a second to lose. **Tobacco**. At the street corners shadows accost you; the corner merchants are at their posts. It is a matter of running: hands in pockets, someone is watching. **Café-Bar**.

At the entrance a player piano can be heard. The odor of alcohol makes the couples waltz.

They are there.

Around the tables, dangling from lips cigarettes are consumed: "a new star sings an old, sad song." One can turn one's head.

The sun alights on a tree, and the reflections in the windows are bursts of laughter. A gay story like a shop that sells oil paints.]

The first sentence evokes the film's opening sequence, in which we discover the little tramp asleep in a vacant lot. Following a hilarious game of hide and seek with a policeman, who sees him steal a hotdog, Charlie spies an advertisement outside an employment office for someone to work in a brewery. Since a bunch of loafers also spot the notice, he hurries to apply for the job ahead of them. As Soupault observes, "il n'y a plus une seconde à perdre." Unfortunately, Charlie is no match for the other applicants, who consistently outmaneuver him. Back outside, he rescues his canine co-star and watches a pack of dogs raid a merchant's food stand. Soupault briefly describes the merchants in the streets and inserts a sudden flashback. Once again we see the loafers with their hands in their pockets and the tramp scurrying into the employment bureau.

Resuming his narrative, Soupault shifts to the cheap dance hall where Charlie finds the girl of his dreams working as a singer. Although the words "**Cafe-Bar**" serve to identify the premises, like "**Tabac**" a few lines earlier, neither sign appears in the film. Like the player piano, who replaces a four-piece band in *A Dog's Life*, they were invented by Soupault for the occasion. By contrast, the portrait of the dance hall's clientele, who surround Charlie and the singer ("Ils sont là"), is entirely accurate. The hall is filled with boisterous couples smoking, drinking, and dancing with gay abandon. The *"nouvelle étoile [qui] chante une ancienne et triste chanson"* is Charlie's lady love, who earlier reduced her audience to tears. The phrase itself reproduces one of the film's captions. Her song was so sad, Soupault recalls, that the tramp kept turning his head away to avoid being drenched by his neighbor's (grossly exaggerated) tears.

The final paragraph introduces three separate metaphors that are linked to each other metonymically. The first metaphor compares

the sun, glimpsed through the branches of a tree, to a bird alighting on a bough. Since the sun's downward course indicates it is about to set, the trope announces that the text is about to conclude. It is time for the author (and the reader) to retire. The second metaphor equates the sun's reflections in some windows to bursts of laughter—presumably uttered by members of the film's audience. Involving an implicit play on words (*éclats* also means "splinters of glass"), it reminds us that *A Dog's Life* is a comedy. The movie is not only funny, the third metaphor insists, but as colorful and as cheery as a well-stocked paint store. Without a doubt, it implies, Chaplin is an accomplished artist.

Whereas American critics agree that *A Dog's Life* is a very funny film, French reviewers are not so sure. Unlike the former, who concentrate on the comic elements, they have tended to neglect the work's apparent optimism and to focus on other, more disquieting aspects. In 1927, the surrealists themselves insisted that the director was "a terrifying pessimist."[31] More recently, Sadoul has advanced the thesis that *A Dog's Life* is a parody of the Hollywood dream machine.[32] If these interpretations seem a trifle forced, critics on both sides of the Atlantic are agreed that *The Immigrant* (1917) is a splendid social satire. As Theodore Huff remarks, it is an advanced comedy that compares favorably with any of Chaplin's later works.[33] Sadoul downplays the comic elements and extols the work's subversive nature. "Ce film au vitriol," he exclaims, "dénonce un des mensonges-clefs de la propagande américaine" (This vitriolic film . . . denounces one of the key falsehoods of American propaganda).[34] Entitled *Charlot voyage* in French, the movie is divided into two approximately equal halves. The first part follows a group of immigrants, including Charlie, as they sail across the ocean to their new home. The second chronicles the tramp's misadventures once he arrives. Like Sadoul, the surrealists praised the first half in particular for attacking the myth of America as the Land of Liberty.

> Let us remember the tragic spectacle of the steerage passengers labeled like cattle on the deck of the ship landing Charlot in America; the brutalities of the law's representatives, the cynical examination of the emigrants, the dirty hands fumbling the women in the land of Prohibition, under the classic stare of Liberty Lighting the World . . . , the threatening shadow of the cops who run down the poor, popping up at every street-corner, suspecting everything, beginning with the vagabond's wretched suit, then his perpetually falling cane . . . then the hat, the mustache, and so on down to the frightened smile.[35]

Published in *Littérature* in August 1919, Soupault's review was divided into two parts like *The Immigrant* itself. Consisting largely of images taken from the film, each section concluded with a metaphor that commented succinctly on the preceding passage. Although Soupault neglected the distressing episodes singled out by later viewers, he hinted at an underlying malaise toward the end.

Le roulis et l'ennui bercent les journées. Nous avons assez de ces promenades sur le pont: depuis le départ, la mer est incolore. Les dés que l'on jette ou les cartes ne peuvent même plus nous faire oublier cette ville que nous allons connaître: la vie est en jeu.

C'est la pluie qui nous accueille dans ces rues désertes. Les oiseaux et l'espoir sont loin. Dans toutes les villes les salles de restaurants sont chaudes. On ne pense plus, on regarde les visages des clients, la porte ou la lumière. Est-ce que l'on sait maintenant qu'il faudra sortir et payer? Est-ce que la minute qui est là ne nous suffit pas? Il n'y a plus qu'à rire de toutes ces inquiétudes.

Et nous rions tristement comme des bossus.

[The rolling and the boredom lull the days to sleep. We have had enough of these promenades on deck: since our departure the sea has been colorless. Throwing dice or playing cards can no longer make us forget the city we are going to encounter: life itself is at stake.

The rain welcomes us in these deserted streets. The birds and hopefulness are lost in the distance. In every city the restaurants offer a warm refuge. One no longer thinks, one observes the customers' faces, the door, or the light. Do they realize it is time to pay and leave? Isn't a minute there enough for us? The only course that remains is to laugh at all these anxieties.

And so we laugh sadly like so many hunchbacks].

The first two lines evoke the trials and tribulations of a long sea voyage. Although the passengers encounter a violent storm early in the film, Soupault chooses to ignore this highly amusing sequence. Instead the verb *bercer* suggests the ship is being rocked gently by the waves, like a baby in its mother's arms. To relieve the monotony that sets in before long, the passengers take endless walks on deck, which only aggravates the situation. Since the vessel's size prevents them from going very far, they must constantly retrace their steps. And since they are exposed to the same view day after day, this distraction quickly becomes tedious. Reduced to a pale imitation of itself, even the ocean fails to interest them. To while away the time, therefore, some of the passengers resort to gambling. Flush with his winnings

from a dice game, the tramp meets an old woman and her daughter whose savings have been stolen. Accused of being a thief when he slips some money into the girl's pocket, he pulls a gun when the real thief tries to cheat him at cards. Despite their anecdotal interest, Soupault neglects these details and focuses on the gambling, which he transforms into a metaphor for the trip itself. In abandoning the Old World for the New, the passengers are gambling that they will be able to better their lot in life. Throughout the voyage they dream incessantly of the city that awaits them, which they know only through (idealized) pictures.

When the immigrants finally reach New York, we learn in the next paragraph, they find they have simply exchanged one bunch of problems for another. Instead of brass bands and speeches welcoming them to America, they discover the streets are deserted and that it is pouring rain. Nobody really cares if they live or die. The hope that sustained them for so long falters with the discovery that the bluebird of happiness has flown the coop. Rather than invoke the indignities suffered at Ellis Island, so graphically portrayed in the film, Soupault invents a depressing landscape (or cityscape) for the immigrants to inhabit. Finding a coin on the sidewalk, the tramp goes into a nice warm restaurant where he encounters the girl once again. Whereas the film's second half is cleverly constructed around the elusive coin, which passes from Charlie to another customer to the enormous waiter and back to Charlie, Soupault does not mention this comic device at all. He merely asks whether the tramp realizes the time has come to pay the bill. This rhetorical question and the following one introduce a note of uncertainty suggesting that something is amiss. Since this is a comedy, however, Soupault advises us to laugh at the tramp's problems instead of taking them seriously. And yet, he concludes, our amusement is tempered somehow by a lingering sadness. Deep down inside we know perfectly well that hunger and poverty are not funny. Only a moral hunchback, someone with a deformed sense of humor, could derive enjoyment from another person's misery.

For reasons that are not entirely clear, *Sunnyside* (1919) received disappointing reviews from most of the critics, and viewers stayed away from the film in droves. Despite an advertising campaign that included lines such as "How to win a maiden's heart by one who nearly doesn't," the movie was a commercial failure.[36] Although it was known in France as *Une Idylle aux champs*, the life that it portrayed was anything but idyllic. A devastating parody according to

Sadoul, the film depicts "un ouvrier agricole aux Etats-Unis, travaillant de l'aube à la nuit, aux ordres d'un patron avare et cagot" (an American farmhand working from dawn to dusk for a miserly, hypocritical boss).[37] While Gerald McDonald maintains that it is much gentler than most of Chaplin's works, the hapless farmhand receives endless kicks in the pants in the performance of his duties.[38] Whereas Sadoul believes Chaplin sought to expose the deplorable condition of agricultural workers, in fact the abuse is so exaggerated that it is hard to take seriously. Whatever the "réalités sociales" of the period, the film recounts the adventures of a single individual searching for love and happiness.

Like so many of Chaplin's works, *Sunnyside* mixes humor and sentiment in approximately equal amounts. Once again we witness the transfiguring power of love, which inspires a social outcast to transcend his miserable existence. The first half charts his sorry condition as farmhand and flunky at the Hotel Evergreen, ironically situated in a village called Sunnyside. The second traces his efforts to win the love of a beautiful maiden, played as usual by Edna Purviance, which are ultimately successful. Published in *Littérature* in February 1920, Soupault's review followed the same format.

Les poètes savent faire des additions sans avoir jamais rien appris. Charlie Chaplin conduit les vaches sur les sommets où repose le soleil. Au fond de la vallée, il y a cet hôtel borgne qui ressemble à la vie, et la vie n'est pas drôle pour ce garçon qui se croit sentimental.

Nous rions aux larmes parce que les fleurs sont celles du pissenlit et que dans les coquillages on écoute l'amour, la mer et la mort.

[Poets know how to do sums without ever having been to school. Charlie Chaplin drives the cows to the mountain tops where the sun reposes. Down in the valley is a disreputable hotel that resembles life itself, and life is no fun for this boy who has sentimental pretensions.

We laugh until tears come to our eyes because the flowers are dandelions and because one can hear the sound of love, the sea, and death in the seashells.]

By this date, Soupault's approach to Synthetic Criticism had become well defined. Falling back on his familiar model, he replicated the film's structure, highlighted selected images, and devised a rhetorical framework. As before, each paragraph evokes certain events, neglects others, and culminates in a metaphorical statement. At first glance, the text seems to begin with a declaration of poetic princi-

ple. Since poets proceed intuitively, it appears to proclaim, creative
writing courses are basically a waste of time. The sentence refers not
to poetic praxis, however, but to two of Charlie's innumerable du-
ties. Besides working as a farmhand, he runs the hotel store and
waits on tables in the cafe. Despite his lack of education, he has fig-
ured out how to do basic arithmetic. In his spare time, he milks the
cows and pastures them on the sunny hillsides. For a few hours every
day he leads a pastoral existence, at one point even joining a troupe
of nymphs in their dance. By contrast, the life he leads in the valley,
where little sunlight penetrates, is harsh and unrewarding. Like the
hotel itself, which quickly acquires an emblematic status, it is gloomy
and depressing.

All this changes as soon as love enters the picture. While Charlie's
romance with Edna has its ups and downs, it gives new meaning to
his miserable existence and introduces an element of hope. For the
first time in his life, happiness seems to be within his grasp. Soupault
ignores the complications that ensue when a handsome city dweller
tries to woo Edna away and focuses on the initial, idyllic phase. As a
token of affection, he recalls, Charlie presents his sweetheart with a
bouquet of flowers—which upon closer inspection turn out to be
dandelions. Finding a large seashell shortly thereafter, he puts it to
his ear and listens briefly to the sound of the waves. Although
Chaplin's lighthearted clowning introduces a lyrical note, Soupault
injects a disquieting message at several junctures. As in *The Immi-
grant*, our laughter gives way to tears at the realization that every-
thing is not as amusing as it seems. Looming over the composition,
the gloomy hotel proclaims that life is a sordid affair in general
("cet hôtel borgne qui ressemble à la vie"). Despite love's momen-
tary distractions, the seashell whispers, life—like the poem itself—
must inevitably end with death.

3

Critical Syntheses

Benjamin Péret

IF ARAGON'S TEXTS ARE EACH CONSTRUCTED AROUND A METAPHORIC equation, as we noted in the previous chapter, they are sprinkled with metonymic images as well. And whereas Soupault's reviews clearly privilege metonymy, they also include various metaphors. Since these two tropes play a fundamental role in communication, as Roman Jakobson has shown, this situation is not terribly surprising.[1] Although one mode may predominate over the other, discourse is normally governed by similarity as well as contiguity. What makes Benjamin Péret's works so remarkable, by contrast, is that his vision is almost exclusively metaphoric. Since the role of metonymy is sharply restricted, contiguous relations are relatively scarce. This is true whether one considers his poetry or his prose. In addition to the metaphoric density and kaleidoscopic imagery that characterizes Péret's style, many of the early compositions employ metaphors borrowed from science and/or mathematics.

Published in *Les Feuilles Libres* in April 1922, one of Péret's more interesting experiments with Synthetic Criticism was inspired by both disciplines. Reviewing Tzara's *Calendrier cinéma du coeur abstrait.—Maisons* (*Cinematic Calendar of the Abstract Heart.—Houses*) (1920), which included nineteen woodcuts by Arp, he drew on analytical geometry, physics, and chemistry in that order:

> Quand je dis un cela peut aussi signifier deux. Une pomme tombe d'un point X sur un plan Y. La Pomme éclate comme une trompette en touchant le plan J. Qu'est devenu le point X?
>
> Dans un tube de Crookes sourit un estomac à côté d'un danseur monocle. Comment allez-vous Tzara?—Pas mal, merci, et vous?
>
> Il n'y a aujourd'hui que des prêtextes, mais ils ne tuent pas toujours, telle cette fin de "Maison Flake":
>
> [he quotes the last nine lines]

Après cela, si les étoiles se cristallisent, si les barbiers deviennent des empereurs, si le tabac nourrit les poissons d'eau douce, est-ce notre faute à nous qui voulons vivre comme des épingles? Quelquefois un cheveu passe. Si on le suit, on arrive à une grande ville qui ressemble à Paris, mais qui n'est pas Paris. Quant aux singes du langage laissez-les à l'air libre ils se décomposeront rapidement et de si jolis papillons chimiques s'envoleront de la charogne et iront plus loin exploser en répandant des vapeurs où l'on retrouvera les parfums mélanges du citron et du peroxyde d'azote.

Croyez-moi ou ne me croyez pas, ce livre est un beau livre, utile comme un shampooing, agréable comme une locomotive, et que je ne suis pas près d'oublier.

[When I say one that can also signify two.

An apple falls from point X onto plane Y. The apple bursts like a trumpet upon touching plane J. What has happened to point X?

In a Crookes tube a stomach smiles beside a dancer with a monocle. How are you, Tzara?—Not bad, thanks, and you?

Today there are only pretexts, but they don't always kill, like the end of "Flake House":

[he quotes the last nine lines]

After that, if the stars crystalize, if barbers become emperors, if tobacco nourishes fresh-water fish, is it our fault who want to live like straight pins? Occasionally a hair passes. If you follow it, you arrive at a large city that resembles Paris, but which is not Paris. As for the language monkeys leave them in the open air and they will decompose rapidly and such pretty chemical butterflies will emerge from the carcass that will later explode emitting an odor of lemon and nitrogen peroxide.

Believe it or not, this is a beautiful book, as useful as a shampooing, as pleasing as a locomotive, which I will not soon forget.]

The first sentence echoes various statements in Tzara's manifestos that, unlike most of his poetry, are written in a declarative mode. As such, it exemplifies his nonsensical approach to writing in general which, paradoxically, often turns out to make sense. Resembling a Dada aphorism, the sentence seems to self-destruct while hinting obscurely at a mathematical model. On the one hand, it is obviously absurd. While a letter may possess a numerical value (a = 2), a number cannot possibly represent another number (1 = 2). On the other hand, the sentence says a great deal about the two men's poetics. Like Tzara, whose works are fiercely antilogical, Péret is not afraid to contradict himself. Like the latter, he refuses to assign a permanent value to his words because poetry—because to some ex-

tent all discourse—is largely indeterminate. For if thought originates in the mouth, as Tzara was fond of proclaiming, its mission is not complete until the speaker's words reach the listener's brain. In a similar manner, it is the reader who ultimately decides what the author of a particular text was trying to say.

The next three sentences refer to a related problem that greatly complicates the reader's task: the unconventional nature of Tzara's inspiration. Since he rejects such traditional principles as organic unity and logical development, his compositions seem largely incoherent. Like the initial sentence, therefore, this section illustrates the shortcomings of Cartesian rationalism. Whereas traditional poetry resembles Euclidean geometry, which is restricted to three dimensions (X, Y, Z), Tzara's works resemble non-Euclidean geometry, which possesses an indefinite number of dimensions (A, B, C, D, E, F, G, H, I, J . . .). Whereas Isaac Newton's apple was restricted to the former universe, Tzara's enables him to transcend traditional boundaries. Although orthodox poets, geometers, and apples proceed in a linear fashion, his itinerary is circuitous, erratic, and unpredictable. Eventually even Tzara's apple bursts—like a blast of music from a trumpet—when it collides with plane J. By this time its point of origin has long ceased to matter. What counts is not the author's intentions but the impact of the poem on its audience.

At this juncture, Péret compares Tzara's poetry to a device that revolutionized the study of medicine. Toward the end of the nineteenth century, Sir William Crookes invented a primitive X-ray tube that allowed doctors to view a patient's insides for the first time. Like this amazing invention, Tzara's works provide a precious glimpse of a domain that was formerly inaccessible. Inspired by the poet's example, Péret trains the Crookes tube on the volume before him and discovers a strange new world. Since X-rays reveal internal structures, Péret situates this world inside the tube in an early version of *l'un dans l'autre*. Unexpectedly, he discovers the author—who is recognizable from his monocle—dancing with a charming stomach at the center of the universe he has created. Without missing a step, Tzara returns Péret's greeting and whirls his partner across the floor. Among other things, this alludes to the end of "Calendrier cinéma du coeur abstrait," which occupies the first half of the book. Disdaining any attempt at formal closure, Tzara simply greets three of his fellow Dadaists: Arp, Francis Picabia, and Georges Ribemont-Dessaignes.

Quoting at length from one of the "Maisons" that make up the

second half of the volume, Péret explains that Tzara's works are not texts so much as "pre-texts." Whereas conventional compositions are highly structured, his are conceived as informal exercises. Péret demonstrates his own poetic skills in the next section, which swarms with striking imagery. Instead of evoking Arp's illustrations, which resemble those in *Vingt-cinq poèmes* (see chapter 2), he prefers to tap his own imagination. Don't blame us, he exclaims, if the stars suddenly crystalize, if barbers acquire royal prerogatives, or if fish begin to chew tobacco. We are simply catalysts. Our job as straight pins is to jab the existing social body over and over until it reacts. Who can predict what will happen after that? The important thing, he continues, is to seize whatever opportunity presents itself. As Tristan discovered when he first met Iseut, the pursuit of a single strand of hair can have tremendous consequences. A humble journey may become a marvelous quest. This is something the "language monkeys," i. e., conventional writers, fail to understand. Since they are rotten through and through, Péret gleefully envisions his arch enemies decomposing rapidly in the sun. Unexpectedly, he transforms the byproducts of decay into a cloud of butterflies.

The text concludes at this point with an enthusiastic endorsement and two outrageous similes à la Lautréamont. Tzara's book is not only as sleek and powerful as a locomotive but as useful as a bottle of shampoo! Ironically, despite its ultramodern inspiration, the volume turns out to exemplify Classical ideals. It is not only pleasing to contemplate (*dulce*) but eminently useful (*utile*) as well.

In March 1922, the Paul Guillaume Gallery sponsored a blockbuster exhibition by Giorgio de Chirico. Consisting of fifty-five paintings by the founder of the *scuola metafisica*, it attracted considerable attention. Since the surrealists had long admired de Chirico's work, Breton contributed an introduction to the catalogue.[2] As so often when he was writing for the general public, it took the form of a traditional essay. Adopting a professorial style, he made no attempt to invoke the Surrealist muse. "J'estime qu'une véritable mythologie moderne est en formation," he intoned. "C'est à Giorgio de Chirico qu'il appartient d'en fixer impérissablement le souvenir" (In my opinion, a genuine modern mythology is beginning to emerge. It belongs to Giorgio de Chirico to give eternal form to its memory). By contrast, when Péret reviewed the exhibition in *Littérature* in September, he adopted a more creative approach.

Après avoir regardé le monde, G. de Chirico sourit de toutes ses dents et demanda à son voisin de table: —Idiot, tout cela est faux, n'est-ce pas?

Non content d'intervertir l'ordre des facteurs il pose de nouvelles equations où l'on retrouve toujours la même inconnue: x = 2 + 2. Il préfère lui qui s'y connaît une paire de claques à un coucher de soleil sur la grève.

Ayant compris ce qu 'il ne fallait pas comprendre: *La Révélation du solitaire, La Récompense du devin, Le Rêve de Tobie, Le Printemps de l'ingénieur,* il établit un nouveau circuit, puis satisfait de lui partit à cheval sur une lampe à acétylène droit devant lui vers Jérusalem. Jérusalem délivrée . . . Par qui? par G. de Chirico—mais délivrée du Christ et non des Turcs (heureusement!)

Après avoir regardé dans le cimetière les beaux tombeaux il vit quelques morts qui s'agitaient dans leur tombe. Il les aida à sortir de leur trou et se laissa conduire par eux à une usine où des tours fabriquaient toute une orfèvrerie sentimentale. Un mannequin guidait la machine qui ne se trompait jamais. Trois oranges tournaient autour et traçaient une circonférence de 4 mètres de diamètre en 2 minutes. Dans un coin il y avait diverses planètes qui effectuaient leur habituel mouvement de rotation, et une sorte de petit animal qui se rattachait au crapaud par le charme et au serin par la forme, et qui sautait de l'une sur l'autre sans se reposer. Alors Chirico s'arrêta et sourit de nouveau. Il avait compris.

[Having contemplated the world, G. de Chirico flashed a broad smile and asked a neighboring diner:

"Idiot, all that is false isn't it?"

Not content with reversing the order of the factors, he formulates new equations which all contain the same unknown: x = 2 + 2. Experience has taught him to prefer a pair of galoshes to a sunset on the beach.

Having understood that which surpasses all understanding: *The Hermit's Revelation, The Soothsayer's Reward, Tobit's Dream, The Engineer's Springtime,* he inaugurated a new circuit, then, satisfied with his creation, headed straight for Jerusalem astride an acetylene lamp. Jerusalem rescued . . . by whom? By G. de Chirico—but rescued from Christ and not from the Turks (fortunately!).

Having contemplated the handsome tombs in the cemetery, he spied several of the dead stirring in their graves. He helped them climb out of their holes and allowed them to lead him to a factory where some towers were fabricating a whole sentimental goldsmithy. A mannequin guided the machine, which never made a mistake. Three oranges revolved around it and traced a circumference 4 meters in diameter in 2 minutes. In a corner, various planets were rotating in their customary manner, and a small animal—as charming as a toad but shaped like a canary— hopped ceaselessly from one to the other. Then Chirico halted and smiled once again. He understood what it meant.]

If imitation is the sincerest form of flattery, as traditional wisdom insists, then Péret's review is extraordinarily sincere. While it borrows occasional images from de Chirico's iconography, it attempts above all to duplicate his enigmatic style. Instead of focusing on the pictures, four of which are mentioned by name, Péret constructs a composite portrait of the artist himself. Unlike the previous text, the composition is conceived not as a series of overlapping metaphors but as an aesthetic parable. Despite assorted scientific and mathematical references, the dominant model is sacred rather than secular. Casting de Chirico in the role of a biblical prophet, Péret evokes his miraculous abilities before following him on an epic voyage to the Holy Land. Not surprisingly, the key terms turn out to be *regarder* and *comprendre*. Like his illustrious forebears, de Chirico possesses second sight and superior understanding. Like them, he is able to perceive the true nature of the world and to grasp its underlying order.

This is the subject of the first section, which recounts how the artist came to reject conventional realism. Persuaded that traditional depictions of the world were false, he invented a radical new method of portraying reality. Like Copernicus before him, Péret implies, de Chirico devised a series of equations that more accurately described man's relation to the cosmos. As the prevailing system was completely realigned, certain objects became increasingly prominent and others receded into the background. A pair of old galoshes, for example, was discovered to be more important than a beautiful sunset. Indeed, everyday objects occupy the foreground in many of de Chirico's paintings, where they are elevated to mythic proportions. Having restored the planets to their proper orbit ("circuit"), like Copernicus who showed they revolved around the sun, the painter leaves to found a New Jerusalem. Symbolizing his commitment to modern aesthetics, he chooses an acetylene lamp for his fiery steed instead of a more traditional mount such as Pegasus. In contrast to the hero of Torquato Tasso's *La Gerusalemme liberata* (1575), who drove the Turks from the sacred capital, he must expel the Christians who supplanted them, since their worldview is hopelessly antiquated.

Arriving in Jerusalem, de Chirico encounters several corpses whom he miraculously brings back to life. Since phantoms play a prominent role in his paintings, he is accustomed to mediating between life and death. In exchange, the grateful dead introduce him to a marvelous new realm that dovetails with his own vision of the

world. Indeed, the strange scene possesses an uncanny resemblance to a number of de Chirico's works. Many of his early paintings feature huge towers, for example, which loom over deserted city squares. And his later works are dominated by mannequins bearing mute witness to the human condition. Whereas these are immobilized, like prehistoric beasts imprisoned in a block of ice, Péret transforms them into living beings engaged in various activities. Like factory workers everywhere, the towers and the lone mannequin guide their machines through a series of prescribed maneuvers.

Those workers who are not assigned to machines are carrying out related tasks. While one wonders what skills the planets possess, the three oranges are accomplished mechanical draftsmen. In contrast to the workers operating machines, however, they play no role in de Chirico's paintings. Although the artist experimented with various fruits and vegetables for awhile, oranges are conspicuously absent from his repertoire. Like the mysterious planets, they allude not to specific motifs but to de Chirico's fondness for cosmic metaphors. Works such as *Le Philosophe et le poète* (figure 3), for instance, portray the creative artist as an omniscient Architect poring over celestial blueprints or as an Astronomer probing the riddle of the universe. One painting is even entitled *L'Astronome.*

The strange beast hopping restlessly from one planet to the next is more difficult to explain. What kind of animal resembles a toad, on the one hand, and a canary on the other? Half bird and half amphibian, it has nothing whatsoever to do with de Chirico's paintings. For that matter, does Péret really expect us to believe that toads are charming? Gradually one perceives that he is evoking not de Chirico but the Comte de Lautréamont, whose work teems with bizarre hybrids and outrageous comparisons. In keeping with his calculated perversity, Lautréamont finds repulsive things attractive and vice versa. "Qu'as-tu donc fait de tes pustules visqueuses et fétides," he asks a passing toad, "pour avoir l'air si doux?" (What have you done with your slimy, stinking pustules to make yourself look so agreeable?).[3] In addition to disgusting animals, *Les Chants de Maldoror* swarms with surprising juxtapositions and disturbing scenes. Gazing at the varied activities taking place before him, de Chirico is struck by the similarities between Lautréamont's technique and his own. Taking in the scene at a glance, he bursts into a broad smile. Like an explorer thousands of miles from home, he is delighted to encounter someone who speaks his own language.

Péret employed a different strategy three years later, when he

Figure 3. Giorgio de Chirico, *The Philosopher and the Poet*, 1915. Oil on canvas, 32³/₄ × 20⁵/₈″. Whereabouts unknown.

agreed to preface the catalogue for an exhibition by Joan Miró.[4] Whereas the artist's first show in Paris had been a failure, his second, which took place in June 1925, was a *succès de scandale*. Consisting of thirty-one works, including fifteen drawings, it concentrated on the period 1921–1924. During these eventful years, Miró experimented with three separate styles. Abandoning his realistic manner, he flir-

ted briefly with precisionism before adopting the radical mode that signaled his conversion to surrealism. By comparison, Péret's poetry is much more homogeneous. Remarkably, it combines psychic automatism with perverted logic but also insists on grammatical clarity. Of all the surrealists, J. H. Matthews notes, "Péret is the poet who respected with most fidelity the principle of automatic writing."[5] Understandably, since it is subject to various restraints, his critical poetry is not quite as spontaneous. In principle at least, it cannot afford to stray too far from the work(s) it is ostensibly reviewing. Although "Les Cheveux dans les yeux" ("Hair in Ones Eyes") recounts a story that is totally illogical, therefore, it proceeds in a logical fashion. Masquerading as a first person narrative, it mixes conscious and unconscious processes but never loses sight of Miró.

Un jour que je descendais l'avenue des Champs-Elysées, un monsieur obèse, décoré de la Légion d'honneur et des Palmes académiques, m'accosta et me demanda poliment:
—Monsieur, pourriez-voux m'indiquer où est l'arbre à sardines?
Je lui avouai mon ignorance et lui enumérai les diverses espèces d'arbres que je connaissais: l'arbre à saucisson, l'arbre à serrure, l'arbre à vinaigre, l'arbre à hussards de la mort, l'arbre à mouchoirs agitées en signe d'adieu, l'arbre à cures, l'arbre à bicyclette, l'arbre à gaz, l'arbre à lunettes, et bien d'autres encore, mais à chacun il hochait doucement la tête en signe de dénégation; puis, comme il insistait: "Je veux voir l'arbre à sardines!", je l'envoyai chez Joan Miró qui a, quelque part, une précieuse plantation d'arbres mystérieux qui chantent des symphonies héroiques les jours d'enterrement et des marches nuptiales lorsqu'un roi d'une quelconque Bulgarie est, au cours d'une promenade sentimentale, décapité par un enfant de douze ans.
Et sachez que cet homme petit, au regard étrange, a vu dans votre corps le fragment d'os d'où sortira, tout à l'heure, une légion d'hirondelles annonciatrices de la découverte de l'Amérique; sachez que vos chaussures n'ont plus aucun mystère pour lui, qu'il sait exactement quelle quantité de liqueur séminale entre dans la composition de votre gilet, ce qu'on peut esperer de votre foie et de cet âne qui s'obstine à ne pas braire parce qu'on lui a refusé les derniers sacrements à l'occasion de son cinquième anniversaire. Et pourtant, il a bien droit à ces sacrements, lui le descendant direct et unique—unique comme le regard du sauvage qui voit pour la première fois de son existence une pierre à fusil s'unir à un geranium—de saint Pierre et de la bosse du dromadaire ailé qui, un soir d'automne, s'enfuit du harem de Haroun-al-Rachid, pour aller quêter, sur les routes de nuages, le gland des pauvres.

[One day when I was walking along the Champs-Elysees, an obese gentleman, decorated with the Legion of Honor and the Academic Palms, accosted me and asked politely:

"Sir, could you tell me where to find the sardine tree?"

I confessed my ignorance and enumerated the various kinds of trees with which I was familiar: the salami tree, the lock tree, the vinegar tree, the cavalrymen of death tree, the waving handkerchiefs goodbye tree, the priest tree, the bicycle tree, the gas tree, the eyeglasses tree, and many others . . . , but after each one he shook his head; then, since he continued to insist: "I want to see the sardine tree!", I advised him to seek out Joan Miró, who has—somewhere—a precious plantation of mysterious trees that sing heroic symphonies on days when burials take place and wedding marches whenever a king of Bulgaria or whatever, taking a walk with his beloved, is decapitated by a twelve-year-old child.

And I can tell you that that diminutive man with the strange gaze has seen the fragment of bone in your body from which a flock of swallows will soon emerge announcing the discovery of America; I can tell you that your shoes hold no mystery for him, that he knows exactly how much seminal fluid your vest is composed of, how much can be expected of your liver and of that donkey that stubbornly refuses to bray because they refused to administer the last rites on his fifth birthday. And yet he is perfectly entitled to these rites because he is the direct descendent—as unique as the look in a savage's eyes when, for the first time in his life, he sees a flint unite with a geranium—of Saint Peter and the hump of the winged dromedary which escaped from Haroun-al-Rachid's harem, one fall evening, in order to solicit acorns for the poor on the roads made of clouds.]

Dated April 23, 1925, the preface is divided into two halves, each of which revolves about a single image borrowed from Miró's iconography. In contrast to the first section, which evokes the painter's earlier style, the second section is devoted to his surrealist manner. Although the title "Les Cheveux dans les yeux" has a pleasant ring to it, it turns out—like many of Péret's titles—to be completely gratuitous. It bears no more relation to the text it ostensibly introduces than it does to Miró's pictures. Apart from this problem, which the reader does not become aware of until later, the story begins uneventfully. Strolling along a Parisian boulevard, the narrator encounters a visitor from out of town, evidently a distinguished academic, who stops to ask him for directions. Interestingly, he seems to have had a special significance for the author, who had employed him in another text the previous year.[6] As before, his dominant characteristic is obesity, which makes him easy to recognize. Whereas formerly

the professor proved to be adept at trading insults, the present sce-
nario calls for him to act politely.

While people ask for directions every day in Paris, most of them
are trying to find a museum or an important monument. However,
we soon learn that the professor is no ordinary tourist. Turning his
back on the Eiffel Tower and the Louvre, he wants to locate a sar-
dine tree he has heard about. This introduces the central motif of
the first section, which appears in multiple guises: the marvelous
tree. It also allows Péret to insert repeated bursts of automatic imag-
ery as he develops the theme in more detail. Since none of the fan-
tastic trees he names satisfies the professor, he advises him to seek
out Miró, who has a whole plantation at his disposal. In fact, a num-
ber of paintings from his so-called "realistic" phase include highly
stylized trees (See figure 4), whose fanciful designs seem to have
made quite an impression on Péret. Struck by their unusual appear-
ance, which was purely cosmetic originally, he deduces that they pos-
sess unusual talents as well, like being able to sing. Their collective
voices provide a beautiful accompaniment on sad occasions, such as
funerals, and on joyful occasions, such as weddings or—and here
Péret indulges in a little black humor—a royal assassination.

At this point, the author turns to his readers and addresses them
directly. His initial comments are concerned not so much with the
artist's pictures as with the artist himself, whose strange gaze testifies
to his mysterious powers. Portraying Miró as a gifted seer, Péret em-
ploys four parallel metaphors that are frankly invasive. Linked to-
gether by *voir* and *savoir*, they evoke the painter's ability to divine
our innermost secrets. Neither our bones nor our internal organs
nor even our clothing can escape his scrutiny. While the reference
to swallows could conceivably allude to flocks of birds that appear in
some of Miró's paintings, Péret focuses above all on his curious style.
When he first began to explore surrealism, Miró reduced his human
subjects to a random assortment of physical features, connected to
each other by straight lines. Thus *Portrait of Madame K.* (figure 5)
juxtaposes two breasts, seen from different angles, with the lady's
head, ear, heart, and pubic triangle. This is all that remains of Miró's
original model; the rest of her must be reconstructed piece by piece.
Inevitably, one is reminded of Apollinaire's description of the Cu-
bists: "Un Picasso étudie un objet comme un chirurgien dissèque
un cadavre" (Picasso studies an object as a surgeon dissects a ca-
daver).[7] The same observation applies to Miró at this stage of his
career, who wields his brush (or pen) like a scalpel.

Figure 4. Joan Miró, *Vegetable Garden With Donkey*, 1918. Oil on canvas, 25¼ × 27⅝″. Whereabouts unknown.

Unexpectedly, we discover we have been subjected to the same operation (in both senses of the word) as Madame K. Having exposed the reader to Miró's keen gaze, which probes the latter's bones, shoes, vest, and liver, Péret turns away and focuses his attention on another object. The fifth item on his list is a donkey, which is showing just how disagreeable it can be. Whereas other donkeys reveal their displeasure by braying loudly, this one stubbornly refuses to make a sound. Like the marvelous tree, the donkey comes from Miró's iconography and constitutes the central image in the section where it occurs. Indeed, it is almost certainly taken from a painting entitled *Vegetable Garden With Donkey* (figure 4), which depicts the animal in question browsing contentedly in a country setting. Ironically, since Péret's text extols the artist's surrealist style, the picture is painted in his earlier manner. However, this poten-

Figure 5. Joan Miró, *Portrait of Madame K.*, 1924. Oil and Charcoal on canvas, 45¹/₄ × 35″. Whereabouts unknown.

tially damaging discovery is offset by the text's delirious imagery, which gradually accelerates until it reaches the donkey. At this point, Péret pulls out all the stops and switches to a fully automatic mode.

Although the rest of the preface is largely incoherent, one perceives that it is governed by two mechanisms in particular: substitution and negative conversion (a special form of substitution). Little by little, one realizes that it incorporates the remnants of an earlier account—buried in the author's unconscious—that these mechanisms have managed to obscure. Underlying Péret's text is the story of an old man about to die who begs a priest to administer the last rites, only to be refused. In the later version, the old man has been transformed into a young donkey which, instead of protesting, stubbornly remains silent. The scene no longer takes place at his deathbed but rather at his fifth birthday party. As a direct descendent of Saint Peter, indeed his *only* descendent, he clearly deserves to receive the holy sacrament. Playing on the other sense of *unique*, Péret creates an elaborate simile recalling the discovery of the New World. His protagonist is as unique as an Indian's amazement when he sees an explorer fire a flintlock rifle. Even more amazingly, the flint in his own rifle strikes against a geranium rather than steel. We know from the ur-text, moreover, that his mother was as saintly as his father (whose name was probably suggested by the Galerie Pierre). Escaping from a harem right out of the *Arabian Nights*, she spent the rest of her life helping people afflicted with poverty. In Péret's version, she is transformed into a flying dromedary who collects acorns, instead of alms, for the poor.

PAUL ELUARD

In December 1923, Paul Eluard and his wife Gala went to Rome to meet Giorgio de Chirico, who was exhibiting eighteen pictures at the second Biennale. Not only did they make the artist's acquaintance, but they wound up staying with him as well. Before they returned to Paris the following month, Eluard purchased a number of paintings from de Chirico, whose works he had long admired, and commissioned him to paint a double portrait of Gala and himself. In addition, he composed a brief poem celebrating the artist's enigmatic vision. Entitled "Giorgio de Chirico," it appeared in *Mourir de ne pas mourir* (1924) where it was the only one of the twenty-three

works concerned with art. Although Eluard had previously devoted a poem to Max Ernst, this was only the second time he experimented with *poésie critique,* to which he would return again and again in the years to come.

Un mur dénonce un autre mur
Et l'ombre me défend de mon ombre peureuse.
O tour de mon amour autour de mon amour,
Tous les murs filaient blanc autour de mon silence.

Toi, que défendais-tu? Ciel insensible et pur
Tremblant tu m'abritais. La lumière en relief
Sur le ciel qui n'est plus le miroir du soleil,
Les étoiles de jour parmi les feuilles vertes,

Le souvenir de ceux qui parlaient sans savoir,
Maîtres de ma faiblesse et je suis à leur place
Avec des yeux d'amour et des mains trop fidèles
Pour dépeupler un monde dont je suis absent.

[One wall denounces another wall
And the shadow defends me from my timid shadow.
Oh tower of my love around my love,
The walls fled whitely around my silence.

You, what were you defending? Pure, insensitive sky
Trembling you sheltered me. The light thrown into relief
Against the sky that no longer mirrors the sun,
The daylight stars amid the green leaves,

The memory of those who spoke from ignorance,
Masters of my weakness and I am in their place
With loving eyes and hands too faithful
To depopulate a world from which I am absent.]

As Michel Décaudin observes, "peu d'oeuvres poétiques ont . . . des liens aussi nombreux avec les autres formes d'expression artistique que celle d'Eluard" (few bodies of poetry have . . . as many links to other forms of artistic expression as Eluard's).[8] In this regard, he distinguishes four ways in which the poems are allied to painting. They may be accompanied by illustrations, they may serve as illustrations themselves, they may be inspired by a work of art, or they may result from interartistic collaboration. A brief glance reveals that "Giorgio de Chirico" belongs to the third category, with one important difference. Rather than a particular painting, Eluard takes the

artist's entire oeuvre as his point of departure. "Eluard lit Chirico
. . . sans aucune reduction de sens," Jean-Yves Debreuille remarks,
"mais en déployant selon [ses] suggestions ses propres impressions
et son propre désir" (Eluard reads Chirico without trying to simplify
his meaning, while deploying his own impressions and his own de-
sire according to [the artist's] suggestions).[9]

Asked to name their favorite surrealist poet, most devotees of
French literature would probably choose Eluard. Because he ob-
serves conventional syntax and uses short, declarative sentences,
readers generally consider his poems to be much more accessible
than those of his colleagues. Ironically, as it turns out, this reputa-
tion is largely undeserved. Despite Eluard's limpid style, his poetry
presents numerous problems and is frequently difficult to decipher.
Despite its apparent simplicity, for example, "Giorgio de Chirico"
resists any attempt to impose a single, unified interpretation. Like
de Chirico's art, which derives much of its effect from multiple per-
spective, the poem is fraught with ambiguity. That it consists almost
entirely of alexandrines, arranged in three equal stanzas, is initially
deceiving. Although it looks like a conventional poem, it steadfastly
refuses to behave like one. Like de Chirico, one critic notes, Eluard
constructs a nonreferential universe with elements that, taken indi-
vidually, each possess a specific referent (Debreuille, p. 174). In
both cases, he concludes, the disorientation that results is attribut-
able to syntagmatic rather than paradigmatic factors. Both men jux-
tapose elements taken from real life to form an imaginary world.

Whereas Péret focuses on de Chirico's mannequin paintings and
metaphysical interiors, Eluard concentrates on the earlier Italian
square series. As Jean-Charles Gateau observes, the poem repeats
key elements from these works in an obsessive pattern: "mur"
(three times), "tour" and "(au)tour" (four times), "ciel" (twice),
and even "place."[10] Other terms that evoke de Chirico's enigmatic
universe are "ombre" (twice), "silence," "lumière," "dépeupler,"
and "absent." The artist's presence is especially evident in the first
stanza, which describes any number of paintings from this period.
The Departure of the Poet (figure 6), for example, depicts a large public
square that for some reason is almost completely deserted. Except
for one or two people, who are dwarfed by its monumental propor-
tions, there is no sign of life. In contrast to the wall on the left, which
is brightly illuminated, that on the right is hidden in shadow—as is
much of the square itself. Judging from this and other shadows, the
time appears to be early evening. This impression is reinforced by

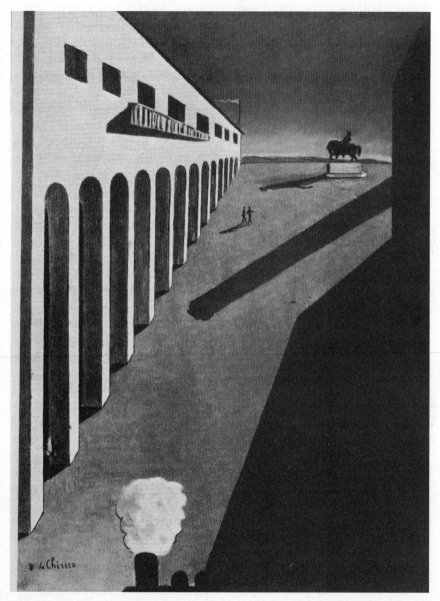

Figure 6. Giorgio de Chirico, *The Departure of the Poet*, 1914. Oil on canvas 34 × 16″. Whereabouts unknown.

the darkening sky and the band of light extending across the horizon as the sun sinks out of sight. Like the scene in the painting, Eluard's square is framed by two massive walls (probably divided into arcades) and partially immersed in shadow. Whereas only one of de Chrico's walls recedes into the distance, those in the poem both converge toward a common vanishing point. Like the painting, finally, the poem features a prominent tower that looms over the deserted expanse like a silent witness.

If the nouns in Eluard's composition refer to de Chirico's art, Gateau affirms, the adjectives and verbs trigger a reaction that seems to alternate between fear and reassurance (p. 98). Similarly, Anne Hyde Greet detects an undercurrent of menace and of loneliness mixed with desire that produces conflicting feelings in the reader.[11] What makes the poem so disturbing, Lori Walters adds, is the persistent conflict between presence and absence that undermines its foundations.[12] In particular, she claims, it "exprime l'extrême aliénation d'esprit du narrateur . . . [qui] devient le témoin lucide de sa désintégration psychique" (expresses the narrator's extreme derangement as he becomes a lucid witness of his own psychic disintegration) (pp. 214–15). That this condition stems from his efforts to impose presence on a world inhabited by absence is clear to Debreuille as well (p. 182). In his opinion, the narrator's ego does not disintegrate but simply becomes unstable (p. 191).

In general, there is widespread agreement that the dominant tone in the poem is that of anguish. Whereas most critics trace this feature back to de Chirico's paintings, Walters is convinced that its source is largely autobiographical. Observing that Gala and Max Ernst were having an affair, she argues that the composition expresses Eluard's sense of betrayal, his desire for vengeance, and his ultimate impotence. In her estimation, the poem is essentially "la plainte d'un amant malheureux" (a lover's sorrowful lament) (p. 213). The anguished tone that permeates the work results from "une déception amoureuse"—a disappointment in love but also amorous deceit. According to this interpretation, the poet denounces Gala's scandalous behavior in the first stanza and proclaims his eternal fidelity in the last. Certainly, as Debreuille notes (p. 181), the fact that "amour" is repeated three times suggests that conjugal love is an important theme. And Walters is undoubtedly right that "Giorgio de Chirico" contains echoes of Eluard's marital troubles. Nevertheless, that it is concerned with a disintegrating marriage—or even a disintegrating psyche—is far from self-evident. Nor, in retro-

spect, does it seem possible to describe the dominant tone as anguish. To the contrary, Greet remarks (p. 92), Eluard simply evokes the mystery and melancholy associated with de Chirico's early pictures.

At this point, I want to pursue another line of inquiry that promises to be more rewarding. According to a number of indications, beginning with the title, "Giorgio de Chirico" is concerned primarily with aesthetic issues. Its subject is de Chirico's paintings and the sensations they produce in the spectator. While critics generally assume Eluard is describing a picture—either real or imaginary—hanging on a wall somewhere, the situation is actually quite different. A close reading reveals he is not just a passive viewer but is inscribed in the scene he is describing. Transplanted to de Chirico's world, Eluard finds himself immersed in the picture's virtual reality. The poem itself is divided into three movements. The initial movement records his impressions as night begins to fall, the second contrasts these with earlier impressions, and the third celebrates his visionary quest. Whether Eluard is alone or accompanied by Gala is difficult to say. However, remembering that many of the painter's works contain two tiny figures, one suspects she is standing by his side.

Surprisingly, in view of its radical premises, the poem is written in blank verse. With a single exception, it consists entirely of unrhymed alexandrines. From the fact that the first line contains eight syllables Debreuille deduces that the painting is somehow incomplete (p. 180). More importantly, its linear thrust resembles that of the two walls, whose placement at either end of the line parallels their position on either side of the square. Since they are arranged symmetrically, each wall "denounces" the other in the sense that it calls attention to its partner. The next two verses exhibit a similar preoccupation with bilateral symmetry. Tired of his shadow, which pursues him relentlessly, Eluard manages to elude it by standing in the shadow of one of the walls. While his shadow is fearful—presumably of being swallowed up by the protective darkness—the poet himself is overflowing with love. "O tour de mon amour autour de mon amour," he exclaims in a burst of paronomasia. Assuming the second hemistich merely echoes the first, without proposing an additional message, the verse would reiterate Eluard's "towering love" for Gala. Assuming "autour" actually functions as a preposition, the verse would evoke the image of Gala wrapped securely in the poet's love ("mon amour autour de mon amour"). In either case, the

tower appears to symbolize Eluard's monumental love for his wife, whose surrealist surname, so Gateau informs us, was in fact "tour" (p. 101).

The fourth line introduces a series of verbs in the imperfect and refers to a previous scene. As such, it marks the beginning of the second movement, which juxtaposes "un passé illuminé, originaire, celui où 'ciel' était le 'miroir du soleil,' à un présent crepusculaire . . . où les ombres grandissent tandis qu'apparaissent les premières étoiles" (a luminous, originary past, in which the "sky" was the "sun's mirror" with a present bathed in twilight . . . where the lengthening shadows witness the appearance of the first stars) (Gateau, p. 99). As night descends, Eluard remembers how the square looked earlier, when it was drenched in sunlight. Now as well as then, he does not feel suffocated by the walls around him, as Walters (p. 213) supposes, but marvels at the square's vast dimensions, which extend all the way to the horizon. Under the circumstances, his silence is (and was) perfectly understandable. It testifies not to his inability to communicate, as Walters maintains, but to his sense of awe. Eluard simply refuses to profane the preternatural stillness that blankets the square.

The most difficult task, Gateau declares (p. 99), is to sort out the various references to "je," "tu," "ceux qui," and "leur" in the poem. Thus Greet observes that "'toi' may refer to the eye of the gazer, of the painter, of the sky, or to the poet or his reader" (p. 92). And Gateau believes it refers to Gala who, concerned about her husband's health, constantly watched over him. Although none of these possibilities can be definitely eliminated, syntactic considerations lead one to conclude, together with Debreuille (p. 179), that the pronoun refers to "ciel." Like the shadow that shelters Eluard as the sun sets, the sky seems to have come to his defense earlier in the day. But how could anything so insubstantial, one wonders, possibly protect the poet? And from what could it possibly protect him? The explanation, one eventually realizes, is much the same as before—with one important difference. Seeking to elude his persistent shadow earlier in the day, Eluard escaped not by diving into the shade but by walking into the middle of the square. As the sun rose higher and higher, his shadow grew progressively smaller until, by midday, it had vanished altogether. By this time the sky was pulsating ("tremblant") with solar energy. The light was so intense that the sky resembled a concave mirror, with the poet situated precisely at its focal point.

The final movement coincides essentially with the third stanza, which once again contrasts the past with the present. Unlike the first two movements, it eschews description in favor of introspection. Its subject is no longer de Chirico's architecture but rather Eluard himself, who reflects on his recent experience. Among other things, it includes a meditation on the value of the artist's achievement and on the nature of his own aesthetics. These concerns manifest themselves in a whole new series of oppositions, both implicit and explicit, that embody conflicting values. On the one hand, Eluard opposes ignorance to knowledge, dominance to subservience, and strength to weakness. On the other, he contrasts love with indifference, fidelity with infidelity, presence with absence, and ultimately life with death.

"Ceux qui parlaient sans savoir," Gateau (p. 99) assures us, were Gala and Eluard who, as young newlyweds, naively exchanged vows they could never keep. However, the next line indicates that the individuals in question exercised some kind of control over the poet, which appears to invalidate this interpretation. One suspects in addition that "ma faiblesse" refers to Eluard's sickly adolescence, when he contacted tuberculosis. Thus the line would seem to allude either to his parents or—more likely—to various teachers ("maîtres"), whose ignorance did not prevent them from posing as authorities. "Dans la troisième strophe," Walters asserts, "le narrateur atteste son impuissance à rien changer à sa situation" (In the third stanza . . . the narrator admits he is powerless to change his situation) (p. 213). To the contrary, Eluard explicitly informs us that he has managed to turn the tables on his former oppressors ("je suis à leur place"). They can no longer exploit his weakness because he has finally assumed command. What has empowered him, he intimates, is the very knowledge that escaped his masters previously.

Since Eluard was still a minor, his parents were able to impose their will on him. Since he was young and inexperienced, his teachers succeeded in imposing their opinions. Now that he is grown and able to think for himself, he realizes much of what they told him was wrong. At this point, the poem's focus expands to include not only aesthetic but ethical considerations. Whereas Eluard's masters taught him to dislike nontraditional art, he is filled with admiration for what avant-garde writers and artists have accomplished. Whereas they taught him to dislike people who differed from themselves, his eyes are full of love for humanity in general. Like his heart, his hands are fully committed to the human cause.

That these two concerns—the ethical and the aesthetic—are interrelated is demonstrated by the final line, which evokes a barren world devoid of any human presence. On the one hand, this recalls the recent devastation wrought by the First World War, which caused Eluard to become a confirmed pacifist. Seen from this angle, "ceux qui parlaient sans savoir" were the politicians and generals who were responsible for the war. On the other hand, the line also alludes to the deserted public squares depicted in so many of de Chirico's pictures. Despite his high regard for the artist, Eluard confesses he has no desire to emulate him. A world in which people have ceased to play a role holds no more attraction for him than a world whose inhabitants have been exterminated. What makes life worth living, at least for Eluard, is the human element that de Chirico consciously suppresses. Since art is made by and for human beings, he concludes it should address some of their common preoccupations.

By the time *Capitale de la douleur* appeared, in 1926, Eluard had begun to experiment with *poésie critique* in earnest. Interspersed among the various poems were compositions devoted to Picasso, André Masson, Paul Klee, Max Ernst, Georges Braque, Jean Arp, and Joan Miró. Although each of these sheds valuable light on the intersection of poetry and painting, the last work deserves to be singled out in particular. Among other things, Greet declares, "Joan Miró" is one of the most successful poems in the group (p. 98). Indeed, Manuel Esteban insists that it is one of the most beautiful poems in the entire volume.[13] Like Péret, who was amazed at how rapidly Miró had progressed, Eluard contrasted his latest works with his earlier manner. By this date, however, the artist had abandoned his previous approach, exemplified by *Portrait of Madam K* (figure 5), and had developed a brand-new style. Having exhausted the possibilities of the former, which drew heavily on Cubism, he had begun to investigate abstraction. Instead of decomposing a scene into its constituent elements, he experimented with random shapes and colors.

> Soleil de proie prisonnier de ma tête,
> Enlève la colline, enlève la forêt.
> Le ciel est plus beau que jamais.
> Les libellules des raisins
> Lui donnent des formes précises
> Que je dissipe d'un geste.
>
> Nuages du premier jour,
> Nuages insensibles et que rien n'autorise,

Leurs graines brûlent
Dans les feux de paille de mes regards.

A la fin, pour se couvrir d'une aube
Il faudra que le ciel soit aussi pur que la nuit.

[Predatory sun imprisoned in my head,
Carry off the hill, carry off the forest.
The sky is more beautiful than ever.
The dragonflies above the grapes
Endow it with concrete shapes
That a single gesture dissipates.

The first day's clouds,
Impassive and gratuitous clouds,
Their seeds are consumed
In the blazing flames of my gaze.

In the end, in order to cloak itself in dawn
The sky must be as pure as the night.]

Whereas Eluard refused to espouse de Chirico's vision of a world without people, he embraced Miró's more humanistic view whole-heartedly. While the former was undeniably a great artist, the latter's sympathies were much closer to his own. Indeed, as several critics have noted, the two men had a great deal in common. Although each worked in a different medium with different requirements, their aesthetics, their values, and even their styles were similar. Like Eluard's poems, Miró's paintings were characterized by simplicity, brevity, and economy of means. Like Miró's paintings, Eluard's poems were highly personal, occasionally whimsical, and intensely lyrical. In addition, the two collaborated on a number of projects over the years, culminating in the publication of *A toute épreuve* in 1958. Not only were their artistic visions compatible, one discovers, but each seems to have identified with the other on more than one occasion.

Before we can devise an interpretive strategy for "Joan Miró," we need to determine who is speaking. At first glance, one is tempted to equate the narrator with the author and the text itself with a critical commentary. At second glance, one begins to suspect that the words are actually uttered by somebody else. Eventually one perceives that the work differs from the preceding poem in another important respect: the artist is speaking rather than the poet. Just as Eluard explored de Chirico's world previously, Miró has decided to invade

Eluard's realm. We no longer hear the latter's voice but the former's as he describes his recent progress. Instead of a series of random impressions, the poem consists of Miró's reflections concerning the kind of art he is trying to create. On the one hand, it functions as a dramatic monologue, on the other as an aesthetic meditation.

Although the critics all agree that the poem evokes Miró's latest style, there is only partial consensus beyond this point. According to Greet, for example, it describes "a painting in process, from the first dismissal of objective reality to the final purity of the finished work" (p. 101). She even believes she can identify the painting in question. According to Gateau (p. 142), the poem refers not to a specific picture but to the artist's transformation from a primitive realist to a full-blown abstractionist. And while Esteban (p. 16) basically sides with Gateau, he differs with regard to the work's perspective. In effect, each man assigns the composition a different position in the evolutionary sequence. Whereas Gateau places it at the end of Miró's development, Esteban situates it in the interval between the two styles. Whereas the first critic claims it marks the triumph of abstraction, the second believes it predicts the direction Miró's art will take. Surprisingly, the three approaches have more in common than initially meets the eye. For one thing, Esteban's interpretation is not as innocent as it seems. Like Gateau's analysis, it assumes an *a posteriori* knowledge of the artist's stylistics. For another thing, Miró recapitulates his evolution each time he paints a picture since, momentarily at least, it represents the furthest point in his development. Thus whether Eluard's poem describes a single painting or the artist's evolution makes little difference. What matters is how Miró conceived of his artistic mission.

In the last analysis, therefore, "Joan Miró" is concerned with the painter's aesthetics. Above all, we will see that it celebrates his conversion to abstraction. Although one can detect traces of various works, it celebrates the principles underlying his latest style. As in "Giorgio de Chirico," the text is divided into three stanzas, each of which functions in a slightly different manner. More particularly, each examines Miró's art from a different angle. The first stanza rejects conventional realism, the second evokes the artist's primordial inspiration, and the third praises his persistent quest for purity. In contrast to the previous composition, which is entirely regular, the stanzas diminish in length as the work progresses. Thus the poem simultaneously describes and illustrates the role played by reduction and purification in Miró's works.

These principles are especially evident in the first stanza, which is dominated by the image of the rising sun. Whereas one would expect the sun to illuminate the surrounding terrain, just the opposite occurs. Instead of revealing the landscape's contours and prominent features, it completely effaces them. Usurping a privilege traditionally reserved for God, Miró commands the sun to remove the hills and the forest stretching before him. According to Debreuille (p. 188), the first verse: "Soleil de proie prisonnier de ma tête" establishes a metaphoric relation between the sun and the speaker's head. Esteban (pp. 20–22) detects a similar link, from which he deduces that the painter draws his inspiration from the sun. Nevertheless, the apparent symmetry of "soleil" and "tête" is highly misleading. Although they occupy opposite ends of the verse, the latter's structure is not chiastic but reiterative. The elements in the second phrase are not reversed, as Debreuille and Esteban assume, but parallel those contained in the first phrase. A close reading reveals that "soleil" is paired with "prisonnier" instead of with "tête." For reasons that gradually become apparent, the sun is imprisoned in Miró's head. Like everything else in the poem, it arises from his imagination and can thus be manipulated at will. Within the boundaries constituted by his art (and the poetic text), Miró is the undisputed master of all he surveys.

As Greet (p. 99) points out, the initial phrase is modeled on a common expression: *oiseau de proie* (bird of prey), which it simultaneously displaces and invokes. Like Eluard's famous pronouncement: "La terre est bleue comme une orange" (The earth is blue like an orange), which has intrigued numerous critics, it derives from a simple substitution.[14] This operation is so widespread in his works that it may represent a conscious mechanism. In any event, the sun is depicted not just as a prisoner but as a predator as well—as an eagle or a hawk confined to a mental cage. Like a hunter with a trained falcon, Miró releases the captive sun and sends it on an aesthetic mission. Swooping down on the trees and hills, it carries them off in its talons together with his earlier style, with which these features are associated. Nothing remains to block our view of the morning sky which, the painter confides, "est plus beau que jamais."

At one level, therefore, the poem commemorates "the victory of pure light" over Miró's earlier preoccupation with realistic form (Greet, p. 100). At another level, it allows us to glimpse the artist himself as he prepares to paint an actual picture. "In 1925," Dawn Ades explains, "he began to cover his canvases freely with great

waves of color . . . On this background now floating in a space which ha[d] nothing to do with perspectival space and the horizon line, he place[d] forms and lines from his developing language of signs.[15] Requiring two separate operations, this process is described in the initial stanza. First of all, Miró brushes a wash over the canvas in order to give it a uniform color. At this point in his career, he tended to favor either blue or yellow. Once the paint has dried he traces a series of enigmatic designs, some of which resemble "libellules" and "raisins," utilizing random procedures. Although Gateau (pp. 142–45) associates the dragonflies with an actual painting, like the grapes they probably refer to general shapes rather than to specific motifs. Nevertheless, Miró reminds us, his brush can destroy as well as create. Despite their precision, these features can obliterated—like the hills and the forest—with a single stroke.

Whereas Miró obscured some markings by painting over them, he smeared others, using a rag or a sponge, until they were unrecognizable. As much as anything this is the source of the "nuages" in the second stanza, which represent smudges on the canvas as well as clouds. At this point, Eluard expands his central metaphor in order to emphasize the artist's originality. Miró's works herald the appearance not only of dawn, we learn, but of the very first dawn. They are not just new but ultra-new, not just inspired but completely unprecedented ("que rien n'autorise"). Once again the author insists that Miró is endowed with miraculous abilities. While he does not exist prior to God, as Greet maintains, he manages to usurp his divine role. Having created heaven and earth, which are empty and formless initially, Miró commands: "Let there be light!" In painting an abstract picture, he not only replicates the process described in the Bible but succeeds in creating his own universe. In addition, Greet (p. 101) notes that the stanza probably refers to a work entitled *La Naissance du monde* (*The Birth of the World*), which dates from the same period. However, the painting itself bears little resemblance to Eluard's text. Covered with a murky brown wash and numerous dark streaks, it seems to be bathed in sulfuric acid rather than light.

In contrast to the preceding lines, which are relatively accessible, the rest of the stanza is rather obscure. Following the appearance of the "nuages," Miró remarks: "Leurs graines brûlent / Dans les feux de paille de mes regards." However, we have no idea what kind of seeds he is thinking of nor what their relationship might be to the primordial clouds. Neither is it clear why Miró wishes to incinerate them in his fiery gaze nor how he manages to do so. On the one

hand, the seeds appear to continue the theme of birth and (re)generation introduced previously. On the other hand, the fact that we witness their destruction suggests they are associated with sterility and death. Not surprisingly, perhaps, most critics choose to ignore this section. As far as Miró's art is concerned, the lines undoubtedly allude to the black dots that punctuate many of his paintings. In addition, Gateau (p. 145) believes they evoke sparks from Midsummer Night's bonfires, but we have seen previously that the earth is uninhabited. In view of the poem's cosmic scenario, the lines could conceivably describe a few persistent stars shining in the morning sun. Nevertheless, although the seeds presumably originated in the clouds, there is no reason to assume they are still there. To the contrary, like seeds everywhere when they reach maturity, they seem to have fallen to the ground. Rather than sparks or stars, they probably represent drops of dew which the sun's rays are beginning to evaporate.

This situation alerts us to a subtle change in the relation between Miró and the sun. By the end of the poem, the artist has abandoned his initial role as Creator and has come to identify with the solar disc. In exchange the sun, and eventually the morning sky, acquire distinctly human properties. The text concludes, amid these personifications, with a statement of artistic principle and a stunning play on words: "A la fin, pour se couvrir d'une aube / Il faudra que le ciel soit aussi pur que la nuit." In order to be reborn, art and nature need to break decisively with the past. Before a new day can dawn, Miró insists, it must be preceded by a period of darkness. Before art can be transformed, it must be subjected to deliberate and systematic erasure. Since, as Debreuille (pp. 188–89) observes, "aube" designates not only the dawn but an ecclesiastical garment as well, the final stanza acquires pronounced religious overtones. Like a priest preparing to celebrate mass, the sky removes its dark cassock and dons a long white robe. Like the two of them, Miró implies, the true artist proceeds by purification and illumination.

4

André Breton

The Ideal Palace

Returning to Paris from Provence in September 1931, André Breton and Valentine Hugo stopped to visit an architectural curiosity in Hauterives, a small town in the Drôme region. Erected between 1879 and 1912 by Ferdinand Cheval, a rural mailman, the Ideal Palace was constructed of stones he had painstakingly collected and set in concrete. It was "[un] magnifique labyrinthe," Breton recalled a few years later, "entouré de gigantesques statues, creusé de grottes" ([a] magnificent labyrinth surrounded by gigantic statues and honeycombed with grottos).[1] As several generations of tourists have discovered, the sheer magnitude of Cheval's achievement is impressive. Rising as much as thirty feet in places and extending for some eighty-five feet, the main walls are heavily encrusted with exotic ornamentation. At times one seems to glimpse a mosque, a Hindu temple, a medieval castle, and—unexpectedly—a Swiss chalet. Within the palace precincts, which were never intended to be inhabited, one discovers numerous passageways, terraces, and staircases flanked by strangely-shaped columns bearing poems and aphorisms composed by the architect.[2]

For these and other reasons that will become apparent, this experience made a lasting impression on Breton, who returned with several photographs to show his colleagues. While the *Palais idéal* demonstrated that surrealism could be made to encompass architecture, its significance extended into other domains as well. On the one hand, it provided the surrealists with a concrete model to explore at a crucial stage in their development. On the other, it provided a theoretical model whose repercussions were destined to be far-reaching. When *Les Vases communicants* (*Communicating Vessels*) appeared the following year, for example, it included a photograph of Breton contemplating Cheval's fabulous structure (figure 7).

Figure 7. André Breton examining a portion of Ferdinand Cheval's *Ideal Palace* (1879–1912) in 1931.

Whereas all the other illustrations refer to corresponding sections of the text, there is no mention of the Ideal Palace anywhere in the book. Although critics have tended to dismiss the photograph accordingly, we will see that it plays a major role in the volume.

Nineteen thirty-two also witnessed the publication of a book of poetry entitled *Le Revolver à cheveux blancs* (*The White-Haired Revolver*), which contained a poem devoted to Breton's recent discovery. A fascinating composition in its own right, "Facteur Cheval" ("The Mailman Cheval") furnishes a rare glimpse—as do several poems by Federico García Lorca—of the surrealists' experiments with architectural ekphrasis.

> Nous les oiseaux que tu charmes toujours du haut de ces belvédères
> Et qui chaque nuit ne faisons qu'une branche fleurie de tes épaules
> aux bras de ta brouette bien-aimée
> Qui nous arrachons plus vifs que des étincelles à ton poignet
> Nous sommes les soupirs de la statue de verre qui se soulève sur le
> coude quand l'homme dort
> Et que des brèches brillantes s'ouvrent dans son lit
> Bréches par lesquelles on peut apercevoir des cerfs aux bois de corail
> dans une clairière
> Et des femmes nues tout au fond d'une mine
> Tu t'en souviens tu te levais alors tu descendais du train
> Sans un regard pour la locomotive en proie aux immenses racines
> barométriques
> Qui se plaint dans la forêt vierge de toutes ses chaudières meurtries
> Ses cheminées fumant de jacinthes et mue par des serpents bleus
> Nous te précédions alors nous les plantes sujettes à métamorphoses
> Qui chaque nuit nous faisons des signes que l'homme peut
> surprendre
> Tandis que sa maison s'écroule et qu'il s'étonne devant les
> emboîtements singuliers
> Que recherche son lit avec le corridor et l'escalier
> L'escalier se ramifie indéfiniment
> Il mène à une porte de meule il s'élargit tout à coup sur une place
> publique
> Il est fait de dos de cygnes une aile ouverte pour la rampe
> Il tourne sur lui-même comme s'il allait se mordre
> Mais non il se contente sur nos pas d'ouvrir toutes ses marches
> comme des tiroirs
> Tiroirs de pain tiroirs de vin tiroirs de savon tiroirs de glaces tiroirs
> d'escaliers
> Tiroirs de chair à la poignée de cheveux

A cette heure où des milliers de canards de Vaucanson se lissent les
 plumes
Sans te retourner tu saisissais la truelle dont on fait les seins
Nous te souriions tu nous tenais par la taille
Et nous prenions les attitudes de ton plaisir
Immobiles sous nos paupières pour toujours comme la femme aime
 voir l'homme
Après avoir fait l'amour

[We the birds you continue to charm from these towers
And who nightly form a flowering branch from your shoulders to the
 arms of your beloved wheelbarrow
Who tear ourselves away from your wrist more keenly than sparks
We are the glass statue's sighs as it rises on one elbow when man has
 fallen asleep
And when bright fissures open in his bed
Fissures through which deer with coral antlers can be glimpsed
And several naked women at the bottom of a mine
Do you remember you would get up then you would leave the train
Without glancing at the locomotive consumed by immense
 barometric roots
Moaning in the virgin forest with all its battered boilers
Its smokestacks belching hyacinths and propelled by blue serpents
We would go before you then we plants liable to metamorphoses
Who send nightly signals to each other that man can intercept
While his house collapses and he wonders at the strange intersections
That his bed attempts with the hallway and the staircase
The staircase branches out indefinitely
It leads to a millstone door it suddenly opens out onto a public square
It is made of swans' backs with one wing extended to form a railing
It turns around as if it were going to bite itself
But no it is content as we progress to open all its steps like drawers
Bread drawers wine drawers soap drawers mirror drawers staircase
 drawers
Drawers of flesh with handles of human hair
At the hour when Vaucanson ducks preen their feathers by the
 thousands
Without turning around you would seize the trowel of which breasts
 are made
We would smile at you you would hold us by the waist
And we would assume the postures of your pleasure
Immobile forever beneath our eyelids as a woman likes to see a man
After making love.]

Like so many surrealist poems, which despite the difficulties they pose are intensely lyrical, "Facteur Cheval" is essentially a monologue. More precisely, since the person to whom it is addressed is in no position to respond, it constitutes a one-sided dialogue. That individual, one quickly surmises, is Cheval himself who is present in spirit if not in actual fact. Although he was no longer living, the Ideal Palace kept his memory alive and served as a charming memorial. This much can be ascertained from the first line, which is uttered by a flock of birds perched on top of the palace. Or perhaps the words are spoken by a single bird acting as their representative. Every night, instead of roosting in the nearby trees, the birds fly to a (purely imaginary) statue of the architect pushing a wheelbarrow, where they arrange themselves along his outstretched arms like blossoms on a branch. A more touching tribute would be hard to imagine. Like St. Francis before him, Cheval seems to have been a simple, dedicated soul who inspired trust in animals and human beings alike.

Although one detects a few metonymic references, such as the wheelbarrow and the trowel used to construct the palace, the poem is overwhelmingly metaphoric. Since the surrealists favored the second trope over the first by a wide margin, this is not terribly surprising.[3] Rather than reduce the edifice to the sum of its parts, Breton adopts a more organic approach. Instead of singling out individual traits, he replicates its structure at two different levels. By employing a convoluted syntax he manages to imitate the palace's labyrinthine floor plan. The absence of punctuation makes it even harder for readers to situate themselves. In addition, by subjecting the speaker(s) to a series of metamorphoses, Breton mimics the shifts in architectural style that characterize different sections of the palace. The fact that this procedure is thematized halfway through the poem alerts us to its importance.

The first example of metamorphosis occurs in the fourth line where the birds are transformed into sighs. As if this were not enough, the sighs are emitted by a glass statue that also possesses the ability to move. Exemplifying the surrealists' fascination with *le merveilleux*, the statue incorporates a number of oppositions which explain its eerie appeal: fragile vs. sturdy, transparent vs. opaque, outspoken vs. mute, animate vs. inanimate, and ultimately human vs. nonhuman. Like the monument to Cheval in line 2, this invention may have been suggested by various sculptures adorning the Ideal Palace. Whatever the explanation, the statue is juxtaposed with

a second figure in the poem: "l'homme [qui] dort." For reasons that gradually become apparent, the former does not awaken (note its recumbent posture) until the latter has fallen asleep. The two actions are not only symmetrical but occur with impressive regularity according to the sporadic refrain. That the figures switch places "chaque nuit" suggests they represent conscious and unconscious aspects of a single individual. Or rather, since "l'homme" turns out to refer to mankind in general, they dramatize the alternation between dream and reality that characterizes the human condition.

What fascinated Breton above all, he confided in "Situation surréaliste de l'objet" (1935), was that Cheval drew his inspiration entirely from his dreams. Unlike contemporary buildings, whose rational origins were only too evident, the Ideal Palace provided an example of "irrationalité concrète" (*OC*, Vol. II, p. 478). Ever since the Second Manifesto (1930), moreover, Breton had sought to abolish a number of dichotomies, conceptual as well as perceptual, that impressed him as totally gratuitous. The most urgent task, one he explored at length in *Les Vases communicantes*, was to eliminate the division between conscious and unconscious activity, to find ways in which they would be free to intermingle. "Le poète à venir," he exclaimed in the final paragraph, "surmontera l'idée déprimante du divorce irréparable de l'action et du rêve" (Future poets will overcome the depressing idea of an irreparable divorce between action and dream) (*OC*, Vol. II, p. 208). Whereas the poets had yet to reconcile the two domains, a simple mailman, with no artistic training whatsoever, had already accomplished this feat. The Ideal Palace was an astonishing achievement not because of its size or the length of its construction but because, as Breton remarked a few years later, "[il] montr[ait] la possibilité de mettre fin à l'opposition immémoriale du rêve et de la réalité" ([it] demonstrat[ed] the possibility of abolishing the immemorial opposition between dream and reality) (*OC*, Vol. II, p. 1832). All at once one realizes why *Les Vases communicantes* concludes with a photograph of the palace. Depicting Breton standing at the entrance to one of the grottos, beneath a whimsically fashioned bridge, it exemplifies the process in question. Indeed, to judge from the cover of the paperback edition, it makes a better emblem than the communicating vessels themselves. Like the structure in the picture, Breton implies, the poet must strive to bridge the gap between conscious and unconscious worlds.

The beauty of this psychic operation is that it allows the reader (or viewer) to travel in either direction. If the model spans the interval

between night and day, between our irrational and rational person-alities, the reverse is also true. On the one hand, the Ideal Palace translates unconscious impulses into concrete shapes. As an inscrip-tion proudly proclaims, it is a place "où le songe devient la réalité" (where dream becomes reality) [4]. On the other hand, since the pal-ace is a repository of dreams, it provides tantalizing glimpses of un-conscious activity. Theoretically at least, one can return to their source, interpret them, and discover their latent content. Whether we make the *Palais idéal* the starting point or the goal of our quest, its significance remains the same. As "Facteur Cheval" insinuates, it serves primarily as an entrance to the world of dream. By contrast, the photograph in *Les Vases communicantes* shows Breton emerging from the palace—like Orpheus returning from his voyage to the un-derworld. Unlike his mythical predecessor, who failed to accomplish his mission, Breton returned with precious information about the unconscious.

Not surprisingly, in view of the preceding discussion, the uncon-scious also plays a prominent role in the poem. Since it becomes more accessible during sleep, when the conscious censor is relaxed, Breton shifts the action from the palace to the bedroom. As if the bed were constructed of lava, several fissures open beside the sleep-ing "homme," revealing a glowing interior and some very strange inhabitants. The scenes that follow, one eventually realizes, are dreams issuing from mankind's collective unconscious. Beginning with the magnificent deer, or perhaps with the glass statue, we expe-rience a whole series of marvelous encounters. Although various deer figure among Cheval's sculptures, the animals in the poem are a different breed altogether. Not only do they seem to be alive, but they are equipped with bright red antlers made of coral. Or again, since coral comes in other colors, perhaps their antlers are pink or white. We know from *L'Amour fou* (*Mad Love*) (1937), in any case, that this substance held a particular attraction for Breton. "L'inan-imé touche ici de si près l'animé," he explained, "que l'imagination est libre de se jouer à l'infini sur ces formes d'apparence toute minér-ale" (The inanimate so closely resembles the animate that one's imagination is perpetually stimulated by these life forms, which ap-pear to be entirely mineral) (*OC*, Vol. II, p. 681).

Similarly, the women in the next line consist of flesh and bone rather than clay. Unlike the female sculptures adorning the palace, which are generally clothed, they are completely naked. Readers who are familiar with Breton's writings will immediately recognize

one of his favorite fantasies.[5] "J'ai toujours incroyablement sou-haité," he confessed in *Nadja* (1928), "de rencontrer la nuit, dans un bois, une femme belle et nue" (I have always had an incredible desire to encounter a beautiful, nude woman at night in a forest) (*OC*, Vol. I, p. 668). The closest Breton had come to realizing his fantasy, he confided in the same paragraph, was during a visit to a movie theater, where he spied a naked prostitute strolling up and down the aisles. Evoking this incident twenty-three years later, he re-called how her body's "phosphorescent whiteness" was accentuated by the dark.[6] Since "Facteur Cheval" was set in the middle of a pal-ace, Breton modified the imaginary scene accordingly. The fact that the edifice contained several grottos induced him to transfer the se-ductive women from the forest to a mine, which offered the same privacy and isolation. As before, the darkness does not obscure the women but rather emphasizes their dazzling nudity.

The next four lines present another of Breton's fantasies which, while not as overtly sexual, recurs just as regularly. Or rather, since the poet himself is not directly involved, perhaps it should be classi-fied as an obsessive image. The final paragraphs of *Nadja*, in any case, celebrate a unique kind of beauty that the surrealists were the first to recognize and which Breton called "convulsive" (*OC*, Vol. I, pp. 752–53). Only works that exemplified this aesthetic principle, he proclaimed, were truly beautiful. The orgasmic nature of convul-sive beauty, which was "neither dynamic nor static," was apparent from the accompanying text. To illustrate this new aesthetic, Breton imagined a train straining restlessly against its brakes in the Gare de Lyon, eager to depart but continually held in check. Returning to this subject in *L'Amour fou*, he lamented that he was unable to illus-trate his remarks with "la photographie d'une locomotive de grand allure qui eût été abandonnée durant des années au délire de la forêt vierge" (the photograph of a powerful locomotive abandoned for years to the delirium of a virgin forest) (*OC*, Vol. II, p. 680).[7]

Among other things, one suspects Breton was influenced by Gior-gio de Chirico, whose paintings depict trains halted before brick walls, unable to proceed. Conceived as a monument both to victory and to disaster, Breton added, his convulsive locomotives exist "at the exact moment their movement ceases." This describes the en-gine in "Facteur Cheval" as well, which combines some of the first machine's features with others belonging to the second machine. Like the locomotive in *L'Amour fou*, it is covered with roots and ten-drils that have invaded every opening. Judging from the exotic

flowers, vines, and snakes, it is imprisoned by a tropical jungle, where vegetation grows at an alarming rate. Applied to the immense roots that threaten to crush the hapless machine, the adjective "barométrique" is puzzling initially. However, the term refers not to the barometer's ability to predict the weather but to its physical appearance. Just as the column of mercury responds to variations in the air pressure, the water in the roots rises or falls according to supply and demand. Like the locomotive in *Nadja*, on the other hand, the engine refuses to adopt a passive role and protests vociferously against its fate. Like a spotted deer struggling in a tiger's jaws, it strives to free itself from the jungle's embrace but only succeeds in bruising its battered boilers. Jean-Pierre Cauvin offers the following gloss:

> The image vividly symbolizes the victory of the unconscious over the conscious. The locomotive, as a male symbol, has penetrated the virgin forest, identified with the female principle, and has been absorbed by it. A complex artifact constructed by human ingenuity as a powerful vehicle for the fulfillment of human imagination and desire is assimilated by the raw power of nature.[8]

In addition the locomotive appears to serve as a metaphor for the Ideal Palace. The more one considers the situation, the more convinced one becomes that Cheval was inspired by contemporary reports—perhaps even photographs—of ancient temples reclaimed from the jungle after centuries of neglect. The most famous was Angkor Wat, rediscovered in 1861, which was explored by several French expeditions while Cheval was constructing his palace. Like these impressive monuments (and like the locomotive), the *palais idéal* is covered with roots and vines that form an extensive sculptural network. As such, Breton's metaphor implies, it functions not only as an entrance to the dream world but also as a site of convulsive beauty. Despite its undeniable solidity and enormous bulk, therefore, the palace is pulsating with energy. Significantly, Breton declared in "Le Message automatique" that its design was originally inspired by local cave formations (*OC*, Vol. II, p. 383). Together with the locomotive, coral, and crystals, he added in *L'Amour fou*, these were also sources of convulsive beauty (*OC*, Vol. II, p. 680).

By this time the poem's speaker or speakers have become plants which, like the serpents, inhabit the tropical jungle, mankind's dreams, and the Ideal Palace. Simultaneously recalling Baudelaire's trees in "Correspondances," which "laissent parfois sortir de con-

fuses paroles" (occasionally allow confused words to escape), they exchange messages that are occasionally intercepted by human beings. As "l'homme" continues to sleep, he dreams his house is destroyed by an earthquake and that his bed winds up next to the spiral staircase. Although the palace contains four staircases that fit this description, Breton is probably alluding to the one on the right of the main facade. Swooping upward in a graceful arc, it is exposed to the open air like that in the poem. Descending in the opposite direction, the first set of stairs leads to a formal garden, while the second opens out onto a public square.

In contrast to the original model, the staircase in "Facteur Cheval" possesses several unusual properties. For one thing, it branches off in every conceivable direction like a tropical vine. For another, it is made out of feathers instead of wood or stone. Judging from appearances, the graceful curve of Cheval's staircase reminded Breton of a swan arching its neck. Enlarging this metaphor to encompass the entire bird and translating it into concrete terms, he envisioned a staircase made of actual swans, whose extended wings conveniently form the railing. For yet another thing, each of the stairs opens like a drawer whenever somebody steps on it. Salvador Dalí adopted a similar procedure a few years later when he painted a series of human figures with drawers emerging from their bodies. The first three drawers in the staircase contain items that are usually found in the pantry: bread, wine, and soap. The second three contain items that belong to radically different categories: mirrors (or perhaps ice cream), staircases, and human flesh. As in the surrealist game *l'un dans l'autre* ("one in the other"), the idea that any object can be contained in any other object dissolves existing categories and encourages us to question our logocentric assumptions. However, the preposition "de" seems to acquire a new function at this point that problematizes the status of the entire series. Although the drawers could conceivably contain pocket mirrors, miniature staircases, and pieces of flesh, they appear to be made of these materials instead. This situation compels us to reexamine the first three drawers which, one discovers, may also be composed of the items in question. At the very least, their relation to the bread, the wine, and the soap is ambiguous. The impossibility of deciding between the two perspectives increases the sensation of *dépaysement* ("disorientation") that has assailed the reader from the beginning.

As elsewhere in Breton's work, the phrase "A cette heure où" suggests that what we are about to witness is highly unusual.[9] At the

same time, paradoxically, it implies that the event in question occurs on a regular basis. Prompted undoubtedly by the setting sun, thousands of mechanical ducks begin to preen their feathers at the same hour every evening. Invented by Jacques de Vaucanson in 1738, the birds have apparently continued to reproduce until they constitute an immense flock. Clustered around the Ideal Palace for reasons that eventually become evident, they are presumably preparing to go to sleep. As such their presence is primarily emblematic, stressing the importance of psychic automatism and dream to the surrealist mission.

Complementing their symbolic role, the ducks introduce the final section of "Facteur Cheval," where we glimpse the architect working on a portion of the palace. At this point, the speaker or speakers have been transformed from tropical plants into female statues that adopt "les attitudes de [son] plaisir." Holding the statues by the waist, Cheval gives each of them breasts and arranges them in beguiling poses. To be sure, this activity is fraught with sexual overtones that have serious implications. Cheval does not seem to be sculpting statues so much as to be making love to several women. Responding to his passionate commands, they joyfully assume a variety of sexual positions. Whereas the man usually dozes off after lovemaking, this role is reserved for the statuesque women, who fall into a deep sleep that is destined to last forever. The poem concludes with an extended metaphor, therefore, that celebrates the creative act and proclaims the superiority of the surrealist vision. Above all, it implies, the creation of the Ideal Palace was a monumental labor of love. Like an ardent lover, Cheval put all his energy into the project, never swerved from his goal, and derived intense satisfaction from its completion. One suspects these comments apply to Breton as well who, in seeking to pay homage to the humble mailman, appears to have been inspired by his example.

SURREALISM AND PAINTING

I.

Discussing *Le Surréalisme et la peinture*, which Breton revised and expanded twice following its publication in 1928, Michael Riffaterre distinguishes three kinds of texts:

Certains ont l'ampleur, le ton à la fois prophétique et polémique des *Manifestes*; d'autres, nés de l'occasion, semblent n'être que des notules annonçant des vernissages, mais toujours bâtis autour d'une image, se révèlent proches du poème en prose; les plus complexes font alterner la théorie, la paraphrase des textes visuels, l'historique d'un mouvement et le rappel nostalgique des grands moments du surréalisme.

[Some possess the breadth, the simultaneously prophetic and polemical tone of the *Manifestos*; others, products of the moment, seem to be brief notices announcing previews of the artists' works but, centered around a single image, approximate poems in prose; the most complex alternate between theory, visual paraphrase, the history of surrealism, and nostalgic memories of decisive moments in its evolution.][10]

Although these texts take the form of prose commentaries, Riffaterre believes their inspiration is essentially poetic. Despite their obvious differences, he maintains that the principles they embody are those of lyrical ekphrasis. Beyond the fact that they have the same author and are concerned with similar subjects, however, they seem to have little in common. The only other thing they share, Anna Balakian observes, is their high degree of enthusiasm.[11] A similar problem arises when one examines the texts' poeticity which, like their supposed unity, is largely illusory. For the most part, as we saw in the first chapter, Breton adopted a discursive style that was anything but poetic. Since his remarks were addressed to the general public, whom he hoped to enlist in the surrealist cause, he did not wish to be either obscure or outrageous. In contrast to "Facteur Cheval," therefore, the essays are logical, well organized, and surprisingly accessible. While they examine the role of surrealism in art, they do not employ surrealist methodology themselves. Ironically, although Breton was probably the most important surrealist critic, he rarely wrote in a Surrealist mode. His occasional experiments with surrealist criticism per se are confined almost entirely to his poetry.

A rapid survey of *Le Surréalisme et la peinture* sheds additional light on Breton's original project. From the beginning, it would seem, the volume was conceived as both a defense and an illustration of surrealism. While the two functions were obviously complementary, Breton assigned the first role to the text and the second role to the pictures that accompanied it. This explains why his remarks are dominated by polemical, theoretical, and historical concerns. Nevertheless, as Riffaterre declares, one encounters a few brief notices from time to time that resemble prose poems. On a few occasions,

Breton could not resist the temptation to combine criticism with poetry. Introducing a painter named Edgar Jené in 1948, for example, he devised the following text:

L'art de Jené ce ménure-lyre au carreau de gypse d'une fenêtre de grotte donnant sur les premières prairies de feu en fleurs dans une tête prise en écharpe par une aurore boréale et dévalant outre-monts pour surprendre au lever les jeux du pollen et de la rivière comme une femme qui glisse sur la barque d'étincelles de tous les regards dans le décolleté des neiges qui s'arborisent au fond des mers contre nos vitres pour enluminer ce texte hermétique du XXe siècle: "Chaque monde a la forme d'un oiseau très compliqué: l'oiseau est assis au milieu sur une sphère comme sur un oeuf; un énorme satellite tourne autour, il a presque la forme d'une pelure d'orange fendue en fragments, réunis à l'un des pôles, l'orange étant retirée. L'âme de l'oiseau se meut dans une boucle qui va de la sphère centrale à la pelure déployée; elle la picore puis retourne couver la sphère. Cependant le tout est une âme d'oiseau. Les couleurs en sont magnifiques."

[The art of Jené this lyre-bird at the pane of gypsum in a grotto window overlooking the fiery meadows in their first flowering in a head intersected by an aurora borealis and flowing down beyond the mountains to surprise the nascent games of the pollen and the river like a woman who glides on the ship full of sparks of everyone's glances in the low neckline of the snows that trace delicate patterns at the bottom of the sea against our windowpanes in order to illuminate this hermetic 20th century text: "Each world assumes the shape of a very complicated bird: the bird is sitting in the middle on a sphere as if it were an egg; an enormous satellite revolves about it, shaped nearly like orange peelings that have been joined together again at one of the orange's former poles. The bird's soul moves in a loop extending from the central sphere to the unfolded peel; it pecks at the peel then returns to sit on the sphere. And yet the whole ensemble is a bird's soul. Its colors are magnificent."][12]

In general, Balakian affirms, Breton considers an artist's work from the point of view of its genesis. What interests him above all is "the psychological vantage point of the artist, his notion of reality, his choice of subject, the means rather than the degree of execution of intent, not the finished product but the process of creating the structure, not its relation with other art, but its contingency with life, as a product not of the hands and the palette but of the mind's labyrinth."[13] These observations apply not only to Breton's conventional

criticism but also to that which aspires to the condition of poetry. To be sure, texts such as "Facteur Cheval" and "Edgar Jené" reveal as much about the author as about the artist in question. Others, such as the "proses-parallèles" published in *Constellations* (1959), seem to neglect the creative artist altogether.[14] Nevertheless, despite their undeniable subjectivity, one notes the same concerns in all these works. Breton focuses invariably on the artist's inspiration, how it is transmuted into art, and what it reveals about the labyrinthine operations of the mind. The later subject is implicitly thematized both in "Facteur Cheval," whose narrator guides us through the palace's winding passageways, and in "Edgar Jené," which is situated in an underground grotto. It is reflected as well in their convoluted sentences, which meander across the page in response to unconscious impulses. In contrast to the first work, which contains invisible commas and periods, the first eight lines of the second work are linked together by prepositions and conjunctions. Whereas the former proceeds by stops and starts, the latter flows effortlessly toward its eventual goal.

Like many of the previous poets, Breton chooses a striking image to represent Jené and his art: an Australian lyre-bird. Whereas the Synthetic critics reserved their emblems for the conclusion, he introduces the image at the very beginning, where it presides over the rest of the text. Jené's pictures must be very beautiful indeed, the reader imagines, to merit such a magnificent metaphor. In common with the lyre-bird they are undoubtedly graceful, symmetrical, and elegant. However, this impression is quickly dispelled by the accompanying illustration, entitled *Sylvanna,* which possesses none of these qualities. Like many of the artist's works, it depicts indistinct shapes overlaid with a heavy impasto and obscured by murky shadows. Interestingly, Jené's paintings appealed to German viewers in particular—doubtless because of their expressionist technique.[15] While it remains to explain how they are related to the lyre-bird, we can safely rule out physical resemblance. Breton was attracted to the bird not so much because of its appearance, one eventually realizes, but because of its name, which allowed him to transform it into an Orphic emblem. In this capacity, it testifies to the divine nature of Jené's inspiration and implies that it is essentially poetic.

As we discovered earlier, subterranean grottos play a special role in Breton's works as sources of convulsive beauty. Surprisingly, although "Edgar Jené" is situated in just such a cavern, the (implicit) narrator pays no attention whatsoever to his surroundings. Turning

his back on the limestone formations, he gazes out a window, like the lyre-bird, with rapt attention. Why anybody would bother to install a window in an underground chamber is puzzling, to say the least. One wonders what there could possibly be to look at and—since the pane is made of gypsum rather than glass—how anyone could possibly see it. Unexpectedly, it turns out to be a magic window that reveals a marvelous new world. On the one hand, the fact that it provides a conduit between the two realms recalls the looking glass in *Alice in Wonderland*. On the other hand, the fact that it is opaque reminds one of a television set. In 1948, to be sure, the second invention appeared to be no less miraculous than the first.

The concept of a magic window itself, however, dates back to 1928 and the publication of *Le Surréalisme et la peinture*. Introduced at the beginning of the volume, it determined the form much of the discussion would take and influenced the evolution of surrealist aesthetics in general. In particular, the concept was associated with the persistent quest for *le merveilleux*, with the desire to discover the source of convulsive beauty. "Il m'est impossible," Breton explained initially, "de considérer un tableau autrement que comme une fenêtre dont mon premier souci est de savoir sur quoi elle donne" (It is impossible for me to envision a painting otherwise than as a window, my first concern being to know what it looks out on).[16] By the same token, as "Edgar Jené" demonstrates, the equation turns out to be reversible. The reason the grotto window is nonfunctional, one perceives, is that it was never intended to be a window. On the contrary, it serves as a metaphor for the artist's pictures which, in turn, are conceived as communicating vessels. Despite their technical accomplishment and original inspiration, they act primarily as catalysts. In keeping with Breton's dictum, the viewer gazes not at but through the paintings into the marvelous domain that lies beyond. Whereas Duchamp had transformed a pane of glass into a work of art in *The Bride Stripped Bare By Her Bachelors, Even*, Breton urged the surrealists to reverse the process.

Thus far Breton's instructions to the viewer are cogent, concise, and perfectly clear. At the same time, they conceal a basic paradox that subverts their claim to authority. As one soon discovers, the operation is impossible to carry out in actual practice. The magic window metaphor breaks down when one attempts to apply it to a particular painting. After all, there is a vast difference between a pane of glass and a work of art (despite Duchamp's attempt to combine them). While we usually look through a window without seeing

it, one must see the painting before one can "look through" it. Although the picture is not the end in itself, it is the indispensable means to that end and as such impossible to ignore. Before its various elements can stimulate the viewer's imagination, they must be perceived by the latter's retina, translated into neural impulses, and transmitted to the brain. Only then can one transcend the painting itself and explore the virtual reality it opens onto.

In contrast to the passage from *Le Surréalisme et la peinture*, which focuses on the second step, "Edgar Jené" illustrates the entire process. For if the magic window reveals a fabulous landscape, the landscape itself refers repeatedly to the magic window. Jené's pictures serve not only as the point of departure for Breton's vision but also as a continual point of reference. Many, if not most, of the landscape's features were suggested by one or more paintings. Some of the images were borrowed verbatim, others differ significantly from their original models. Although the lyre-bird is conspicuously absent, for instance, several paintings feature avian cousins that are equally impressive. Thus *L'Oiseau Roc* (1946) portrays the legendary Arabian bird against a background reminiscent of Dante's *Inferno,* and *L'Oiseau des ruines* (1945) depicts a gigantic bird hovering above a mysterious city lying in ruins. Similarly, while the "barque d'étincelles" seems to have been invented especially for the occasion, ships of varying shapes and sizes appear in a number of Jené's works.

By contrast, the northern lights that illuminate the disembodied head refer to a specific painting: *Le Fils de l'aurore boréale* (*The Son of the Aurora Borealis*) (1948), in which a large humanoid figure observes the shifting patterns that fill the night sky. For that matter, the head itself plays a prominent role in the artist's iconography where, as *Sylvanna* demonstrates, it is invariably depicted in silhouette. Nevertheless, any similarity between the latter work and "Edgar Jené" is purely coincidental. For if Breton's text dates from 1948, when the artist had his first one-man show in Paris, *Sylvanna* was not painted until 1954.[17] Although the text contains numerous references to Jené's earlier style(s), Breton inadvertently paired it with a later illustration when he incorporated it into *Le Surréalisme et la peinture* in 1965. After 1948, however, the artist developed a whole new manner that, except for perpetuating one or two motifs, bore little resemblance to his previous efforts. He no longer painted recognizable figures, for instance, but adopted an abstract style that was vaguely anthropomorphic. With few exceptions he no longer used bright

colors but limited his palette to somber hues, which he applied with a trowel rather than with a brush.

Recalling the artist's earlier paintings, the scene deftly sketched by Breton is anything but somber. On the contrary, it soon becomes apparent that it is ablaze with color. While the aurora borealis shimmers overhead, draping the sky in curtains of light, the meadows are covered with millions of flowers. In contrast to the former's delicate pastels, the latter's red, yellow, and orange petals make the meadows look as if they are on fire. Since the flowers and the northern lights are visible at the same time, the drama presumably takes place at daybreak. This impression is strengthened by the expression "au lever," which seems to refer to the sunrise. As the sun peeks over the horizon, its rays strike the mountain tops initially, illuminating the highest meadows ("les premières prairies") first before descending to the valley floor. Thus the passage embodies a temporal transition, on the one hand, and a spatial transition on the other. As night gradually turns into day, we follow the carpet of flowers as it descends from the mountain heights to the river bottom far below.

At this juncture, Breton introduces a simile of epic proportions that threatens to overwhelm the reader. The tangle of indirect allusions, ambiguous antecedents, and implicit relations is so complex that it seems impossible to unravel. Time after time a promising avenue of investigation leads to an interpretive impasse. Only after an exhaustive analysis do we finally grasp the principles at work here. Eventually one perceives that the simile is structured around two parallel activities, governed by "dévaler" and "glisser" respectively. Flowing gracefully down the mountainside, Breton insinuates, the flowery carpet resembles a skier descending a snowy slope. The first term is obscured by a profusion of prepositional phrases, the second by two additional metaphors. Besides syntactic ambiguity, therefore, the simile is complicated by metaphoric interference.

For reasons that are not immediately evident, the skier glides down the slope on a glittering boat rather than on conventional skis. Since many of Jené's pictures depict female subjects, in any case, Breton decided to make the skier a beautiful woman. The fact that she is wearing a low-cut gown explains why she has attracted the admiring glances of so many men which, in turn, allows us to understand why she has exchanged her skis for such a strange mode of transportation. The source of the marvelous "barque d'étincelles," one realizes in retrospect, is none other than the *regards étincelants* emanating from the woman's admirers. Proceeding according to

unconscious cues, Breton transformed the noun into a metaphor, the adjective into another noun, and linked them together with a preposition. In addition, the poet draws an implicit comparison between the woman's breasts, which are clearly visible, and the snowy hills around her. Or rather, since the comparison is never made explicit, he integrates the woman herself into the winter landscape. This idea was undoubtedly suggested by several of Jené's paintings, for example *Paul Celan* (1948), in which a female silhouette participates in the natural setting.

Breton pulls back at this point and views the scene from within the grotto once again. More precisely, since this has been his vantage point all along, he distances himself from the scene in question, which suddenly appears to be taking place at the bottom of the sea. At the same time, he becomes aware of the windowpane in front of him which regains its identity and its former opacity. As frequently happens when the temperature drops below freezing, the window seems to be covered with frost, whose delicate tracings branch out in every direction. In this way, the text manages to come full circle and concludes much as it began—with the image of a marvelous bird juxtaposed with the magic window. While the second bird does not appear to be as beautiful as its predecessor, it is much more remarkable. Unknown to naturalists and mythographers alike, it is unique in the history both of ornithology and of the human imagination as well. According to a footnote, Breton encountered this *rara avis* in a curious book by Denis Saurat entitled *Victor Hugo et les dieux du peuple*, which includes a collection of twentieth-century materials apparently authored by psychics.[18] The documents themselves, Saurat confides in the introduction, were collected by Dr. M. Joycey Fisher and obtained with the help of the director of the *London Psychic Times*. Impressed by the cosmic bird and its supernatural abilities, Breton appropriated most of the original paragraph, incorporated it into "Edgar Jené," and assigned it a central role in the composition. Relegating his own text to the margin, he explained that, like a medieval illumination, it serves to illustrate the document in question. For that matter, this observation undoubtedly describes Jené's pictures as well. Thanks to works such as these, which have accustomed us to unconscious mechanisms, we are prepared to marvel at the psychic text's strange beauty.

II.

Although Toyen was born and raised in Czechoslovakia, where she was baptized Maria Čermínová, she spent the last thirty-three years

of her life in Paris. Despite her undeniable talent she remains, in
José Pierre's words, "the least acknowledged of the great Surrealist
painters."[19] And yet, Sarane Alexandrian insists, "there is no doubt
that she is an artist of the first rank who brought to painting some-
thing of what Kafka gave to literature."[20] In his opinion, which is
shared by many other critics, "her work is one of the Surrealist se-
crets most worthy of being discovered."[21] Like his colleagues, Breton
was highly impressed by Toyen's dedication to surrealist principles,
by her startling originality, and by her uncanny ability to tap the un-
conscious. Together with Benjamin Péret and Jindrich Heisler, he
published a slim volume in 1953 that sought to make her work bet-
ter known. Paying homage to Toyen's indomitable spirit, which had
survived numerous personal and political tragedies, he declared
that her art was "lumineuse comme son coeur et pourtant traversée
de présages sombres" (as luminous as her heart and yet traversed by
dark forebodings).[22]

Breton's essay was reprinted in the final edition of *Le Surréalisme
et la peinture*, together with another text he had composed for an
exhibition of Toyen's work in 1958. Whereas the first piece differs
little from traditional art criticism, with its analytical bias and exposi-
tory style, the second is written in a surrealist mode. Entitled "La
Somnambule," it functions not as a commentary but as a work of art
itself.

Tu m'auras et tu ne m'auras pas, toute en veilleuse surgissant du plus
profond des chapelles d'Eros qui battent la campagne, mise à perte de
vue pour toi seul des dessous des noctuelles. Et vers toi, du marais livide
de leur lit, tes amantes, leur sang n'a fait qu'un tour, auront beau décrire
mille courbes convulsives, je n'aurai, moi, qu'à glisser pour faire éclore
dans ton coeur les graines de fuchsia et les bulles de Füssli. C'est pour
toi que ma tête se renverse sous le haut radar du peigne. A ta rencontre
je m'avance entre la lumière et l'ombre: fais de moi ce que tu ne voudras
pas. Si le bas de mon voile se givre à la croisée, ne le soulève pour rien
au monde, tu en serais quitte pour les ténèbres de la mémoire, mais
baise ma mule *cerise*.

[You will have me and you will not have me, my vigilant light arising
from the depths of the chapels of Eros that scour the countryside, ex-
tending nearly out of sight for you alone from the noctuid moths' abdo-
mens. And toward you, from their bed's livid swamp, your lovers, whose
blood has merely completed a single cycle, will describe a thousand con-
vulsive curves in vain, as for me, I need simply slip fuchsia seeds and Füs-

sli bubbles into your heart for them to bloom. It is for you that my head bends back beneath the high radar of the comb. I go to meet you between the light and the shadow: do with me what you do not wish to. If the lower edge of my veil frosts over at the casement window, do not lift it for anything in the world, you would be left with the shadows of memory, but kiss my *cerise* slipper.][23]

Positioned directly beneath the heading: "TOYEN" (printed in boldface capitals), the title seems at first glance to describe the artist. Suspended high above the text, which is displaced toward the lefthand margin, it appears to portray her as someone who inhabits the world of dreams. This impression is heightened by the discovery that the text is addressed to Breton by a female speaker. Or perhaps it is intended for the reader/viewer—the recipient is not identified. Presumably uttered by the somnambulist, at any rate, it assumes the form of a monologue addressed to a masculine admirer. In contrast to Breton's earlier essay on Toyen, which directly precedes it, the composition is not accompanied by illustrations. However, it benefits indirectly from two photographs on the opposite page, one of which reproduces a painting entitled *La Somnambule* (figure 8). Depicting an invisible woman dressed in a long, diaphanous gown, the work dates from 1957. Breton's text is uttered not by Toyen, one suddenly realizes, but by the woman in this painting. If every poem is a "speaking picture," as Simonides of Keos proclaimed long ago, this is doubly true of "La Somnambule."

Although the English translator of *Le Surrealisme et la peinture* calls the composition (and the painting) "The Clairvoyante," this title is highly misleading. While the woman in both works undoubtedly possesses supernatural abilities, she does not appear to be able to read minds or foresee the future. On the contrary, her extraordinary power stems not from her sight but from her lithe body, which despite its lack of visibility, is hauntingly erotic. If "clothes make the man" according to a well-known saying, they literally allow the viewer to construct Toyen's women. In this regard *La Somnambule* resembles a number of other paintings, such as *Les Fêtes de la soie* (*Silken Feasts*) (1962), which depicts three invisible women dressed in slinky gowns whose latent presence is fraught with desire. Like them, the female sleepwalker invites the viewer to satisfy his carnal appetite, to indulge in a *fête de la chair.* In general, Whitney Chadwick declares, Toyen integrates the erotic into the emotional content of her paintings using eroticism "as the basis for a new language of psychological association and suggestion."[24]

Figure 8. Toyen, *The Sonambulist*, 1957. Dimensions and whereabouts unknown.

Discussing an earlier painting by Toyen, Renée Riese Hubert remarks that "desire consolidates the bridge between absence and presence, between void and plenitude."[25] This phenomenon can also be observed in *La Somnambule* as well as in the text by Breton. Both works celebrate the erotic impulse which, emerging from the depths of the unconscious, transforms the world around us. Or rather they celebrate the mythic figure of the somnambulist, who incarnates this mysterious impulse. That she resembles a votive light emanating from an underground chapel implies that her mission is sacred. Similarly, the fact that *battre la campagne* also means "to become delirious" suggests an analogy between erotic and religious ecstasy. Situated at the intersection of visibility and invisibility, the sleepwalker mediates in addition between a whole series of oppositions. Usurping the role (and the symbolism) of the communicating vessels, she dissolves traditional antinomies and exerts an important unifying force. What makes her so tantalizing is not her beauty, which is invisible, but the fact that she is simultaneously available and unavailable. Like a ray of light, the first sentence announces, she can be seen but not grasped, desired but not possessed. And yet, she assures her frustrated admirer, she exists "pour toi seul."

The sentence ends on this paradoxical note amid considerable confusion. Suddenly adopting a vanishing perspective, the scene is invaded by a number of noctuid moths that for some reason exhibit their fuzzy undersides. According to one authority, they are also called owlet moths because their eyes glow in the dark whenever light strikes them.[26] While the genus comprises several common pests such as cutworm and cornborer moths, it includes some large, showy specimens as well—one of which is perched on the somnambulist's right shoulder in Toyen's painting. On the one hand, the "noctuelles" reinforce our initial impression that the scene takes place at night, which is confirmed by *La Somnambule*. On the other hand, their presence reactivates the very first metaphor in Breton's text. Since the sleepwalker is depicted (depicts herself) as a source of light, it is not surprising that moths are attracted to her. She represents not only a source of erotic illumination, therefore, but seems to constitute a beacon shining in the wilderness.

Like the moths drawn helplessly toward the light, she proclaims in the next sentence, Breton is powerless to resist her charms as well. The young women who occupy his bed are only babies ("leur sang n'a fait qu'un tour") who are positively ugly by comparison. Like frogs and other swamp dwellers, they wallow in their own filth and

that of others. Like snakes they writhe in the coils of their passion without managing to ensnare the poet. Whereas they seek in vain to capture Breton's heart, the somnambulist knows how to make love bloom whenever she desires. Although the reference to fuchsias is unexpected, the flower has the same shape and the same color as the human heart. By contrast, the allusion to "les bulles de Füssli" is highly misleading. To be sure, Breton is referring to Johann Heinrich Füssli (1741–1825), a Swiss artist who spent many years in England where he was known as Henry Fuseli. The transition from the fuchsias to Füssli himself seems to have been motivated by phonetic similarities in their names.[27] In addition, Breton may have been familiar with the artist's aesthetic pronouncements. "A hundred and thirty years before the advent of the Surrealists," Ruthven Todd writes, "he remarked that 'one of the most unexplored regions of art are dreams.' "[28]

However, the "bulles" associated with the painter are much more difficult to identify. Although the reader proceeds on the assumption that the reference is thematic, it turns out to be amazingly ambiguous. It refers not only to bubbles, for example, but to medallions, Papal edicts, blisters, a kind of mollusc, ornamental nailheads, and a host of other things—none of which have anything to do with Füssli. A leading authority on the artist, David H. Weinglass, would solve the problem by interpreting the term metaphorically. Zeroing in on the first meaning, he suggests that Breton was thinking of Füssli's effervescent imagination.[29] Because the latter believed in dreaming as creative work, he adds, Breton may have considered his *Aphorisms on Art* and his *Lectures* as artistic edicts. If he is correct, the somnambulist would be linked to the creative imagination. On the other hand, the term may be interpreted metonymically as well. Breton may simply be alluding to a group of drawings on buff-colored paper, which in French is called *papier bulle*. Visiting his studio, one contemporary observer reported that it was filled with "galvanized devils—malicious witches brewing their incantations—Satan bringing Chaos, and springing upwards like a pyramid of fire—Lady Macbeth . . . humour, pathos, terror, blood and murder [which] met one at every look!"[30] In this instance, despite her erotic origins, the somnambulist would be associated with the grotesque. Like Shakespeare's plays, which provided Füssli with frequent subjects, she would instill wonder and awe in the heart of the beholder but also pity and fear.

Whichever interpretation one chooses to adopt, the somnambu

list's role continues to be highly erotic. Reverting to a more seductive mode in the next sentence, she describes her preparations to meet her lover. Since she combs her long hair without looking at it, Breton jokes that the comb is equipped with radar. Before long, the sentence implies, she will arch her body rather than her neck as the poet makes passionate love to her. Advancing to meet him, she pauses on the threshold between the light and the shadow and invites him to embrace her. This moment is immortalized in Toyen's painting and accounts for the threshold imagery that pervades the text. Night is juxtaposed with day, sleep with wakefulness, the unconscious with the conscious, and dream with reality.

At the very instant the sleepwalker gives herself to the poet, however, she issues a strange command. She orders him to treat her not as he wishes, as one would expect, but as he does *not* wish. Do not lift my frosted veil under any circumstances, she tells him, because you will discover there is nothing behind it. Indeed, this prohibition extends to Toyen's painting, where it is not her face that is veiled but rather her body. Do not attempt to undress me, the somnambulist exclaims in effect, because you will find that I am wholly immaterial. Since I do not fully belong to your world, I cannot make love with you. This abrupt reversal interrupts the previous scenario, which was predicated on the fulfillment of their mutual desire. While the reader has been looking forward to the sleepwalker's surrender, like Breton himself, their love must remain forever unconsummated. As she proclaimed at the beginning of the text, "tu m'auras et tu ne m'auras pas." The final phrase shifts the discourse to another register and presents a different solution. Drawing herself up to her full height, she commands: "baise ma mule *cerise.*" Although the color of her footwear recalls its etymology (< *mulleus* = "red slipper"), the phrase itself is modeled on the expression "baiser la mule du pape" ("to kiss the Pope's slipper"). Thus the text concludes not with the gesture of love that we anticipated but with a gesture of submission and devotion.

5

Catalan Experiments

THE COMPOSITIONS WE HAVE EXAMINED THUS FAR ALL HAVE ONE THING in common: they were written by charter members of the surrealist group in Paris. Nevertheless, despite Breton's efforts to safeguard the movement's purity, the forces unleashed by surrealism—like the unconscious impulses it sought to liberate—proved to be impossible to contain. For one thing, although various inviduals were expelled from the group when they deviated from the official line, they continued to write or to paint in a surrealist manner. For another thing, surrealism elicited widespread interest outside France as artists and writers in other countries began to explore its possibilities. Nor were the original surrealists dismayed by this development since it was accompanied by increased recognition and prestige. Indeed, they took advantage of every opportunity to attract new adherents to their cause. As early as 1922, for instance, Breton delivered a lecture to an avid audience in Barcelona in which he expounded surrealist doctrine. And three years later, Aragon extolled the virtues of Surrealism in a lecture in Madrid, which was equally influential.[1] From its inception, it seems, surrealism was conceived as an international movement that would revolutionize literature, art, and life in general.

J. V. FOIX

A prominent member of the Barcelona avant-garde, which included such luminaries as Joan Miró and Salvador Dalí, J. V. Foix was an exceptionally fine poet. In this capacity, he helped to forge not only the modern Catalan idiom but the Catalan response to French surrealism. Unfortunately, the fact that he wrote almost exclusively in Catalan has prevented his work from receiving the recognition it deserves. And yet, Josep Miquel Sobrer observes, Foix "produced a

96

poetry that is the verbal equivalent of the great visual innovations of his contemporaries."[2] While this describes his oeuvre in general, it is especially true of three compositions that were later incorporated into *KRTU* (1932) devoted to Dalí, Miró, and Artur Carbonell respectively.[3] "Foix's work on painting goes beyond critical evaluation and interpretation," Sobrer adds, "for it is at once a poetic creation and a document of the creative act itself."[4] Among other things, as I have shown elsewhere, it is characterized by multiplication, metamorphosis, and obsessive motifs that reflect the poet's persistent quest for the marvelous.[5]

Entitled "Presentació de Salvador Dalí," the first composition was published in *L'Amic de les Arts* on January 31, 1927. Since Dalí had illustrated his "Conte de Nadal" ("A Christmas Story") the previous month, Foix was undoubtedly eager to reciprocate. The fact that the Galeries Dalmau had invited the artist to exhibit a number of his latest works provided the perfect occasion. Although Foix may have hoped to generate a little publicity for the show, which ran from December 31, 1926, to January 14, 1927, the exhibition ended before the text appeared in print. Accompanied by several reproductions, it did not seek to describe Dalí's works so much as to convey some of the impressions they engendered in the viewer. The best way to celebrate the artist's compelling vision, Foix decided, was to translate his achievements into poetry. Utilizing a technique he had perfected previously, he devised a fantastic narrative and embroidered it with a series of bizarre details.

No fa gaires dies que a la cantonada de casa un hàbil adolescent amb una senalla carregada de llibres me n'oferia, en veu baixa, bells exemplars originals: herbaris amb làmines cromo-litografiades, prolegòmens de biologia, formularis naturistes, i, també, cartes celestes, atlas de geografia històrica amb els processos de formació i desaparició misterioses del continent atlàntic. Portava també, reproduïdes, les més singulars imatges recollides a les andanes de les avingudes subterrànies del presomni. Disposat a refusar-ne l'oferta, em sorprengué la seva desaparició sobtada, tot deixant-me entre mans una invitació a l'obertura de l'exposició Dalí a les Galeries Dalmau, i un catàleg en blanc.

[Not many days ago, at an intersection near my home, a clever adolescent carrying a bag full of books offered me, lowering his voice, some beautiful original editions: herbariums with colored lithographs, introductory texts in biology, collections of formulas describing natural phenomena as well as celestial charts and atlases of historical geography

describing the mysterious processes of the Atlantic continent's forma-
tion and disappearance. He also possessed reproductions of the most pe-
culiar images gathered on the sidewalks or the subterranean avenues of
pre-sleep. About to reject his offer, I was surprised by his sudden disap-
pearance, after leaving an invitation in my hands to the opening of the
Dalí exhibition at the Galeries Dalmau and a blank catalogue.]

While the events recounted in the first paragraph are somewhat
unusual, they are not beyond the realm of possibility. Leaving (or
perhaps returning) home one day, Foix encounters a young man
who is trying to sell a collection of books. However, the fact that he
lowers his voice when he approaches the poet suggests that he is in-
volved in some kind of shady transaction. Our initial suspicions are
intensified, moreover, by the discovery that the volumes all seem to
be first editions. How would a callow adolescent ever acquire such
precious works, one wonders, except by stealing them? And why else
would he be peddling them on a streetcorner? Regardless of their
provenance, the volumes themselves reflect a specialized taste that
is also remarkably eclectic. According to Foix, each one examines a
major branch of scientific inquiry, including botany, biology, phys-
ics, chemistry, astronomy, and geography. Rather unexpectedly,
some of the works are devoted to the lost continent of Atlantis,
whose emergence and disappearance they purport to describe.
Equally unexpectedly, but reflecting the broader surrealist theme,
the pedlar has illustrations of various dreams for sale as well. Like
the phrase "Il y a un homme coupé en deux par la fenêtre" ("There
is a man cut in half by the window"), celebrated by Breton in the
First Manifesto, they contain images generated by the unconscious
during the period immediately preceding sleep.[6] Like many surreal-
ist writers who cultivated the image of the labyrinth, Foix compares
the unconscious itself to an underground city.

Before the poet can reply, however, the young man thrusts a cata-
logue and an invitation to the Dalí show into his hands and immedi-
ately disappears. Even more puzzling than the pedlar's sudden
dematerialization is the fact that the catalogue is blank. Intrigued by
the strange encounter, Foix decides to visit the Dalmau Gallery him-
self the following evening.

De sis a set de la tarda, en aquests dies d'hivern, pels carrers de la
ciutat i per les grans porteries senyorials, les bruixes estenen llurs amples
mocadors virolats i, abans de lliurar-se a la farandola per les placetes de

surburbi, s'escorren invisibles entre els vianants amb un greu soroll de picarols, respirs profunds, besades furtives, i escampen a llur pas aquell baf característic de pomes al caliu. Passeig de Gràcia amunt, en aquella hora, en dirigir-me divendres passat a can Dalmau, no vaig precisar que l'adolescent del dia abans tenia una rara semblança amb el pintor Dalí, que era ell indubtablement, camuflada només la corbata i allargades enginyosament les celles.

[From six to seven in the evening these winter days, on the city streets and by the mansions' elegant gates, the witches spread their large, gaudy scarves and, before abandoning themselves to the lively dancing in the suburban squares, flow invisibly among the crowd with the low sound of bells, heavy sighs, and furtive kisses, leaving behind the unmistakable odor of baked apples. Heading up the Passeig de Gràcia at that hour last Friday, on my way to Dalmau's, I did not realize the adolescent from the day before bore an amazing likeness to the painter Dalí, whom he undoubtedly had been only with his necktie camouflaged and his eyebrows cleverly lengthened.]

Like Barcelona in winter, according to the narrator, the poem acquires a supernatural aura at this point that pervades the entire work. As if it happened all the time, a number of witches appear, disappear, and reappear once again before joining in the dancing that presumably marks a public occasion. Flourishing their colorful scarves like gypsies, they pass through the crowd of spectators undetected. Except for a whiff of baked apple, no trace remains of their invisible passage. As night falls, a church bell sounds in the distance, and young lovers embrace in the shadows. Foix does not pause to observe any of this, however, but takes a suburban train from Sarrià, where he lived, to the center of town.[7] Making his way to the Passeig de Gràcia, he follows the broad boulevard to the Plaça de Catalunya, where it ends. From there it is a short walk to the Carrer Portaferrissa, leading from the Ramblas to the Cathedral. At the time, Foix recounts, he had no idea that it was Dalí who had tried to sell him the books the previous day. Arriving at Dalmau's gallery, which was situated at number 18, he encounters an unexpected obstacle.

Però en pretendre entrar a les Galeries, em vaig acovardir en adonar-me que hi havia de porter el delCercle Eqüestre. M'cn tornava descoratjat, quan s'aturà davant meu mateix l'auto de les col.legiales, que cada capvespre desapareix pel carrer de la Diputació entre núvols de llustrina i d'encens, deixant un rastre de carmí lluminos. Baixaven del cotxe de dues en dues, plegaven curosament llurs grans ales postisses i es nuaven

estretament als llavis llampla llagada de llurs corbates. Darrere de tot, la més petita, per retrobar el camí, deixava anar boletes de càmfora. Com si s'endinsessin en una selva verge, desaparegueren cautelosament a la penombra de l'entrada.

[But as I was about to enter the Gallery, I was dismayed to discover that the doorman was the same one as at the Equestrian Association. Discouraged, I turned to leave, when the schoolgirls' automobile halted right before me, the one that disappears down the Carrer de la Diputació every evening amid clouds of glossy silk fabric and incense, leaving a luminous crimson trail. They got out of the car two by two, carefully folded their large artificial wings, and tied their bowties' broad bow tightly over their lips. Finally the smallest girl began dropping mothballs so as to find her way back. As if they were entering a virgin forest, they cautiously disappeared into the doorway's darkness.]

As C. B. Morris notes, Foix intensifies the atmosphere of mystery and malaise in his works "by his inextricable blend of reality—which he presents as abnormal—and fantasy—which he authenticates by his use of *adonar-se* [to perceive], by his cool, almost detached, narration."[8] Despite his unremarkable demeanor, for example, the doorman seems to possess the eerie ability to be in two places at once. In addition, for reasons that are never made clear, his presence fills the poet with dread. By contrast, despite their bizarre appearance, the schoolgirls fail to elicit the slightest astonishment. Since they pass by every evening, Foix has apparently grown accustomed to seeing them. Dressed in fancy silks and emitting clouds of perfume, they streak past the University of Barcelona night after night in a crimson blur. On the night in question, the girls have decided to visit the Dalmau Gallery. Parodying a device in *Hansel and Gretel,* the youngest one marks their trail with mothballs (instead of bread crumbs) as they advance into the fearful darkness. Whereas the doorman possesses a certain demonic quality, the fact that the girls are wearing wings testifies to their angelic nature. Foix was undoubtedly prompted to introduce them by one of the catalogue's two epigraphs, by Jean Cocteau: "Nous abritons un ange que nous choquons sans cesse; nous devons être gardiens de cet ange" (We are inhabited by an angel whom we continually shock; we should be this angel's guardians).

"By contradicting himself so often in his prose poems," Morris declares, "Foix sought to record his anxious search for exactitude by choosing at random from what he called the 'beautiful concrete'

one object to supersede another." As he is about to retrace his steps, the poet suddenly perceives that the sinister doorman has vanished and that he is free to enter the gallery after all.

Aleshores vaig constatar que el porter del Cercle Eqüestre havia estat substituït per un gnom barballarg que em feia amables senyals, e el vaig seguir. Pel llarg passadís sentíem les nostres passes com si es perdessin per les vastes sales del pis de dalt. A banda i banda del corredor, unes llargues vitrines on adés hi havia llibres i més llibres, mostraven exemplars raríssims d'ocells dissecats.

—¿I doncs, senyor Dalmau, tanmateix aneu reformant vostres Galeries?

En entrar a la sala d'exposicions, En Dalí amoixava un ocellàs multicolor que reposava damunt la seva espatlla esquerra.

—¿Superrealisme?

—No, no.

—¿Cubisme?

—No, tampoc: pintura, pintura, si us plau.

[Then I noticed that the doorman from the Equestrian Association had been replaced by a long-bearded gnome who was making friendly gestures in my direction, and I followed him. We heard our footsteps echoing down the long corridor as if they were lost in the vast rooms above us. On both sides of the hallway, there were long glass cases containing more and more books and displaying stuffed specimens of extremely rare birds.

"And so, Mr. Dalmau, are you still renovating, your Gallery?"

At the entrance to the exhibition hall, Dalí was stroking a large multicolored bird perched on his left shoulder.

"Surrealism?"

"No, no."

"Cubism?"

"Not that either: painting, painting, if you please."]

To Foix's immense relief, the "gnom barballarg" who suddenly appears treats him in a friendly manner. Recalling one of the Seven Dwarfs, he turns out to be the gallery's proprietor, who affected broad-brimmed hats and a long, triangular beard. Exchanging small talk with the latter, Foix follows him down the hallway, marvelling at the rare birds in the display cases. Although Dalmau offered a wide assortment of things for sale, however, his interest was essentially limited to art objects (including antiques).[9] At no time in his career did he ever deal in stuffed animals, and yet, according to Foix, his

gallery resembled a museum of natural history. This discrepancy, which threatens to undermine the text's authority, encourages us to seek a rhetorical solution. Upon reflection, one realizes that the birds are actually metaphors for Dalí's paintings, which are just as rare, just as beautiful. That the cases also contain rare books prompts us to reconsider the first paragraph as well. Like the birds, the books and illustrations that the pedlar (who is really Dalí) tries to sell Foix are metaphors for the artist's pictures, which are not only equally rare but equally valuable. On the one hand, they imply, Dalí's art is the product of a scientific mind that dispassionately analyzes a given subject in detail. On the other hand, it is characterized by a deep-seated eclecticism reflecting his endless curiosity.

Entering the exhibition room, Foix encounters Dalí himself who, like Long John Silver, has a large, flashy parrot on his shoulder. Translated into metaphorical terms, this seems to indicate that he is standing before a large painting. In response to the poet's questions, he insists that he belongs to no particular school, that he is simply interested in painting. At this stage of his career, as this dialogue reveals, Dalí was still undecided. Not until six months later, encouraged by Miró and García Lorca, did he begin to paint in a surrealist mode. Foix's remarks refer not to Dalí's mature works, therefore, with their melting watches and flaming giraffes, but to his earlier, less spectacular efforts. By this time he had experimented with some half dozen styles, none of which turned out to be entirely satisfactory. A rapid survey reveals that these included pointillism, Purism, primitivism, Marc Chagall's visionary cubism, and Giorgio de Chirico's metaphysical art.

However, the artists to whom Dalí responded the most intensely were the nineteenth-century realist painters and, paradoxically, cubist painters such as Picasso and Braque. Reflecting his interest in cubist aesthetics, the catalogue contained a second epilogue by the latter artist: "Le peintre pense en formes et cadences" (The painter thinks by means of shapes and rhythms). Balancing this statement, the list of works concluded with a quotation by Ingres: "Si l'on consulte l'expérience, on trouvera que c'est en se rendant familières les inventions des autres qu'on apprend, dans l'art, à inventer soi-même, comme on s'habitue à penser en lisant les idées d'autrui" (Experience teaches us, in Art, that we learn to be creative by familiarizing ourselves with other creations, just as one learns to think by reading other people's ideas). Interestingly, half the works at the Dalmau Gallery adhered to the realistic model, while the remaining

half illustrated various cubist principles.[10] The former included a hauntingly beautiful painting entitled *Panera del pa* (*Basket of Bread*) which, as Dawn Ades points out, seems to have been inspired by the seventeenth-century artist Francisco de Zurbarán.[11]

The following section describes the exhibition in more detail. Or rather, since Foix makes no attempt to be objective, it evokes the vivid impressions that Dalí's paintings made on him. Taking his visitor by the arm, the artist accompanies him as he examines each one of the thirty works in turn.

I em mostra els finestrals del palau meravellós que havia bastit a can Dalmau. Vaig tenir consciència exacta de trobar-me als moments precisos de la naixença d'un pintor. L'aula de vivisecció mostrava, descarnats, il.limitats paisatges fisiològics: belles arbredes sagnants ombrejaven els breus estanys on els peixos pugnen del matí al vespre per deseixir-se de llurs ombres. I en el fons de les pupil.les del pintor, de l'arlequí i de la maniquí, estels negres fugaços en un cel d'argent. Pensava romandre-hi, quan del fons de cada tela sortiren, en tocar les set, els famosos fantasmes.

[And he showed me the windows of the marvelous palace he had constructed in Dalmau's gallery. I was conscious of witnessing the precise moments of the birth of a painter. The vivisection classroom displayed bare, limitless physiological landscapes: beautiful bleeding woods cast their shade upon the brief ponds whose fish struggle from dawn to dusk to rid themselves of their shadows. And in the depths of the painter's, the harlequin's and the mannequin's pupils, black shooting stars appeared against a silver sky. I was contemplating remaining there when, from the depths of each canvas as the clock struck seven, the famous phantoms emerged.]

Struck by the richness of Dalí's vision, which was immediately discernible, Foix chose to compare the exhibition to an opulent palace. What interested him was not the palace so much as its marvelous windows. Like the window made of gypsum in Breton's "Edgar Jené," examined in the previous chapter, these serve as a metaphor for the pictures adorning Dalmau's walls. The metaphor itself was taken from *Le Surréalisme et la peinture*, which was serialized in *La Révolution Surréaliste* several years before it appeared in book form. "Il m'est impossible," Breton wrote in 1925, "de considérer un tableau autrement que comme une fenêtre dont mon premier souci est de savoir sur quoi *elle donne*" (It is impossible for me to envision a paint-

ing otherwise than as a window, my first concern being to know what it looks out on).[12] While Foix's text embodies a similar approach to art, inviting us to view the paintings as windows opening onto a surreal landscape, the poet focuses initially on Dalí's technical achievement. Unexpectedly, Foix confides, he feels as if he were present during a miraculous birth. Since Dalí had not yet developed his surrealist manner, it is difficult to know how to interpret this remark. Most likely it refers to the artist's experiments with an exacerbated, highly stylized cubism during 1926 and early 1927.

Abandoning his obstetrical metaphor in the next line, Foix compares the gallery not to a delivery room, or even a hospital, but to a physiology classroom. In keeping with this new metaphor, he compares Dalí's paintings to posters depicting various biological features in abundant—and gory—detail. The choice of this particular setting, which emphasizes Cubism's analytical bias, may have been suggested by Apollinaire's observation in Les Peintres cubistes: "Un Picasso étudie un objet comme un chirurgien dissèque un cadavre" (Picasso analyzes an object as a surgeon dissects a cadaver).[13] That the posters illustrate the dissection of living animals (vivisection) makes them all the more shocking. At the same time, they provide glimpses of an eerie landscape surrounding the palace whose sanguinary shapes are cloaked in menacing shadows. Although the trees are drenched in blood and the fish leap frantically into the air, Foix confides, the scene possesses a certain beauty. In addition, the classroom contains a harlequin and a mannequin whose pupils, like those of the artist, mirror the night sky. Rather than "windows of the soul," as eyes have traditionally been considered, these serve as cosmic windows, suggesting that they are privy to the secrets of the universe. Unexpectedly, since black and white (or silver) are reversed, the latter appears to be captured by a photographic negative. As Ades notes, the passage echoes Breton's preface to the catalogue of the first exhibition of surrealist painting, held in Paris in 1925, in which the titles of various works are woven together to form a fantastic narrative.[14] Foix, she explains, "incorporates into his text the 'harlequin' and the 'tailor's dummy,' both titles of works exhibited." While the second painting was not listed in the catalogue, a reproduction appeared in L'Amic de les Arts the following month in a review of the exhibition by Sebastià Gasch.[15] Besides the mannequin and the harlequin, moreover, the show included several Paisatges (Landscapes) and a color drawing entitled Peixos (Fish).

Foix's visit to Dalí's exhibition concludes with a second supernatu-

ral occurence which, like the witches evoked at the beginning, establishes a parallel between the surrealist vision and various forms of occult experience. Precisely at the stroke of seven, phantoms emerge from each of the paintings and drape the scene in diaphanous veils. Why this miraculous apparition occurs at seven o'clock instead of, say, midnight, is as puzzling as the apparition itself. Perhaps Dalmau used to close the gallery at this hour, leaving the paintings free to commune among themselves. Or perhaps he used to turn on the lights, bathing the gallery in a luminous glow. Whatever the explanation, one suspects the ghostly visitors were inspired by Giorgio de Chirico's paintings, in which phantoms play a significant role.[16] We know in any case that Foix greatly admired the Italian painter, who influenced him on numerous occasions. Interestingly, the last line seems to echo a similar line from an article Breton had published about de Chirico six months earlier: "Quand il fut de l'autre côté du pont les fantômes vinrent à sa rencontre" (When he reached the other side of the bridge the phantoms came to meet him).[17] As Foix remarks in the next paragraph, Dalmau's phantoms cloak the gallery in an otherworldly splendor.

> És un bell espectacle: subtils, us cobreixen amb llurs vels i us encomanen llur immaterialitat. Si molts de barcelonins ho sabessin, l'espectacle dels fantasmes que omplen cada capvespre les sales de can Dalmau, seria per a ells l'obertura a l'"altre" mon.

> [It is a beautiful spectacle: they cover you with their subtle veils and bestow their immateriality upon you. If many Barcelona residents knew of it, the spectacle of the phantoms invading Dalmau's rooms every evening would provide them with an opening into the "other" world.]

His curiosity satisfied, Foix leaves the gallery at last and decides to head for home. Retracing his earlier steps, he walks along the Avinguda Portal de l'Angel (whose name recalls the angelic schoolgirls) until he reaches the Plaça de Catalunya. Crossing this large public square, he prepares to head up the Passeig de Gràcia which, unexpectedly, is completely deserted.

> En abandonar les Galeries, el Passeig de Gràcia, desert, sense arbres, sense fanals, era una immensa avinguda alineada per centenars de *Shell*, amb la testa lluminosa reflectida dolçament damunt l'asfalt. Una voluntat superior a la meva féu que, per comptes d'anar-me'n camí de casa pel carrer de Provença, em refugiés al *Service Station* del carer d'Aragó.

[Upon leaving the gallery, I discovered the Passeig de Gràcia was deserted, with no trees, with no streetlights, an immense avenue lined with hundreds of Shell gasoline pumps, their luminous heads softly reflected by the asphalt. A will superior to my own forced me, instead of returning home along the Carrer de Provença, to take refuge in the Service Station in the Carrer d'Aragó.]

For some reason the avenue is devoid of any human traces. Although it can scarcely be very late, there are no people on the sidewalk and no cars in the street. For that matter, there are no longer any trees or streetlights, which seem to have been uprooted by some mysterious force. Or rather, the streetlights have been transformed into (old-fashioned) gasoline pumps whose "heads" are illuminated. Emblazoned with the Shell Oil Company logo, the familiar yellow icons recede into the distance in two parallel lines. This is not a reassuring sight, nevertheless, but one that is profoundly disturbing. In a similar vein, Breton would confide in *Nadja* the following year that he could never view a blinking advertisement for Mazda lightbulbs without a feeling of trepidation.[18] The presence of so many signs, stretching as far as the eye can see, creates an eerie atmosphere like that which Foix professed to detect in Dalí's paintings. This impression is reinforced by the verbe *alinear*, which means both "to line" and "to alienate." Providing one last glimpse of the surrealist marvelous, the mysterious emblems disorient not only the avenue but the spectator as well. Confronted with an alienated (and alienating) cityscape, Foix stops three blocks before the cross-street he would normally take home and seeks refuge in a service station. If at one level one is tempted to conclude that he needs to use the restroom, this interpretation is inconsistent with the rest of the text. At the level of the surrealist narrative, the irresistible impulse to which he suddenly succumbs is clearly that of stark terror.

Foix published another critical poem three years later in connection with an exhibition that took place at the Galeries Areñas. Consisting of nineteen paintings and assorted drawings by Artur Carbonell, the show ran from November 29 to December 13, 1930.[19] In addition to a list of the works that were exhibited, two of which were reproduced as illustrations, the catalogue included introductory texts by Foix and by M. A. Cassanyes. Like these authors, as Lucía García de Carpi remarks, Carbonell was "uno de los pioneros del surrealismo catalán."[20] Although he never achieved the popularity of Dalí or Miró,

he contributed to the development of surrealist art in Catalonia and produced some extremely fine paintings. Whereas Foix invented a marvelous (if somewhat macabre) palace for Dalí to preside over, his text on Carbonell describes a marvelous encounter.

El vaig trobar, en ple març calcinós, a la platgeta mateix de Sant Sebastià. Anava vestit d'angel, amb una túnica de seda blanca, excessivament llarga, ornada amb irreproduïbles filigranes d'or. Cobria el cap amb una riquíssima perruca rossa cenyida amb una diadema de margarides i duia els llavis pintats del mateix blau cel magnífic que li segreguen els ulls. Un àngel tot sol, en un matí desert, arran de mar, havia d'exaltar, per força, la meva imaginació. Vaig deixar el gonfanó amb l'efígie de Sant Bartomeu, que passejo tot el dia des del cap de la Vila a la Parròquia, arrambat a un mur mig esfondrat, vaig refer-me la llaçada del roquet i em vaig acostar a l'infant desconegut. Mai, com en aquell moment, no m'havia adreçat a ningú emprant, de cop i volta, el dolç argot escolar: ¿*Opoi quepet dipius Apartupur Caparboponepell?* Va acostar totes dues ales al pit i amb una gran reverència va respondre: *Sipi!*

[I found him in the midst of a quicklimy March at the Sant Sebastià beach. He was dressed like an angel in an excessively long tunic of white silk, which was adorned with golden filigree. His head was covered with an exuberant blond wig crowned with a chaplet of daisies, and his lips were painted with the same magnificent sky blue secreted by his eyes. An angel all alone by the sea on a deserted morning inevitably excited my imagination. I leaned the standard with the effigy of St. Bartholomew— which I had carried all day long from the center of town to the parish church—against a ruined wall, I retied the bow of my surplice, and I approached the unknown child. Never before had I addressed anyone in the sweet slang of the schoolyard, as I did at that moment: "Ipisn't youpour napame Apartupur Caparboponepell?" He folded both wings against his chest and replied with a deep bow: "Yepes!"]

As one eventually perceives, this encounter takes place in the popular resort town of Sitges, located on the Costa Dorada some thirty miles below Barcelona. Despite (or perhaps because of) its tourist status, the town was the site of a surprising amount of avant-garde activity. Not only was *L'Amic de les Arts* published in Sitges, but a number of artists and writers made it their home, including Artur Carbonell who was born and raised there. Although Sitges is not mentioned by name until the very end, Foix's original readers would have recognized two prominent landmarks: the Church of St. Tecla and St. Bartholomew and St. Sebastian's Beach. Unlike the main

beach which stretches from the front of the church as far as the eye can see, the latter, which lies behind the church, is relatively small (as the suffix -*eta* indicates). Not surprisingly, it appeals primarily to the local inhabitants. Foix apparently decided to situate his encounter with Carbonell on this beach because of its association with St. Sebastian, which contributes to the text's religious thematics. Since the scene takes place in March, when the weather is still quite cold, the beach is deserted. On the one hand, the adjective "calcinós" may refer to the "caustic" effect of the wind and the waves. On the other, it may evoke the slate gray color of the sky and the water.

As we have had ample opportunity to observe, one of the hallmarks of surrealist texts is the sense of disorientation (*dépaysement*) that they produce in the reader. Foix achieves this effect in "Artur Carbonell" by distorting and collapsing two familiar frames of reference: the professional and the temporal. In the first place, he transforms an ordinary meeting between the poet and the painter into a miraculous encounter between a priest and an angel. In the second place, he confounds the past and the present in such a way that we cannot tell them apart. At times the two characters seem to be adults, while at other times they seem to be children playing in the sand. For reasons that are never explained, moreover, Foix's vocation appears to be permanent, but Carbonell's is only temporary. The former, who is attached to the nearby church, has chosen to embrace the priesthood. In this capacity, he participates in the annual religious procession in honor of St. Bartholomew (which takes place in August rather than March). By contrast, the latter is only impersonating an angel. Although he may also have been involved in the celebration, he is free to leave (or to play in the sand) when it is over. For some bizarre reason his cherubic lips are painted blue instead of pink or red, as one would expect. Perhaps he is merely cold or, then again, perhaps he has been sampling the sacrificial wine.

Despite several irreducible contradictions, the surface narrative turns out to be relatively coherent. It remains to determine the nature of the relationship, which is far from evident, between Foix's text and Carbonell's art. While the angel motif recalls any number of *Annunciations* by earlier artists, there is a world of difference between these works and those that were exhibited at the Dalmau Gallery. Carbonell is not to be confused with Fra Angelico, who would presumably have been scandalized by his refusal to paint religious themes. Beginning in 1928, according to García de Carpi, Carbonell

began to paint in two distinct manners that were fundamentally incompatible. That year witnessed the creation of *Christmas Eve*, for instance, whose wildly contorted shapes contrasted markedly with the realistic portraits that he continued to produce.[21] By 1930, when Dalmau agreed to the exhibition, the artist was equally committed to both styles. Reflecting the two aesthetics, the illustrations in the catalogue were divided between a realistic portrait of a boy and an anti-realistic picture of two women in conversation (figure 9). Entitled *Dialogue*, the second painting was not as radical as some of the others that were exhibited, including *Christmas Eve*, but served as a bridge between the realistic and the surrealistic styles. Resembling a photographic negative, García de Carpi declares, the work depicts "seres angélicos cuyos volúmenes se diluyen bajo el juego de las curvas" (angelic beings whose volumes dissolve beneath the play of the curved lines).[22] According to all indications, this is the work that inspired Foix's composition. The latter refers not to actual angels, or to pictures of angels, but to the angelic atmosphere that pervades the painting. The link between the two works is stylistic rather than iconographic.

At this point in the narrative, the perspective suddenly shifts to enable the two characters to reinact scenes from their childhood. Addressing Carbonell in the Catalan equivalent of pig latin, in which every vowel is repeated and preceded by the letter "p," Foix asks if he can play in the sand with him.

Ens vam donar les mans i, riba enllà, ens vam posar a garbellar sorra amb els dits de dues mans entrecreuats. Jo que li dic: —¿Què faràs, tu, quan seràs gran?—Per tota resposta va inflar, tant com va poder, les dues galtes. Aleshores, ell em diu:—¿I tu? —Avergonyit dels meus trenta anys esterìls, vaig descordar-me el coll de la sotana per mostrar-li, callat i amb el dit, la nou del coll, que ascendia i davallava vertiginosament. Mai més no ens hem dit res.

De tant en tant li dono a llegir el catorzè vers d'un sonet. Per tot commentari, infla les galtes. Aleshores ell em dibuixa i em pinta, damunt la tela, un pit (de la Matilde, de l'"Enriqueta, de la Josefina). Per tota resposta li ensenyo la laringe prominent. Només quan, de tant en tant, ens trobem per Sitges, jo passejant el gonfanó de Sant Bartomeu i ell, vestit d'àngel, que cull petxines i caragols marins, podem repetir-nos, amb cordial delectança, el nom: —*Caparboponepell*! —començo jo. I ell respon: —*Fopoix*. Aleshores encreuem altra vegada els dits de les dues mans esquerres i garbellem sorra.

Figure 9. Artur Carbonell, *Dialogue*, 1930. Oil on canvas, $31^{1}/_{2} \times 27^{1}/_{2}''$. Whereabouts unknown.

[Holding each other's hands, we began to sift sand down on the beach between our interlaced fingers. I asked him: "What do you want to do when you grow up?" His only response was to puff out his cheeks as much as possible. Then he asked me: "What about you?" Ashamed of my thirty sterile years, I unbuttoned the collar of my cassock and pointed silently to my Adam's apple, which moved vertiginously up and down. We have not talked to each other since. From time to time I show him the fourteenth line of a sonnet. His only response is to puff out his cheeks. Then he draws a breast for me (Mathilda's, Henrietta's, Josephine's) and paints it on the canvas. My only response is to show him my prominent larynx. Otherwise, when we meet in Sitges from time to time, I carrying St. Bartholomew's banner and he, dressed as an angel, gathering seashells and marine snails, we cordially delight in repeating our names. "Caparboponepell!" I begin. And he replies: "Fopoix!" Then we link the fingers on our left hands together again and sift sand.]

The second half of Foix's text depicts the two children at play and contrasts the respective careers that await them when they grow up. Since children make friends easily, Carbonell welcomes his new playmate and invites him to join in a game he has just invented. Sitting across from each other, they clasp hands and let the sand slowly trickle through their fingers. On the one hand, since it resembles a primitive handshake, this simple gesture alludes to their enduring friendship. On the other hand, it also refers to the twin figures in *Dialogue,* who seem to be holding hands as well. As they continue playing, moreover, the boys talk about many different things and so create a dialogue of their own. In addition, their verbal exchange is punctuated by a number of curious gestures whose meaning is not immediately clear. In reply to a question about his future career, Carbonell merely puffs out his cheeks—a gesture that could be interpreted as indecision, resignation, or frustration but which probably indicates that he hasn't the slightest idea what he wants to do. Nor does Foix fare any better when Carbonell asks him the same question, despite the fact that he has suddenly become an adult again. Unable (or unwilling) to find the right words, he points silently to his Adam's apple and demonstrates its mobility.

Foix's bizarre response is motivated above all by a feeling of intense shame. Despite his relatively advanced age, he laments, he continues to lead a sterile existence. On one level, this refers to the vow of celibacy he pronounced when he became a priest and to the fact that he can never marry. "And yet," he silently exclaims, "I will show you that I am extraordinarily virile." Unbuttoning his collar

(read "trousers"), he points with pride to his Adam's apple, which becomes a convenient phallic symbol. At a deeper level, Foix's shame and consequent exhibitionism reflect the anxiety he feels about his decision to become a poet. Although he had participated in a number of avant-garde activities, he had published only one slim volume of poetry by that date, *Gertrudis* (1927). "And yet," he silently exclaims, pointing to his larynx, "see what a powerful poetic voice I have!" Since Foix was thirty-seven (not thirty) at the time, he was keenly aware of the contrast between his poetic accomplishments and his poetic promise. All his subsequent meetings with Carbonell, he concludes, have followed the same pattern. According to the familiar ritual the two men joyfully shake hands, call each other by their slang names, and show each other their latest compositions. Urging his friend to abandon his monastic lifestyle, Carbonell tempts him with visions of carnal bliss—pictures of naked models—while Foix points to his virile Adam's apple and dreams of a greater glory.

SALVADOR DALÍ

Since Foix wrote almost exclusively in Catalan, never venturing far from Barcelona, he has yet to receive the recognition he so richly deserves. By contrast, another Catalan surrealist was destined to win worldwide fame: Salvador Dalí. Indeed, as a result of his continual self-promotion, Dalí is probably the best known of all the surrealists—the only one who has achieved celebrity status. As an artist he did not have to worry about the language barrier, and when he moved to Paris he was able to make his work available to a wider public. Although Dalí's most important contributions were in the realm of surrealist art, throughout his career, as Dawn Ades points out, he wrote almost as much as he painted.[23] In 1927 and 1928, for instance, he published an average of more than one article a month in *L'Amic de les Arts*. Equally at home in Catalan and Spanish, he eventually published a number of important writings in French. At the same time that he was writing about modern art and collaborating on several manifestos, he began to experiment with poetry.[24]

As one might expect, given the obsessive nature of Dalí's inspiration, the poems that appeared in *L'Amic de les Arts* and clsewhere are related not only to the paintings of the same period but to the notorious film *Un Chien andalou* (*An Andalusian Dog*), which he cre-

ated together with Luis Buñuel. While they were not written in response to these works, and thus do not have a critical function, the fact that they spring from a common source enables them to enter into a common dialogue. Although Dalí's poetry plays a complementary rather than a critical role, there is little qualitative difference between the two modes of expression, at least insofar as surrealism is concerned. The first true poem to appear in Catalan, as opposed to several prose texts that had been published previously, was entitled "Poema de les cosetes" ("Poem of Small Things"). Published in *L'Amic de les Arts* in August 1928, it was dedicated to Sebastià Gasch "amb tota l'alegria antiartística" (with great antiartistic joy). Dalí was probably referring to the *Manifest Antiartístic català*—also known as the *Manifest Groc*—on which he, Gasch, and Lluís Montanyà had collaborated in March. Attacking traditional Catalan culture and art, this manifesto was followed by a similar text in May in which Dalí condemned the *sardana* (Catalonia's national dance), among other things, and exclaimed: "Per respecte a l'art . . . proclamem-nos anti-artistes" (Out of respect for art . . . let us proclaim ourselves anti-artists).[25] In keeping with this sentiment, "Poema de les cosetes" broke decisively with the past and charted a radically new course to pursue.

Hi ha una coseta petita posada alta en un indret.
Estic content, estic content, estic content, estic
 content.
Les agulles de cosir es claven en els niquelets dolços
 i tendres.
La meva amiga té la mà de suro i plena de puntes de
 París.
Una sina de la meva amiga és una calma garota, l'altra
 un vesper bellugadís.
La meva amiga té un genoll de fum.
Els petits encisos, els petits encisos, els petits encisos, els petits
 encisos, els petits encisos, els petits encisos,
 els petits encisos, els petits
 encisos . . . ELS PETITS ENCISOS PUNXEN.
Llull de la perdiu és vermell.
Cosetes, cosetes, cosetes, cosetes, cosetes, cosetes,
 cosetes, cosetes, cosetes, cosetes, cosetes,
 cosetes . . .
HI HA COSETES, QUIETES COM UN PA.

[There is a tiny little thing situated in a high place.
I am happy, I am happy, I am happy, I am happy.

The sewing needles pierce the small nickles, which are
 soft and tender.
My girl friend has a cork hand full of black tacks.
One of my girlfriend's breasts is a calm sea urchin,
 the other a mobile wasps' nest.
My girl friend has a knee of smoke.
The small magic charms, the small magic charms, the
 small magic charms, the mall magic charms, the
 small magic charms, the small magic charms, the
 small magic charms, the small magic charms . . . THE
 SMALL MAGIC CHARMS PRICK.
The partridge has a red eye.
Small things, small things, small things, small things,
 small things, small things, small things, small
 things, small things, small things, small things,
 small things . . .
THERE ARE SMALL THINGS, TRANQUIL AS A LOAF OF BREAD.]

Although Dalí and Foix were equally committed to the surrealist
adventure, although they moved in the same circles and published
in the same journals, they obviously conceived of surrealist poetry in
radically different ways. Whereas Foix depicts a familiar world that
gradually becomes stranger and stranger, Dalí's world is totally un-
recognizable. Whereas Foix's poetry has a story to tell and is care-
fully constructed, Dalí's works resemble the ravings of a lunatic.
"The only difference between myself and a madman," he was fond
of proclaiming, "is that I am not mad."[26] Situated at opposite ends
of the surrealist experience, Foix's inspiration is closely allied to
dreams, while Dalí's is related to that which characterizes automatic
writing. Since Dalí cultivated dislocation and the suppression of an-
ecdotes, Morris explains, "the multiple details and objects thrown
up indiscriminately by his imagination are strung out shapelessly."[27]
Above all, they are the product of what Dalí himself referred to as
"the aesthetics of objectivity."[28] "What primarily characterizes these
poems," Haim Finkelstein notes, "is the objective statement pre-
sented in a deadpan manner, often without any causal or conse-
quential continuity."[29] It is precisely the world of small things, he
continues, that constitutes a unifying vision in these poems, a world
that includes intimate objects and things found at the beach. "These
'small things' are presented as objective 'facts' rather than as terms
of some metaphoric association."
 As other writers have observed, Dalí's works do not resemble tradi-

tional poems so much as lists and catalogues of images that obsessed him at this stage of his career. The "small things" which are the subject of the present poem would reappear the following month in "Peix perseguit per un raïm" ("Fish Pursued by a Grape"), whose protagonists are reduced to "cosetes petites" and which contains references both to cork and to smoke.[30] Similarly, breasts and needles play a prominent role in "La meva amiga i la platja" ("My Girl Friend and the Beach"), published the preceding year.[31] It comes as no surprise, perhaps, to learn that "Poema de les cosetes" was one of Dalí's earliest compositions. Hoping to publish it in a journal called *Gallo* (*Rooster*), edited by García Lorca in Granada, he sent the latter a Spanish version in October 1927.[32] "For Dalí, in the autumn months of 1927, ardently desiring to create 'new' things," Finkelstein observes, "painting and poetry became quite interchangeable."[33] Beginning in the summer of 1927 and continuing for several years, he introduced swarms of heterogeneous objects—often the same objects, as we have seen—into his various works. Like his poetry, his canvases exhibit a growing tendency, in Finkelstein's words, "to fill up, indeed to clutter at times, the surface of the painting with a profusion of forms . . . scattering them through earth and sky."

This trend is observable in paintings such as *La mel és més dolça que la sang* (*Honey is Sweeter than Blood*) (figure 10), whose title recurs in "La meva amiga i la platja" where it serves as an epigraph. As in "Poema de les cosetes," the painting is strewn with disparate objects which, despite their profusion, have little or no relation to each other. Both the objects themselves and their placement on the canvas seem to be completely gratuitous. Compounding the difficulty that confronts the viewer, many of the objects are impossible to identify or are barely recognizable. In addition, the perspective is seriously distorted by conflicting diagonals that criss-cross the painting—a device, like many of the objects, that Dalí inherited from de Chirico. Despite the artist's commitment to objectivity, Finkelstein detects some disturbing personal references.

> Lorca's head, which appeared so often in Dalí's paintings of 1926, is seen lying on the sand, accompanied by Dalí's shadow, and looking more dead than in any of the earlier paintings. It is surrounded by the rotting corpses of a man and a donkey, a decapitated woman, and a shark with its belly carved up. Dalí's severed head, its eyes wide open, is to be seen there, too, separated from Lorca's by an extremely attenuated arm.[34]

Figure 10. Salvador Dalí, *Honey Is Sweeter Than Blood,* **1927. Dimensions and whereabouts unknown.**

And yet, despite the grotesque images that dominate this and similar paintings, the same authority insists—rightfully, I believe—that they are meant to be viewed primarily as signs. "All things considered," he concludes, "these works disclose intellectual control and emotional distancing that are apparent even as Dalí's vocabulary became increasingly steeped in visions of violence and mutilation."[35] If the decomposing donkey prefigures the excesses of *Un Chien andalou* (1929), where we find it draped over a grand piano, the rows of needles point to "Poema de les cosetes," which is a much quieter work. Indeed, the reason Dalí is attracted to small things, the reason they make him so happy, he confides, is that they lead such a tranquil existence. Their material presence and their diminutive proportions fill him with an inexplicable joy. "Salvador insiste en la plasmación de la estética de lo diminuto," Alfonso Sánchez Rodríguez proclaims, "y en el intento de fijar esa sensación de estatismo [que la acompaña] (Salvador strives to translate his aesthetics of the miniature into material form and to record the sensation of immobility [that accompanies it]).[36] Dalí's aesthetics stems in turn

from de Chirico, whose Metaphysical Interiors exemplify the same fascination with small (often geometrical) objects, some of which are to be found in *La mel és més dolça que la sang*. Although this fascination would undergo several transformations in the years to come, Dalí never really lost his love of small things.

In general, as Finkelstein declares, Dalí's poetry "tends to fluctuate between the conceptual or abstract and the visual, with the visual often taking the lead."[37] In "Poema de les cosetes" this trait appears in the very first line which, despite its attempts to be precise, is maddeningly vague. While we learn that the object in question is tiny and that it is in a high place, we have no idea what it looks like. Nor is the second line, in which the poet proclaims his joy, any more accessible. Only in retrospect does the reader perceive that the two lines are related according to cause and effect. Although the objects in the third line are easy enough to visualize, they are equally problematic. Defying the laws of physics and commonsense experience, several needles have been thrust into a bunch of coins which, like the famous watches in *The Persistence of Memory* (1931), have become soft and tender. Once again Finkelstein provides important insight into the basic principle at work here. "Another hallmark of Dalí's vision," he writes, "is the dialectics of the soft and hard . . . animating these 'small things' and the metamorphoses of matter they undergo."[38] Hard and soft objects are not only juxtaposed with each other, but the former may be transformed into the latter and vice versa. On the one hand, the needles and the nickles are clearly sexual symbols whose conjunction crudely suggests sexual intercourse. On the other hand, Finkelstein speculates that the dialectics between hard and soft in general reflects the ambiguity shared by Dalí and García Lorca with regard to sexual roles.

Following the third line, which we may conceive as either a landscape (like *La mel és més dolça que la sang*) or a still life, Dalí introduces a portrait of his girlfriend, who appears in other poems as well. This portrait, which anticipates Breton's "L'Union libre" (1931), is remarkable not only for its bizarre description but for the fragmentary manner in which the woman is depicted. As in Dalí's paintings from this period, in which human figures are reduced to torsos and miscellaneous body parts, the woman consists of her random attributes, which are enumerated one by one. All we see of her is a hand, two breasts, and a knee. The first two objects recur in paintings such as *La mel és més dolça que la sang* and *Cenicitas* (*Little Ashes*) (1927–1928), while breasts were also featured in *Un Chien an-*

dalou. Thanks to the Spanish version Dalí sent García Lorca, we
know that the "Puntes de París" in the woman's hand are actually
black tacks. Since her hand is made of cork, they may be stuck into
it (like the needles piercing the nickles), or again she may simply be
holding them. In either case, the image prefigures the famous scene
in *Un Chien andalou* in which a swarm of ants emerge from a hole in
a man's hand. While the woman is equipped with two breasts, the
fact that they consist of a wasps' nest and a sea urchin destroys any
attempt at symmetry. In contrast to the first object, which seems to
have been an isolated experiment, the second plays a major role in
Dalí's works from this period, including "La meva amiga i la platja"
and "Peix perseguit per un raïm." In one of the more memorable
scenes from *Un Chien andalou,* the camera zooms in on a hairy fe-
male armpit and then dissolves to a close-up of a sea urchin resting
on the sand. Continuing the dialogue between soft and hard, finally,
the woman's knee is transformed into a puff of smoke. Despite its
fragmentary nature, the portrait that emerges possesses a certain co-
herence. Dissolving traditional oppositions, according to Dalí, the
surrealist heroine is both tangible and intangible, as cool as a cu-
cumber and yet endowed with a fiery temperament.

 The poem concludes on a tranquil note, amid a flurry of repeti-
tion, as Dalí turns to the subject announced in the title: the beauty
of small things. For those who have really learned to look, he pro-
claims over and over, small objects are embued with magical proper-
ties. They exert a magic spell ("enciso") on viewers that serves not
to put them to sleep, as happens in so many fairy tales, but to wake
them up ("PUNXEN")—to instill them with a new awareness. The
repetition of "els petits encisos" and "cosetes" indicates that they
are related, stresses the intensity of this relation, and gives their re-
spective sections an encantatory quality. More than anything, per-
haps, the poem encourages us to participate in Dalí's visionary
quest, to discover the secret magic of ordinary objects. Toward this
end it concludes with two examples—one of which is animate, the
other inanimate—that suggest different viewing strategies: a par-
tridge and a loaf of bread. Like Dalí in the first instance, we can
isolate the object in question and focus on one of the parts of which
it is composed. Or we can adopt Dalí's second strategy, which is to
insert the object into a brand-new context. Like a photographer we
may zoom in on a particular detail, or we may change filters in order
to view the object in a new light.

Although Catalonia and the rest of Spain were seething with avant-garde activity during this period, Dalí was especially excited by what was taking place in France. In the summer of 1929, therefore, he moved to Paris, where he was able to fraternize with the French surrealists and to participate in their activities. Except for vacation trips to Catalonia, he remained there for a number of years. Quickly assimilated into the French movement, Dalí contributed a whole series of articles and paintings to journals such as *La Révolution Surréaliste, Le Surréalisme au Service de la Révolution,* and *Minotaure.* While Breton eventually came to despise Dalí, whom he accused of rampant commercialism, he was extremely impressed by his talent initially. Among other things, Breton agreed to write a preface for the catalogue that accompanied Dalí's first one-man show in Paris, which took place at the Camille Goemans Gallery from November 20 to December 5, 1929.[39] "C'est peut-être, avec Dalí," he announced at one point, "la première fois que s'ouvrent toutes grandes les fenêtres mentales" (For the first time perhaps, Dalí has opened our mental windows wide). Elsewhere, calling his art "jusqu'à ce jour le plus hallucinatoire qu'on connaisse" (the most hallucinatory in existence), Breton advised his fellow surrealists to cultivate voluntary hallucination like the painter.

By this date Dalí's art had evolved beyond the accumulation and enumeration of "small things" and had acquired a pronounced visionary character. However, it would undergo a radical transformation in the next few years, as the artist experimented with a new hallucinatory aesthetics that would make his earlier efforts seem pale by comparison. At the same time, his obsession with putrefaction and scatological subjects increased, and he began to explore overtly Freudian themes in paintings such as *The Great Masturbator* (1929). Traces of all these developments are to be found in a poem Dalí published in 1934 entitled "Poema agafat al vol, no taquigràficament" ("Poem Seized on the Wing, Not by Shorthand").[40] Since it appeared in a Catalan journal, it was written in his native language.

Veig una ossamenta pútrida i de qualsevol manera. Damunt els ossos una màquina de cosir. Sobre la màquina una ventada de vent subjectada per una palla. Més amunt, una bufetada que es rentava les dents amb una truita a la francesa d'alumini. A la màquina de cosir, el setrill del petroli i sobre el setrill un rellotge tou, com un formatge de Camemberg que regalima, i se li veia l'os, se li veia l'os de la punta del dit gros del peu.

I tot allò no era més que un ruc podrit. l'ossamenta, la màquina de cosir era el ventrell, el vent subjectat per la palla el seu cap, i la bufetada que es rentava les dents amb una truita a la francesa d'alumini no era altra cosa que un eixam de mosques que voltaven el ruc mort i putref-acte.

[I see a putrid pile of bones lying every which way. On top of the bones, a sewing machine. On top of the machine, a gust of wind attached by a straw. On top of that, a gust brushing its teeth with an alu-minum trout prepared *à la française.* Inside the sewing machine, the oil can and on the oil can a soft watch, like a runny Camembert cheese, and the bone was exposed, the bone was exposed at the end of the big toe.

And all that turned out to be a rotting donkey. The pile of bones and the sewing machine were its stomach, the wind attached by the straw, its head, and the gust that was brushing its teeth with an aluminum trout prepared *à la française* turned out to be a swarm of flies that were circling the putrified donkey.]

In 1952 André Parinaud published a series of interviews with Breton in which the latter discussed the development of surrealism and described its most significant contributions. "Si, comme l'a soutenu Arthur Cravan, 'tout grand artiste a le sens de la provoca-tion,'" he replied to one question, "il faut reconnaître que nul n'en a porté le goût plus loin que Dalí, aussi bien dans l'art que sur sa personne" (If, as Arthur Cravan maintained, "every great artist has a sense of provocation," it must be admitted that nobody has devel-oped this principle further than Dalí, both in his art and in his per-son).[41] By 1934 Dalí had managed to violate every conceivable taboo in his works and had perfected the outrageous persona that would contribute to his fame. Although "Poema agafat al vol" contains none of the scatological references or sexual imagery that the gen-eral public found so offensive (and titillating), in its own way it is equally shocking. While we have encountered the theme of putre-faction in other works, the metamorphological confusion that in-vades the second half is totally unprecedented. Adding to the confusion, the objects in the poem are not only unrelated but are piled on top of each other like rags and bottles in a refuse heap. The composition resembles a *cadavre exquis,* where several artists would each complete a portion of a drawing working independently from the others. It also recalls a sculpture Dalí created in 1932, in which a sugar cube was suspended above a glass of milk balanced on top of a number of other objects.

Dalí's obsession with piling objects on top of each other can be traced back to 1927, the date that he completed a painting entitled *Apparatus and Hand.* Nevertheless, "Poema agafat al vol" is more obviously related to several later works, including a series of engravings for a deluxe edition of the Comte de Lautréamont's *Chants de Maldoror,* which appeared the same year as the poem.[42] Reflecting the scandalous nature of this legendary text, they comprise, in Dawn Ades' words, "a series of variations on the themes of sexual cannibalism, death, and eroticism."[43] Although the first theme is absent from the poem, the remaining two occur to varying degrees. Dalí introduces the theme of death at the very beginning, symbolized by the pile of bones that serves—literally—as the composition's foundation. Where the bones came from, what they are doing here, and why they are scattered about is never explained. Even more astonishingly, the next sentence informs us that a sewing machine is perched precariously on top of the pile. Once again, we have no idea how it got there nor how it is related to the bones.

While sewing machines are conspiciously absent from Dalí's iconography, as are machines in general, *Les Chants de Maldoror* contains an important exception to this rule. One illustration (figure 11) depicts a grotesquely deformed old man, whose limbless torso is supported by a primitive crutch, devouring an equally repulsive child who is trapped in a sewing machine. Among the various references that traverse this nightmarish image, three deserve to be singled out in particular. In the first place, as so often in Dalí's works, the scene was partially inspired by Freudian theory. "The idea of being eaten by the father," Freud remarks in *The Problem of Anxiety,* "belongs to the typical stock of primal childhood ideas."[44] Interestingly, the ravenous figure in Dalí's engraving resembles the father of modern psychiatry himself. Drawing on ancient Greek mythology, Freud points to the second allusion in the same passage. According to all indications, the individual in the picture is Chronos (known to the Romans as Saturn), whom we see devouring one of his children. This identification is confirmed by the soft watch draped across his skull, since Chronos was the Greek god of time.

If the drama that envelopes the human figures belongs to myth and to the primal unconscious, the setting in which it takes place comes from *Les Chants de Maldoror.* For the illustration alludes as well to a famous passage in which the following simile occurs: "beau comme . . . la rencontre fortuite sur une table de dissection d'une machine à coudre et d'un parapluie" (as beautiful as . . . the chance

Figure 11. Salvador Dalí, engraving from *Les Chants de Maldoror*, by the Comte de Lautréamont, Paris, 1934 (plate XIV).

encounter of a sewing machine and an umbrella on a dissecting table).[45] The arbitrary conjunction of these images derives its extraordinary force, Breton explained in *Les Vases communicants* (*Communicating Vessels*), because they serve as sexual symbols.[46] The umbrella represents a man, the sewing machine a woman, and the dissecting table the bed on which they are making love. Indeed, Freud declares in *The Interpretation of Dreams*, "it is highly probable that all complicated machinery and apparatus occurring in dreams stand for the genitals."[47] Whereas the sewing machine in Dalí's engraving occupies its original role, the umbrella has been replaced by the father figure, whose phallic symbolism is impossible to mistake. The encounter, which retains its sexual character, takes place not on a dissecting table but on a long, flat plane stretching far into the distance (which Dalí borrows from de Chirico).

Like the scene depicted in Dalí's engraving, the first half of the poem portrays a (symbolic) sexual encounter. Where it differs from the graphic version is not so much in the objects it employs—which are merely symbols—but in juxtaposing abstract and concrete, conceptual and visual. While the sewing machine plays its customary female role, the fact that it is paired with a gust of wind obscures the basic mechanism at work here. It is difficult to conceive of the wind as a phallic object. In order to achieve the desired effect, therefore, we need to select another image that is more convincing. A quick survey turns up three objects that have phallic pretensions: the aluminum trout, the oil can, and the big toe with the bone protruding. Any one of these will do. In some ways the metallic fish is the most promising, since it derives from de Chirico's paintings in which it plays an identical role. On the other hand, many of the engravings in *Les Chants de Maldoror* depict phallic (nose) bones and—on one occasion—bones from a foot. Continuing the dialogue between hard and soft, the soft watch had become a familiar emblem by this date. Discussing symbolic objects in 1931, for instance, Dalí classified it as an "objet transubstancié" ("transubstantiated object").[48] Well before that, he had seriously contemplated including it in "Poema de les cosetes." Unexpectedly, the version he sent to García Lorca contained the following line: "Mi amiga tiene un reloj pulsera de macilla" (My girl friend has a watch made of putty).

Despite their common concern—indeed obsession—with sexual intercourse, neither the engraving nor "Poema agafat al vol" depicts this subject in a favorable light. Since Dalí possessed a tremendous ambivalence toward sexual relations, which simultaneously tempted

him and filled him with disgust, this is perhaps not surprising. Whereas sexual intercourse is conceived as an act of cannibalism in the first instance, it is associated with putrefaction in the second. Not only does it take place on a bed of putrid bones but, in an act of legerdemain that would have astonished Houdini, it undergoes a startling metamorphosis in the final section. Glancing at the scene a second time, Dalí perceives that he was mistaken, that he is actually looking at a rotting donkey. In a gesture worthy of Giuseppe Arcimboldo, the objects described in the first section are incorporated into the unfortunate animal. The conclusion is inescapable: sex = death and decay.

While images of decomposing donkeys had long figured in Dalí's works, the conclusion of "Poema agafat al vol" marked a new stage in his aesthetic development. In this poem and in paintings such as *Invisible Sleeping Woman, Horse, Lion* (1930), and *Phantom Chariot* (1933), he experimented with an exciting new method which he called "paranoiac criticism." This method, which would form the basis for most of his future work, was first described in an article entitled (significantly) "L'Ane pourri" ("The Rotten Donkey"). "Je crois," Dalí announced in 1930, "qu'est proche le moment où, par un processus de caractère paranoïaque et actif de la pensée, il sera possible . . . de systematiser la confusion et de contribuer au discrédit total du monde de la réalité" (I believe the moment is near when, through an active paranoiac thought process, it will be possible . . . to systematize confusion and to contribute to the total discrediting of the world of reality).[49]

Briefly, since much has been written on the subject, Dalí proposed to carry out this operation by creating multistable images—images that encourage contradictory or simply different readings.[50] Whereas the confusion in Wittgenstein's famous Duck-Rabbit drawing derives from reversals between left and right, that in the paintings results from reversing the relation between front and back, figure and ground. While the former dynamic is restricted to a single plane, the latter process is theoretically three-dimensional. In the first painting mentioned in the preceding paragraph, a reclining female nude turns out to contain a horse and a lion (and vice versa). In the second, the driver of a covered wagon is transformed into a bell tower (and vice versa). Elsewhere, Dalí confuses a face with a fruit dish and a bust of Voltaire with the inhabitants of a slave market. Since each object is contained in the other, the equation is com-

pletely reversible. Since the dividing line between figure and ground is erased, neither object takes precedence over the other. If the miscellaneous objects in "Poema agafat al vol" dissolve to become a donkey, the donkey eludes our grasp and is transformed into a sewing machine, an aluminum trout, and a surprisingly pliant watch.

6

The Spanish Experience

Like their colleagues in Paris, the Spanish surrealists were strongly attracted to motion pictures which, despite the absence of sound, offered exciting new possibilities.[1] Not only was the new art form instantaneously accessible, but the invention of montage and other techniques allowed the director (and the writer) to manipulate time and space at will. While the general public flocked to the cinema seeking to be entertained, the surrealists were intrigued by a whole range of technical innovations, which they sought to imitate in their own works. Although they experimented with critical poetry as well, their efforts differed from the initial French models in one important respect. In contrast to the Synthetic poets (See chapters 2 and 3), who concentrated on a specific work, the Spaniards preferred a more general approach. Whereas Soupault focused on a single film, for example, poets such as Federico García Lorca and Rafael Alberti were inspired by a collection of films featuring a particular actor. Like their counterparts in France, they were especially fond of comedies—whose madcap, slapstick humor, Virginia Higginbotham points out, was "easily distorted into the bizarre and nonsensical imagery of Surrealism."[2]

Federico Garcia Lorca

Whereas the French surrealists prized Charlie Chaplin's comedies, the Spanish surrealists preferred films that featured Buster Keaton, whose comic genius manifested itself in a different manner. Interestingly, Rafael Utrera reports that the Spaniards were repelled by the "excessive sentimentality" of Chaplin's films.[3] What attracted them to Keaton, one surmises, was his stoic personality and manly bearing. The earliest text in which he appears, entitled *El paseo de Buster Keaton* (*Buster Keaton Goes for a Ride*), is in some ways the most

intriguing. Written by Lorca apparently in July 1925, it was not published until 1928 when it appeared in his journal, *Gallo*.[4] One of three short plays belonging to his *teatro breve*, this enigmatic composition has received a surprising amount of critical attention.[5] While its popularity is partly due to Lorca himself, who has become one of modern poetry's superstars, the play turns out to be important in its own right. As C. B. Morris declares, it has "a density and a profundity out of all proportion to its size."[6] In addition, the play contains a number of themes that were to become increasingly important and anticipates the publication of *Poeta en Nueva York* (1929–30).

That Lorca's play is indebted to the silent cinema, and to comedy in particular, is evident from its title. Interestingly, the dialogue consists of short snippets like the subtitles (or intertitles) that were projected onto the screen periodically. Further examination discloses an example of cinematic terminology: "gros plan" ("close-up") and the presence of cinematic techniques, such as montage. In addition, the text appears to call for piano music at one point and for gramophone music at another. Lorca himself claimed that *El paseo de Buster Keaton* was conceived as a "diálogo fotografiado" (photographed dialogue), which has suggested to some critics that it is a filmscript rather than a play.[7] However, Robert G. Havard has convincingly demonstrated that this impression is mistaken.[8] For one thing, there is an emphasis on verbal virtuosity in the descriptions that far exceeds the demands of a simple scenario. For another, apart from the reference cited above, there are no directions for the camera. "What Lorca has in fact brilliantly captured," Havard concludes, "is the illusion of celluloid gymnastics: the mood of the cinema."

Similar considerations lead Higginbotham to classify the work as "a modern farce in which dialogue is subservient to the motions and actions of the characters."[9] And yet, while this description is undoubtedly closer to the mark, *El paseo de Buster Keaton* is not a satisfactory play either. Once again, in contrast to the incredibly banal dialogue, the descriptions that accompany the spoken words are much too elaborate. Masquerading as stage directions, they clash with the ostensible purpose of the scenario and call for numerous effects that are impossible to realize in the theater. In other words, the work belongs to the ultramodern genre (or subgenre) known as the unperformable play, which attracted the surrealists in particular. (The fact that it has actually been performed on stage does not alter its basic unrepresentability.) Like many surrealist plays, *El paseo de Buster Keaton* was intended first and foremost to be read. For this

reason, given the emphasis placed on textuality, it is best conceived as a poem—a critical poem in which poetry, criticism, and film intersect.

In this connection, it is instructive to reexamine Lorca's debt to the silent cinema. According to Utrera, for instance, the stage directions contain "metáforas disparatadas, antítesis irreconciliables, notas poéticas que parecen la transformación en palabras de las imágenes Keatonianas de la pantalla" (absurd metaphors, irreconcilable antitheses, poetic notes that appear to be the verbal transformation of the Keatonian images on the screen).[10] If we view this transformation as an effort to approximate Keaton's style, this statement is undoubtedly correct. Although Lorca seems to have taken a few images from specific films, he was interested primarily in their slapstick technique. Instead of duplicating Keaton's imagery, therefore, he strove to create images that were the equivalents of those he saw on the screen. Lorca's greatest debt to Keaton's films is apparent not in this area, nevertheless, but in his choice of his unforgettable protagonist. As critics have generally realized, the work revolves about the poker-faced comedian, whose bizarre experiences provide most of its continuity. To the extent that they encourage us to arrive at certain conclusions, they also provide considerable food for thought.

At first glance, however, following an initial reading, Keaton appears to have been seriously miscast. For despite the presence of the famous comedian, the play is not the least bit amusing. If *El paseo de Buster Keaton* is a farce, as various slapstick elements would suggest, it is a sinister farce at best. As the play opens, a rooster crows twice, heralding the arrival of dawn and evoking Lorca's journal *Gallo*. But the promise of the new day is immediately contradicted by the events that transpire. Holding his four children by the hand, Keaton enters and suddenly stabs them to death. The fact that his dagger is made of wood does not lessen the impact of this terrible gesture. If on the one hand it is obviously a movie prop, like the dagger in *The High Sign* (1921) or *The Cameraman* (1928), on the other hand the children seem to be just as dead as if it were made of steel. Lying on the ground, they display no sign of life as Keaton counts them to make sure he has killed every one. All he can find to say as he gets on his bicycle and prepares to leave is "pobres hijitos míos" (my poor children). It is hard to say which of these actions is the most shocking: the bloody infanticide we have just witnessed or Keaton's apparent lack of emotion. Although Havard has argued that the

murders may be construed as an act of euthanasia, in the light of later events, Keaton's calm demeanor suggests on the contrary that he is a psychopath.[11] The fact that the killings are basically inexplicable (except as the act of a deranged individual) sets the stage for what follows, which is equally inexplicable. As such, they come to symbolize the absurdity of life itself.

Keaton's brutal act is particularly incongruous and disturbing, Higginbotham remarks, because it is followed by a scene of innocence and pleasantry.[12] The rest of the play depicts Keaton as he rides his bicycle through a city park in Philadelphia. Before reaching the park, however, he must pass through a slum, where he glimpses the dire poverty in which most African-Americans lived. Sitting in a vacant lot amid heaps of old tires and rusty gas cans, a Negro is slowly eating his straw hat. If *comer paja* (to eat straw) is Granada slang for masturbation, as Havard avers, it is hard to believe this fact has any bearing on the play.[13] That the Negro is forced to consume his hat is explained not by an active libido but by his hopeless poverty. He not only has nowhere to live, but he has nothing else to eat. As he would do in *Poeta en Nueva York,* which contains glimpses of poverty in Harlem, Lorca depicts America as a brutal country ruled by oppressive forces—psychic as well as societal. Indeed, as *El paseo de Buster Keaton* demonstrates, he was convinced the two were connected. In the last analysis, the Negro's plight turns out to be related to that of the children who have just been murdered. Like them, he incarnates the theme of brutality, of man's inhumanity to man, that Lorca found so disturbing. Like them, he is an innocent victim.

That Lorca harbored numerous preconceptions about life in the United States—doubtless gleaned from the media—is clear from this and other passages. Among other things, one would love to know how he learned about African-American poverty and what led him to situate his play in Pennsylvania. Why did he choose Philadelphia, one wonders, instead of New York or Chicago, which were much better known? Did this city have any special significance for him? How much, if anything, did he actually know about the City of Brotherly Love? Judging from several indications, Lorca seems to have some acquaintance with the city and to have chosen it for a definite reason. Whether he learned about Philadelphia from printed sources, a film, or a friend is difficult to say. At any rate, the rest of the play appears to take place in Fairmount Park, which is one of the largest parks in the world (8900 acres). Our initial impression of the park is rather disconcerting. "¡Qué hermosa tarde!"

Keaton exclaims as he rides along one of the paths; "Da gusto pasearse en bicicleta" (What a beautiful afternoon! Riding a bicycle is fun). As a parrot flutters in the background, he unexpectedly encounters an owl which, instead of hooting, bursts into song like a canary. "¡Qué bien cantan los pajarillos!" Keaton observes; "es emocionante" (How nicely the birds sing! I find it moving). Totally disoriented, the reader no longer knows if it is morning, noon, or night or whether the action takes place in North America or in the tropics. Time and space have been telescoped into a single indeterminate entity.

As we have seen previously, systematic disorientation is one of the hallmarks of surrealism, which seeks to create a privileged space for the drama it enacts. Conflict, contradiction, and confusion are thus virtues because they are essential to the surrealist enterprise. At the risk of destroying the effect that Lorca obviously wanted to produce, it should be noted that the contradictions can be explained rationally. On the one hand, the abrupt transition from morning to afternoon corresponds to what film makers call a "jump cut," where the action suddenly shifts to a future moment. On the other hand, the montage of sights and sounds that assails Keaton as he enters the park suggests he is passing by (or perhaps through) the Philadelphia Zoo, which occupies a section of Fairmount Park. This impression is strengthened by subsequent references, including one to a pair of zebras. Continuing on his way, Keaton crosses a marshy area and a field planted somewhat implausibly with rye.

El paisaje se achica entre las ruedas de la máquina. La bicicleta tiene una sola dimensión. Puede entrar en los libros y tenderse en el horno del pan. La bicicleta de Buster Keaton no tiene el sillín de caramelo y los pedales de azúcar, como quisieran los hombres malos. Es una bicicleta como todas, pero la única empapada de inocencia. Adán y Eva correrían asustados si vieran un vaso lleno de agua, y acariciarían, en cambio, la bicicleta de Keaton.

[The landscape shrinks between the machine's wheels. The bicycle has only one dimension. It can enter books and stretch out in a baker's oven. Buster Keaton's bicycle does not have a caramel seat or sugar pedals that might appeal to bad guys. It is a perfectly ordinary bicycle but the only one steeped in innocence. Adam and Eve would take fright and run away if they saw a glass full of water, but on the other hand they would stroke Keaton's bicycle.]

Although bicycles played a prominent role in other silent come-dies, Keaton rarely employed them in his own films. The most im-portant exception is *The General* (1927), in which a Confederate engineer pursues a locomotive that has been stolen by Union forces. Forced to abandon the handcar he has been using after it is de-railed, he grabs a nearby bicycle and continues the chase. As Morris declares, the bicycle ride in *El paseo de Buster Keaton* almost certainly derives from this film.[14] While Lorca may have written a first draft of the play in 1925, this fact plus the reference to *Gallo* indicate that the final version dates from 1928. Like the bicycle in *The General*, therefore, the machine that Keaton rides through the park is ex-tremely old-fashioned, a museum piece rather than a practical means of transportation. Equipped with a huge front wheel like a tricycle, it makes a perfect comic vehicle.

Despite Lorca's assurance to the contrary, Keaton's bicycle pos-sesses some extremely unusual properties. Suddenly zooming in on this machine, the first line focuses on the bicycle itself and ignores the surrounding landscape. At the same time, it manages to suggest that the bicycle can actually shrink the landscape somehow, which is viewed between its revolving wheels. Since Keaton seems to be rid-ing at a right angle to the viewer, the machine appears to occupy a single plane—or rather—as one discovers with amazement, it occu-pies a single dimension. Reduced to a horizontal (or perhaps a verti-cal) line, it could serve as a bookmark or a poker for a wood-fired oven. Luckily Lorca confides, the bicycle is not edible and so will not tempt anyone to steal it. In addition, it is "empapada de inocen-cia"—like Keaton himself who is portrayed, in Edwards' words, as "an innocent in a hostile world."[15] As his vehicle, it serves not only to transport him but is endowed with his principal attribute. The reference to Adam and Eve demonstrates, moreover, that their inno-cence is of Edenic proportions. Why the same individuals should be frightened of a glass of water is anybody's guess—perhaps because they have never seen one before.

Despite Keaton's passive demeanor, whose origins are apparently pathological, despite his callous behavior at the beginning of the play, he is not completely devoid of feelings. Suddenly overcome by a burst of emotion, he exclaims "¡Ay amor, amor!" (Oh love, love!). Moved by the thought of the birds singing in their cages, whose song he also found moving, Keaton is reminded of his own situation. The shock is so intense that it knocks him off his bicycle which, escaping from him, runs furiously after two gray butterflies. Suspended half a

millimeter above the ground, the machine turns out not only to have a will of its own but to be able to fly. Abandoned by his magic bicycle, which never returns, Keaton is left with a few bruises and no one with whom to share his life. Whether the "amor" that obsesses him involves a particular woman or merely love in general is never made clear. Whether it is situated in the past, the present, or the future is also impossible to ascertain. These difficulties not with-standing, critics have generally interpreted Keaton's exclamation as a simple yearning for love. Considered in this light, his search for "amor" would parallel the bicycle's pursuit of the butterflies, which like love are ephemeral and elusive. Nevertheless, another parallel can be deduced from these circumstances that is equally plausible: that Keaton has been abandoned by his wife who, like the fickle bicy-cle, has run off in search of other pleasures. Motivated by anger, or perhaps in a fit of despondency, he has exacted the ultimate revenge by killing their four children.

However one chooses to interpret Keaton's words, his outburst provides no lasting insight and is followed by another abrupt mood swing. Picking himself up off the ground, he declares: "No quiero decir nada. ¿Qué voy a decir?" (I have nothing to say. What could I say?). These remarks convey not the futility of trying to communi-cate, as Havard maintains, but rather the futility of trying to change anything.[16] Like the opening line of *En attendant Godot* (*Waiting for Godot*): "Rien à faire" (Nothing to be done), which bristles with metaphysical overtones, they are uttered in a spirit of resignation. Although Keaton's attempts to communicate may be inadequate, they continue throughout the play. Addressed primarily to the reader, they lead to a dialogue of sorts when two additional charac-ters are introduced in the second half. For the moment, Keaton's words prompt an anonymous voice to reply: "Tonto" (Fool). Since this pronouncement is not accompanied by exclamation marks, it seems to be a description as much as a judgement. Focusing initially on Keaton's expressive eyes, which were made even more expressive by the use of eyeliner, the following passage comes to much the same conclusion.

Sigue andando. Sus ojos, infinitos y tristes, como los de una bestia recién nacida, sueñan lirios, ángeles y cinturones de seda. Sus ojos, que son de culo de vaso. Sus ojos de niño tonto. Que son feísimos. Que son bellísimos. Sus ojos de avestruz. Sus ojos humanos en el equilibrio seg-uro de la melancolía. A lo lejos se ve Filadelfia. Los habitantes de esta

urbe ya saben que el viejo poema de la máquina Singer puede circular entre las grandes rosas de los invernaderos, aunque no podrán comprender nunca qué sutilísima diferencia poética existe entre una taza de té caliente y otra taza de té frio. A lo lejos brilla Filadelfia.

[He continues on his way. His eyes, infinite and sad like those of a newborn beast, dream of lilies, angels, and silk sashes. His eyes, which are like the bottom of a glass. His eyes of an idiot child. How ugly they are. How beautiful they are. His ostrich eyes. His human eyes in the sure balance of melancholy. Philadelphia can be seen in the distance. The inhabitants of this city know perfectly well that the old poem of the Singer sewing machine can circulate among the large roses in the greenhouses, although they will never be able to understand what a subtle poetic difference exists between a hot cup of tea and a cold cup of tea. Philadelphia glimmers in the distance.]

As Lorca observes, Keaton's eyes were his most expressive feature and appeared to be suffused with an immense sadness. Contrasting with the impassive mask that he habitually adopted, they exerted a strange attraction upon the viewer, who was simultaneously charmed and repelled by their expression. Despite the fact that Keaton has killed his children, which continues to trouble the reader, he turns out to be a sympathetic character. Judging from the expression in his eyes, he is capable of much greater feeling than one would have suspected. He is not an insensitive brute after all but, like Chaplin's little tramp, someone whom life has treated unfairly. His poker face is simply a protective mask, Havard concludes, which "he has learnt to grow as a means of combating the vulgar aggression of his environment.[17] Surprisingly, Keaton is even revealed to be something of a dreamer as he imagines an idyllic existence filled with flowers, angelic faces, and the rustle of silk—an existence dominated by a distinctly feminine presence. One wonders if he is dreaming of his former wife and children or if this vision is reserved for some future moment. That Keaton is given to dreaming, moreover, suggests that despite his apparent deficiencies he is really a poet at heart. Peering deeply into his eyes, one perceives that he is as innocent as a newborn lamb or, Lorca adds somewhat ominously, an idiot child. Like the mentally retarded boy in John Steinbeck's *Of Mice and Men*, who also kills somebody, he gazes uncomprehendingly at the world around him.

At this point, Lorca begins to develop a theme that has only been implicit until now. Glimpsing Philadelphia's skyline in the distance,

he shifts his attention to the city's inhabitants, who consider themselves cultured but who are out of touch with the modern age. The reason Keaton's poetic talent has gone unrecognized, Lorca complains, is because they are still wedded to nineteenth-century aesthetics. The key to this passage lies in the striking contrast created by juxtaposing the sewing machine amid the flowers with the hot and cold cups of tea. As we have seen previously, the surrealists commonly identified the sewing machine with (female) sexual passion. This fact plus the needle's rapid to-and-fro motion have encouraged at least two critics to view Lorca's machine as a symbol of masturbation.[18] On the contrary, the poet tells us himself that it symbolizes "el viejo poema," that is, poetry composed according to the traditional (but outmoded) model. Like the traditional poetic line, with its uniform length and regular rhythm, the needle moves steadily back and forth with precise, even strokes. Like the traditional rhyme scheme, with its repetitive consonants and harmonious vowels, the moving parts produce a series of musical effects. Lest we harbor any doubt about the aptness of the analogy between the mechanical and the poetic voice, Lorca notes that the sewing machine is a Singer. That the machine is circulating among "las grandes rosas de los invernaderos" alludes to the exceptional role that roses have played in traditional poetry. At the same time, it brings us back to Fairmount Park which boasts a Horticulture Center consisting of several greenhouses and an arboretum. "Esto es un jardín" (This is a garden) Keaton remarks in the next line, referring to the fact that the entire park is landscaped.

By contrast, modern poetry dispenses both with rhyme and with regular lines and looks elsewhere for its subject matter. Written in free verse or even in prose, it is distinguished by its self-conscious stance and by its choice of subjects that were formerly considered unpoetic. Eschewing traditional symbols of beauty, such as roses, it tends to focus on less obvious objects that deserve to be called to our attention—in this case, a cup of tea. While the inhabitants of Philadelphia can certainly tell whether a cup of tea is hot or cold, Lorca proclaims, they are ill equipped to appreciate the difference. Only the modern poet, who has discovered the aesthetic value of everyday objects, can translate this experience into poetic terms. What distinguishes the two cups of tea is not their temperature so much as the sensory experience each produces and the complex associations that are evoked in turn.

The theme of modern, liberated poetry gives way at this point to

a related theme: that of modern, liberated womanhood. Personified by an American Woman, who accosts Keaton as evening draws near, it leads to a symbolic exchange that appears to revolve about the latter's sexuality. From this and subsequent events, Havard and Edwards deduce that she is a prostitute and that Keaton eventually succumbs to her commercial charms. However, since a public park is an unusual place to encounter a streetwalker, what transpires is far from clear. Upon reflection she appears to be yet another caricature—like the Negro eating his straw hat and like Keaton himself—of an American figure portrayed in the media. Rather than a prostitute, she simply seems to be a liberated female from the 1920s, whose most flamboyant representative was the American flapper. Like Keaton's bicycle, which is imbued with the same innocence as its owner, the American Woman's footwear tells us all we need to know about her. "¡Oh, qué zapatos!" Lorca exclaims. "No debemos admitir esos zapatos. Se necesitan las pieles de tres cocodrilos para hacerlos" (Oh, what shoes! Those shoes should be outlawed. It takes three crocodile skins to make them). On one level, as critics have pointed out, the sacrifice of so many crocodiles illustrates the destructive power of a civilization that exploits nature for its own ends. On another, equally important level, it marks the American Woman as a femme fatale.

Keaton's new acquaintance is not only seductive, moreover, but, like her liberated American sisters, she is aggressive. Addicted to the pursuit of pleasure, she knows exactly how to get what she wants. Eager to acquire a handsome new boyfriend, she inquires: "¿Tiene usted una espada, adornada con hojas de mirto?" (Do you have a sword adorned with myrtle leaves?). In reply, Keaton shrugs his shoulders and balances on his left foot, which prompts her to ask a second question: "¿Tiene usted un anillo con la piedra envenenada?" (Do you have a ring with a poisoned stone?). In response, Keaton slowly closes his eyes and balances on his right foot. That these questions are concerned with Keaton's sexual identity is easy enough to demonstrate. Like Lautréamont's fortuitous encounter between an umbrella and a sewing machine, which Lorca was probably thinking of, the objects in question are sexual symbols. The fact that myrtle is associated with Venus reinforces the sword's phallic image. However, since the poisoned stone is a negative marker, it subverts the ring's vaginal pretensions and transforms it into an anal symbol. The American Woman is concerned to know not whether Keaton is a man or a woman, therefore, but whether he is heterosex-

ual or homosexual. Angered by his bizarre reaction to her first question, she asks a second question that is doubly insulting.

To be sure, Keaton's second response is no more satisfying than his first. Nor is his inappropriate behavior any easier to interpret. Although it is tempting to argue that his elaborate balancing act reflects his inability to choose between heterosexuality and homosexuality, between purity and temptation, this is almost certainly incorrect. The problem with Keaton's replies, as the American Woman recognizes, is not that they are ambiguous but that they are not replies at all. At the end of the one-sided exchange, she finds herself still waiting for an answer. "¿Pues entonces?" (Well, then?), she asks in a puzzled voice. However, the response (or reaction) to this question, when it finally comes, is no more satisfactory than the first two. Despite her seductive manner, one comes to realize, Keaton is oblivious to her presence. As his next comments reveal, he is lost not in endless deliberations but in a dream that proves to be much more attractive. At this point, the action is interrupted by a brief lyric interlude.

> Cuatro serafines con las alas de gasa celeste bailan entre las flores. Las señoritas de la ciudad tocan el piano como si montaran en bicicleta. El vals, la luna y las canoas estremecen el precioso corazón de nuestro amigo. Con gran sorpresa de todos, el Otoño ha invadido el jardín, como el agua al geométrico terrón de azúcar.

> [Four seraphim with wings of celestial gauze dance among the flowers. The city girls play the piano as if they were riding a bicycle. The waltz, the moon, and the canoes cause our friend's beautiful heart to quiver. To everyone's great surprise, Autumn has invaded the garden, like water on a geometrical cube of sugar.]

As Havard declares, the last phrase contains one of Lorca's "most precise and beautiful images."[19] Since it seems to be spring initially, with singing birds setting the stage for love, the change of seasons comes as something of a shock. Coinciding with the transition from day to night, it concludes the American Woman's attempt to seduce Keaton, which is ultimately unsuccessful, and introduces the final scene. Admittedly, it is a perfect night for love—a little too perfect as it turns out. As the moonlight streams down upon Centennial Lake, illuminating pairs of lovers drifting in their canoes, a band of angels dances to the strains of piano music wafted on the night air. This idyllic portrait is marred by a certain artificiality, like the seraphim's

gauze wings, that suggests Lorca is parodying the romantic scenes in Hollywood movies. Like the piano music, whose monotonous rhythm betrays a lack of feeling, the description is too mechanical, too full of clichés. These shortcomings are lost on Keaton, however, who finds the scene totally enchanting. Surrounded by the "lirios, ángelos y cinturones de seda" of which he was recently dreaming, he feels his heart swell with emotion. This response confirms our earlier impression, conveyed by his expressive eyes, that Keaton is capable of great feeling. Once again, the fact that he possesses a "precioso corazón" encourages us to regard him as a sympathetic character.

While the romantic scene causes Keaton's heart to quiver with emotion, the emotion in question is not love, as the American Woman would like, but excitement. Keaton is excited not by her amorous overtures but by the passionate dream he has been entertaining, which grows more and more intense as the evening wears on. "Quisiera ser un cisne" (How I would like to be a swan), he confides to the American Woman, who is still waiting for an answer to her question. At this point, she presumably realizes she has been wasting her time and leaves in a huff. Whatever her reaction, Keaton's surprising confession finally allows us to understand his puzzling behavior preceding the lyric interlude. Glancing at the waterfowl preening their feathers by the lake, which balance first on one leg, then on the other, he ignores the Americana's questions, and tries to imitate them. Centennial Lake was famous for its swan population then as now, including several rare trumpeter swans, one of which lived to the ripe old age of twenty-nine. However, the swan that Keaton dreams of becoming is far more than an inhabitant of Fairmount Park. Like the bird motifs and images of flying that proliferate in the text, it symbolizes his aspiration to free himself from earthly cares and preoccupations. That Keaton is drawn to the magnificent swans, with their sinuous curves and graceful movements, testifies to his poetic sensibility as well. More importantly, since Rubén Darío and others had transformed the swan into a symbol of the poet, it reveals his poetic aspirations.

Unfortunately, as Keaton admits in the next sentence, his dream is doomed to failure. "Porque ¿dónde dejaría mi sombrero?" he asks himself; "¿Dónde mi cuello de pajarita y mi corbata de moaré (Because where would I leave my hat? Where my celluloid collar and my silk tie?). Before he can become a swan, it turns out, he must remove his clothes to avoid being imprisoned in them. What deters

him is not the prospect of finding himself naked in a city park but the realization that he would have to drape his clothing over some bushes. On the one hand, Keaton's objections are clearly absurd. Given the opportunity to realize the dream of a lifetime, the lack of a place to hang his clothes seems a minor inconvenience. On the other hand, his objections possess a certain internal logic of their own. Since Keaton has presumably paid good money for his clothing, he does not want it to become soiled. Even more to the point, since he might wish to resume his human shape sometime, he does not want to risk having it stolen. At the symbolic level, to be sure, Keaton acknowledges the impossibility of escaping the human condition and the problems created by modern civilization. In a similar vein, although here the situation is more complicated, he concludes that he will never become a poet. By 1928 (or 1925), however, Keaton's concept of poetic endeavor was hopelessly out of date. Like the *modernista* poetry with which it was associated, the emblematic swan had become extinct. Ironically and unbeknownst to himself, Keaton had created a new kind of poetry that was attracting the attention of cinemagoers all over the world, including Lorca and his friends.

As Keaton is lamenting his supposed misfortune, a girl with a wasp waist and an elaborate hairdo arrives on a bicycle. Although she appears to be normal in every other respect, she has the head of a nightingale. Apparently a great fan of Keaton's movies, she swoons when he introduces himself and falls off her bicycle. "Sus piernas a listas tiemblan en el césped como dos cebras agonizantes," Lorca comments; "Un gramófono decía en mil espectáculos a la vez: 'En America hay ruiseñores'" (Her striped legs quiver on the lawn like two moribund zebras. A gramophone was proclaiming in a thousand movie theaters simultaneously: "In America there are nightingales"). The first sentence, which presumably describes the girl's striped stockings, reminds us that the action takes place near a zoo. The second sentence evokes the introduction of "talking pictures" during the late 1920s and their widespread popularity. Thanks to modern technology, a single film could be duplicated and distributed to a thousand different theaters, making it possible for large numbers of people to view it at the same time. Why this particular film should be concerned with nightingales is never made clear. The phrase in question could be uttered in any number of situations. Indeed, since they issue from a gramophone—which suggests the film is a musical—one suspects the words are sung rather than spoken.

"If a nightingale could sing like you," Maurice Chevalier crooned in *The Big Pond* (1930), "They'd sing much sweeter than they do."

While the girl with the nightingale's head recalls several paintings by Max Ernst, as Julio Huélamo Kosma remarks, she appears to have been invented especially for the occasion.[20] And yet, despite the assurance with which Lorca introduces her at this point, her role is ambiguous at best. Although her tightly corseted figure and elaborate hairstyle link her to the previous century, their significance is lost on the modern reader. Attempts to connect her to Florence Nightingale (1820–1910), for example, are ultimately unsuccessful. Could she possibly be a singer like Jenny Lind (1820–87), one wonders, who was known to her contemporaries as the "Swedish Nightingale"? These and similar speculations are rendered moot by the discovery in the next line that the mysterious girl is named Eleonora. Unfortunately, like the earlier details this additional clue appears to lead nowhere. Rather than a historical figure, one is forced to conclude that she is a symbolic construct. This interpretation dovetails with her hybrid identity and strange appearance. Unlike Keaton, who chooses not to become a swan, she is half bird and half girl. Bridging the gap between the avian and the human world, she resembles a nightingale but retains the ability to think and speak like a human being. Like the swan, in addition, which was considered the epitome of physical beauty, the nightingale was renowned for its beautiful song. Celebrated by countless poets from Bernard de Ventadour to Keats, it had come to be associated, like the swan, with traditional poetry. The reason the girl is dressed in old-fashioned clothes, therefore, is because she symbolizes poetry that has become outmoded. Discovering she is speaking to Buster Keaton, she faints not just because he is a movie star but because he embodies a brilliant new poetics.

Keaton's response is frankly puzzling. Kneeling by the girl's side, he tries both to revive her and to reassure her at the same time. "Señorita Eleonora," he cries, "¡perdóneme, que yo no he sido!" (Excuse me, Miss Eleanor; it wasn't me). Calling her name again and again in progressively quieter tones, he suddenly gives her a kiss. The reader is left not with a feeling of closure but with innumerable questions that remain to be answered. How is it that Keaton recognizes the girl, for example, while she appears not to know him at all? Since he is a famous movie star, one would expect the reverse to occur. Who is the mysterious girl anyway, and what is her relation, if any, to Keaton? Is she famous as well—perhaps another movie star?

How can he introduce himself to her one moment and kiss her the next? Morris suggests he is playing yet another role: that of Prince Charming awakening Sleeping Beauty.[21] Perhaps Keaton has finally found the girl of his dreams, someone who will return his passionate love. Or again perhaps he simply succumbs to her beauty. What is the mysterious event to which Keaton alludes, finally, and why does he feel compelled to excuse himself? Is he telling the truth or merely seeking to avoid being blamed? On the one hand, he may be denying responsibility for the death of his children. On the other, that he caused the girl to fall off her bicycle. Lorca deliberately leaves it up to the reader to decide.

That the first explanation is probably correct is suggested by the final stage direction: "En el horizonte de Filadelfia luce la estrella rutilante de los policías." The critics generally agree that the line describes the flashing lights of police cars which, seen against the Philadelphia skyline, resemble bright stars. Somehow, it would seem, the police have determined that Keaton is responsible for the murder of his children and are coming to arrest him. Since there don't appear to have been any witnesses, he must have left his fingerprints on the knife. Like so many slapstick comedies, especially those starring the Keystone Cops, *El paseo de Buster Keaton* ends with the protagonist being pursued by the police. Like Chaplin, however, Keaton preferred a more sentimental conclusion in which the hapless protagonist got the beautiful girl. Reviewing the play for the last time, one perceives that it incorporates both of these endings: the police chase is superimposed upon the romantic conclusion and vice versa. The reason Keaton kisses the girl who falls off the bicycle, it turns out, is because it is time for the play to end. And yet, the reader exclaims in protest, how can this possibly be? How can a story that began in such a horrible fashion conclude on such a happy note? How can Lorca permit a psychopathic killer to live happily ever after? Lorca would undoubtedly reply that the problem ceases to exist, or at least ceases to have any meaning, once we accept the play's antirealistic premises. Like the wooden dagger with which Keaton pretends to kill his children, the drama enacted in *El paseo de Buster Keaton* is purely symbolic. Among other things, this fact explains why the experience leaves him unmoved: he knows it is only pretense. Since the crime is only imaginary, therefore, like art itself, it is not really a crime at all.

RAFAEL ALBERTI

Above all, Higginbotham concludes at the end of her ground-breaking study, Lorca was attracted by the strongly visual quality of surrealism.[22] That his own imagination was essentially visual can be seen from the keen interest he displayed in cinematic techniques and from his attempts to adapt them to his own works. These remarks apply to another writer as well, Rafael Alberti, whom Havard calls "Spain's finest and most authentic Surrealist poet."[23] Four years younger than Lorca, whose work he greatly admired, Alberti composed a remarkable series of poems in 1929 that was conceived as a tribute to the comics of the silent screen.[24] Seeking a title that would reflect the latter's zany, madcap humor, which he strove to capture in his own compositions, Alberti chose a line from a seventeenth-century play by Pedro Calderón de la Barca: "Yo era un tonto y lo que he visto me ha hecho dos tontos" (I was a fool, and what I have seen has made me two fools). Since *tonto* can also be translated as "jester" or "clown," the title aptly describes the boisterous pranks and verbal clowning that give the volume its distinctive tone. In addition, as Morris notes, it conveys Alberti's increasing dissatisfaction with the status quo and his willingness to provoke, even outrage his audience.[25]

Despite Alberti's growing reputation, Anthony Geist remarks, *Yo era un tonto y lo que he visto me ha hecho dos tontos* has received relatively little critical attention. For various reasons, it remains "uno de sus libros más originales y menos estudiados" (one of his most original and least studied books).[26] It deserves to be better known, Carlos Alberto Pérez insists, not only because of its intrinsic merit but because it sheds important light on Alberti's aesthetic and spiritual development during an extremely crucial period.[27] Although linguistic stumbling blocks confront the reader at every turn, the original project was perfectly straightforward. Alberti sought to document each of the comics' originality, Morris explains, "by enabling them to do in his poems what they could not do in the films in which they made their names: talk."[28] The challenge lay not just in translating his visual impressions into verbal equivalents but in creating a different poetic discourse for each comic. Despite the distortions and incongruities that proliferate in *Yo era un tonto*, Alberti managed to create a recognizable persona for each of his protagonists. His task was

made slightly easier by devoting each composition to a single comic, who assumed the starring role as if it were a movie. The only exception is a poem in which Laurel and Hardy appear together because they were a comedy team. Having accidentally wrecked seventy-five or seventy-six automobiles, they blame the whole thing on a banana peel.

As several critics have pointed out, the individuals in *Yo era un tonto* inhabit a world that is governed by its own peculiar set of laws. Like the films in which they appeared, the poems are filled with absurdities from beginning to end. Like other surrealist works, they are dominated by a vision of the absurd that is both amusing and strangely disquieting. For if Alberti introduced a new kind of humor into Spanish literature, Morris declares, "there is a deep vein of seriousness underlying the verbal buffoonery of his poems."[29] Despite his continual clowning around, in his poetry as in real life, he took his mission seriously. It is incumbent upon us as readers to acknowledge Alberti's serious intentions, which are masked by various comic devices, and to interrogate his texts closely. Upon close examination, for example, one discovers that the poems in *Yo era un tonto* are suffused with an immense sadness. "Al igual que los àngeles en *Sobre los ángeles*," Geist comments, "los tontos albertianos encarnan múltiples facetas de un sentido trágico o tragicómico de pérdida" (Like the angels in *Concerning the Angels*, Alberti's fools embody multiple facets of a tragic or tragicomic sense of loss).[30]

On May 4, 1929, the members of the Cineclub in Madrid were treated to a dramatic reading of the initial three poems by Alberti himself. The first composition was devoted to Charlie Chaplin, the second was concerned with Harold Lloyd, and the third was entitled "Buster Keaton busca por el bosque a su novia, que es una verdadera vaca" ("Buster Keaton Searches Through the Forest for His Sweetheart, Who Is Actually a Cow"). As Edgar O'Hara points out, the lengthy title recalls the explanatory captions that were utilized in silent films.[31] We know from contemporary witnesses that Alberti dazzled his audience, accompanying his words with sound effects, gestures, and an expressive pantomime. Indeed, traces of this memorable experience can be found in the work's subtitle: "poema representable" ("a performable poem"). And Pérez claims that each poem constitutes its own dramatic scenario, reproducing Chaplin's nervous gestures, Harry Langdon's somnambulistic style, and Lloyd's dynamism according to its respective protagonist.[32] The same principle can be detected in "Buster Keaton busca por el bos-

que a su novia," which possesses the same rhythm (and the same structure) as many of Keaton's movies. In the poem, as on the screen, the stone-faced comic ambles aimlessly through life with no idea where he is going.

As Pérez was the first to perceive, each of the poems in *Yo era un tonto* is constructed around one film in particular, which it simultaneously imitates and parodies. Entitled *Go West* (1925), the movie that inspired "Buster Keaton busca por el bosque a su novia" tells the story of a drifter who rides the boxcars to Arizona, where he attempts to become a cowboy. "A hapless, unloved, pathetic creature named Friendless," as one film critic puts it, Keaton falls in love with a cow named Brown Eyes, who loves him in return.[33] Cast in the form of a monologue, Alberti's poem depicts the pitiful protagonist searching for his bovine sweetheart, who has inexplicably wandered off. As in *Go West*, he is dressed in full cowboy regalia including chaps, a leather vest, and a bandanna tied around his neck. Except for his ridiculous porkpie hat—a Keaton trademark—the transformation is complete.

> 1, 2, 3 y 4.
> En estas cuatro huellas no caben mis zapatos.
> Si en estas cuatro huellas no caben mis zapatos,
> ¿de quién son estas cuatro huellas?
> ¿De un tiburón,
> de un elefante recién nacido o de un pato?
> ¿De una pulga o de una codorniz?
> (Pi, pi, pi.)

> [1, 2, 3, and 4.
> My shoes do not fit in these four footprints.
> If my shoes do not fit in these four footprints,
> to whom do these four footprints belong?
> To a shark,
> to a newborn elephant, or to a duck?
> To a flea or to a quail?
> (Cheep, cheep, cheep.)].

Since Alberti's composition and Lorca's *El paseo de Buster Keaton* feature the same protagonist, one would expect to find a certain number of similarities between them. However, the points of contact are too numerous to be purely coincidental, and they are not the sort that are likely to result from chance encounters. Like Lorca's

text, for example, which begins with Keaton counting the four children he has just slaughtered, Alberti's poem begins with Keaton counting four footprints left by Brown Eyes. Like the first work, in which the cries of a rooster, a canary, and parrots are intermingled initially, it is punctuated by bird calls that provide an eerie counterpoint to the bizarre dialogue. These and other similarities lead Pérez to suggest that the dramatic poem and the "poema representable" may have been conceived as a joint exercise.[34] And yet, despite their intriguing resemblance to each other, the two works are really quite different. Lorca expresses his anxiety and emotional chaos in *El paseo de Buster Keaton*, Higginbotham concludes, "by the disorderly sequence of events."[35] In *Yo era un tonto*, by contrast, Alberti expresses his own anxiety and anguish in the disorderly sequence of the images which, as Eric Proll remarks, are juxtaposed in a capricious manner.[36] What fascinated Alberti about the cinema, Morris declares, was its images "which flit across the screen so rapidly and unpredictably" and which he tried to duplicate in print.[37]

Not surprisingly, "Buster Keaton busca por el bosque a su novia" shares numerous stylistic traits with the other poems in the volume. In addition to its capricious imagery, O'Hara calls attention to the frequency with which Arabic numerals appear, which are usually gratuitous.[38] This device was inspired not by the cinema but by contemporary advertisements, which led many poets to experiment with "poster poems" following World War I. Alberti seems to have adopted it, in conjunction with his efforts to modernize Spanish poetry, in order to give his works a brand-new look. That his poetry is filled with phonic echoes reflects a larger problem in O'Hara's opinion, demonstrating "the profound difficulty the poet experiences in trying to escape from rhyme."[39] However, this interpretation ignores the possibility that the rhymes and near rhymes are deliberate. It is clear from "Buster Keaton busca por el bosque a su novia" that Alberti does not wish to abandon rhyme but rather to redefine it, to expand the number of phonic possibilities in order to gain more flexibility. He varies not only the length of his lines, therefore, but the way in which they end, incorporating assonance and approximate rhymes into his prosodic arsenal. As often as not, moreover, two lines will end with the same word, in keeping with the dominant stylistic principle: repetition. Not content to rhyme "zapatos" with "zapatos," Alberti repeats entire phrases such as "estas cuatro huellas" again and again. In the last analysis, this is basically what makes "Buster Keaton busca por el bosque a su novia" a per-

formance poem. Together with the various sound effects, the phonic patterns produce an extraordinary effect that can only be realized by reading the poem aloud.

Interestingly, the portrait of Keaton that emerges from the first seven lines differs considerably from Lorca's depiction the previous year. Whereas the protagonist of *El paseo de Buster Keaton* was abstracted from a whole series of films, Alberti's character is drawn from a single movie. Whereas the former was a poetic dreamer, the latter is a social misfit, a perpetual outsider who is ignored or dismissed by everyone around him. "Of all the Keaton heroes," Daniel Moews remarks, the character portrayed in *Go West* is "the one absolute loner." So complete is his estrangement that "he seems to live apart in the alien realm of a madman or simpleton."[40] If anything, this tendency is even more pronounced in "Buster Keaton busca por el bosque a su novia," whose hero seems to be either mentally retarded or insane. Although his initial perplexity is probably intended to be comical, it is also extremely puzzling. Pursuing the elusive Brown Eyes, whom Alberti has renamed Georgina, he encounters four footprints that are almost certainly hers but which for some reason he fails to recognize. Having laboriously counted them, he tries them on to see if perhaps they are his own footprints. What finally dissuades him is not that there are four of them or that they are obviously the wrong shape or that he has never come this way before but the discovery that his feet are too big—which suggests he is wearing clown shoes.

Still refusing to admit the obvious, Friendless speculates about who could have left the footprints. Of the five animals that he proposes, each of which is more ridiculous than the other, only the elephant possesses the correct number of feet. But elephants live too far away, and in any case their feet are too large. Similar objections prevent the shark—which has no feet at all—the duck, the flea, and the quail (which we hear cheeping in the underbrush) from being viable candidates. Unable to reach a conclusion, Friendless resumes his quest for his errant sweetheart.

> ¡Georginaaaaaaaa!
> ¿Dónde estás?
> ¡Qué no te oigo, Georgina!
> ¿Qué pensarán de mí los bigotes de tu papa?
> (Paaa páááááááááá.)
> !Georginaaaaaaaa!

¿Estás o no estás?
Abeto, ¿dónde está?
Alisio, ¿dónde está?
Pinsapo, ¿dónde está?

[Georginaaaaaaaa!
Where are you?
Why don't I hear you, Georgina!
What will your papa's mustache think of me?
(Paaa paaaaaaaaaa.)
Georginaaaaaaaa!
Are you here or not?
Spruce, where is she?
Trade wind, where is she?
Fir, where is she?]

For some reason, perhaps in order to make her seem more human, Alberti has rechristened the cow Georgina. While "Brown Eyes" ("Ojos Castaños") sounds nicer in Spanish than in English, it would have been a strange name for Friendless to shout and would have emphasized the difference between them. Morris suggests that Alberti borrowed the name from Chaplin's *The Gold Rush* (1925), which contains the following subtitle: "Georgia! GEORGIA!! GEORGIA!!!"[41] Like these exclamations, Friendless's cries increase in intensity (and length) as the poem progresses. With a little ingenuity, one could doubtless discover many other features that are duplicated in various films, especially those directed by Keaton. The reference to "un pato" recalls the family of ducks in *The Scarecrow* (1920), for example, and the duck that Keaton tries to shoot from a canoe in *Battling Butler* (1926). Similarly, the mysterious "bigotes" recall the fake mustache worn by the detective in *Sherlock Jr.* (1924) and the pencil-thin mustache affected by the foppish son in *Steamboat Bill, Jr.* (1928). And yet, in contrast to many critical poets who reproduce motifs from the work(s) they are "reviewing," Alberti refers to Keaton's films only sporadically. The animals and objects invoked in the poem are taken not from a catalogue of motifs but from the poet's imagination.

Advancing amid the echoes created by his desperate cries, Friendless is struck by a very peculiar thought: "¿Qué pensarán de mí los bigotes de tu papá?" Since bulls do not have mustaches, which in any case are incapable of thinking, the question appears to make no sense. Perhaps he dreads having to confess to the cow's mustachioed

owner, who is also his boss, that he has no idea where she is. Out of
desperation, like countless Romantic poets before him, he calls on
Nature to aid him in his quest. Receiving no response from the wind
or the trees, he turns to the birds around him, from whom he learns
that he is on the right track.

> ¿Georgina pasó por aquí?
> (Pi, pi, pi, pi)
> Ha pasado a la una comiendo yerbas.
> Cucú,
> el cuervo la iba engañando con una flor de reseda.
> Cuacuá,
> la lechuza, con una rata muerta.
> ¡Señores, perdonadme, pero me urge llorar!
> (Guá, guá, guá.)
>
> [Did Georgina pass by here?
> (Cheep, cheep, cheep, cheep.)
> She passed by at one o'clock eating grass.
> Cuckoo,
> the crow tried to trick her with a reseda blossom.
> Caw, caw,
> the owl, with a dead rat.
> Excuse me, gentlemen, but I feel like crying!
> (Wah, wah, wah.)]

 Although the birds' reply could conceivably be uttered by the
birds themselves, the fact that it alternates with their original cries
suggests that it is a translation, that Friendless is simply repeating
what they have told him. Despite his limited intelligence and his
strange appearance, he possesses at least one redeeming quality: like
St. Francis (and Dr. Dolittle), he is able to converse with the birds
around him. These particular birds are unusually intelligent, it
would seem, for they are able to tell Friendless what time they spied
Georgina eating grass. Since they presumably do not own watches,
which would be difficult to wear in any case, one wonders how they
knew it was one o'clock. Perhaps they heard a clock chime in the
distance. As Morris remarks in the critical edition, the animals in
the poem resemble those in children's stories that possess the same
abilities as human beings. That the crow and the owl should seek to
deceive Georgina, however, introduces a sinister note into the pro-
ceedings—reinforced by the image of the dead rat. A rapid review

of their traditional symbolism reveals that all three are associated with darkness and death, with demonic forces and evil impulses.[42] As far as one can tell, the two birds sought to cast some kind of spell on the cow. In contrast to the dead rat, the reseda blossom is lovely to look at and emits a wonderful perfume. On the one hand, since it possesses certain sedative properties (< lat. *resedare* = "to calm"), the crow may have tried to drug Georgina. On the other hand, since according to the *Grand Larousse Encyclopédique* it symbolizes (loving) tenderness, he may have tried to deceive her with tender words and false promises. In either case, the world is a very dangerous place for someone as sweet and innocent as Friendless's fiancée. In the poem as in the movie, she clearly needs someone to protect her.

At this point, something totally unexpected occurs: Friendless suddenly bursts into tears. What makes this development so shocking, Morris observes in a note to the critical edition, is that Keaton never cried in any of his films. The perpetual victim of poverty and injustice, he maintained his rigid composure through thick and thin. His atypical behavior in Alberti's text seems to have a twofold explanation, alluding both to his role in *Go West* and to his role in the poem. In *Go West*, Moews explains, Keaton appeared "in about the heaviest white-face makeup since *Our Hospitality*, which combined with heavily rimmed eyes [made] him seem a mask of sorrow, a crying clown."[43] In the poem, he is clearly overcome by emotion when he hears that the crow and the owl have tried to dupe his bovine sweetheart. Eventually regaining control of himself, he resumes his search for the errant Georgina.

> ¡Georgina!
> Ahora que te faltaba un solo cuerno
> para doctorarte en la verdaderamente útil carrera de
> ciclista
> y adquirir una gorra de
> cartero.
> (Cri, cri, cri, cri.)
> Hasta los grillos se apiadan de mí
> y me acompaña en mi dolor la garrapata.
> Compadécete del smokin que te busca y te llora entre
> los aguaceros
> y del sombrero hongo que tiernamente
> te presiente de mata en mata.

[Georgina!
To think you needed only a single horn
to obtain a doctorate in the truly useful career of
 cycling
and to acquire a mailman's cap.
(Crick, crick, crick, crick.)
Even the crickets take pity on me
and the tick accompanies me in my sorrow.
Pity the tuxedo that is looking for you and bemoaning
 your fate amid the intermittent showers
and the bowler hat that tenderly
expects to find you from one grove to the next.]

Georgina is not only a wayward animal, it turns out, but a serious scholar who was on the point of receiving her doctorate when she disappeared. Perhaps the strain of writing a dissertation was too much for her, or perhaps she was having trouble with her last chapter. At the same time, Alberti indulges in a bit of (surrealist) humor that undercuts her academic pretensions. The first part of the joke, one that certainly is not lost on current job seekers, is that the doctorate would only have qualified her to become a cyclist. However, this was preferable to becoming a professor, Alberti assures us in the second part, because she would have become a useful member of society instead of a drone. In point of fact, we learn subsequently, Georgina would not have used her bicycle to compete in races but rather to deliver the mail. Unfortunately, the poet concludes, her career plans were sabotaged by the fact that, like all Jersey cows, she has no horns. And yet city ordinances required that her bicycle be equipped with a (single) horn for safety reasons.

Accompanied by crickets and at least one tick, who commiserate with him, the hapless lover continues his fruitless search. Dressed in an elegant tuxedo borrowed from any one of half a dozen films, Keaton keeps expecting to find Georgina at any moment. Unfortunately, his elegant appearance is marred by the fact that he is wearing a bowler hat, which adds to the incongruity of the situation. Together with the mailman's cap, it may allude to a scene in *Steamboat Bill, Jr.* (1928)—containing "one of Keaton's best comic routines" according to one authority—in which thirteen hats are placed on his head in rapid succession.[44] Worst of all, since Friendless has been caught in several downpours, his hat and clothes are soaking wet. So much water is dripping from the tuxedo, Alberti jokes, that

it appears to be crying (*llorar* = "to weep"). Ignoring his own increasingly desperate situation, Friendless utters a long, drawn-out cry:

> ¡Georginaaaaaaaaaaaaaaaaa!
> (Maaaaaa.)
> ¿Eres una dulce niña o eres una verdadera vaca?
> Mi corazón siempre me dijo que eras una verdadera vaca.
> Una dulce niña.
> Una verdadera vaca.
> Una niña.
> Una vaca.
> ¿Una niña o una vaca?
> O ¿una niña y una vaca?
> Yo nunca supe nada.
> > Adiós Georgina.
>
> > > (¡Pum!)

> [Georginaaaaaaaaaaaaaaaaa!
> (Moooooo.)
> Are you a sweet girl or are you actually a cow?
> My heart always told me you were actually a cow.
> A sweet girl.
> An actual cow.
> A girl.
> A cow.
> A girl or a cow?
> Or a girl and a cow?
> I never could decide.
> > Goodbye, Georgina.
>
> > > (Bang!)]

Returning to the question format adopted at the beginning, which never produces any answers, the final section leaves readers with quite a few questions of their own. At long last, when it seems that Friendless will never find Georgina, his cries elicit a response. While he addresses her directly in the final lines, it is not clear whether she is actually present or simply somewhere in the vicinity. Now that he has found her, he is faced with a second problem that threatens to undermine his happiness. Although the answer should be fairly obvious, he is unable to decide if Georgina is a cow or a girl. If he listened to his heart, he informs us, he would choose the first solution. And yet he confesses that, for reasons that remain inexpli-

cable, he has never been able to make up his mind. According to Pérez, Friendless is disconcerted by the ambiguity that informs the world around us, rendering efforts to discriminate between rival phenomena completely useless.[45] Geist observes that his quest for Georgina parallels Alberti's search for a new poetic language, on the one hand, and for transcendental meaning on the other. The indecision that racks Friendless at the end of the poem results from the discovery that "el lenguaje mismo parece subvertir la posibilidad de significación" (language itself appears to subvert the possibility of meaning).[46]

By accelerating the oscillation in Friendless's mind between the girl and the cow, the final scene performs his increasing confusion even as it depicts it. As Morris has pointed out, the conclusion was suggested by a corresponding scene in Go West.[47] "In this film the emotions of human and animal are so alike," Moews adds, "that it is no wonder poor Friendless remains confused and incapable of distinguishing between them or of deciding to which group he belongs."[48] Once Friendless reaches Arizona and begins working for a rancher, the latter's daughter alternates with Brown Eyes as his potential romantic partner. At the end, having rescued the rancher from financial ruin, he earns his eternal gratitude. "My home and anything I have is yours for the asking," the rancher proclaims. "I want her," Friendless replies, pointing not to the girl, as everyone supposes at first, but to the cow placidly chewing her cud. As the film ends, all four of them drive off into the sunset together with Friendless and Brown Eyes sitting side by side in the rumble seat. Inspired by the huge success of The Gold Rush, Jim Kline concludes, Go West is "one of [Keaton's] most slyly satirical films."[49] Like Keaton, Alberti parodies the sentimental endings of which Chaplin was so fond by having his protagonist fall in love with a cow.

At one level, the confusion that invades the poem reflects the dilemma Friendless faces in the film: whether to choose the rancher's daughter or one of his cattle. At another level, as we have seen, the confusion stems from the fundamental indeterminacy that undermines the text at this point. As much as anything, Friendless is confronted with a problem of identity. In both cases, he finally succeeds in dominating the confusion that threatens to destroy him by taking a decisive action. Whereas he chooses the cow over the girl in Go West, he appears to reject her in the poem. No sooner has he located Georgina, for whom he has been searching high and low, than he tells her goodbye. The only way he can dispel the confusion that be-

sets him, be it perceptual, ontological, or semiotic, is to turn his back on it. Unable to resolve this confusion and unwilling to live with it, he decides to eliminate its immediate source. Unable and unwilling to provide true poetic closure, Alberti adopts a similar solution: he ends the poem with a shot. While Pérez assumes that Friendless commits suicide, perhaps with one of the pistols that appear in *Go West*, he could also solve his problem by shooting Georgina. However, both interpretations ignore the fact that the script calls for the poet to perform this final sound effect, as he has performed all the others. According to all indications, Alberti drew a pistol at this point during his reading, as he did on at least one other occasion, and suddenly fired into the air.[50] Whether performed or simply evoked, the unexpected action effectively brings the poem to an end.

7

The Canary Islands

DESPITE THEIR GEOGRAPHICAL ISOLATION, THE CANARY ISLANDS WERE unusually hospitable to the surrealist movement and produced a group of poets and painters who followed French developments closely. In Eduardo Westerdahl, Agustin Espinosa, Pedro García Cabrera, Domingo López Torres, and Domingo Pérez Minik, Morris declares, Spanish surrealism found "its most enthusiastic and enlightened champions."[1] Headquartered in Santa Cruz de Tenerife, the Canary Islanders authored numerous publications, organized several art exhibitions, and published their own journal. Appearing from February 1932 to June 1936, the *Gaceta de Arte* was, in Morris's estimation, "the Spanish literary magazine most sympathetic to Surrealism and most dedicated to publicizing its works and doctrines." In manifesto after manifesto, the group publicized surrealist principles and denounced bourgeois society. Among the modern ills stemming from bourgeois repression and regimentation, they announced in December 1933, were syphilis, neurosis, tuberculosis, nervous diseases, insanity, suicide, prostitution, and war.[2] Impressed by their commitment to surrealist goals, André Breton, his wife Jacqueline, and Benjamin Péret paid a visit to the Canary Islands in May 1935. During their lengthy stay, which coincided with an important exhibition of surrealist art, Breton delivered several lectures, granted interviews, and collaborated in various ways with his surrealist hosts.

DOMINGO LÓPEZ TORRES

One of the most important contributors to the *Gaceta de Arte* was Domingo López Torres who, as Morris declares, possessed "an intimate and sensitive awareness of the Surrealists' aims and achievements."[3] In article after article he summarized their debt to Freud,

153

reviewed their literary accomplishments, and defended their artistic creations. In October 1932, he explained that surrealism strove to effect both a psychic and a social revolution in order to restructure everyday existence.[4] On the one hand, he remarked, "el surrealismo rompe violentamente con todo lo que se opone a la natural expansión del subconsciente" (surrealism is violently opposed to everything that impedes the natural expansion of the subconscious). On the other hand, it sought to abolish class distinctions and to create a new society in which everyone would live together in harmony. An accomplished poet as well as a critic, López Torres published a poem in the *Gaceta de Arte* in December devoted to Picasso, about whom he had written an article four months earlier. Accompanied by a terra cotta head of the painter by Pablo Gargallo, it was simply entitled "Picasso."

> Buscándote,
> buscandote desesperadamente.
> Adivinánote
> en la imperfecta geometría
> de pizarras gastadas,
> te encontré,
> no en la mañana azul,
> ni rosa;
> sino, limitado y perfecto
> (sin la gorra de viaje sobre el marco,
> sin color,
> sin patrón de guitarras,
> sin nombres,
> sin aspecto de Napoleon caldo
> llevando de las bridas el caballo),
> en el exacto acercamiento
> del asfalto y las cosas distantes.
> Todo lo lejos, cerca,
> desde entonces.
>
> [Searching for you,
> searching desperately for you.
> Divining your presence
> in the imperfect geometry
> of worn-out blackboards,
> I encountered you,
> neither in the blue,
> nor in the pink morning;

but, confined and perfect
(without a traveling cap on the frame,
without color,
without a master of guitars,
without names,
without the appearance of a defeated Napoleon
leading his horse by the reins),
in the precise joining
of asphalt and distant things.
Everything afar, near,
since that moment.]

Divided into two unequal halves, which are numbered accordingly, the poem recounts the poet's search for Picasso's most significant achievements, his encounter with the artist's cubist paintings, and his discovery that cubism has been superseded. Dismissing Picasso's blue and rose periods, which coincided with the dawn ("mañana") of his professional career, López Torres was delighted to discover that his mature works embodied a radically different aesthetic. Despite the imperfect geometry of various paintings, cubism proved to be the perfect vehicle for the painter's genius. In contrast to the false realism of Picasso's earlier style, with its insistence on physical exactness, the cubist works relied heavily on the power of suggestion, leaving it up to the viewer to complete the partial outlines and rudimentary forms mentally. Ironically, the poet implies, imperfection turned out to be an asset rather than a liability, enabling the artist to attain a new degree of perfection. The reference to worn-out blackboards recalls a statement in his previous article which, like several other remarks, allows us to elucidate the poem in more detail.[5] Picasso's paintings resembled "una pizarra llena de figuras geométricas," he declared, "donde la falta de limpieza superpone nuevos cuerpos a viejas formas borrosas" (a blackboard filled with geometric figures, some of which have been only partially erased, so that new designs are superimposed on earlier, blurry forms).

The references to Picasso's art in the first stanza seem to be primarily stylistic. Nevertheless, while the poet evokes the principal characteristics of the cubist paintings, he also lists a number of traits that are absent. Opening a lengthy parenthesis at one point, he introduces five parallel statements that describe what is missing in Picasso's works: caps, color, guitars, names, and a Napoleonic

appearance. In retrospect, the first and the last propositions appear to refer to Picasso himself. By the end of the poem, moreover, it becomes apparent that López Torres is evoking the artist's initial experiments with cubism. The portrait that gradually emerges is of the young Picasso fired by his recent discoveries rather than the postwar bon vivant, who often sported "una gorra de viaje" and who resembled a dissipated Napoleon. By contrast, the three central propositions refer to the earliest paintings, which witnessed the development of Picasso's analytic style. Rather than *Les Demoiselles d'Avignon* (1907), often considered to be the first cubist painting, the poet cited five other works in his article: *Les Pains sur la table* (1908), *Isabeau* (1908), *Portrait de Braques* (1909), *La Mandoliniste* (1910), and *Guitariste* (1910). As he notes in the poem, guitars and the names of newspapers and alcoholic beverages did not appear in Picasso's paintings until later, when he began to experiment with synthetic cubism. In addition, he restricted his palette to earth tones, leading critics to complain that his works lacked color. "Se buscaba no el color visto," the poet explained earlier, "sino el color pensado" (What mattered was imaginary color rather than physical color).

Picasso's most important contribution, the poet confides, following his parenthetical outburst, was to abolish the difference between far and near. By eliminating three-dimensional perspective and superimposing the objects in his paintings, he abolished the distance between them. By collapsing the distinction between background and foreground, he abandoned the hierarchical assumptions underlying realistic art and conferred a new immediacy upon the objects in question. The following lines echo this observation and remind us that cubism dispensed with form and color as well as depth.

> Tú, Picasso, tan lejos,
> tan cerca,
> que ya te están asesinando
> todos.
> Yo mismo
> Desde entonces
> perdidos por la forma y los colores.
> Todos.
> De boca en boca
> el popular secreto
> de las nuevas ventanas

[You, Picasso, so far
so near,
that everyone is murdering
you.
I as well.
Form and color lost
since that moment.
Everyone.
From mouth to mouth
the popular secret
of the new windows
opened to navigation].

The statement that Picasso has become the target of a band of murderers is frankly surprising. That López Torres includes himself among those who seek to kill the painter is even more astonishing, since it is clear that he admires the latter's art. On the one hand, he may be referring to hostile critics who, especially in the beginning, insisted that cubism was a hoax. On the other hand, he may be alluding to Picasso's imitators, whose technical versatility failed to compensate for their lack of inspiration. In either case, the poet would seem to be confessing his own shortcomings. Incorporating a striking oxymoron, the last four lines evoke cubism's eventual triumph as it evolved from an arcane practice to the dominant aesthetic of the period. As cubism gained in popularity, attracting numerous converts among artists and critics, it became in effect a "popular secreto." The first section concludes with an equally striking mixed metaphor conceived in the surrealist mode: the image of an open window is superimposed on that of the Panama (or Suez) canal. Whereas Breton wanted to know what a window looked out upon (see chapter 4), López Torres wanted to know where it led. The image itself anticipates René Magritte's *Time Transfixed* (1938), which depicts a locomotive emerging from an open fireplace. In a similar vein, the poet portrays cubism as a ship sailing through an open window in search of new worlds to conquer.

The second section traces Picasso's evolution—and that of his fellow cubists—through 1918 and concludes with a violent diatribe. For our purposes, the two central stanzas are the most interesting.

Braque, Marcoussis, Gris,
levantando técnicamente planos
de las nuevas ciudades de Picasso.

Picasso, por la playa
del mar universal de la pintura,
toreando a los nuevos arquitectos.

[Braque, Marcoussis, Gris
erecting technical planes
of Picasso's new cities.

Picasso, on the shore
of painting's universal sea,
bullfighting with new architects.]

By the end of World War I, López Torres explained in his earlier article, Picasso had momentarily exhausted the possibilities of cubism and had begun to look elsewhere for inspiration. Following a period that witnessed the creation of his best works, "en 1918, con *Arlequin* se despide para las nuevas playas" (with the appearance of *Harlequin* in 1918, he set sail for new shores). As art historians have pointed out, this work marked a new stage in Picasso's development and in the evolution of cubist painting. Having experimented with neoclassicism the previous year, he combined realism and cubism in several monumental canvases depicting human figures, which had been conspicuously absent previously. While Georges Braque, Louis Marcoussis, Juan Gris, Jacques Lipchitz, and Albert Gleizes were content to explore cubism's basic premises, the poet added elsewhere, Picasso "navegaba por otras aguas, camino de otras playas" (was sailing other seas, the path to other shores). In his eyes, the artist was engaged in a voyage of exploration as great as any ever attempted by Columbus.

Since Picasso's voyage has ended by the time the poem resumes, since he has discovered what he was looking for, López Torres drops his obsessive sailing metaphor but retains the image of the explorer standing on a foreign shore. The cubists are no longer portrayed as sailors accordingly but as architects engaged in building a brave new world. Despite their technical expertise, however, Picasso's colleagues lack the necessary vision to conceive and execute the kind of plans the project requires. Depicted as competent workers, they simply carry out his instructions. The supreme architect remains Picasso, who pores over the blueprints for the new cities he has imagined and supervises their construction. That he is the principal innovator and the leader of the cubists is evident from the second stanza as well, where he appears in the guise of a matador. Since

bullfighting plays a prominent role in Picasso's pictures (and in the Spanish psyche), this metaphor is not as arbitrary as it may seem. Over the years, quite a few Spanish poets have chosen to portray Picasso as a torero, including Vicente Aleixandre and Rafael Alberti.[6] As if the sudden change in identity were not surprising enough, the image that results is doubly (and deliberately) incongruous. This is no ordinary bullfight but one in which Picasso is pitted against multiple adversaries—who turn out to be human beings rather than animals. Dressed in a suit of lights, the artist sidesteps adroitly as Braque, Marcoussis, and Gris rush toward him with murder in their eyes. Pivoting skillfully as they pass by, he redirects their energy in such a way that they do his bidding, never losing control. Thanks to Picasso's vision and leadership, the poet cries in the final stanza, realism has been consigned to the dusty attic of academic art.

EMETERIO GUTIÉRREZ ALBELO

In 1933, Emeterio Gutiérrez Albelo published a poem in the *Gaceta de Arte* in which he paid tribute to the comic genius of Charlie Chaplin. Dedicated to Luis Ortiz Rosales, it appeared the same year in a collection of the author's poetry entitled *Romanticismo y cuenta nueva* (*Romanticism and New Account*). One of the few poems devoted to specific individuals, "Zumo de Charlot" ("Charlie's Juice") consists of a series of surrealist adventures. Whereas Philippe Soupault's texts were each inspired by a particular film, to which they inevitably alluded (see chapter 2), Gutiérrez Albelo focused on Chaplin himself—on the collective persona that emerged over the years from his entire oeuvre.

> charlot paseando
> —vacilante—
> sobre una rua empedrada de chisteras,
> y de guerreros cascos
> con los zapatos llenos de agujeros, llenos de *dóllares*, llenos de clavos.
> trepando
> hasta el grifo helado
> de una botella de agua de *seltz*,
> que vomita luceros triturados,
> desabridos,
> recién quemados.
> pero él cae, embriagado.

de mil cosas.
—*cock-tail* cósmico, trágico—
sobre cristales de champaña,
en un lecho burlado
charlot, pescando,
con su bastón elástico
a la orilla de un río de hojalata,
una sirena . . . de auto,
asesino de soñadores y de gatos.
¡charlot, charlot, charlot!, charlot, clavado
—faro triste—
en el eje de un mundo de sombra y de fracaso.

[charlie, strolling
—unsteadily—
on a street paved with bowler hats
and with soldiers' helmets
with his shoes full of holes, full of dollars, full of nails.
climbing
to the icy spigot
of a bottle of seltzer water,
which vomits ground-up,
bitter,
recently burnt stars.
but he falls, intoxicated.
with a thousand things.
—a tragic, cosmic cocktail—
on champagne goblets,
In a poor excuse for a bed
charlie, fishing,
with his flexible cane
on the bank of a river of tin,
for a siren . . . in an automobile,
the murderer of dreamers and cats.
charlie, charlie, charlie! charlie, nailed
—sad beacon—
to the axis of a world of darkness and failure.]

The portrait of the little tramp that emerges in the course of the poem is not only entertaining but deliberately amusing. Despite the distortions introduced by various surrealist procedures, his antics have a familiar ring to them. Divided into three apparently unrelated scenes, the poem attempts to express the essence ("zumo") of Chaplin's character. Each scene depicts Chaplin engaged in a pre-

posterous activity, oblivious to the absurdity of his situation and un-deterred by the prospect of almost certain failure. Like Alice in Wonderland, he escapes unscathed from one bizarre experience after another, protected by his inherent optimism and his naïveté. His first adventure befalls him as he prepares to walk down a city street. Rounding the corner, he discovers it is paved not with paving stones but with bowler hats and military helmets, which makes it al-most impossible to advance. Whereas the helmets offer a hard sur-face to walk on, it is difficult to maintain his balance. And as soon as he steps on a hat, he smashes it flat as a pancake. Like the bowler hats, Chaplin's dilapidated shoes were part of his habitual costume and thus a familiar motif. While he normally stuffed the holes with newspaper, in keeping with his impoverished condition, he stuffs them with dollar bills in the poem—which poses an interesting ques-tion. If he has money, why doesn't he use it to buy a pair of new shoes? More importantly, why doesn't he take the nails out of his shoes, which must be painful to walk on and which impede his prog-ress even more?

These and similar questions are never answered. We never learn how (or why) the street was created nor what Chaplin seeks to ac-complish. Conceived as a *récit de rêve*, the scene—like those that fol-low—catapults the reader into the world of dreams, where questions of logic and motivation are irrelevant. Like numerous surrealist poems, moreover, "Zumo de Charlot" is loaded with semantic ambi-guity. In the absence of a stable, delimited context, many words are free to assume multiple identities. Rather than holes, for example, Chaplin's shoes may be full of pincushions (another meaning of "agujeros"), which are certainly no more implausible than dollars and nails. Instead of bowler hats, the marvelous street may be paved with fishing creels, onion skins, barrels, hooves, skulls, or even brains. There simply is no way to be sure. Aware that variant readings are possible, readers can only choose the most likely interpretation and hope for the best. Like a soldier picking his way through a mine-field without a map, they proceed cautiously, alert for indications that will permit them to navigate the maze successfully.

The next adventure is as unexpected as the first. All of a sudden we glimpse Chaplin climbing a gigantic seltzer bottle, drawn to its icy summit like a mountain climber scaling a snowy peak. This com-parison is not as fanciful as it may seem, for the bottle turns out to resemble a snow-capped volcano in the succeeding lines. As if the ascent were not dangerous enough, Chaplin finds himself enve-

loped in a shower of blazing sparks issuing from the bottle's spout. Intoxicated by the beauty of the scene, which the author compares to a cosmic cocktail, he suddenly loses his grip and, unable to find another hold, plummets to his death. Once again the reader is left with a number of puzzling questions that are impossible to answer. Why have normal proportions been reversed, one wonders, so that Chaplin is dwarfed by a humble seltzer bottle that towers over him like Mount Everest? Has he decreased in size, like Alice in Wonderland, or has the bottle gotten bigger? Perhaps they have simply traded places, leaving the rest of the world unaffected. And what kind of seltzer bottle emits a stream of sparks instead of carbonated water? For that matter, since it cannot function by itself, who is operating the seltzer bottle? Whoever he is, he seems to be immense and to have a wicked sense of humor. Little by little the suspicion grows on the reader that the scene is a cosmic joke imagined by God.

Before we have time to lament Chaplin's tragic fate, he appears in a third scene. Somehow he has managed to survive the terrible fall and is back to his old tricks again. Reclining on a collection of champagne glasses, which could conceivably be filled with champagne, he is engaged in a popular outdoor sport: fishing. Whether the glasses are resting on a bed of some sort or whether they constitute Chaplin's bed themselves is difficult to say. In any case, any resemblance between the comic actor and a serious fisherman is purely coincidental. For one thing, he is using the wrong kind of pole to fish with. Instead of a bamboo cane, Chaplin insists on using his walking cane—as familiar to moviegoers as his bowler hat—which has suddenly become flexible. One wonders how he accomplished this miraculous transformation and whether he can reverse the procedure when he has tired of fishing. For another thing, the river in which Chaplin is fishing is unlike anything we have ever seen before, since it is filled with molten metal rather than with water. Or perhaps the metal has solidified, imprisoning his hook, line, and sinker or forcing it to remain on the surface. In either instance, the scene defies the reader's imagination. As if that were not enough, the poet encourages us initially to believe that Chaplin is fishing for a fabulous creature: a mermaid. However, the "sirena" in question turns out to be associated not with mythology but with the modern automobile, the enemy of unwary pedestrians and of cats and dogs roaming the streets. Although the term could conceivably designate some kind of warning device, it almost certainly alludes to the modern

flapper, who is portrayed as a femme fatale precisely because she is such a reckless driver.

Despite Chaplin's humorous antics, the poet concludes, he is essentially a tragic figure. The perpetual underdog who is continually rejected by society, he manages to survive by his wits and an occasional lucky break. Adrift in an absurd world that subjects him to one humiliation after another—or rather marooned on its shore like a weary castaway—he symbolizes the human condition. At the same time, he serves as a beacon shining in the wilderness, albeit a sad one, whose faint light strives in vain to dispel the dark shadows. The final image, which confirms this impression, brilliantly dramatizes his predicament. For if the reckless flapper is an avatar of the mythological sirens, who lured sailors to their doom, Chaplin is the modern equivalent of Jesus Christ. Nailed to a cross by his enemies, surrounded by the forces of darkness, he bravely endures the role that has been thrust upon him—which is primarily to suffer.

José María de la Rosa

The year 1933 witnessed the disappearance of *Le Surréalisme au Service de la Révolution* in Paris, which ceased publication following the May issue, and the creation of a new journal entitled *Minotaure*. Published in a deluxe format by Albert Skira, the first number sported a magnificent cover by Picasso, who had begun to experiment with surrealism and whose presence dominated the entire issue. In addition to the cover, which had been specially commissioned, it included a lengthy article on the artist by André Breton accompanied by a large number of illustrations. Amid abundant proof of Picasso's creative genius, whose originality and power were undeniable, a group of drawings entitled "Une Anatomie" caught the attention of at least one viewer in Tenerife.[7] Astonished by the manner in which Picasso combined arbitrary shapes to form a series of predominately female figures, José María de la Rosa recorded his impressions in a poem that bore the title "Ante la 'Anatomía'de Picasso."[8]

> El huevo fecundado en la curva de una matriz estética
> es como loco grito en la distancia gris o
> cisne que dormido, extravió sus huesos;
> y la sonrisa de la graciosa fuente,

con sus desperezados brazos, con ojos en el tórax,
vientre o rostro,
con los desnudos pies sin dedos ni uñas,
guardando el equilibrio en la goma de una sombra a rayas,
es como río escondido en sus proprias orillas,
de dientes regulares y estratégicos.

[The fertilized egg in the curve of an aesthetic womb
is like an insane cry in the grey distance or
a sleeping swan that misplaced its bones;
and the smile of the graceful fountain,
with its arms outstretched, with eyes in its thorax,
belly, or face,
with its bare feet without toes or toenails,
maintaining its balance in the glue of a striped awning,
is like a river concealed between its own banks,
of uniform and strategic teeth.]

Depicting thirty figures arranged in groups of three, Picasso's
anatomy lesson was conducted with ingenuity, grace, and more than
a little humor. Reducing the human figure to its basic elements, he
experimented with a variety of geometrical forms which he com-
bined in every conceivable way (figure 12). Although some of the
drawings were eventually transformed into plaster sculptures, most
of the figures look as if they could have been constructed by a clever
carpenter. "Some are rigid and elegant," Roland Penrose remarks,
"some soft and bloated, some tenuous and fragile, some massive
and tough."[9] Contemplating the astonishing creatures portrayed in
the drawings, Rosa catalogues their most important features in the
course of the poem. The first stanza focuses on two forms that are
illustrated by figure 12. As he declares, the second creature's U-
shaped torso has a distinctly uterine configuration. The fact that it
is punctuated by a belly button, which resembles a fertilized egg,
allows him to develop the metaphor further. Positioned at the very
beginning, the image of the egg in the womb serves as a convenient
emblem of Picasso's creative imagination. In addition, it introduces
two similes whose relation to the initial image—and to each
other—is problematic. One wonders what the fertilized egg, the in-
sane cry, and the sleeping swan could possibly have in common.
Gradually the realization dawns on the reader that they are linked
together by the intense surprise associated with each of these events.
Like the misty landscape, which is disturbed by a hideous cry, the

Figure 12. Pablo Picasso, portion of "An Anatomy," 1933. Pencil drawings, dimensions and whereabouts unknown. From *Minotaure*, No. 1 (February 15, 1933).

womb is surprised by the arrival of a fertilized egg, which suddenly implants itself. Awakening from a deep sleep, the swan is astonished to discover that it has no bones.

By contrast, the poet continues, some of Picasso's creations look like wooden fountains. This is especially true of the fifth creature, whose outstretched arms possess the graceful curves evoked in the poem. While the portraits can generally be said to be cheerful, however, none of the figures is actually smiling. Not only do they have no toes or toenails, consistent with the verbal description, but they have no feet whatsoever. And although some of them appear to have eyes in their chest, like the fourth creature, a careful examination reveals that these are actually breasts. Varying in number from one figure to the next, the eyes themselves are consistently located on the face. The reference to a striped awning is puzzling until one realizes that each leg casts a shadow (another meaning of "sombra") represented by four or five lines. Seemingly glued to the latter, Picasso's creations maintain their precarious balance with difficulty. Conceivably inspired by the third creature which, like many of her surrealist sisters, is endowed with a *vagina dentata*, the final simile is circular in nature. Rosa compares the fountain's facial expression to a river whose parallel banks resemble two rows of teeth parted to reveal a smile.

The following stanzas continue the inventory of anatomical features that are discernible in Picasso's drawings.

> Ved la serenidad del pene joven, correctamente torcido
> y estudioso, al que ofrece alimento una esposa sin falda,
> con importancia de retórico medievo o escarabajo, que se
> contonea
> —dignamente—, con su velocidad de ancas en pico.
> Su cuello conserva unas lamentables huellas de chimenea
> sin teja o ladrillo difunto
> y al fondo todo un paisaje en la pantalla de cines paralíticos.
>
> O aquel jazz-band frenético, que servidos sus senos
> en un plato, trata de devorarlos febrilmente, de reojo,
> acechando una seta con cuernos,
> que desfallece con distinción de rumba o borrachera.
>
> Los muslos tiernos, partidos por la justa rodilla,
> como raíz de muela agonizante, sostiene un ombligo
> que de mirar con amarilla pena,

conmueve al triste clavo, zambo, tristísimo
con el cuello suelto.

[Admire the serenity of the young penis, correctly bent
and studious, offered nourishment by a skirtless wife,
with the gravity of a medieval rhetorician or a scarab,
who wiggles
—in a dignified manner—, with her velocity of angular hips.
Her neck retains a few pitiful traces of a chimney
without tile or defunct brick
and a whole landscape in the background on the screens of
 paralytic cinemas.

O that frenetic jazz band which, presented with her breasts
on a platter, tries feverishly to devour them, slyly
watching a mushroom with horns,
fainting with the distinction of a rumba or a drunken spree.

With tender thighs, separated by the just knee,
like the root of a dying molar, she supports a navel
to be regarded with yellow sorrow,
she shakes the pitiful nail, monkey, made more pitiful
by its loose neck.]

Completing the anatomical catalogue examined previously, in-
spired by Picasso's drawings, the next three stanzas refer repeatedly
to parts of the body. Complementing the initial portrait, allusions to
a penis, hips, breasts, thighs, a neck, a knee, and a navel emerge
from the surrealist quagmire. Since none of Picasso's creatures pos-
sesses any obvious masculine attributes, the presence of the first
item is surprising. In fact the poet was probably thinking of another
of Picasso's works, entitled *La Grande Statue*, which was depicted a
few pages earlier in a photograph by Brassaï. Constructed entirely of
plaster, it possessed a prominent phallus which, if not "estudioso"
was at least "correctamente torcido." From this and subsequent ref-
erences one gathers that one of the characters is a man, who for
some reason appears to be naked. The latter is juxtaposed in turn
with one of Picasso's women, also naked, who proves to be his wife.
Like any number of figures in *Une Anatomie*, she possesses triangular
hips, which she shakes provocatively, and a tubular neck that resem-
bles a chimney flue. Like the third creature in figure 12 (and like St.
Agatha, martyred in the third century), she carries her breasts on a
platter. Viewed from a different angle, her belly and breasts, like

those of the fifth creature, resemble a mushroom with horns. Since these are anatomical drawings, the nakedness of the woman and her partner is perhaps not surprising. And yet the reason they have removed their clothes, one finally realizes, is so they can make love. The first stanza describes their initial embrace, the second (in which the man is compared to a frenetic jazz band) their moment of greatest passion, and the third the period immediately following their lovemaking. Throbbing like an infected tooth, the man's organ reverts to its original, simian appearance. Drooping forlornly like a bent nail, it resembles that of *La Grande Statue*.

The poet interrupts his anatomical litany at this point to interject some of his private thoughts. Adopting an architectural setting, he examines the objects that surround him and engages in an extended reverie.

> Junto a este clásico capitel, que es manco,
> un casco de limón con alfileres
> como una carabela que vuelve a navegar entre coches
> y radios,
> con la firma mesana de rosas de polilla,
> sondeando el espacio con sus patas deformes,
> vigas, como borquillos tostados y chasqueantes
>
> Ante la silla,siglo XVIII, como ángel o
> enamorado tísico perdido, siento la tentación de acomodarme
> y guardar el paquete de recuerdos
> y subir y bajar en rueca deliciosa que mueve el lino
> de cabeza blanca,
> hospedarme en el feudal castillo a as de copas
> y dejar
> que la obscena mujer de juegos prohibidos
> acuda a la batalla de los sexos
> que ha promovido el águila o paleta de tréboles y anteojos,
> ante los dos amantes que son melocotones, champagne o
> cataratas,
> risa o tierra sin nombre.
>
>
> [Beside this classical, armless capital,
> a lemon peel with some pins
> like a caravel threading its way between cars
> and radios,
> with its signature sail of moth roses,
> probing the space with its deformed legs,
> beams, like crunchy, roasted donkeys.

> Standing before the 18th century chair, like an angel or
> a hopelessly consumptive lover, I feel tempted to sit down
> and to guard the package of memories
> and to move up and down like the white-headed flax
> on a delightful distaff,
> to lodge in the feudal castle with its ace of hearts
> and to let
> the obscene woman of forbidden games
> oversee the battle of the sexes
> instigated by the eagle or the palette of clubs and binoculars,
> before the two lovers who are peaches, champagne, or waterfalls,
> laughter or a nameless country.]

The site of the poet's musings seems to be an ancient castle, one of many that dot the Canary Islands, which still retains some of its furnishings. Masquerading as a description, the first two lines are strangely disquieting. Like the classical pillar, which is subjected to metaphorical mutilation, the lemon beside it has undergone a similar torture. Despite the ambiguity of the phrase "con alfileres," it appears to be pierced by dozens of hatpins. Since *casco* also refers to a ship's hull, the citrus pincushion generates the first of two surrealist similes. In homage to Christopher Columbus, who visited the Canary Islands on a number of his voyages to the New World, Rosa compares the lemon peel to a caravel. Firmly anchored in the fifteenth century, the imaginary vessel sails into Tenerife's harbor once again amid symbols of modernity such as radios and automobiles. As if this apparition were not miraculous enough, the ship seems to be alive. Feeling its way with its pedal extremities, it bridges the gap not only between the present and the past but between animate and inanimate categories. Like the mutilated capital, the caravel's legs (or conceivably its feet) bear a negative marker: they are deformed. The second simile, in which the vessel's legs are compared to toasted donkeys, is worthy of Salvador Dalí. Indeed, one suspects that it was inspired by the latter's paintings or by *Un Chien andalou* which, as we saw in chapter 5, are filled with dead donkeys.

Judging from the foregoing, the castle is probably the Castillo Paso Alto, built several centuries earlier to defend Tenerife's port. Looking around, the poet is filled with sexual thoughts at the sight of a spinning wheel and an antique chair. On the one hand, the sight of flax wound on a distaff induces a masturbatory fantasy. On the other hand, Rosa's yearning to inhabit a castle crowned by a heart betrays his desire to experience the pleasures of love. He is

tempted not only to gratify his own sexual impulses, he confides, but to encourage others to do so as well. Like many a feudal lord, who organized knightly competitions, he proposes to hold sexual contests whose participants will employ the arms of love. Whereas formerly the lord appointed his seneschal to supervise the activities, he intends to choose "la obscena mujer de juegos prohibidos"— perhaps the owner of a local brothel. Among other things, the phrase echoes the title of a book of poetry published by Luis Cernuda: *Los placeres prohibidos* (*Forbidden Pleasures*) (1931). Although the role of the eagle and the clubs is unclear, the poet will presumably use the binoculars to view the sexual jousting. Appropriately, the games will be witnessed by the two lovers encountered previously, who serve as a convenient emblem. A final cascade of metaphors evokes their amorous intoxication, their unconfined joy, and their utopian existence.

Rosa abandons this subject in the following stanza and returns to Picasso's drawings. Resuming his catalogue of body parts, which he evokes in no particular order, he creates a nightmarish portrait of skeletal remains that borders on the incoherent.

> De vértices redondos,
> con un cráneo suspenso
> la esbelta guillotina de rodillas infladas,
> como senos repletos de existencias,
> amenaza al esófago—zepelin naufragado—,
> entre la indiferencia o
> el acero—tornillo de redondo hachazo en el cerebro—,
> mientras las púas circulares como huesudos traseros
> dejan al aire blanco,
> la firmeza de una invisible pantorrilla
> escrutando las terrazas vírgenes, pobladas de triángulos,
> con sólo una vaina
> desconsuelo de alondras y naranjas; de dedos enguantados
> que se hunden en firmes y geográficas esferas.
>
> [From rounded vertices,
> with a skull hanging
> the slender guillotine with inflated knees,
> like wombs crammed with existences,
> menaces the esophagus—shipwrecked zeppelin—,
> with either indifference or
> steel—wood screw an axe planted in the brain—,

while the circular teeth like bony buttocks
are exposed to the white air,
the firmness of an invisible calf
scrutinizing the virgin terraces, inhabited by triangles,
with only a single sheath
sorrow of larks and oranges; of gloved fingers
that dissolve into firm, geographic spheres.]

With a little effort, one can eventually identify most of the references, which turn out to be generic rather than specific. Whereas the very beginning of the poem describes two lovers, the above lines constitute a (fragmentary) group portrait. As the text declares, for example, two of the creatures in figure 12 possess spherical "knees" (probably intended to represent buttocks) which, reviving an earlier metaphor, Rosa compares to pregnant wombs. The slender guillotine alludes to the torsos of the first and fifth creatures, consisting of two vertical boards that are roughly parallel. Since the object at the center—which the poet mistakenly identifies as the esophagus—is spherical, he compares it to a zeppelin. Since it is isolated from the rest of the body, he jokes that it resembles a zeppelin marooned in the middle of the ocean. Suspended beneath a sword of Damocles, beneath safety and danger, the esophagus vacillates between indifference and fear. "El acero" may refer to the guillotine's blade, to the screw mentioned in the text, or to the axe. As Rosa remarks, the first creature's head and neck resemble a giant wood screw, which threatens to pierce the sphere below. Similarly, many of the heads seem to have been trimmed by an axe or even to have an axe sticking in them. While triangular shapes and horizontal planes ("terrazas") abound, the circular teeth belong to the third creature, who possesses a *vagina dentata* rather than bony buttocks. The "vaina" or sheath can be found in the first and fifth women, where it represents a vagina as well. By contrast, the last two lines are resolutely hermetic. Although they tell us nothing about Picasso's drawings, they possess a strange beauty all of their own.

The final two stanzas return to the drawings and introduce the lovers once again:

Con el libro entornado entre los flacos miembros
la dama, abanicando una sospecha
se inicia en la dulzura de un vino de asterioides
que le ofrece el jinete
en la tarjeta de sus globos colgantes y gemelos . . .

Jardines, macetones, pecheras de camisa,
reverencias y culpas—maniquíes de nervios—,
Anatomía de Pecados Justos,
llegamos al final de un beso hueco
como nota de yerto celuloide.

[With the book half closed between her thin legs
the lady, fanning a suspicion
enjoys the sweetness of a wine of asteroids
that the gentleman offers her
on the card with her twin, hanging globes . . .

Gardens, flowerpots, shirtfronts,
reverences, and sins—mannequins of sinews—,
Anatomy of Righteous Sins,
we arrive at the end of an empty kiss
like a rigid note of celluloid.]

Their passion spent, the woman leafs through a book while the man prepares a postcoital aperitif. Closing the volume halfway when he offers her the drink, she leans forward and tastes the heavenly ("de asteroides") concoction. The book itself appears in the final group of Picasso's drawings (not shown), where one of the women depicted appears to clench it between her legs. Upon closer inspection, it turns out to be her vagina which, unlike the earlier "sheaths," has a triangular shape. Depicted in other drawings, the twin globes on the tray represent her breasts, which are normally bullet shaped. Although their nipples usually point upward, Picasso inverted the breasts in one instance to form wine bowls, a whimsical touch that Rosa carries a step further. On another occasion, the artist gave one of the woman a vagina that was conical instead of triangular (see figure 12). Extrapolating from the fact that it resembles a flowerpot, the poet imagines an elegant existence for his characters, who spend their time in beautiful gardens, at formal occasions, and in bed. Although they are guilty of sins of the flesh, these are righteous sins, he proclaims, because they were committed with joy and abandon. As the lovers exchange one last kiss, Rosa abruptly distances himself from them and reminds us of their factitious origins. They are not flesh and blood, after all, but mannequins created by Picasso and endowed with momentary life by himself. Since they are merely drawings, their kiss strikes a hollow note that resounds from one end of the collection to the other. Interestingly, the sound re-

verberates throughout the poem as well—from the "huevo fecundado" in the first line to the "huesos" of the surprised swan to the "beso hueco" with which the drama concludes.

PEDRO GARCÍA CABRERA

Although Picasso never joined the surrealist movement, he was adopted by the surrealists almost from the beginning and soon became an enthusiastic convert. His art "participe objectivement du surréalisme depuis 1926" (has participated objectively in Surrealism since 1926), Breton noted twelve years later, adding that he had written several surrealist poems as well.[10] Not surprisingly, Picasso was even more popular with the Spanish surrealists, who viewed him as their champion. One of the very last texts devoted to the painter was composed by Pedro García Cabrera who, like the other poets in this chapter, was associated with the *Gaceta de Arte* in Tenerife. Saddened by the artist's recent death, he published "Requiem por Picasso" in *El Día* on April 8, 1973.

Que se fundan los televisores
y enmudezcan los teletipos
cuando den la noticia
de que has llegado a la estación de término,
a la diana del plomo.

Que pedaleen los horizontes,
desfilen las mujeres con los pechos al aire,
batan sienes los mares
y suban ascensores a tus hombros
a ver si tus ex manos
levantan otra vez las alas
de insectos que se cumplen haciéndose el amor.

Pero ya no hay remedio
y han caído en picado
tus palomas de paz
contra la flecha de tu rostro inmóvil.

[Let the television sets melt
and the teletypes be struck dumb
when they break the news
that you have arrived at the last station,
at the target's bulls-eye.

Let the horizons pedal their bicycles,
the women march by with bare breasts,
the sea beat its head,
and elevators rise to your shoulders
to see if your ex-hands
are again pulling the wings off
insects expiring while they make love.

But there is no remedy
and your doves of peace
have shattered into pieces
against the spire of your motionless face.][11]

Although the term "requiem" implies that the composition is modeled on a church service, one discovers the title is purely metaphorical. Rather than a mass sung for the repose of Picasso's soul, the poem is a cry of anguish at the news of his death. More precisely, it is a surrealist elegy in which the poet laments Picasso's passing and praises his accomplishments. While García incorporates two motifs from the artist's paintings, his response is almost entirely metaphoric. Indeed, death itself is rendered by a double metaphor that conveys its inevitability. Since Picasso was 92, it was far from unexpected. Like a train speeding toward a distant city, or a bullet speeding toward a target, he has simply reached the destination that has been reserved for him from the beginning. Death is not something that has snatched him away, according to this spatio-temporal logic, but something he has gone to meet. To be sure, this does not mean that the news is welcome. As centuries ago, when the bearers of ill tidings were sometimes executed, the poet wishes a similar fate would strike their modern counterparts. And yet the destruction of the teletypes and television sets that he envisages is not intended as punishment so much as a sign of universal grief. As in more traditional elegies, the poet exhorts all of nature to join him in mourning Picasso's death.

This theme is made more explicit in the second stanza, which exploits another traditional convention. Addressing himself to the seas, the horizons, and to women all over the world, García calls on them to join the procession of mourners who have come to pay their last respects. Their grief is so intense that the anthropomorphic seas beat their temples with their fists, and the women rend their garments and bare their breasts. The second image was probably taken from *Guernica* (1937), Picasso's most famous painting, which depicts

a similar situation during the Spanish Civil War. Returning to Picasso himself, the poet chooses a concrete metaphor to convey the greatness of his achievement: he transforms the artist into a monumental statue. Unfortunately, this creates a problem that threatens to disrupt the realistic narrative. Wishing to view Picasso one last time, the mourners find that he has become such a gigantic figure that they can no longer see his face or his hands. Luckily, someone has installed a bank of elevators nearby, and the viewing proceeds without a hitch. Arriving at Picasso's shoulders, the mourners look involuntarily for a sign of life, for some trace of the marvelous spirit that animated the artist. Engaged in a similar quest, García searches for a metaphor that will produce the revelatory shudder that characterizes *le merveilleux*. Situating Picasso at the intersection of Eros and Thanatos, of sexuality and cruelty, he visualizes him pulling the wings off of mating (and therefore helpless) insects.

Most elegies conclude with an attempt to offer some kind of consolation, especially Christian elegies, which assure us that the deceased will be happier in heaven. By contrast, "Requiem por Picasso" ends on a note of resignation that was implicit in the initial train and bullet metaphors. There is no remedy against death, the poet insists, and the process is irreversible. Like the mating insects, who "find their completion" ("Se cumplen") in death, Picasso has succumbed to his natural fate. Whereas the logic of the second stanza suggests that the petrified artist is horizontal, as befits a cadaver, the final stanza implies that he is standing upright, as befits a statue. Indeed, the statue is so tall that, like the Empire State Building, it constitutes a navigation hazard. While airplanes have managed to avoid it so far, the artist's famous doves of peace—created toward the end of his career—have not been as lucky. At the symbolic level, the doves' demise may be a reference to the war in Vietnam, which had ignited widespread protests. At the realistic level, where they function as metonymic signs, their demise coincides with that of their creator. Although Picasso's art would continue to inspire generations of viewers, the artist himself was finished painting.

8
Argentina and Peru

DESPITE THE HISTORICAL TIES THAT HAVE BOUND LATIN AMERICA TO Spain, during the twentieth century the dominant cultural influence was exerted by France. Beginning with the great *modernista* poet Rubén Darío, generations of Latin American artists and writers looked to Paris for instruction and inspiration.[1] Astounded by the cultural vitality of the French capital, the birthplace of one aesthetic revolution after another, they sought not just to emulate certain poets and painters but to vie with them in devising new means to apprehend (and to express) modern reality. "La influencia más destacada en la nueva poesía," Aldo Pellegrini observed, "es la del surrealismo" (The most prominent influence on the new poetry is that of surrealism).[2] In particular, he continued, Latin American poets were attracted to the movement's attempt to effect revolutionary change—both in poetic language and in society at large. In countries such as Argentina, Colombia, Chile, Peru, Mexico, and Venezuela, which possess "[la] mayor densidad poética" (the greatest poetic density), they profited from surrealism's unprecedented freedom, dazzling imagery, and experimental orientation. The important role of magic in pre-Columbian cultures may also explain why Latin American writers embraced surrealism so enthusiastically.

ALDO PELLEGRINI

As the founder of the first surrealist group in Latin America, Pellegrini spoke with undeniable authority. Coming from a tireless promoter of surrealism in Argentina and a prominent surrealist poet, his words reflected many years of experience. That surrealism surfaced initially in the Argentine republic is perfectly understandable. Of all the Latin American nations, it was not only the most prosperous but enjoyed the closest relationship with France. Despite Argen-

176

tina's seemingly remote location, moreover, Buenos Aires was surprisingly sophisticated. In contrast to many European nations, Jorge Luis Borges reports, all educated Argentines knew French.[3] Pellegrini first encountered André Breton in *Littérature*, which ceased publication in June 1924, and then in the journal that succeeded it in December. "El primer numero de *La Révolution Surréaliste* que llego a mis manos a poco de su aparición," he later recalled, "me deslumbró" (The first issue of *La Révolution Surréaliste*, which came into my hands shortly after its publication, dazzled me).[4] Although he was studying to become a doctor, Pellegrini was strongly attracted to the movement. Together with some of his fellow medical students, he founded a surrealist group in 1926 which, among other things, published a review entitled *QUE*. Although the group dissolved four years later, he continued to organize and participate in surrealist activities during the next four decades. When Argentine surrealism experienced a renaissance during the 1950s, with the emergence of a new group centered around a journal called *A Partir de 0* (*Starting From 0*), Pellegrini was not only involved but was in large part responsible.

A man of many talents, who practiced medicine most of his life, Pellegrini became a prominent art critic as well as an accomplished poet. Despite his interest in the visual arts, few references to painting or sculpture occur in his poetry which, reflecting his own experience, tends to be concerned with universal human themes. Since his poems are so personal, so much the product of his own unique vision, they ignore the achievements of other artists and writers. Seemingly the single exception, "Estandarte de tormentas" ("Storm Warning") is dedicated to a fellow surrealist: Enrique Molina.[5]

> ¿Quién ha despertado tus monstruos y tus salvajes caballos en la
> lluvia?
> el cielo está lleno de ojos perdidos
> el agua de la vida gotea de los grifos
> pájaros de quietud picotean la tarde
> en esa calma ¿adónde van tus monstruos?
> los he visto caminar sobre los vientres desnudos con talones de
> plumas
> talones blandos y aéreos de mercurios incandescentes
> los he visto caminar con talones de acero sobre las palabras
> muertas
> y perderse en la niebla de las horas.

[Who has aroused your monsters and your wild horses in the rain?
the sky is filled with lost eyes
the water of life drips from the faucets
birds of stillness are pecking at the evening
where are your monsters going in that calm?
I have seen them treading on naked bellies with their feathery
 heels
the soft, aerial heels of mercury lamps
I have seen them treading with heels of steel on dead words
and losing themselves in the hours' mist.]

"Estandarte de tormentas" is divided into two equal stanzas, each of which contains nine lines, followed by a coda consisting of a single line. The first stanza focuses on the disturbing aspects of Molina's poetry, the second on its redeeming qualities, and the conclusion on the two poets themselves. To many readers Molina's poetic vision seems stark and desolate. As Enrique Anderson-Imbert remarks, he likes to hug his wounds.[6] And yet, the critic continues, "he is surprised to find that from the depths of the ruins, his own life being so sad, he can still admire the beauty of the world." Molina himself is convinced that poetry and suffering are inseparable. "Como el amor," he insists, "la poesía es la persecusión de un secreto imposible" (Like love, poetry is the pursuit/persecution of an impossible secret).[7] The poet is tormented by the secret he pursues both because it is impossible to attain and because it is impossible to face. His suffering will never be alleviated until he overcomes both these obstacles. Pellegrini's title alludes to this dilemma in two different fashions. On the one hand, since the distance between storm (*tormenta*) and persecution (*tormento*) is so minimal in Spanish, the former inevitably conjures up the latter. On the other, since the storm in the title is clearly metaphorical, it alludes to the torments of the poet's soul. Taken as a whole, however, the title refers not to Molina himself but to his poetry. Like a flag ("estandarte") signaling the approach of a violent storm, each poem bears the unmistakable signs of the poet's anguish. Each poem is written in a style that might best be described as surrealist *Sturm und Drang*.

If the title introduces a central metaphor, the first stanza is dominated by symbols of Molina's overpowering anguish: monsters and, to a lesser extent, wild horses. Where have they come from, Pellegrini asks, and where are they going? The answers to these questions are buried deep in Molina's unconscious, which is also the source of

the monsters he has failed to exorcise. In contrast to their violent behavior, which betrays their violent passions, the scene is draped in a preternatural stillness—like that enveloping a blank page. A vast calm embraces the evening sky as a gentle rain falls on the surrounding landscape. And yet this tranquil scene, like the sky itself, contains a number of disturbing images. If the sky were clear, one might reasonably conclude that the thousands of eyes looking down at us were stars. But since it is raining, it is impossible to transform them into harmless metaphors. The dripping faucets in the next line present the reader with another kind of problem. While they appear to have a metaphoric function, we do not know if they refer to the rain clouds or to the mysterious eyes filling the sky. Although "el agua de la vida" may evoke the life-giving properties of rain, it may also reflect the traditional image of life as a vale of tears. While the precious drops of water may revive the natural surroundings, at the same time they are lost forever. Like an accident victim slowly bleeding to death, life itself seems to be slipping away. This comparison is not as fanciful as it may appear at first glance. For the birds of stillness are not simply hunting for insects in the grass, it turns out, but are engaged in a much more ominous mission. Close examination reveals that they are pecking at the thousands of eyes overhead, which are shedding tears of blood.

As the bloody rain continues to fall, Pellegrini focuses on the monsters that inhabit Molina's torturous universe, which is divided into two domains. Since he has witnessed their depredations at first hand, his observations stem from personal experience. The first domain, which like the second is introduced by the phrase "los he visto caminar," is that of the erotic. "Todo texto de Molina," Margo Glantz proclaims, "convoca el erotismo instalado en un cuerpo desnudo" (Each of Molina's texts invokes the eroticism emanating from a naked body).[8] Struck by the same fact, Pellegrini constructs an earthly paradise that is literally paved with naked women from one end to the other. Since it is impossible to walk between the women, who form a pneumatic mattress, the monsters choose to walk over them. This potentially painful experience, whose sexual overtones are clear, is mitigated by the discovery that the monsters' feet are surprisingly light. Instead of sharp hooves, they are equipped with winged heels which enable them to hover in the air like mercury lamps overlooking a busy highway. The second domain that the monsters have managed to invade, the poet continues, is that of poetry. To the extent that a poem is conceived as a record of

past utterances, as identical to the written form in which it has been cast, it represents a collection of "palabras muertas." In contrast to the erotic monsters, who deliver feather caresses as they pass, those that traverse Molina's poetry trample it into the dust, obscuring the landscape for hours. Their heels are no longer soft and pliable but instead are encased in steel jackboots. Despite Molina's pervasive eroticism, the poet appears to be saying, his works are haunted by the continual prospect of violence.

The second stanza, which praises Molina's poetic voice, describes three parallel discoveries he has made during his voyage of aesthetic exploration.

> ¿Por qué amo tu voz fruto de tumultos, embriaguez de
> cocinas y templos,
> de muslos habitados por tortugas,
> de botellas suspendidas en las naves de la bocas?
> has descubierto el lente de las metamorfosis
> que da furor de nieve a las manos caídas
> y virtud de cántaro a la carne aletargada
> has descubierto el árbol que hace nacer los senos
> las noches que cabalgan
> has descubierto que la soledad es un canto.

> [Why do I love your voice the fruit of turmoil, the intoxication of
> kitchens and temples,
> of thighs inhabited by tortoises,
> of bottles hanging in the nave of the mouth?
> you have discovered the lens of metamorphosis
> that imparts the snow's fury to fallen hands
> and the pitcher's virtue to drowsy flesh
> you have discovered the tree that makes breasts grow
> the nights on horseback
> you have discovered that solitude is a song.]

Formulated as a rhetorical question, the first three lines evoke Molina's tumultuous world in passing but focus on his lyric voice and passionate vision, which Pellegrini finds intoxicating. As the emblematic kitchens and temples testify, this intoxication is sacred as well as profane, divine as well as domestic. In some respects, the poet continues, it resembles sexual bliss and alcoholic euphoria. On the one hand, the juxtaposition of thighs and tortoise (a traditional phallic symbol) clearly refers to sexual intercourse.[9] On the other,

the fact that the mouth contains a nave suggests that it is a church—in this case, dedicated to the consumption of wine. The first discovery that Molina has adroitly exploited in his poetry is that of metmorphosis. Unlike, say, a magnifying glass, which simply makes objects look bigger, Molina's magic lens enables him to turn snow into human hands and ordinary objects like a pitcher into human flesh. In a similar fashion, he has discovered how to tap the energy emanating from the Tree of Life, which causes girls to develop breasts and the earth to keep on turning. The nights may resemble horseback riders because they present an endless procession or because they span the distance between dusk and dawn. Last of all, Molina has discovered how to exploit the solitude that so oppresses him by making it the subject of his poetry. For that matter, he told an interviewer, "toda poesía es una expresión del sentimiento de soledad esencial del hombre" (all poetry is an expression of man's fundamental solitude).[10] Although we cannot escape this feeling of loneliness, we can partially alleviate it by expressing it in lyric form. "Un día," Pellegrini concludes, "nos encontramos en esos abismos de aire irrespirable" (One day we met in those suffocating abysses). One of the reasons Molina's poetry appeals to him is because he has experienced this solitude himself.

César Moro

Despite Pellegrini's example, the rest of the Argentine surrealists showed little interest in critical poetry. In order to study the genre's fortune in Latin America, we need to follow a trail leading to Peru, Chile, and Mexico, which proved to be more hospitable to interartistic experimentation. And yet surrealism had to struggle to establish itself in these countries as well. "Es difícil encontrar en Latinoamérica un ambiente más hostil y cerrado hacia el espíritu renovador de la vanguardia," Stefan Baciu writes, "que la ciudad de Lima en la década de los años de la formación del surrealismo: los 20 y los 30" (It is hard to find an atmosphere more hostile and more closed to the avant-garde's spirit of renewal in Latin America than the city of Lima during the 1920s and 1930s when Surrealism appeared on the scene).[11] The initial group, which was destined to revolutionize Peruvian poetry, was centered around two men: César Moro and Emilio Adolfo Westphalen. Although surrealism was very much a French invention, Breton and his colleagues welcomed collaborators from

every country imaginable, leading one critic to compare the movement to an international hotel.[12] Arriving in Paris in 1925, Moro discovered the surrealists before long, enthusiastically adopted their cause, and began to participate in their activities. Among other things, he collaborated on *Le Surréalisme au Service de la Révolution*, on a tract entitled *La Mobilisation contre la guerre n'est pas la paix* (*Mobilizing Against War Is Not Peace*), and on a collective homage to a young woman accused of having poisoned her parents.[13]

Returning to "Lima la horrible," as he titled one of his poems, after an eight year absence, Moro strove to transplant surrealism to his native soil. Together with Westphalen, he organized and participated in a number of surrealist activities, culminating in the creation of a journal in 1939 entitled *El Uso de la Palabra* (*The Use of the Word*). Proclaiming their belief in the ultimate liberation of mankind, the first (and only) issue included texts by Breton and Eluard. By this time, Moro had moved to Mexico, where he remained for the next ten years. Although he engaged in numerous surrealist activities there, he continued to promote the development of Surrealism in Peru. While most of Moro's poetry is written in French, during his stay in Mexico he composed a number of poems in Spanish, published posthumously in *La tortuga ecuestre* (*The Equestrian Tortoise*) (1957). Dated April 1938, one of the more interesting texts is entitled "André Breton."

> Como un piano de cola de caballo de cauda de estrellas
> Sobre el firmamento lúgubre
> Pesado de sangre coagulada
> Arremolinando nubes arco-iris falanges y planetas y miriadas de
> aves
> El fuego indeleble avanza
> Los cipreses arden los tigres las panteras y los animales nobles se
> tornan incandescentes
>
> El cuidado del alba ha sido abandonado
> Y la noche se cierne sobre la tierra devastada
>
> La comarca de tesoros guarda para siempre su nombre
>
> [Like a horsetail piano trailing stars
> In the gloomy firmament
> Heavy with coagulated blood
> Whirling clouds rainbows phalanxes and planets and myriad birds
> The indelible fire advances

The cypresses flame the tigers the panthers and the noble animals
 glow incandescent

The dawn's caution has been abandoned
And night hovers above the devastated earth

The treasure vault guards his name forever]

Whether Moro had any idea before he left Lima that Breton was
planning to visit Mexico is impossible to say. He was delighted to see
the surrealist leader, in any case, whom he hastened to welcome
when he arrived in April 1938. During the next three and a half
months, the two men saw each other frequently and collaborated on
several projects, including an exhibition of surrealist art. On May 1,
the journal *Letras de México* published a number of texts by Breton,
reproductions of surrealist paintings, and a collection of surrealist
poems. The latter included "André Breton," which Moro seems to
have written specifically for this occasion. An anthology of Surrealist
poetry in translation appeared in *Poesía* the same month, for which
he was also responsible. "El Surrealismo," Moro proclaimed with his
characteristic enthusiasm, "es el cordón que une la bomba de di-
namita con el fuego para hacer volar la montaña" (Surrealism is the
fuse that connects the flame with the dynamite in order to blow up
the mountain).[14] Among other things, this statement allows us to re-
solve a persistent dilemma in "André Breton" that threatens not to
undermine Moro's portrayal of the poet so much as to distort it.

The first stanza, which has a distinctly apocalyptic tone, appears
to describe the end of the world. Recalling the fate of Sodom and
Gomorrah, a shower of fire and brimstone rains down on the inhabi-
tants in preparation for the Last Judgment. As the fire advances,
consuming everything in its path, all trace of life disappears from
the face of the earth. Since nothing suggests that this is a religious
poem, one is tempted to give these events a political interpretation.
By 1938 much, if not all, of Europe was under siege by the Fascists,
who were preparing to conquer the world. Viewed in this light, the
coagulated blood could conceivably refer to the Spanish Civil War,
which was far from over, and the gloomy firmament to the approach
of World War II, which was looming on the horizon. Like Moro,
Breton never lost an opportunity to protest the Fascist intervention
in Spain or to denounce the Fascist build-up that was threatening
the rest of Europe. And yet, as the quote from *Poesía* suggests, the
conflagration in "André Breton" is to be welcomed rather than

feared. Like the explosion caused by the surrealists' dynamite, it represents a form of deliverance rather than a catastrophe. As such, it evokes surrealism's attempt to destroy previous modes of cognition, to effect a tabula rasa, in order to refashion the world in its own image. In choosing to portray surrealism as an indelible fire, Moro may have been thinking of a similar poem by Breton himself, entitled "Sur la route qui monte et descend" ("On The Road That Rises and Descends"), in which surrealist inspiration is depicted as an all-devouring flame.[15] Since Breton viewed fire as an alchemical operation, it is generally an image of purification and renewal in his poetry. "Moralement," he remarked ten years later, "où le feu n'est plus, rien n'est plus" (Morally, where there is no longer any fire, there is nothing).[16]

Ultimately, of course, the indelible blaze leads to Breton himself who, as surrealism's acknowledged leader, is responsible for its relentless advancement. Since the portrait that gradually emerges is implicit, we need to comb the rest of the poem for clues. The first line, which is virtually impossible to translate, exemplifies one of the surrealists' favorite games: "l'un dans l'autre" (one in the other). Thus the piano is contained in the tail, which is contained in the horse, which is contained in the trail, which is contained in the stars. At the purely linguistic level, this astonishing sequence was generated by an amusing play on words. Since in Spanish a grand piano is literally a "piano with a tail" (un piano de cola), Moro decided to give it a horse's tail, which triggered other associations as well. As if this were not enough, he constructed an elaborate surrealist simile whose initial term consisted of the entire first line. As he progressed, he added a number of details to the initial portrait in order to emphasize its cosmic dimension: a gloomy sky, whirling clouds, and phalanxes of planets. Coupled with the starry trail that streaks across the sky, these details suggest that Breton is portrayed as a fiery meteor (or comet) who has set the world aflame. While this interpretation has much to recommend it, the poem may describe a terrestrial rather than a celestial phenomenon. In particular the editors of Breton's collected works, who are under the impression that Moro was Mexican, believe that Breton is depicted as "[un] volcan qui bouleverse et illumine" ([a] volcano that destroys and illuminates at the same time).[17] The second and third lines could conceivably describe a sky darkened by smoke and ash as red-hot lava flows down the slope, consuming everything in its path. In either case, the incandescent animals may have been inspired by Dalí's flaming gi-

raffes, introduced the previous year. Whatever happens in the future, Moro assures us, posterity will treasure Breton's accomplishments forever.

Like the preceding poem, "Westphalen" was written in 1938 and published in *La tortuga ecuestre*. Dated January 10, it was probably composed before Moro left for Mexico, leaving his friend and colleague in charge of the surrealist mission in Peru. Whereas Breton was depicted as a fiery emissary, as a meteor or a volcano, Moro portrayed Westphalen as an intrepid explorer hacking his way across a tropical wilderness.

Como un abrevadero de bestias indelebles
Partido por el rayo desbordando el agua
Refleja la migración de las aves de tierra
En la noche de tierra salobre

Un portón cerrado sobre un campo baldío
Refugio del amor clandestino
Una igualdad de piedra que se cierra bajo
La gota de agua que sube de la tierra
Sobre centenares de cabezas decapitadas
Una mujer desnuda como una lámpara

Hace brillar los ojos de los muertos
Como peces de caudas de fibrillas argentíferas
El oro y el hierro conocen su destino
De tierra podrida el pulular de la selva
Le acompala y vierte sobre los hombros
De los fantasmas familiares mantos arborescentes
Cascadas de sangre y miríadas de narices

[Like a drinking trough for indelible animals
Divided by the overflowing beam of light the water
Reflects the migration of the world's birds
In the brackish earthen night

A large door shut on a wasteland
Refuge of clandestine love
An equality of stone closing beneath
The drop of water emerging from the earth
Above hundreds of decapitated heads
A woman naked as a lightbulb

Causes the eyes of the dead to shine
Like fish trailing silvery fibrils

Gold and iron know his destiny
Anchored in the rotten earth the swarming jungle
Accompanies him and spills arborescent cloaks
Waterfalls of blood and myriads of noses
On the familiar phantoms' shoulders]

Like "André Breton," the poem begins with a simile that extends throughout the first stanza. Reaching a clearing in the jungle, where he pauses momentarily, Westphalen encounters a brackish pond at which various animals have come to drink. Judging from the previous poem, in which "indelible" acts as an intensifier, the pond attracts fierce animals like lions and tigers. The beam of light that traverses it is undoubtedly cast by the moon, which allows us to see the reflections of hundreds of migrating birds passing overhead. Suddenly the scene changes, and we glimpse Westphalen in another unexpected role: as the guest of a primitive tribe somewhere in the jungle. Somehow, despite the headhunters' unbelievable ferocity, he has managed to gain their acceptance. Indeed, the available evidence suggests that he is a frequent visitor. Gradually one perceives that the village serves as a refuge from the demands (and the prohibitions) of civilization. Whenever he tires of civilized society, the explorer returns to the village, where he is inevitably housed in the local temple. There he engages in the same unspeakable rites as his savage hosts, which appear to revolve about sex and death. That the naked priestess engages in frenzied lovemaking with Westphalen and the others seems fairly clear. Less clear is the relationship between her and the pile of skulls at her feet, whose absent eyes shine with insistent lust. Were these individuals killed in battle, one wonders, or sacrificed during religious ceremonies? Whatever the explanation, the skulls serve as macabre offerings to the priestess's equally macabre beauty.

For better or worse, the poem never really concludes but—like Westphalen himself—simply continues on its way. Refreshed by his stay in the village, by the chance to recharge his unconscious batteries, the explorer resumes his journey through the tangled jungle of the human psyche. Like the hero of Joseph Conrad's famous novel, who pursues a similar itinerary through the jungle, he is engaged in a voyage into the heart of darkness. Conceived as the repository of unconscious impulses, the jungle opens to embrace him as he passes. Accompanied by images of mutilation and bloodshed, escorted by the ghosts of former warriors, Westphalen pursues the sur-

realist adventure to the very end. In contrast to the rotten soil from which the jungle springs—whose fetid odor bourgeois society strives to repress—he is associated with two essential minerals: gold and iron. That these minerals preside over his destiny ensures that his voyage of exploration will be successful. Thanks to his iron determination, he will eventually find what he is seeking, which will turn out to be extremely valuable.

Emilio Adolfo Westphalen

To Westphalen himself goes the honor of having published the first collection of surrealist poetry in Peru: *Insulas extrañas* (*Strange Islands*), which appeared in 1933. In general, Anderson-Imbert declares, the poet seems to give us "only those splinters that were broken off his poems in the process of writing them."[18] The fragmentation is so extensive in *Insulas extrañas,* he continues, that the splinters are reduced to specks of dust "blown about by a dark wind of emotion." By this date, Westphalen recalled many years later, he had read *Nadja* in English translation and the Second Manifesto in the original French.[19] When Moro returned from Europe the following year, he brought several volumes of Breton's poetry with him which had a considerable impact on his future colleague. Although *Abolición de la muerte* (*Abolition of Death*) (1935) was basically completed, Westphalen made a few changes at Moro's suggestion, incorporated a frontispiece by Moro (who was also an artist), and added an epigraph by Breton: "Flamme d'eau guide-moi jusqu'à la mer de feu" (Flame of water guide me to the sea of fire).[20] Encouraged by Moro, whose surrealist credentials were impressive, Westphalen began to take an increasing interest in art, in psychoanalysis, in Marxism, and in anthropology. At one point, the two men even enrolled in a course on psychiatry, taught by a Peruvian specialist at a local hospital.

If Moro represented "la otra cara de Westphalen" in many respects, Baciu observes, the reverse was true as well: Westphalen often seems to have served as Moro's alter ego.[21] And yet, since each poet possessed his own distinct voice, their relationship was essentially complementary. Although the two men each created a poetic portrait of the other, for example, their compositions have little or nothing in common. Apart from a common devotion to surrealist principles, they share few recognizable traits. Entitled "César

Moro,'' Westphalen's poem appeared three years before his col-
league's, in the catalogue of an exhibition of surrealist art that they
organized in 1935. While the poet planned to collect it in a volume
entitled *Belleza de una espada clavada en la lengua* (*The Beauty of a
Sword Piercing a Tongue*), whose title recalls Vicente Aleixandre's *Es-
padas como labios* (*Swords Like Lips*) (1932), this project never materi-
alized.[22]

> Por un camp de miga de pan se alarga desmesuradamente una
> manecilla de reloj
> Alternativamente se iluminan o se apagan en ella unos ojos de
> cangrejo o serpiente
> Al contraluz emerge una humareda de pestañas caladas
> Y dispuestas como una torre que simulara una mujer al desvestirse
> Otros animales más familiares como el hipopótamo o el elefante
> Hallan su camino entre el hueso y la carne
> Una red de ojos de medusa impide el tránsito
> Por el arenal que se extiende como una mano abandonada

> [Lying on a field of breadcrumbs the hand of a watch grows unusually
> long
> The crab or snake eyes adorning it flicker on and off
> Silhouetted against the light a cloud of eyelashes appears lowered
> And arranged like a tower that resembles a woman
> undressing
> Other more familiar animals like the hippopotamus or the elephant
> Make their way between the bone and the flesh
> A net of jellyfish eyes blocks the passage
> Across the sandy expanse extended like an abandoned hand]

Like Moro, Westphalen creates an imaginary setting that illus-
trates his colleague's commitment to surrealism. However, the por-
trait that emerges is less exotic and considerably more nightmarish
than the previous one. That it privileges irrationality to a greater de-
gree also renders it more resistant to interpretation. Metaphor
should not simply have an ornamental function, the poet remarked
elsewhere, but should be devoted to metamorphosis. Poetry is syn-
onymous with change, particularly in the linguistic arena. "La pala-
bra poética,'' he insisted, "es a la vez la muerte y la resurrección del
lenguaje" (The poetic word requires the death and the resurrection
of language at the same time).[23] Similarly, the surrealist mission re-
quires a restructuring of the poetic vision, of the relations between

the words, in order to portray the world in a startling new light. Westphalen chooses to depict not the beauty of this world but its fundamental and irreducible strangeness, which he finds much more appealing. Or rather, he evokes Moro's vision of the world which, seen through the distorting lens of surrealism, is strangely disturbing.

The first cluster of images is worthy of Salvador Dalí, who explored a similar idea in *The Persistence of Memory* (1931). Adorned with flickering eyes rather than jewels, the hand of a watch grows longer and longer before our eyes. Whereas Dalí's melting watches illustrate time's relativity, following Einstein's example, Westphalen's watch seems to focus on its duration. Time not only stands still in Moro's works, but ceases to have any meaning whatsoever. Like Dalí, on the other hand, who compared his watches to Camembert cheeses, Westphalen associates his timepiece with food. Exemplifying the dichotomy between the raw and the cooked, he places the watch in a field not of wheat but of a product made from wheat— bread. The next two lines introduce the first in a whole series of surrealist similes extending throughout the poem: a cloud of eyelashes that resembles a tower. That the tower resembles a naked woman initiates an endless series of comparisons between the three terms and introduces the theme of metamorphosis. While the reference to bone and flesh looks forward to the next section, the location of the events that transpire is anything but clear. Are we trekking through the African jungle, as the hippopotamus and elephant would seem to indicate, or are we strolling along a beach strewn with crabs and jellyfish that have washed up? And if the latter is the case, why is our passage blocked at one point by a net? For that matter, how can the net be made of jellyfish eyes since, apart from the incredible difficulties such a construction would entail, jellyfish have no eyes?

These and many other questions remain unanswered as the incredible journey continues. Apparent from the very beginning, Westphalen's (and Moro's) obsession with the organs of sight is explicitly thematized in the lines that follow, whose macabre imagery is as gratuitous as it is unexpected.

> A cada paso una bola de marfil dice si el aire es verde o negro
> Si los ojos pesan iguales en una balanza cruzada de cabellos
> Y encerrada en un acuario instalado en lo alto de una montaña
> Rebalsando a veces y arrojando a veces como una catapulta

Cadáveres rosados o negros o verdes de niños a los ocho extremos
Cadáveres pintados según las cebras o los leopardos
Y que al caer se abren tan hermosamente como una caja de basura
Extendida en medio de un patio de mármol rosado
Atrae a los alacranes y a las serpientes de aire
Que zumban como un molino dedicado al amor.

[At each step an ivory ball says if the air is green or black
If the eyes weigh the same in a balance lined with hair
And enclosed in an aquarium installed on a mountain top
Sometimes damming up and sometimes flinging like a catapult
The green or black or pink corpses of children with eight limbs
Corpses painted like zebras or leopards
That burst open on impact as beautifully as a can of garbage
Strewn across a pink marble patio
Attracts scorpions and aerial serpents
That hum like a windmill making love.]

Writing twenty years later, Moro's friend and biographer André Coyné stressed the poet's passion for life and his "desconformidad total, sin arrebatos ni arrepentimientos" (total non-conformity, without bursts of anger or regrets).[24] Exemplified by his poetry as by his life, Moro's cult of originality and disdain for established conventions are echoed in the sheer exuberance of Westphalen's images, which succeed each other in rapid succession according to no apparent plan. Rather than an attempt to create a unified whole, the poem consists of a series of marvelous images which, although basically unrelated, are linked together by various syntactic devices. Instead of a crystal ball, for example, the travelers (which surely include Moro) possess a ball of ivory that tells them whether the air is green or black. Why they need to consult a magic ball is hard to say—perhaps because they have lost the power of sight. Thanks to the ivory sphere, in any case, we know that somebody's eyes are being weighed on a very peculiar scale that resembles a catapult. The remaining lines, which are frankly revolting, were inspired by one of the surrealists' favorite authors: the Comte de Lautréamont. Like the author of *Les Chants de Maldoror*, Westphalen constructs an elaborate (and repulsive) simile in which he compares grotesquely deformed bodies to cans of garbage. Continuing an earlier theme, he imagines that they are painted to resemble African animals. In a similar, perverse, vein, he asserts that the corpses and garbage splattered all over the patio are uniquely beautiful. That they attract scor-

pions and snakes, whose buzzing recalls a cloud of flies more than a windmill, is also perceived as beautiful.

The final two lines, which constitute a separate stanza, appear at first glance to serve as a conclusion. Although they terminate the poem, however, they neither summarize the previous lines nor comment on the preceding drama, as one would expect. So far as one can tell, they are completely gratuitous. Rejecting the logical structure of conventional poetry, with its beginning, middle, and end, Westphalen introduces one last image that his readers will not soon forget. "Aparte," he declares, "un hombre de metal llora de cara a una pared / Visible unicamente al estallar cada lágrima" (Standing apart a man of metal is crying with his face turned to a wall / Visible only as each tear bursts forth). From this brief description, one surmises that night has fallen. As each of the robot's tears falls, it apparently emits a short flash, illuminating the scene intermittently like a strobe light or a blinking neon sign. That the robot should be crying at all is cause for wonder. Since he is a machine, one does not expect him to experience emotions or to suffer from the various afflictions that plague human beings. Like the Tin Woodman, moreover, who at one point is caught in the rain, he risks being paralyzed by rust. Unfortunately, we haven't the slightest idea who the robot is or why he is crying. Recalling a similar figure in some of Giorgio de Chirico's paintings, he remains an enigmatic character whose function is primarily emblematic. A suspicion arises nonetheless that he represents Moro who, despite his lust for life, was haunted by a number of private demons. He experienced both passionate pleasure and passionate torment, Coyné informs us—"perseguidor de algo, de alguien, y perseguido con la misma pasión con la que el perseguía" (he pursued something, someone, that pursued him in turn with just as much passion).[25]

9

Chile and Mexico

WHILE THE SURREALIST MOVEMENT HAD AN IMPORTANT IMPACT ON poetry and painting in a number of Latin American nations, it experienced its greatest success in Chile. "En Chile, como en ningún otro país del continente," Baciu declares, "el surrealismo consiguió desarrollarse e imponerse hasta el punto de dominar el ambiente" (In Chile, as in no other country on the continent, surrealism managed to develop and impose itself until it became the dominant force).[1] With the active participation of the international surrealist community, who contributed texts and art works to a number of projects, the Chileans created a movement that revolutionized the way in which their contemporaries, and successive generations, conceived of their aesthetic mission. The initial group consisted of Braulio Arenas, Teófilo Cid, and Enrique Gómez-Correa, who publically embraced surrealism on June 12, 1938, in a series of poems and manifestos delivered at the University of Chile. In December, they published the first issue of a journal entitled *Mandrágora*, which existed until 1943 and which gave the group its name. Something of their revolutionary fervor can be glimpsed in a lecture given by Cid at the University of Chile on June 7, 1939, significantly entitled "Poesía, revolución." "Hagamos esta obra de desinfección moral en nuestro ambiente," he exorted his audience; "aqui se genera la podredumbre, la intriga y demás plagas del espíritu" (Let us proceed to morally disinfect our surroundings . . . which engender putrefaction, intrigue, and other spiritual plagues).[2] Interestingly, the *Mandrágora* group was not only fiercely antibourgeois but possessed a deep-seated hatred of Pablo Neruda (whose surrealist credentials were easily as good as their own). In an act of defiance that has become legendary, Arenas even interrupted a poetry reading by the future Nobel Prize winner, snatching his manuscript and tearing it to pieces.

JORGE CÁCERES

If Anderson-Imbert condemns the Mandragorists for "[elbowing] their way through, savagely breaking everything," he is forced to admit that they liberated poetic imagery from its former servitude, creating "freed images [that] beat their wings and gave poetic intensity to the darkness."[3] Although he devotes most of his attention to Arenas and Gonzalo Rojas, some of the best poetry was written by another member of the group, Jorge Cáceres, who was immensely talented. In addition to being an accomplished poet, Cáceres was an excellent artist and a dancer in the Ballet Nacional de Chile during his brief existence (He was only 25 when he died). Baciu calls him "aquel fantástico, fabuloso Lautréamont chileno, que a los quince años ya habia comprendido el sentido, el simbolo y el valor de la VIOLENCIA" (that fantastic, fabulous Chilean Lautréamont, who at the age of fifteen already understood the sense, the symbol, and the value of VIOLENCE).[4] In order to unleash unconscious impulses, Cáceres realized, surrealism required the poet to violate the linguistic order, to impose his own rules on the words that flowed from his pen. The three poems that follow, each of which is devoted to a different artist, demonstrate that he preferred to disrupt semantic rather than syntactic lines of communication. The first text is entitled "Max Ernst."

Los lagos esquimales disimulados entre las hojas verdes
Se mecen esta tarde a cuerpo de rey
Sobre el estrado del bosque la araña les observa
Con un gesto de elocuencia ella lanza la línea recta
En el marco de manchas negras que llamamos espacio
O en el cielo que ninguna nube autoriza
Un personaje bastante conocido arrastra una cola de
hojas muertas
Él es el guardabosques que saluda a su mujer
Con una sonrisa le señala el progreso del alacran
Ellos están encantados en la copa de la escalera
Sonríen
Sonríen.

[The Eskimo lakes concealed among the green leaves
Sway to and fro this afternoon like a king
On the forest platform the spider observes them
With an eloquent gesture it flings the straight line

Into the setting with black spots that we call space
Or into the sky unauthorized by any cloud
A well-known personage trails a tail of dead leaves
He is the forest ranger who waves to his wife
With a smile he points out the scorpion's progress
They are enchanted in the staircase's goblet
And they smile
Smile
Smile].[5]

By the time *Mandrágora* was founded, Max Ernst had acquired an almost legendary status among the surrealists. Arriving in Paris in 1922, he played an important role in the formation of surrealism and astounded his colleagues with the fertility of his imagination. The utter originality of his inspiration encouraged Breton to develop his theory of the surrealist image, propounded in the First Manifesto in 1924, and the concept of *dépaysement* ("disorientation") that was to become the movement's hallmark. Of all the surrealist artists, he wrote in 1929, "Max Ernst est le cerveau le plus magnifiquement hanté qui soit aujourd'hui" (Max Ernst has the most magnificently haunted brain today).[6] Interestingly, while Ernst's works swarm with startling images, these are conspicuously absent from Cáceres's poem. Conversely, none of Cáceres's images—neither the Eskimos nor the spiders nor the staircase—occurs in the artist's paintings or collages. The most that can be said is that the two men were both attracted to forest settings. This was especially true of Ernst, who published a text in 1934 entitled "Les Mystères de la forêt" accompanied by photographs of tangled tree trunks. "Qu'est-ce qu'une forêt?" he began, pausing to answer his own question: "Un insecte merveilleux. Une planche à dessin" (What is a forest? A marvelous insect. A drawing board).[7] More importantly, Ernst painted a number of pictures of forests over the years, culminating in a jungle series during the early 1940s, that could conceivably have attracted Cáceres's attention.

Instead of replicating prominent motifs from his subject's oeuvre, like many of the critical poets we have examined, Cáceres sought to create a poem that would be the equivalent of one of Ernst's paintings. That the forest drama takes place in Eskimo country, for example, contributes to the general feeling of *dépaysement*. For as everyone knows, Eskimos inhabit a land of perpetual ice and snow whose harshness forces them to wear heavy furs and to take refuge in ig-

loos. At least this is the image in the popular imagination. If there were any lakes, therefore, they would be frozen solid. And if there were any trees, they would be evergreens rather than the deciduous variety evoked in the poem. Neither is it apparent how the lakes can sway back and forth nor why anyone would compare them to kings, who rarely engage in such activity. Although these conflicts are never really resolved, it becomes increasingly evident that the poem takes place not in the frozen North but in a temperate or even a tropical zone. The remainder of the text, which is structured around two parallel acts of observation, implies some sort of collusion between the human world and that inhabited by insects (or at least arachnids). Like the poet himself, a spider perched on part of the lookout tower where the ranger and his wife appear to live casts a silken line into space with the hope that it will be successful. Whereas the spider gazes into the distance, the ranger, arriving home at the end of the day, glances at the scene around him and is delighted to discover a scorpion. Mounting the staircase, he joins his wife on one of the landings who, like him, is wreathed in a beatific smile. While they may simply be "delighted," a growing suspicion arises that they are the victims of some kind of "spell" (*encantado* having both meanings). This impression is reinforced by the fixity and the intensity of their smiles, which recall an earlier observation by Breton. Max Ernst "ne perd pas la grâce de sourire," he noted, "tout en éclairant au plus profond . . . notre vie interieure" (never loses his graceful smile while profoundly illuminating our internal life).[8]

As late as 1926, Breton later confided, the question of whether art could possibly embody surrealist principles was still being debated by the surrealists in Paris.[9] In retrospect, he continued, it is clear that the movement had already been influenced by a number of artists, including Paul Klee, who employed partial automatism in his paintings. Although the Swiss painter played a peripheral role at best in the evolution of surrealism, the fact that he utilized analogous procedures continued to interest the surrealists for many years. In 1925, for instance, in honor of his first exhibition in Paris, Paul Eluard contributed a poem, and Louis Aragon an introduction, to the catalogue. Immediately thereafter Klee participated in the first group exhibition by the surrealists at the Galerie Pierre. More than a dozen years later, as a text entitled "Paul Klee" attests, he continued to appeal to the surrealist sensibility.

Para ser complíce del paisaje que bate a todo vuelo
Como un fuego bien alimentado arriva las manos!
Los niños son culpables de sus ojos verdes sin fin
Ellos han disipado el cielo en pleno día
Con sonrisas encantadoras
Con juegos que no son mas inocentes
Las nubes dentro de la balera el respeto a los mayores
Y las grandes trampas de los cálculos precisos.

Las playas están guardadas por ciegos de ocasión
El sentido del tacto en el ojo de las bañistas
Y la curva de la fiebre sobre las grandes rocas
Sin una palabra de recompensa permanecen en sus puestos
Sobre la balanza deliciosa del buen tiempo.

El pulpo el lobo el tapir el armiño
No son más que el juego de la memoria
Puesto de relieve por la escala animal
El rostro en el desierto las manos en pleno campo
Han quebrado el anillo de las alabanzas.

[In order to be an accomplice of the throbbing landscape
Like a roaring fire hands up!
The children are to blame for their endless green eyes
They have dispersed the sky at midday
With enchanting smiles
With games that are no longer innocent
Clouds in the bathtub respect for adults
And the great snares of precise calculations.

The beaches are guarded by secondhand blindmen
The sense of touch in the bathers' eye
And the fever's curve over the great rocks
They have wasted their time altogether
Without a single word of recompense they remain at their posts
On the delightful scales of fair weather.

The octopus the wolf the tapir the ermine
Are simply the game of memory
An important place on the animal ladder
The face in the desert the hands in the fields
Have broken the ring of praises.][10]

As in the previous text, the relation between "Paul Klee" and the artist who is ostensibly its subject is far from clear. As before, the poem displays none of the images, none of the obvious stylistic traits

that we have come to associate with Klee's paintings. If Cáceres would doubtless have agreed with the painter that "art does not reproduce the visible; rather, it makes visible," his poem possesses none of Klee's whimsicality, none of his childlike delight in the world around him.[11]

Unlike "Max Ernst," which is relatively accessible, the composition is virtually impenetrable. Interspersing nonsense commands and dangling noun phrases, Cáceres disrupts the syntax and sabotages any attempt to impose a coherent interpretation. One is tempted to conclude that the subject of the poem, like that of one of Klee's paintings, is *The Limits of Understanding* (1927) (figure 13). Indeed, if the title were modified to describe *conscious* understanding, this conclusion would be surprisingly accurate. For as Herbert Read declares, "Klee realized . . . that all effort is vain if it is forced: that the essential formative process takes place below the level of consciousness."[12] Whereas the previous poem dramatized the role of disorientation in Ernst's paintings, the present text stresses the role of psychic automatism. Like many of Klee's pictures, in which the artist relinquished conscious control of his brush, it is largely the product of unconscious activity.

In contrast to "Max Ernst," whose syntactic momentum ensures that it flows relatively smoothly, "Paul Klee" is plagued by discontinuity. Each of the three stanzas is isolated from the others, for example, and within a given stanza the subject changes abruptly on at least two occasions. As much as anything, these semantic breaks appear to be directly related to the process of composition. Explaining how to write a surrealist poem in the First Manifesto, Breton advised the poet to write quickly, to avoid preconceived subjects, and to stop as soon as the conscious mind started to intrude.[13] In order to discourage rational intervention, he continued, the poet should arbitrarily choose a word beginning with the letter "l" when he or she resumed writing. In keeping with these instructions, the last two stanzas and the sections following the internal breaks begin either with "l" or with its homonym "el." Complementing these disjunctive strategies, the arbitrary juxtaposition of words and phrases throughout the poem generates numerous semantic incongruities that subvert any attempt to establish a coherent context.

The first two lines, with their peremptory injunction to raise our hands, seem to be particularly arbitrary. Although the image of the landscape throbbing like a roaring fire is striking, Cáceres abandons it immediately in order to introduce the children who will dominate

Figure 13. Paul Klee, *The Limits of Understanding*, 1927. Panel, oil, and watercolor, 21⁵/₈ × 16¹/₈. Whereabouts unknown.

the rest of the stanza. Despite their harmless demeanor, the poet confides, the children are not as innocent as they seem. This statement is confirmed not only by the world "culpables" but by their fathomless green eyes, which suggest they possess a secret knowledge. It is confirmed as well by their charming smiles which, like those of the forest ranger and his wife in the previous poem, are simultaneously enchanting and enchanted. Unlike the latter characters, who are cast in the role of observers, the children interact with the world around them. Indeed, they turn out to possess strange powers that permit them to manipulate natural phenomena in surprising ways. Not only have they dispersed all the clouds in the sky, but they have managed to banish the sky itself. Stripped of its protective mantle, the earth is exposed to the blackness of outer space. The last two lines describe some of the games devised by the children, who like to play with the clouds in the bathtub as if they were cosmic soapsuds. Concealing their cunning calculations, their respectful behavior allows them to dupe adults into believing they are innocent children.

Suddenly, the scene changes in the second stanza, and we find ourselves at the seashore. At one end of the long, sandy beach, the feverish waves break over several rocks sticking out of the water. While a few hardy bathers battle the waves, most of them are stretched out on the warm sand. If the first stanza seems somewhat menacing, the portrait that emerges from the second is frankly amusing. For although the local authorities have taken pains to protect swimmers who use their beach—perhaps with the hope of attracting tourists—these measures are woefully inadequate. Although they have hired several lifeguards to protect swimmers from drowning or being eaten by sharks, the lifeguards are blind! In order to check on the bathers' welfare, they depend on their sense of touch, periodically running their fingers over the bathers' faces and jabbing them in the eye. To make things worse, the city fathers have hired secondhand blindmen, who presumably work for cheaper wages but who are undoubtedly even more incompetent. Adding insult to injury (or infirmity), they have so far avoided paying the lifeguards any salary at all. Either because they are devoted to their new profession or because they cannot see to go elsewhere, the blindmen remain at their posts and soak up the sun.

Counterbalancing the children's devious games, the final stanza introduces four animals that are somehow emmeshed in the game (or play) of memory. Since we have no idea who this remembrance

belongs to or in what context it takes place, it is impossible to be more specific. And since the animals appear to have nothing in common, except that they occupy important evolutionary niches, one wonders what they are doing here. In the absence of any obvious function, they simply become emblems of the animal world. The final two lines, which would normally constitute some kind of conclusion, are even more enigmatic. Although they have a vague biblical ring, they succumb to the forces of decontextualization. Someone somewhere, operating alone or together with other individuals, has managed to prevent someone else from praising another person, deity, or institution. Who perpetrated this act, where it transpired, and for what reason is anybody's guess. Despite the glimpses of another existence that it contains, despite the glimmers of some kind of transcendent meaning that arise, the text concludes by asserting its automatic status. Like many of Klee's paintings, the composition establishes its own reality and refers ultimately to itself. Since surrealist texts are primarily concerned with the generation of words and images, Derek Harris reminds us, they "frequently give no impression of literary closure; they simply come to an end with the cessation of syntactic/semantic flow."[14]

Entitled "Douanier Rousseau," the third poem is dedicated to the surrealist poet Aimé Césaire, who lived in Martinique. Unlike Max Ernst and Paul Klee, who were associated with surrealism to various degrees, Rousseau lived and died before the movement was invented. Since he was a precursor rather than a participant, Cáceres decided to employ a different strategy. Instead of celebrating a central (surrealist) principle in the artist's work, he incorporated images borrowed from Rousseau's iconography. Like the paintings, the poem employs a lush tropical setting filled with exotic flora and fauna.

> Sol explosivo del mediodía sobre los ganados de lanzallamas
> enciende las gargantas sin defensa.
> Los ojos de sol sin defensa de relámpagos bajo las trampas de ardillas
> Bajo las lluvias consecutivas de lianas en las esclusas palpitantes a la
> defensa de los tatuajes
> De los cabellos de boomerang de las manos de los mosquitos
> Una brisa emboscada arrastra plumas de cuervo
> A la entrada del león un rugido de tapicería
> Y la noche será mas corta alrededor del fuego.
>
> Tribu sin nombre.

[The explosive midday sun above the herds of flamethrowers
 incinerates the defenseless throats
The sun's defenseless eyes the lightning's eyes beneath the squirrel
 traps
Beneath the lianas' consecutive rains in the sluicegates palpitating in
 defense of the tattoos
Of the boomerang hair styles of the hands of the mosquitos
A breeze lying in wait trails crow feathers
Upon the lion's entry a tapestry roar
And the night will be shorter around the fire.

Nameless tribe.)

In his authoritative study of primitive modern art, Robert Goldwater distinguishes between romantic, emotional, and intellectual primitivism and primitivism arising from the subconscious. Like Klee (and perhaps Ernst), he declares, Rousseau belongs to the fourth category because his paintings originated in sleeping or waking dreams.[15] Although he considered himself to be a Realist, Pierre Courthion adds, he "was able to transcend reality, forging a pathway into the unknown and prefiguring a future still shrouded in mystery."[16] While many, if not most of Rousseau's paintings depict scenes from French life or friends and relatives, his jungle pictures are far better known. Portraying exotic animals or an occasional native immersed in a profusion of tropical foliage, they exert a powerful fascination on even the casual viewer. Every time he attempted to analyze the paintings, Breton confessed, he halted at the edge of Rousseau's jungle ("for fear of losing myself in that inalienable adjunct of the unconscious").[17] Like the jungle depicted by the artist, which is steeped in primeval mystery, Cáceres' tropical rainforest serves as a repository for unconscious fears. As in a number of paintings, the lush foliage and the animals that inhabit it are broiling (or steaming) in the relentless tropical heat. While Rousseau's sun is never directly overhead, as it is here, its bright orange color indicates that it is extremely hot. Translating this into surrealist terms, the poet imagines that the sun is racked by explosive convulsions which threaten to burn the jungle to a crisp. Since llamas are beasts of burden as well as flames, he groups the solar flamethrowers ("lanzallamas") together in herds.

Although many of the animals are borrowed directly from the paintings, many others are the product of Cáceres's imagination. Some of these do not inhabit the tropics and thus seem out of place.

Others, like the ubiquitous mosquitos, are more appropriate but were never depicted by Rousseau. By contrast, the entrance of the King of the Beasts recalls numerous pictures, including *Jungle With Lion* (1904?), *The Hungry Lion* (1905), and *The Repast of the Lion* (1907). His fearful roar, which spreads across the jungle like a tapestry, reminds its inhabitants that sudden death lurks in the shadows. It also tells them that he is hungry. Besides various animals, these include the members of an anonymous tribe that has yet to be discovered. In contrast to most of the animals, who are powerless to resist, the tattooed natives have a trick up their nonexistent sleeves. Although their Australian coiffures suggest they still live in the Stone Age, they have discovered that lions and other carnivores are afraid of fire. Sitting around a roaring blaze not only protects them from marauding animals but makes the night pass more quickly. While the next two stanzas contain occasional glimpses of the natives, they serve primarily to expand the portrait of the jungle.

En los grandes pozos de polen de bambú de peluche
En los tesoros carcomídos de amapolas voraces
En los reflejos bamboleantes de sicomoros
En la garganta del camaleón
Y a la espalda de los diluvios de eucaliptus tres veces calcinados.

Tribu sin nombre
Sobre los pasos del jabalí
La sorpresa de las chinchillas en las rafagas de centellas
De los cráteres de podredumbres que el viento despliega a vuelo de
 papagayo
En la noche de las selvas que huelen bien
El rayo se precipita al vaso blanco a retoques rojos donde el bufalo
 bebe
En el sueño de los caimanes de un solo golpe.

[In the great wells of pollen of bamboo of plush fabric
In the treasures consumed by voracious poppies
In the sycamores' swaying reflections
In the chameleon's throat
And behind the torrents of triple roasted eucalyptus.

Nameless tribe
On the wild boar's trail
The chinchillas' surprise in the flashes of lightning
Of the rotten craters unfolded by the wind like a parrot in flight
In the perfumed jungle nights

The thunderbolt strikes the white vase with red marks where the
buffalo drinks
In the caymans' sleep with a single blow.]

Like the eucalyptus trees, which are native to Australia, the presence of sycamores in a tropical jungle challenges the imagination. The same observation applies to the incredulous chinchillas, who live in the Andes, and to the dense stands of bamboo which have been imported from the Orient. However, the large, brightly colored flowers that perfume the night air occur in many of the jungle paintings where, as the poet claims, they resemble great wells of pollen made of plush fabric. And while one is surprised to find poppies in the tropics, these seem to be carnivorous cousins that subsist on insects, tree frogs, and small lizards. Although the remaining animals all inhabit the tropics, they are conspicuously absent from Rousseau's pictures, even the metaphoric parrot silhouetted against the volcanic peaks. The single exception is the Cape buffalo that comes to drink from a curiously decorated vase. In 1908, the artist painted two pictures of a tiger attacking an identical animal framed by clusters of oranges and bunches of bananas. Presumably, since it appears to be nighttime, the buffalo is asleep somewhere else when lightning strikes the vase. Fashioned by the anonymous natives, whom we also glimpse hunting wild boar, the red and white artifact is reduced to a pile of rubble.

The poem concludes with a portrait of the natives, who are the subject of the final stanza. Turning away from the jungle that has occupied him previously, Cáceres focuses his attention on its inhabitants.

Tribu sin nombre
De miradas de cometas al fondo del desierto
Respirando afanada en su amor proprio
Para cada seno que se eriza hay una flecha envenenada
Y una cabeza adornada con aretes de pitón
Y perlas totémicas
Hasta la última dimensión de la mirada de pantera
Sin justicia
Desplegando abanicos negros de perlas vagas en la playa que se
evapora tribu sin nombre
Sin justicia
A muerte.

[Nameless tribe
Of comet eyes in the midst of the wilderness
Breathing laboriously in its self-esteem
For each breast that stiffens there is a poison arrow
And a head adorned with horn earrings
And totemic pearls
Until the panther's gaze succeeds
Without justice
Opening black fans of vague pearls on the evaporating beach
 nameless tribe
Without justice
To the death.]

As Pierre Courthion remarks, a sense of universal compassion pervades most of Rousseau's paintings. While he was only too aware that the strong devour the weak, "he sided passionately with the exploited and starving man haunting the factory walls, the defenseless animal, the victim."[18] This is particularly true of the jungle pictures which, besides the hapless buffalos mentioned earlier, depict an antelope, a horse, and a leopard being attacked by various carnivores. Rousseau himself provided the following description of *The Hungry Lion* (1905): "The hungry lion, throwing himself upon the antelope, devours him; the panther stands by awaiting the moment when he, too, can claim his share. Birds of prey have ripped out pieces of flesh from the poor animal that sheds a tear!"[19] Like Courthion and other viewers, Cáceres was struck by the unhappy fate that awaited so many of Rousseau's animals, destined to succumb to jungle predators. What impressed him, one discovers in the first two lines, was their immense vulnerability. Indeed, the phrase "sin defensa" almost threatens to become a refrain. By contrast, Rousseau's treatment of the jungle's human inhabitants is curiously ambivalent. Both *The Snake Charmer* (1907) and *The Dream* (1910) feature a naked female figure who appears to reign over the animals around her—which coexist in perfect harmony. These Edenic portraits are offset by *Forest Landscape With Setting Sun* (1910), in which a jaguar mauls a helpless native, and by the wildly improbable *Tropical Landscape: An American Indian Struggling With an Ape* (1910).

Cáceres' natives, whom we glimpse opening clams by the jungle's edge in search of totemic pearls, are neither lords of their domain nor particularly vulnerable. Magnified by the darkness of their skin, the poet tells us, their bright eyes resemble comets at one point and a panther's gaze at another. In contrast to the animals evoked at the

beginning, who are tormented by the relentless sun, the natives are shaded by dense vines that "come to their defense." Unlike the helpless animals, moreover, they possess not only fire but poison arrows with which to defend themselves—or perhaps attack other tribes. Since lines 4–6 are hopelessly ambiguous it is impossible to be more specific. On the one hand, the natives may be participating in intertribal hostilities. On the other, they may be engaged in any number of peaceful activities. Indeed, together with the natives' proud bearing in the third line, their labored breathing suggests they are dancing. Although they could be celebrating a marriage or a successful hunt, one wonders—perhaps inevitably—whether it is a victory dance. Whereas most of the animals are "sin defensa," the fact that the tribe is "sin nombre" and "sin justicia" places it in an entirely different category. The third expression indicates that the natives do not possess an extensive judicial system—not that they have no sense of justice. While in the eyes of Western civilization the absence of a name and of a legal system constitutes a lack, the natives perceive no need for either, revealing not the inadequacy of their society but their fundamental innocence. They already know who they are, they might well reply, and they are governed by a higher law: the law of the jungle. As the final line reminds us, this law is harsh and unforgiving, and the penalty for its transgression is extinction. Rather than a tropical paradise, the jungle is the site of a daily struggle between life and death. Rousseau's paintings depict precisely this struggle, it also reminds us, in which all too often death proves to be the victor.

Enrique Gómez-Correa

Like César Moro and his associates in Peru, the *Mandrágora* group not only emulated the French surrealists but strove to develop a personal relationship with them. In 1942, for instance, Arenas published the first issue of *Leitmotiv* which, in addition to a number of Chilean contributors, included André Breton, Benjamin Péret, and Aimé Césaire. Entitled "Prolegómenos a un tercer manifiesto del surrealismo o no" ("Prolegomena to a Third Surrealist Manifesto or Not"), Breton's essay denounced previous attempts to create a universal ideology, whose futility was demonstrated by the Second World War. Published only a few months earlier in *VVV*, edited by a Franco-American coalition in New York headed by Breton, it reveals

that the Chileans were corresponding with their French colleagues by this date. Shortly thereafter, Arenas sent a long letter to Breton describing the *Mandrágora* group's accomplishments since its creation in 1938. Entitled "Letter from Chile," it appeared in *VVV* in March 1943 with three poems by Cáceres, Arenas himself, and Gómez-Correa.

While Cáceres died at a tragically young age, the two remaining poets were destined to enjoy long and fruitful careers. As Baciu remarks, Enrique Gómez-Correa represents "el más constante y más coherente defensor de las posiciones surrealistas, además de ser uno de los notables poetas de su país" (the most constant and most coherent defender of Surrealist principles and one of the more important poets in his country).[20] At some point, presumably after the war, he began to correspond with the Belgian surrealist René Magritte, whom he succeeded in meeting about 1950 and later persuaded to draw his portrait.[21] The creator of "the most astounding visual dialectic of our time," in Sarane Alexandrian's words, the artist possessed an uncanny ability to reconcile dream and reality.[22] In Magritte's hand, Breton once remarked, the paintbrush became a magic wand which he wielded with eyes that were simultaneously half open and half closed, enabling him to liberate the latent energy of objects.[23] Shortly after the war, presumably at the Chilean poet's request, Magritte sent him twelve reproductions of his paintings.[24] Marveling at the artist's undeniable genius, Gómez decided to create a *livre d'artiste* in which each of the paintings would be accompanied by a corresponding poem. While letters in the Getty Research Institute reveal that the booklet was to include French translations, this project was eventually abandoned. Published in 1948, *El espectro de René Magritte* (*The Spectre of René Magritte*) contained thirteen texts in Spanish, including an initial poem addressed to Magritte himself. In a brief dedication, Gómez thanked him for the reproductions and explained that his poems attempted to "establecer la mágica correspondencia que existe entre el pintor y el poeta" (establish a magical correspondence between painter and poet).

As Gómez may or may not have known, his project dovetailed perfectly with Magritte's attempts to bridge the gap between artistic and poetic creation himself. Whereas the former sought to translate painting into poetry, the latter strove to translate poetry into painting. In keeping with this agenda, Magritte refused to be called an artist, insisting he was simply a man who liked to think. And indeed, as Alexandrian remarks, "every one of his paintings is an act of po-

etic reflection on the nature of the world."[25] For this reason, the painter confided in 1962, his art was best understood as the creation of "visible poetry."[26] The poetic act consists in the description of inspired thought, he explained, which can be expressed visually as well as verbally. Entitled *Le Bon Sens* (figure 14), the third painting in *El espectro de René Magritte* demonstrates what he had in mind. It is concerned not with "'common' sense," which the artist despised, but with "good sense"—which then as now was far from common.[27] Like many of his pictures, in which surprise plays an important role, it manages to be humorous and serious at the same time. Resting on a blank, ornately framed canvas, which is lying on a table, four apples are juxtaposed with a fruit dish full of pears.

At first glance, despite its reassuring title, Magritte's painting appears to make very little sense. The apples and pears should rest directly on the table, and the canvas should be hanging on the wall. The canvas should not be blank, moreover, but should depict the fruits in question. According to the artist, the title refers to the objects' spatial orientation which, unlike that in conventional still lifes, reflects the discoveries of Newtonian physics. "C'est avec bon sens," he declared, "que la coupe de fruits est placée sur une surface horizontale plutôt que sur un plan vertical" (In accordance with good

Figure 14. René Magritte, *Good Sense*, 1945–1946. Oil on canvas, 18⁷/₈ × 30³/₄″. Whereabouts unknown.

sense, the bowl of fruit is placed on a horizontal surface rather than on a vertical plane).[28] *Le Bon Sens* is more realistic than previous paintings, therefore, because it respects the principle of gravity. The titles of his paintings are not explanations, Magritte declared in the same text, any more than the paintings are illustrations of the titles. The relationship between them is purely poetic. Like his titles, Magritte's subtitles are not only poetic but often—as in the example quoted above—conceived with his tongue firmly in his cheek. For the realization eventually dawns on the viewer, as the artist surely intended, that the horizontal surface in *Le Bon Sens* is simply illusory. Restricted to two dimensions, the picture is confined to a vertical plane like its predecessors. Try as one may, it is impossible to escape the conditions of painting. Ultimately, as Suzi Gablik notes, *Le Bon Sens* is concerned with the limits of pictorial representation.[29] This concern prompted Gómez to write the following poem:

> Un espejo separa siempre lo conocido de lo inconocible
> Y su materia envuelve los cuerpos con una substancia mágica
> Les toma el pulso les anuda las manos
> Les somete a una tenebrosa esclavitud.

> Ahora el espejo se hace comestible
> El hombre siente deseos de hacer proezas comiéndose la luz
> Pero los objetos se ponen de pie
> Se preparan para resistir los ataques.

> [A mirror always separates the known from the unknowable
> And it envelops bodies with a magic substance
> Takes their pulse joins their hands together
> Submits them to a shadowy slavery.

> Now the mirror becomes edible
> Man experiences a heroic urge to devour the light
> But the objects rise to their feet
> Prepare to resist the attacks.]

One of the themes that emerges from *Le Bon Sens*, which occurs in a number of other paintings, is the basic impermeability of the canvas. As elsewhere in Magritte's *oeuvre*, the canvas constitutes a transparent window but also an impenetrable barrier between inside and outside, subjective and objective, and image and object. Prompted by the artist's scrupulously realistic technique, Gómez compares *Le Bon Sens* to a mirror rather than a window. Instead of

opening onto another scene, however, a mirror merely reflects an already existing scene, which would seem to abolish Magritte's dichotomy. Most observers would probably agree that there is no difference between the way an object appears and the way it appears in a mirror. Nevertheless, despite their identical appearance, the fundamental distinction between object and image persists. The poet evokes this dichotomy when he asserts that mirrors separate the known not just from the unknown but from the unknowable. All mirrors are magic mirrors, he proclaims, since the objects they depict possess—or seem to possess—an independent existence. As virtual images, they are simultaneously tangible and intangible. They are enslaved but also liberated by their status as reflections.

Since Gómez's metaphorical mirror depicts apples and pears (or the depiction of apples and pears), he experiences an irresistable urge to consume them. As he attempts to devour the objects in the mirror, however, something totally unexpected occurs: the objects prepare to fight back. Logical reality is not only eclipsed but banished from the rest of the poem. Sight triumphs over all the other senses as the eye asserts its authority.

La magia persiste
Y toda una realidad se transmuta de súbito
Todo sentimiento y toda lógica se hacen absurdos
El ojo tiene la razón
Y no obstante yo me separo de mi propia imagen
Me someto a la ley de las compensaciones
Converso con los objetos en animada charla.

Esto es lo esencial
Echar al mundo un destino
Proveer de alas al espejo
Alimentarse de la resistencia de los objetos
No reparar ni en la gravedad ni en lo que salta del espejo
That is mon cher ami le bon sens.

[The magic persists
And a whole reality is suddenly transmuted
All feeling and all logic becomes absurd
The eye is the locus of reason
And nevertheless I separate myself from my own image
Submit to the law of compensation
Converse with the objects in an animated fashion.

This is the main thing
To cast a destiny upon the world
To provide the mirror with wings
To nourish oneself on the objects' resistance
To ignore gravity and whatever springs from mirrors
That my dear friend is good sense.]

The last two stanzas are concerned not with the metaphoric mir-
ror but with the things that are reflected in it—not with the canvas,
that is, but with the things it depicts. In both instances, the objects
reject their status as images and reassert their original identity—like
the poet himself, who abandons his relfection, shrinks to the appro-
priate size and introduces himself to the animated objects. "Ma-
gritte . . . a abordé la peinture dans l'esprit des 'leçons de chose,'"
Breton remarked in 1941, "et sous cet angle, a instruit le procès sys-
tematique de l'image visuelle dont il s'est plu a souligner les défail-
lances" (Magritte . . . has approached painting as if it were a series of
"object-lessons" and, from this perspective, has put the visual image
systematically on trial, stressing its weaknesses with no little plea-
sure).[30] The lesson that finally emerges from *Le Bon Sens*, and is reit-
erated in "El buen sentido," is that images and objects are
fundamentally incompatible. "The crisis of twentieth-century art
arises from exactly the conditions Magritte has pictured here,"
Gablik explains, "—the fact that real objects are three-dimensional
and have depth, while a canvas is flat."[31] According to Clement
Greenberg, she adds, the effort to resolve this conflict led to the cre-
ation of abstract painting, which is two dimensional.

Taking the side of the beleaguered objects, Gómez advises artists
and viewers to turn their back on images altogether. Surpassing Ma-
gritte himself, who claimed to respect physical laws, he even advises
them to ignore gravitational forces. Objects deserve to be recog-
nized not as articles intended for artistic consumption, he adds, but
as artifacts possessing their own intrinsic value. Instead of deriving
pleasure from their artistic appropriation, he continues, which is in-
evitably inadequate, it is far more rewarding to focus on the ways
they resist that appropriation. Like the painter, therefore, the poet
advises artists to abandon traditional realism, whose illusionistic
premises are thoroughly bankrupt. Anybody with an ounce of sense
realizes that three-dimensional solids cannot be reduced to two di-
mensions. Magritte's whole approach, Breton concluded, "culmine
[en] ce qu'Apollinaire a appelé le 'véritable bon sens, s'entend,

celui des grands poètes'" (culminates [in] what Apollinaire has called "genuine good sense, that is, the sense shared by great poets").[32] This statement describes Gómez as well, whose poem closely paralles *Le Bon Sens* and who understood exactly what the artist was trying to say.

Octavio Paz

By all rights, for reasons that Baciu analyzes in detail, surrealism should have experienced its greatest Latin American triumph in Mexico. And yet, despite the country's revolutionary background, cosmopolitan capital, and educated elite, the movement never really caught on. Most of the surrealist activity was generated by expatriates residing in Mexico, such as Benjamin Péret, Wolfgang Paalen, and César Moro, who failed to act as catalysts. While the history of Mexican surrealism is somewhat disappointing, it includes a few indigenous success stories that are gratifying to examine. The best example is that of Octavio Paz who, as Baciu remarks, was destined to become "el más destacado representante de la poesía y del pensamiento surrealista en Latinoamerica" (the most distinguished representative of surrealist poetry and thought in Latin America).[33] Awarded the Nobel Prize in 1990, he was the second Latin American surrealist (after Neruda) to receive this honor. A profound poet, Anderson-Imbert observes, Paz was determined not only to explore his own depths but to "re-establish the lost unity of man."[34] Thus his personal agenda dovetailed with the surrealist mission in general which, inspired by Freud and Marx, sought to achieve the same goals.

Paz first became aware of surrealism in 1936, when he encountered an article by Breton in *Minotaure* that, in his own words, "me abrió las puertas de la poesía moderna" (opened the doors of modern poetry for me).[35] Destined to become chapter V of *L'Amour fou* (1937), it recounted an episode from his visit to the Canary Islands, stressed the importance of sexual desire, and advised readers to cultivate surprise for its own sake. Increasingly committed to the surrealist enterprise, Paz accepted Breton's and Péret's invitation in 1945 to come to Paris, where he participated in a number of surrealist activities. Among other things, he developed a close friendship with Breton, who declared seven years later: "Le poète de langue espagnole qui me touche le plus est Octavio Paz" (The poet writing in

Spanish who moves me the most is Octavio Paz) and maintained that the latter deserved a prominent place in the history of surrealism.[36] As the years passed, Paz became increasingly interested in modern art and devoted numerous essays to the subject. Toward the end of his career, he even collaborated on several projects by contemporary artists whom he admired. At the same time, he experienced a renewed interest in critical poetry, with which he had experimented in the past, culminating in the publication of *Arbol adentro* (*A Tree Within*) in 1987. In addition to poems about Marcel Duchamp, Joan Miró, and Antoni Tàpies, the volume included a text entitled "Un viento llamado Bob Rauschenberg" ("A Wind Called Bob Rauschenberg"). Commissioned for an exhibition in Mexico City in 1985, the poem inspired Rauschenberg to reciprocate with a collage painting a few years later, entitled *For Octavio Paz* (1990), which he presented to the poet.[37] Consisting of three distinct movements, Paz's tribute to the artist opens with a desolate plain strewn with abandoned objects.

> Paisaje caído de Saturno,
> paisaje del desamparo,
> llanuras de tuercas y ruedas y palancas,
> turbinas asmáticas, hélices rotas,
> cicatrices de la electricidad,
> paisaje desconsolado:
> los objetos duermen unos al lado de los otros,
> vastos rebaños de cosas y cosas y cosas,
> los objetos duermen con los ojos abiertos
> y caen pausadamente en sí mismos,
> caen sin moverse,
> su caída es la quietud del llano bajo la luna,
> su suelo es un caer sin regreso,
> un descenso hacia el espacio sin comienzo,
> los objetos caen,
> están cayendo,
> caen desde mi frente que los piensa,
> caen desde mis ojos que no los miran,
> caen desde mi pensamiento que los dice,
> caen como letras, letras, letras,
> lluvia de letras sobre el paisaje del desamparo.
>
> [Landscape fallen from Saturn,
> deserted landscape,
> plains of nuts and wheels and crowbars,

asthmatic turbines, broken propellers,
electrical scars,
desolate landscape:
the objects sleep side by side,
vast herds of things and things and things
the objects sleep with their eyes open
and slowly fall within themselves,
fall without moving,
their fall is the stillness of the plain beneath the moon,
their sleep is a ceaseless falling,
a descent toward a space with no beginning,
the objects fall,
 are falling,
fall from my forehead that thinks them,
fall from my eyes that do not see them,
fall from my mind that utters them,
fall like letters, letters, letters,
a rain of letters on the deserted landscape.]

The use of the artist's nickname in the title suggests that Paz was familiar not only with Rauschenberg's work but with Rauschenberg himself when he composed the poem. As early as 1965, in any case, he declared that certain works expressed "la poesía de la vida moderna tal como la definió Apollinaire" (the poetry of modern life as defined by Apollinaire).[38] And fifteen years later, quoting the artist directly, he explained that Rauschenberg worked in the area between art and life, whose shifting borders resembled sand dunes that occasionally swallowed him up.[39] Usually classified as a Neo-Dadaist, Rauschenberg is the heir not only of Kurt Schwitters and Marcel Duchamp but of the surrealists who, like him, strove to efface the boundary between art and life. During the early 1950s, moreover, he began to experiment with "combine paintings," which completed the task begun by Magritte. By affixing actual objects to the canvas (or painted surface), the Belgian artist managed to reverse the premise of illusionism and to bring about the collapse of representational art.[40] "Rauschenberg no modifica al objeto," Paz continued in his 1980 article, "pero, al arrancarlo de su contexto, desorienta al espectador" (Rauschenberg does not modify the object . . . but, by extracting it from its context, he disorients the viewer).

Like the second article, "Un viento" evokes Rauschenberg's cult of the object and stresses the role of *dépaysement* in his work. Recalling Dalí's "Poema de les cosetes" (see chapter 5), which is also

strewn with bizarre objects, it evokes a barren moonscape littered with debris left by successive teams of astronauts. Paz is not alluding to specific paintings so much as to the artist's radical collage style, to the juxtaposition of heterogeneous objects (or images of objects) that have been wrenched from their original context. In addition, as he must have known, Rauschenberg had been invited to witness the launching of the space shuttle the previous year, traces of which began to surface in his work soon thereafter. Some of Paz's images, such as the turbines and the propellers, reiterate his conviction that the pictures depict the poetry of modern art. Others are borrowed from the artist's paintings and sculptures, especially those belonging to his "Kabal American Zephyr" series, inaugurated in 1981. *Petrified Relic from the Gyro Clinic* (1981) features a wagon wheel balanced precariously on a typing table, for example, while another (untitled) construction (1985) consists of three bicycle wheels welded together to form a vertical column. Similarly, pictures of Saturn are incorporated into at least two combine paintings, from 1982, entitled *Solar Elephant* and *The Vain Convoy of Europe Out West* (figure 15). The second work also includes a metal wheel framed by images of George Washington and a Flemish (or Dutch) *Hausfrau*.

As several critics have remarked, Rauschenberg's paintings and constructions illustrate his fondness for artistic dissonance instead of harmony. Much of their force derives from his attempt to achieve a certain equilibrium, a creative tension, between elements placed in opposition. That Paz was aware of this is revealed by his 1965 article, in which he declared that the artist's works constituted "un mundo en el que cada color es una exclamación y cada forma un signo que emiten significados contrarios" (a world in which each color is an exclamation and each shape a sign, which emit contrary signifieds). Returning to this theme in "Un viento," Paz introduces three binary oppositions that reflect Rauschenberg's penchant for contradictory elements: between animate and inanimate, conscious and unconscious, and moving and stationary. Like certain objects in *Alice in Wonderland*, the turbines and their companions turn out to be alive. Not only do they sleep with their eyes open, moreover, but they manage to fall without moving a hair. Paz nicely captures this effect in line 15 by repeating and dislocating the phrase "los objetos caen," which becomes "están cayendo." However, the fact that the objects fall within themselves suggests they are in a state of suspended animation, or rather that the occupy a virtual space ("el espacio sin comienzo"). The objects cannot actually be seen, Paz goes

Figure 15. Robert Rauschenberg, *The Vain Convoy of Europe Out West*, 1982. Solvent transfer, acrylic, and paper on wood, 6'2″ × 8'1/2″ × 3'5½″. Whereabouts unknown.

on to say, because they do not exist. The product of his imagination, they rain down on the paper before him in the form of letters and are transformed into words. Taking his cue from Mallarmé, Paz compares the blank page to a barren landscape (or moonscape) that is inhospitable to life. Introduced at the beginning of the poem, this metaphor also describes the blank canvas confronting the artist. Rauschenberg's endeavor resembles his own, Paz concludes, and vice versa. Poet and painter both seek to endow a blank surface with meaning, to transform the desert into a garden, by planting it with symbols of their own devising.

The second stanza describes how Rauschenberg accomplishes this task and introduces another monumental metaphor, alluded to in the title, that complements the earlier one.

Paisaje caído,
sobre sí mismo echado, buey immenso,

buey crepuscular como este siglo que acaba,
las cosas duermen unas al lado de las otras
—el hierro y el algodón la seda y el carbón
las fibras sintéticas y los granos de trigo,
los tornillos y los huesos del ala del gorrión,
la grúa, la colcha de lana y el retrato de familia,
el reflector, el manubrio y la pluma del colibrí—
las cosas duermen y hablan en sueños,
el viento ha soplado sobre las cosas
lo que hablan las cosas en su sueño
lo dice el viento lunar al rozarlas,
lo dice con reflejos y colores que arden y estallan,
el viento profiere formas que respiran y giran,
las cosas se oyen hablar y se asombran al oírse,
eran mudas de nacimiento y ahora cantan y ríen,
eran paralíticas y ahora bailan,
el viento las une y las separa y las une,
juega con ellas, las deshace y las rehace,
inventa otras cosas nunca vistas ni oídas,
sus ayuntamientos y sus disyunciones
son racimos de enigmas palpitantes,
formas insólitas y cambiantes de las pasiones,
constelaciones del deseo, la cólera, el amor,
figuras de los encuentros y las despedidas.

[Fallen landscape,
strewn over itself, a huge ox,
an ox as crepuscular as this century coming to an end,
the things sleep side by side
—iron and cotton, silk and coal,
synthetic fibers and grains of wheat,
screws and a sparrow's wing-bones,
the derrick, the woolen quilt, the family portrait,
the searchlight, the crank, and the hummingbird feather—
the things sleep and talk in their sleep,
the wind has blown over the things,
and what the things say in their sleep
the lunar wind says brushing against them,
says with reflections and colors that burn and explode,
the wind utters forms that breathe and whirl,
the things hear themselves speaking and are amazed,
they were born mute and now they sing and laugh,
they were paralyzed and now they dance,
the wind joins them and separates them and joins them,

plays with them, unmakes them and remakes them,
invents things neither seen nor heard before,
their junctions and their disjunctions
are clusters of throbbing enigmas,
strange and changing forms of passion,
constellations of desire, anger, love,
figures of encounters and farewells.]

Returning to the desolate moonscape, whose existence as we have seen is purely metaphorical, Paz compares it for some reason to a huge ox—which catches the reader by surprise. If the comparison had involved a goat, the allusion would have been relatively easy to decipher. Entitled *Monogram* (1955–1959), Rauschenberg's most famous combine features an angora goat with a rubber tire around its middle which, as Donald Barthelme notes, makes an excellent emblem for the artist's genius.[41] However, a rapid survey of Rauschenberg's work fails to uncover any references to oxen which, in any case, do not play a significant role in his art. Paz chooses to introduce the ox at this point not because it is a prominent motif in the artist's work but because it makes a convenient symbol. The symbolic antithesis of the solar bull, the castrated ox is no longer associated with fertility but becomes a lunar symbol.[42] As such, it represents patience, chastity, sacrifice, and self-denial—virtues traditionally belonging to the artist. A common draft animal before it was displaced by the gasoline engine, the ox is also associated with hard work, a great amount of which has obviously gone into Rauschenberg's creations. As Walter Hopps observes, the range of media, materials, and techniques employed in his art is "probably wider and more varied than [that of] any other artist of this century."[43] Struck by Rauschenberg's extraordinary eclecticism, Paz pauses to give a partial inventory of the materials, objects, and images in his works. Like the propellers encountered earlier, which may refer to the twin fans in *Pantomime* (1961), the grains of wheat may have been inspired by some of the Mexican collaborative paintings and the "colcha de lana" by the paint-splattered quilt in the artist's second most famous work, simply entitled *Bed* (1955).

Although they are less easy to identify, Paz may have borrowed the remaining items from Rauschenberg's art as well. The artist's iconography is so varied and so extensive that it is impossible to be sure. Whether the items are authentic or fictitious matters little in any case, since Paz focuses on Rauschenberg's technique, on the way

he assembles the various elements to create a finished work. For Rauschenberg does not create the images and objects he employs but extracts them from the world around him, where they exist in endless profusion. His task is thus twofold: to select a certain number of items and to combine them in ways that have artistic significance. "Rauschenberg juxtaposes images and objects of great beauty," Linda Cathcart writes, "with those of great hideousness . . . ; he sets things on a huge scale . . . against tiny pieces . . . The whole experience of the work is one of unexpectedness, yet it suggests with great accuracy the emotional quality of our world."[44] Cathcart's second sentence describes Paz's choice of objects as well, which are equally unexpected and which play an equally important role in our lives. The derrick serves to construct our buildings, for example, the quilt to keep us warm, and the grains of wheat to make our bread. We clothe ourselves in cotton and silk, heat our homes with coal, and make our machines from iron (or steel). Like the sparrow's delicate wing bones, so light and yet so strong, the tiny hummingbird feather and the hummingbird itself fill our lives with beauty.

Whereas the objects resemble herds of animals in the first stanza, they assume the appearance of human beings in the second. Or rather, since they retain their identity as objects, they are endowed with human characteristics. Incorporating yet another binary opposition, the objects are simultaneously mute and able to speak. Not only do they know how to talk, moreover, but they have learned to laugh and sing and to dance around in circles. Like Paz, Cathcart is impressed by the exuberance of the artist's works, by the vitality he has managed to instill in them. "Robert Rauschenberg's pieces of art are alive," she insists; "they are so filled with life, in fact, that the uninitiated viewer may be tempted to dismiss them as not being art."[45] They are full of life not only because they depict human activities, one might add, but because they speak to us in a language that is uniquely their own. Since they acquired their linguistic skills from their creator, to continue the metaphor, Paz could have chosen to portray Rauschenberg as a father and/or a teacher. Struck by the artist's radical vision, which imprinted itself on every one of his works, Paz decided instead to depict him as an elemental force. But which elemental force? Rain, which normally alleviates desolate landscapes (cf. Eliot's "The Waste Land"), would have seemed absurd on the moon. Inspired perhaps by the solar wind—a stream of charged particles emanating from the sun—Paz chose to invent a

lunar equivalent. Enveloping the objects in a transparent embrace, the lunar wind brings them to life by transforming them into forms that interact with each other. Since Rauschenberg proceeds intuitively, Paz adds, their arrangement on the canvas is determined by unconscious feelings such as desire, anger, or love.

Whereas the first two stanzas examine the role that the objects play in the landscape, the final section focuses on the landscape itself and introduces the concept of universal speech. Paz seeks above all to determine the ontological status of the work of art and to describe its relation to the world around it.

> El paisaje abre los ojos y se incorpora,
> se echa a andar y su sombra lo sigue,
> es una estela de rumores obscuros,
> son los lenguajes de las substancias caídas,
> el viento se detiene y oye el clamor de los elementos,
> a la arena y al agua hablando en voz baja,
> el gemido de las maderas del muelle que combate la sal,
> las confidencias temerarias del fuego,
> el soliloquio de las cenizas,
> la conversación interminable del universo.
> Al hablar con las cosas y con nosotros
> el universo habla consigo mismo:
> somos su lengua y su oreja, sus palabras y sus silencios.
> El viento oye lo que dice el universo
> y nosotros oímos lo que dice el viento
> al mover los follajes submarinos del lenguaje
> y las vegetaciones secretas del subsuelo y el subcielo:
> los suelos de las cosas el hombre los sueña,
> los sueños de los hombres el tiempo los piensa.

> [The landscape opens its eyes and sits up,
> it sets out walking followed by its shadow,
> it is a stele of obscure murmurs,
> that are the languages of the fallen material,
> the wind stops and hears the clamor of the elements,
> the sand and the water speaking with lowered voices,
> the groans of the pier battling against the salt,
> the reckless secrets of the fire,
> the soliloquy of the ashes,
> the interminable conversation of the universe.
> Speaking with things and with ourselves
> the universe speaks to itself:

we are its tongue and its ears, its words and its silences.
The wind hears what the universe says
and we hear what the wind says
ruffling the submarine foliage of language
and the secret vegetation beneath the ground and the sky: man
 dreams the dreams of things,
time thinks the dreams of men.]

In contrast to the objects that inhabit it, which become increasingly animated, the landscape has remained completely immobile until now. Even when Paz transforms it into an ox, it never budges from its initial, symbolic position. Like the canvas that it represents, the landscape provides a stationary support for images and objects that adorn it. In the third stanza, however, the focus shifts from the blank canvas to the painting that is superimposed on it. No longer simply a convenient surface, it consists of images and objects, colors and shapes, that are structured according to Rauschenberg's inspiration. Springing to life, the metaphoric landscape follows the path blazed by the derrick and the grains of wheat: from object to animal and from animal to human simulacrum. It not only opens its eyes and sits up, like someone awakening from a dream, but it decides to go for a stroll. As if this were not enough, the landscape appears to be muttering to itself as it proceeds. Like a commemorative slab erected by his Mesoamerican ancestors, Paz interjects, it is covered with obscure signs and mysterious images—inscribed in this instance by Rauschenberg. Once again the lesson is relatively clear: works of art possess a language of their own. They communicate by the way they combine the visual elements at their disposal.

At this point, something totally unexpected occurs. Extrapolating from his discussion of visual language, Paz posits the existence of a natural language, a language of things, that is universally intelligible. Paralleling this change of focus—from the world of art to the world around us—the scene dissolves, and we find ourselves back on our home planet. While the transition takes place surreptitiously, our return to earth is unmistakable. It is signaled by a glimpse of waves breaking on a sandy beach and by the sound of an ancient pier groaning beneath the ocean's assault. It is signaled as well by the presence of all four elements: earth, air, fire, and water, which participate in the interminable conversation of the universe. Like Baudelaire in "Correspondances," Paz presents a vision of Nature in which objects "laissent parfois sortir de confuses paroles" (occa-

sionally utter obscure words). Like a landscape painted by an artist, he maintains, the natural landscape is "una estela de rumores obscuros" as well. The problem with Nature's obscure murmurings, as both men recognized, is that they are impossible to understand. We need someone like the artist (or the poet) to interpret for us, to mediate between the phenomenal world and humanity. Someone like Rauschenberg, who translates Nature's utterances into primal images and abstract designs. The universe not only speaks *to* us, Paz concludes, but through us as well. In the last analysis, although we pride ourselves on our intelligence and our doubly articulated language, we resemble the humble objects around us. Since we are the product of natural forces, like those that shaped the rest of the world, we speak not only of Nature but in the name of Nature. Viewed in this perspective, the concept of human agency loses all meaning. Ultimately, as Paz succinctly observes, the universe is only speaking to itself.

Coda

Introduced by Apollinaire at the beginning of the century, critical poetry was transformed subsequently by the surrealists, who displayed surprising ingenuity in adapting it to their own needs. By relating the aesthetic object to the text in new and exciting ways, they succeeded in pushing the genre to its limits. The works examined previously are noteworthy not only for their unusual vitality but for the variety of guises they assume. As we have seen, no two poets conceived of critical poetry in exactly the same manner. Despite their common allegiance to surrealism, each followed his own inspiration and developed his own distinctive style. Indeed, many of the works are so dissimilar that they seem to be completely unrelated. Salvador Dalí's paranoid obsessions differ radically from César Moro's heroic portraits, for example. One would never confuse Benjamin Péret's scientific parables with the eerie adventures recounted by J. V. Foix. And André Breton's artistic tributes scarcely resemble the strange odyssey imagined by García Lorca. In subjecting critical poetry to the demands of the surrealist imagination, these individuals followed markedly different paths. And yet, to the extent that their works embodied the surrealist impulse, they were conscious of pursuing similar goals.

In keeping with surrealist precepts, poets and painters strove above all to evoke the marvelous. By inventing imaginary situations, describing irrational experiences, and employing startling imagery, they hoped to free mankind from its unconscious chains. Poetry was conceived as a revelatory experience, providing glimpses of a previously unsuspected realm. It strove to generate a flash of recognition that, as Breton insisted in the First Manifesto, "l'existence est ailleurs" (existence is elsewhere). This explains the feeling of *dépaysement* that pervades so many surrealist works. It also explains the eerie atmosphere that emanates from many others. In order to evade the conscious censor, the surrealists relied heavily on surprise, which assumed innumerable forms. Some poets utilized fragmentation and radical juxtaposition to disrupt the work's syntax. Others employed

222

lexical substitutions in order to subvert its semantic development. Still others constructed elaborate dream sequences in which metamorphosis played an active role. The latter had an alarming, if predictable, tendency to turn into nightmares.

The ways in which the surrealist poets responded to works of art were equally inspired and equally diverse. As Roman Jakobson has demonstrated, human discourse is invariably either metaphoric or metonymic (or a combination of the two).[1] One topic may lead to another either through similarity ("the metaphoric way") or through contiguity ("the metonymic way"). As I have shown elsewhere, this distinction permits us to analyze surrealist imagery with great precision.[2] In addition, it enables us to determine how critical poems are related to their aesthetic objects. Some of the marvelous encounters we have witnessed turn out to be based exclusively on resemblance. This describes Aldo Pellegrini's and Emilio Adolfo Westphalen's poems, for example, which are constructed around a series of metaphors. Like these works, those by César Moro contain an additional metaphor encompassing the entire intersemiotic relationship. Whereas Moro compares Westphalen to a tropical explorer in one work, Westphalen portrays Moro as a metallic robot in another. The first global metaphor serves as an introduction, while the second constitutes the poem's conclusion.

At the other end of the spectrum, a number of surrealist poets reject similarity in favor of contiguity. Salvador Dalí, García Lorca, and Rafael Alberti reproduce metonymic features of the works in question. Each poet imitates the latter's style, borrows a prominent theme or two, and incorporates selected motifs. Alberti not only copies the rhythm of *Go West* but also duplicates its structure. And Dalí exhibits the same fascination with metamorphosis and the paranoiac-critical method in "Poema agrafat al vol" that characterizes his pictures. Like Emeterio Gutiérrez Albelo, who incorporates fragments of Chaplin's films into his poem, Jorge Cáceres reproduces themes and images from the Douanier Rousseau's paintings. The link between text and artwork is much more tenuous in his remaining works, however, which are conceived as equivalents rather than reflections. "Max Ernst" borrows a single motif from the latter's paintings, while "Paul Klee" imitates the German artist's style. Enrique Gómez-Correa adopted a similar strategy when he simply incorporated a theme from René Magritte's *Le Bon Sens*.

While it is tempting to regard these poets as rhetorical fanatics, in fact they were surprisingly numerous. At least half the writers exam-

ined previously forged purely metaphoric or purely metonymic links between their compositions and other artworks. The remaining poets refused to choose between contiguity and similarity, each of which had its own advantages, and preferred a more flexible approach. Invoking each principle in turn as their needs dictated, they combined them to form interlocking structures. Although Jakobson maintained that metaphor and metonymy were polar opposites— prompting Barbara Johnson to deconstruct his model thirty years later—this was highly misleading.[3] Since similarity and contiguity involve different principles, they cannot possibly be opposed to each other. Rather than sworn enemies, metaphor and metonymy represent different ways of viewing the world. On the one hand, as Jakobson pointed out, they compete with each other in the immediate rush to signify. On the other hand, as the preceding compositions demonstrate, they cooperate with each other to create larger patterns of meaning. The surrealists sensed this instinctively and exploited the two processes in their critical poetry. Skilfully manipulating the twin axes of language, they created works that pay homage both to the surrealist muse and to the artworks that inspired them.

Notes

CHAPTER 1: CRITICAL POETRY

1. Robert W. Greene, "Spiritual Quest and Scriptural Inquiry: Pierre Jean Jouve's Art Criticism" in *Conjunctions: Verbal-Visual Relations*, ed. Laurie Edson, 211 (San Diego: San Diego State University Press, 1996).

2. Thorpe Running, *The Critical Poem: Borges, Paz, and Other Language-Centered Poets in Latin America* (Lewisburg: Bucknell University Press, 1996), 13.

3. See for example Marjorie Perloff, *Wittgenstein's Ladder: Poetic Language and the Strangeness of the Ordinary* (Chicago: University of Chicago Press, 1996), 180–218 and *Radical Artifice: Writing Poetry in the Age of Media* (Chicago: University of Chicago Press, 1991).

4. Charles Baudelaire, "Salon de 1846" in *Curiosités esthétiques, L'Art romantique et autres Oeuvres critiques*, ed. Henri Lemaitre (Paris: Garnier, 1962), 101.

5. Octavio Paz, "Los signos en rotación" in *Obras completas*, 2nd ed. vol. 1:262 (Mexico City: Fondo de Cultura Económica, 1994).

6. Stéphane Mallarmé, notes to *Divagations* in *Oeuvres complètes*, ed. Henri Mondor and G. Jean-Aubry (Paris: Gallimard/Pléiade, 1959), 1576. Although Jean Cocteau later popularized the term in *Poesie critique* (1945), the volume simply collected his writings on literature and art.

7. Gordon Millan, *Mallarmé: A Throw of the Dice: The Life of Stéphane Mallarmé* (London: Secker and Warburg, 1994), 309.

8. For Apollinaire's experiments with visual poetry, see Willard Bohn, *The Aesthetics of Visual Poetry, 1914–1928* (Cambridge, England: Cambridge University Press, 1986), 46–68 and *Modern Visual Poetry* (Newark: University of Delaware Press, 1999), chapter 5: "Landscaping the Visual Sign."

9. See Willard Bohn, *Apollinaire, Visual Poetry, and Art Criticism* (Lewisburg: Bucknell University Press, 1993).

10. Quoted by L. C. Breunig in the préface to *Chroniques d'art (1902–1918)* by Guillaume Apollinaire (Paris: Gallimard, 1960), 14.

11. Ibid.

12. L. C. Breunig and J.-Cl. Chevalier, eds. *Méditations esthétiques: les peintres cubistes* by Guillaume Apollinaire (Paris: Hermann, 1965), 35.

13. L. C. Breunig, "Les Phares d'Apollinaire," *Cahiers du Musée National d'Art Moderne*, no. 6 (1981): 64.

14. André Breton, "Qu'est-ce que le surréalisme" in *Oeuvres complètes*, ed. Marguerite Bonnet et al. (Paris: Gallimard/Pléiade, 1992), 2:244.

15. Renée Riese Hubert, "La Critique d'art surréaliste: création et tradition,"

Cahiers de l'Association Internationale des Etudes Françaises, no. 37 (May 1985), 227. See also Elza Adamowitz, *Ceci n'est pas un tableau: les écrits surréalistes sur l'art* (Paris: L'Age d'Homme, 2004).

16. Roger Navarri, "Critique synthétique, critique surréaliste: aperçus sur la critique poétique," *Revue d'Histoire Littéraire de la France* 78, no. 2 (March–April 1978): 216.

17. See for example W. J. T. Mitchell, *Picture Theory* (Chicago: University of Chicago Press, 1994), Marjorie Perloff, *The Futurist Moment: Avant-Garde, Avant Guerre, and the Language of Rupture* (Chicago: University of Chicago Press, 1986), and Mary Ann Caws, *The Art of Interférence: Stressed Readings in Verbal and Visual Texts* (Princeton: Princeton University Press, 1989).

18. For a discussion of the various ways in which words and images may intersect, including ekphrasis and the *Bildgedicht*, see A. Kibédi Varga, "Criteria for Describing Word-and-Image Relations" and Claus Clüver, "On Intersemiotic Transposition" in *Poetics Today* Vol. 10, no. 1 (spring 1989): 31–53 and 55–90 respectively. Ulrich Weisstein provides an even broader overview in "Literature and the Visual Arts" in *Interrelations of Literature*, ed. Jean-Pierre Barricelli and Joseph Gibaldi (New York: MLA, 1982), 251–77.

19. James A. W. Heffernan, *Museum of Words: The Poetics of Ekphrasis from Homer to Ashberry* (Chicago: University of Chicago Press, 1993), 6.

20. Shimon Sandbank, "Poetic Speech and the Silence of Art," *Comparative Literature* 46, no. 3 (summer 1994): 238.

21. Anna Balakian, *André Breton: Magus of Surrealism* (New York: Oxford University Press, 1971), 151.

22. André Breton, *Yves Tanguy* (New York: Pierre Matisse, 1941), 9.

23. Clüver, "On Intersemiotic Transposition," 58–62.

24. Ibid., 70.

25. Anna Balakian, "Art Criticism as Poetry" in *Celebrating Comparativism*, ed. Katalin Kûrtöi and József Pál, 77–83 (Szeged: Gold, 1994).

26. Renée Riese Hubert, *Surrealism and the Book* (Berkeley: University of California Press, 1988), 125. See125–48 for a study of the surrealist text as illustration.

CHAPTER 2: SYNTHETIC CRITICISM

1. For Breton's indebtedness to Apollinaire, see Willard Bohn, *The Rise of Surrealism: Cubism, Dada, and the Pursuit of the Marvelous* (Albany: SUNY Press, 2002), chapter 5; J. H. Matthews, *Surrealist Poetry in France* (Syracuse, N.Y.: Syracuse University Press, 1969), 53–67, and *André Breton: Sketch for an Early Portrait* (Amsterdam and Philadelphia: Benjamins, 1986), 33–50; Marguerite Bonnet, "Lettres d'Apollinaire à André Breton," *Revue des Lettres Modernes*, nos. 104–7 (1964), special issue *Guillaume Apollinaire 3*, 13–37; Anna Balakian, *Surrealism, the Road to the Absolute*, rev. ed. (Chicago: University of Chicago Press, 1986, 80–99, and "Breton in the Light of Apollinaire" in *About French Poetry from "Dada" to "Tel Quel": Text and Theory*, ed. Mary Ann Caws (Detroit: Wayne State University Press, 1974), 42–53. For Apollinaire's relation to the other surrealists see Marguerite Bonnet, "Aux sources du surréalisme: place d'Apollinaire," *Revue des Lettres Modernes*, nos. 104–7 (1964),

cited above: 38–74, and J. H. Matthews, "Apollinaire devant les surréalistes," *Revue des Lettres Modernes*, 75–85.

2. Matthews, "Apollinaire devant les surréalistes," 77.

3. Bonnet, "Aux sources du surréalisme: place d'Apollinaire," 41–42.

4. Ibid., 40.

5. Bonnet, "Lettres d'Apollinaire à André Breton," 18.

6. Louis Aragon, review of *Calligrammes* by Guillaume Apollinaire, *SIC*, no. 31 (October 1918): 235, and also in *L'Esprit Nouveau*, no. 1 (October 1920: 103–107.

7. Jacqueline Chénieux-Gendron, *Le Surréalisme* (Paris: Presses Universitaires de France, 1984), 252.

8. *Aragon parle avec Dominique Arban* (Paris: Seghers, 1968), 33–34.

9. The printed text, the manuscript, and a note from Aragon are reproduced in *Europe* 44., nos. 451–52 (November–December, 1966): 53–55.

10. Etienne-Alain Hubert, "Rivalise donc poète avec les étiquettes des parfumeurs," *Revue des Lettres Modernes*, nos. 677–81, spécial issue *Guillaume Apollinaire 16* (1983): 179. The bulk of the article is concerned with another text, devoted to Apollinaire's *Bestiaire*, that Aragon published the following April.

11. Georges Duhamel, review of *Alcools* by Guillaume Apollinaire, *Mercure de France*, 103, no. 294 (June 1913): 800–801.

12. J. H. Matthews, *Surrealist Poetry in France* (Syracuse, N.Y.: Syracuse University Press, 1969), 3.

13. Roger Navarri, "Critique synthétique, critique surréaliste: aperçus sur la critique poétique," *Revue d'Histoire Littéraire de la France*, 78, no. 2 (March–April 1978): 219.

14. Bonnet, "Aux sources du surréalisme: place d'Apollinaire," 42.

15. Navarri, "Critique synthétique, critique surréaliste: aperçus sur la critique poétique," 218.

16. Ibid., 220. The following analysis is partially indebted to his discussion on 220–22.

17. Guillaume Apollinaire, *Oeuvres poétiques*, ed. Marcel Adéma and Michel Décaudin (Paris: Gallimard/Pléiade, 1965), 197. Cited in the text hereafter as *OP*.

18. See Jean-Claude Chevalier, "La Poésie d'Apollinaire et le calembour," *Europe*. 44, nos. 451–52 (November–December 1966): 56–76.

19. Jean Cocteau, "Le Menteur" in *Nouveau Théâtre de poche*, 115 (Monaco: Rocher, 1960).

20. Madeleine Boisson, *Apollinaire et les mythologies antiques* (Fasano: Schena; and Paris: Nizet, 1989), 425–27. For the different manifestations of Pan in Apollinaire's work, see 401–34.

21. Guillaume Apollinaire, *Oeuvres en prose complètes*, ed. Pierre Caizergues and Michel Décaudin (Paris: Gallimard/Pléiade, 1991), 2:937–39.

22. Louis Aragon, "Sur les *Vingt-cinq poèmes* de Tristan Tzara," dossier A 111, 15, Bibliothèque littéraire Jacques Doucet. Repr. in Tristan Tzara, *Oeuvres complètes*, ed. Henri Béhar (Paris: Flammarion, 1975), vol. 1:641–42.

23. Mary Ann Caws, *The Poetry of Dada and Surrealism* (Princeton: Princeton University Press, 1970), 98. For additional characteristics see Tzara, *Oeuvres complètes*, vol. 1, 645–46.

24. J. Pérez-Jorba, "Pensées à coupe-papier," *SIC*, nos. 40–41 (February 28–March 15, 1919): 314.

25. "Les Jockeys mécaniques," "Autres Jockeys alcooliques," and "Piéton" were reprinted in *Les Epaves du ciel* (1924) and *Plupart du temps* (1945). "Période horstexte" was reprinted in a collection of short stories entitled *La Peau de l'homme* (1926).

26. See in this connection Sigmund Freud's essay on "Das Unheimliche" ("The Uncanny") in *The Complete Psychological Works*, ed. James Strachey et al. (London: Hogarth and The Institute of Psycho-Analysis, 1955), 17:219–52.

27. Navarri, "Critique synthétique, critique surréaliste: aperçus sur la critique poétique," 222.

28. Dan Kamin, *Charlie Chaplin's One-Man Show* (Metuchen, New Jersey: Scarecrow, 1984), 84.

29. Charles Chaplin, *My Autobiography* (New York: Simon and Schuster, 1964), 203.

30. Georges Sadoul, *Vie de Charlot: Charles Spencer Chaplin, ses films et son temps* (Paris: L'herminier, 1978), 58.

31. Maxime Alexandre, Louis Aragon, et al., "Hands Off Love," *Transition*, 1927. Repr. in Maurice Nadeau, *The History of Surrealism*, trans. Richard Howard (New York: Collier 1965), 270.

32. Sadoul, *Vie de Charlot*, 27.

33. Theodore Huff, *The Early Work of Charles Chaplin* (New York: Gordon, 1978), 23.

34. Sadoul, *Vie de Charlot*, 55.

35. Alexandre, Aragon, et al., "Hands Off Love," 269.

36. Quoted in Gerald McDonald, *The Picture History of Charlie Chaplin* (Nostalgia Press, n. d. and n. p.), unpaginated.

37. Sadoul, *Vie de Charlot*, 63.

38. McDonald, *The Picture History of Charlie Chaplin*, unpaginated.

Chapter 3: Critical Syntheses

1. Roman Jakobson, "Two Aspects of Language and Two Types of Aphasic Disturbances" in *Fundamentals of Language*, by Roman Jakobson and Morris Halle, 2nd ed., 69–96 (The Hague: Mouton, 1971).

2. André Breton, "Giorgio de Chirico" in *Oeuvres complètes*, ed. Marguerite Bonnet et al. (Paris: Gallimard/Pléiade, 1988), vol. 1:251–52. Published previously in *Littérature*, no. 11 (January 1920): 28–29.

3. Isidore Ducasse, *Oeuvres complètes*, ed. Maurice Saillet (Paris: Librairie Générale Française, 1963), 87.

4. Benjamin Péret, "Les Cheveux dans les yeux," *Exposition Joan Miró* (Paris: Galerie Pierre, June 12–27, 1925). Repr. in his *Oeuvres complètes*, (Paris: Corti, 1992), 298.

5. J. H. Matthews, *Surrealist Poetry in France* (Syracuse, N.Y.: Syracuse University Press, 1969), 51.

6. Benjamin Péret, untitled dialogue, *La Révolution Surréaliste* 1, no. 1 (December 1, 1924): 9.

7. Guillaume Apollinaire, *Méditations esthétiques: les peintres cubistes* in *Oeuvres en*

prose complètes, ed. Pierre Caizergues and Michel Décaudin (Paris: Gallimard/Pléiade, 1991), 2:10.

8. Michel Décaudin, "Le Travail du peintre ou le poète, la peinture et la musique," *Europe,* no. 525 (1972): 101.

9. Jean-Yves Debreuille, "Deux Poèmes d'Eluard: 'Giorgio de Chirico' et 'Joan Miró'" in *Litérales: art et littérature,* ed. Jacques Hourriez 191 (Paris: Belles Lettres, 1994). Subsequent references to this work will be cited in the text.

10. Jean-Charles Gateau, *Paul Eluard et la peinture surréaliste (1910–1939)* (Geneva: Droz, 1982), 98. Subsequent references to this work will be cited in the text.

11. Anne Hyde Greet, "Paul Eluard's Early Poems for Painters," *Forum for Modern Language Studies* 9, no. 1 (January 1973): 91. Subsequent references to this work will be cited in the text.

12. Lori Walters, "'Giorgio de Chirico': le poème et le peintre," *Neophilologus* 63, no. 2 (April 1979): 18. Subsequent references to this work will be cited in the text.

13. Manuel A. Esteban, "Eluard et Miró," *Chimerès* (fall 1974): 16. Subsequent references to this work will be cited in the text.

14. Paul Eluard, *Oeuvres complètes,* ed. Marcelle Dumas and Lucien Scheler (Paris: Gallimard/Pléiade, 1968), 1:232. Michael Riffaterre provides an excellent discussion of this line in his *Semiotics of Poetry* (Bloomington: Indiana University Press, 1978), 61–63.

15. Dawn Ades, *Dada and Surrealism* (Woodbury, New York: Barron's, 1978), 40.

CHAPTER 4: ANDRÉ BRETON

1. Rafael Heliodoro Valle, "Dialogo con André Breton," *Universidad* (Mexico), June 22, 1938. Repr. and tr. in André Breton, *Oeuvres complètes,* ed. Marguerite Bonnet et al. (Paris: Gallimard/Pléiade, 1992), 2:1832. Cited hereafter in the text as *OC.*

2. For a detailed study of the palace and its construction see Jean-Pierre Jouve et al., *Le Palais idéal du facteur Cheval: quand le songe devient la réalité* (Paris: Moniteur, 1981). See as well Marc Fenoli, *Le Palais du facteur Cheval* (Grenoble: Glénat, 1990) and Andre Jean, *Le Palais idéal du facteur Cheval à Hauterives (Drôme)* (n.p. 1937), which reproduces sixty-three inscriptions that adorn the palace walls. Besides the illustration in *Les Vases communicantes,* Breton published photographs of this astonishing edifice in "Le Message automatique," *Minotaure,* nos. 3–4 (December 15, 1933): 65 and in *Le Surréalisme et la peinture* (Paris: Gallimard, 1965), 300.

3. Roman Jakobson, "Two Aspects of Language and Two Types of Aphasic Disturbances" in *Fundamentals of Language,* ed. Roman Jakobson and Morris Halle, 2nd ed. (The Hague: Mouton, 1971), 69–96.

4. Jean, *Le Palais idéal du facteur Cheval à Hauterives (Drôme),* 21.

5. Cf. *Poisson soluble,* for example, where Breton recounts an imaginary encounter with a female flasher (*OC,* Vol. I, 377).

6. André Breton, "Comme dans un bois," *L'Age du cinéma,* nos. 4–5 (August 1951). Repr. in *La Clé des champs* (Paris: Pauvert, 1967), 381.

7. A magnificent picture of just such a scene appeared a few months later in

Minotaure, No. 10 (winter 1937), where it accompanied an article by Benjamin Péret entitled "La Nature dévore le progrès et le dépasse."

8. Jean-Pierre Cauvin, "Introduction: The Poethics of André Breton" in *Poems of André Breton: A Bilingual Anthology*, trans. and ed. by Jean-Pierre Cauvin and Mary Ann Caws (Austin: University of Texas Press, 1982), xxii.

9. Cf. "Femme et oiseau" where a similar phrase introduces a voracious sphinx (*"Signe ascendant" suivi de "Fata Morgana"* etc. [Paris: Gallimard, 1968], 143).

10. Michael Riffaterre, "Ekphrasis lyrique," *Pleine Marge*, no. 13 (June 1991): 133.

11. Anna Balakian, *André Breton: Magus of Surrealism* (New York: Oxford University Press, 1971), 151.

12. André Breton, *Le Surréalisme et la peinture*, 2nd rev. ed. (Paris: Gallimard, 1965), 217.

13. Balakian, *André Breton: Magus of Surrealism*, 149.

14. See Anna Balakian, "From *Poisson soluble* to *Constellations*: Breton's Trajectory for Surrealism," *Twentieth Century Literature* 21, no. 1 (February 1975): 48–58; J. H. Matthews, "André Breton and Joan Miró: *Constellations*," *Symposium* 34, no. 4 (winter 1980): 353–76; Georges Raillard, "Breton en regard de Miró: '*Constellations*,'" *Littérature*, no. 17 (1975): 3–13 and "Comment Breton s'approprie les *Constellations* de Miró," *Poésie et peinture du symbolisme au surréalisme en France et en Pologne*, ed. Elzbieta Grabska (Warsaw: University of Warsaw, 1973), 171–82; Willard Bohn, "Semiosis and Intertextuality in Breton's 'Femme et Oiseau,'" *Romanic Review* 74, no. 4 (November 1985): 415–28; Renée Riese Hubert, *Surrealism and the Book* (Berkeley: University of California Press, 1988), 130–37; Richard Stammelman, "'La Courbe sans fin du désir': les *Constellations* de Joan Miró et André Breton," *L'Herne*, no. 72 (Paris: L'Herne 1988) 313–27.

15. See, for example, *Edgar Jené, Rosa und Heinrich Loew: dokument einer Freundschaft* (Mainz: Mittelrheinisches Landesmuseum, 1984), *Edgar Jené: Werke von 1928–1974* (Saarbrucken: Saarland-Museum, 1974), Edgar Jené, *Zeichnungen* (Worms am Rhein: Werner, 1988), and Edgar Jené, *Wasserfarben* (Worms am Rhein: Werner, 1989).

16. Breton, *Le Surréalisme et la peinture*, 2.

17. Originally entitled "L'Art de Jené," Breton's text served as the preface to *Edgar Jené* (Paris: Galerie La Dragonne [Nina Dausset], December 2–21, 1948).

18. Denis Saurat, *Victor Hugo et les dieux du peuple* (Paris: Vieux Colombier, 1948), 253.

19. José Pierre, *An Illustrated Dictionary of Surrealism*, tr. W. J. Strachan (New York: Barron's, n.d.), 160.

20. Sarane Alexandrian, *Surrealist Art*, tr. Gordon Clough (New York: Thames and Hudson, 1985), 134.

21. Ibid. 242.

22. André Breton, "Introduction à l'oeuvre de Toyen" in *Toyen*, by André Breton, Jindrich Heisler, and Benjamin Péret (Paris: Sokolova, 1953),15. Repr. in *Le Surréalisme et la peinture*, 210.

23. André Breton, "La Somnambule," *Les Sept Épées hors du fourreau* (Paris: Galerie Furstenberg, April 30–May 17, 1958). Repr. in *Le Surréalisme et la peinture*, 215. For a text by Benjamin Péret that was included in the same catalogue, see his *Oeuvres complètes* (Paris: Corti, 1992), 6:363.

24. Whitney Chadwick, *Women Artists and the Surrealist Movement* (Boston: Little, Brown, 1985), 116.

25. Renée Riese Hubert, *Magnifying Mirrors: Women, Surrealism, and Partnership* (Lincoln: University of Nebraska Press, 1994), 322.

26. Robert T. Mitchell and Herbert S. Zim, *Butterflies and Moths: A Guide to the More Common American Species*, rev. ed (New York: Golden, 1987), 118.

27. Sigmund Freud analyzes this phenomenon, which he calls "verbal bridging," in *The Interpretation of Dreams*, tr. James Strachey (New York: Avon, 1965), 239, 376 n.1, 410–11, 427, 464, and 568–69.

28. Ruthven Todd, *Tracks in the Snow: Studies in English Science and Art* (London: Grey Walls, 1946), 88.

29. In extensive correspondence with the present author. He bolsters his argument with a quote from Edmond Jaloux, who evokes "ces oeuvres de jeunesse où l'afflux de la vie prend ses accents les plus tumultueux et où l'effervescence suit plusieurs courants à la fois" (*Johann Heinrich Füssli* [Geneva: Cailler, 1942], 175). I would like to thank Prof. Weinglass for his expert advice in connection with this intriguing artist.

30. Cited in E. H. Gombrich, *Meditations on a Hobby Horse and Other Essays on the Theory of Art*, 4th ed. (Chicago: University of Chicago Press, 1985), 121.

CHAPTER 5: CATALAN EXPERIMENTS

1. André Breton, "Caractères de l'évolution moderne et ce qui en participe," presented at the Ateneu de Barcelona on November 17, 1922. Louis Aragon, "Fragments d'une conférence" delivered at the Residencia de Estudiantes, Madrid, on April 18, 1925. Together with subsequent lectures by members of the Paris group in Spain, these are reprinted in C. B. Morris, *Surrealism and Spain, 1920–1936* (Cambridge, England: Cambridge University Press, 1972), 214–27 and 228–31 respectively.

2. Josep Miquel Sobrer, *Catalonia, A Self-Portrait* (Bloomington: Indiana University Press, 1992), 203.

3. J. V. Foix, *Obra poètica*, ed. J. VallcorbaPlana (Barcelona: Quaderns Crema, 1983), 83–93.

4. Sobrer, *Catalonia, A Self-Portrait*, 203

5. Willard Bohn, *The Rise of Surrealism: Cubism, Dada, and the Pursuit of the Marvelous* (Albany: SUNY Press, 2002), 171–94.

6. André Breton, *Manifeste du surréalisme* in *Oeuvres complètes*, ed. Marguerite Bonnet et al. (Paris: Gallimard/Pléiade, 1988), 1:324–25.

7. In "Presentació de Joan Miró" Foix takes the train in the opposite direction. See Note no. 5.

8. Morris, *Surrealism and Spain, 1920–1936*, 54.

9. Dalmau's activities are chronicled in *Las vanguardias en Cataluña 1906–1939* (Barcelona: Fundació Caixa de Catalunya, 1992), 150–75 and in *Miró-Dalmau-Gasch: l'aventura per l'art modern, 1918–1937*, ed. Pilar Parcerisas and Montse Badia (Barcelona: Centre d'Art Santa Mònica, 1993), 49–75. See Also Enric Jardí, *Els moviments d'avantguarda a Barcelona* (Barcelona: Cotal, 1983).

10. Many of the paintings and drawings are reproduced in *Dalí joven (1918–*

1930) (Madrid: Museo Nacional Centro de Arte Reina Sofía, 1994). See also Daniel Abadie et al., eds *Salvador Dalí retrospective 1920–1980*, 2nd ed., (Paris: Musée National d'Art Moderne, 1980), 40–47.

11. Dawn Ades, *Dalí* (London: Thames and Hudson, 1982), 32–33.

12. André Breton, "Le Surréalisme et la peinture," *La Révolution Surréaliste* 1, no. 4 (July 15, 1925): 27. Repr. in André Breton, *Le Surréalisme et la peinture*, 2nd rev. ed. (Paris: Gallimard, 1965), 217.

13. Guillaume Apollinaire, *Oeuvres en prose complètes*, ed. Pierre Caizergues and Michel Décaudin (Paris: Gallimard/Pléiade, 1991), Vol. II, 10.

14. Ades, *Dalí*, 34. The preface itself, which Breton coauthored with Robert Desnos, is reprinted in his *Oeuvres complètes*, 1:915–16.

15. Sebastià Gasch, "Salvador Dalí," *L'Amic de les Arts*, no. 11 (February 28, 1927): 16.

16. See Bohn, *The Rise of Surrealism*, 73–119.

17. André Breton, "Le Surréalisme et la peinture (suite)," *La Révolution Surréaliste*, vol. 2, no. 7 (June 15, 1926): 4. Repr. in *Le Surréalisme et la peinture*, 17. This phrase, which was taken from the F. W. Murnau film *Nosferatu*, seems to have haunted Breton for a number of years. See *Les Vases communicants* (1932) (Paris: Gallimard, 1955), 50, where he describes the mixture of joy and terror that it evoked in him.

18. Breton *Oeuvres complètes*, 1:727. See the photograph on 734.

19. The catalogue of Carbonell's exhibition is partially reproduced in *Las vanguardias en Cataluña 1906–1939*, 556.

20. Lucía García de Carpi, *La pintura surrealista española (1924–1936)* (Madrid: Istmo, 1986), 103. For an excellent survey of Carbonell's career, see 99–103.

21. This painting is reproduced in ibid., 102 and in Ades, *Dalí*, 44.

22. Garcí de Carpi, *La pintura surrealist española (1924–1936)*, 103.

23. Ades, *Dalí*, 40.

24. See Alfonso Sánchez Rodríguez, "Los poemas del primer Dalí (1927–1928)," *Insula* 115, no. 44 (November 1989): 5 and 7. The Spanish and the Catalan texts have been collected in Salvador Dalí, *L'alliberament dels dits: obra catalana completa*, ed. Fèlix Fanés (Barcelona: Quaderns Crema, 1995).

25. Salvador Dalí, "Per al 'meeting' de Sitges," *L'Amic de les Arts*, no. 25 (May 1928), 194–95. The expression, which quickly invaded the avant-garde lexicon, occurs virtually everywhere during this period. Thus an article entitled "Vers la supressió de l'art," by Sebastià Gasch, begins and ends with the phrase: "Estem vivint una epoca meravellosament anti-artistica" (We are living in an era that is marvelously anti-artistic) (*L'Amic de les Arts*, no. 31 [1929]: 2–3).

26. Quoted in Ades, *Dalí*, 119.

27. Morris, *Surrealism and Spain*, 18.

28. Salvador Dalí, "Sant Sebastià," *L'Amic de les Arts*, no. 16 (July 31, 1927): 52–54.

29. Haim Finkelstein, *Salvador Dalí's Art and Writing, 1927–1942: The Metamorphosis of Narcissus* (Cambridge, England: Cambridge University Press, 1996), 39–41.

30. Salvador Dalí, "Peix perseguit per un raïm," *L'Amic de les Arts*, no. 28 (September 1928): 217–18.

31. Salvador Dalí, "La meva amiga i la platja," *L'Amic de les Arts*, no. 20 (November 30, 1927): 104.

32. Salvador Dalí, "Poema de las cositas," *Salvador Dalí escribe a Federico García Lorca*, ed. Rafael Santos Torroella, *Poesía*, nos. 27–28 (April 1987), 68. For a Spanish translation of the Catalan version, published in a satirical journal in 1928, see 139.

33. Finkelstein, *Salvador Dalí's Art and Writing, 1927–1942*, 42.

34. Ibid., 36.

35. Ibid., 54.

36. Sánchez Rodríguez, "Poemas del primer Dalí," 5.

37. Finkelstein, *Salvador Dalí's Art and Writing*, 61.

38. Ibid., 41.

39. André Breton, "Première exposition Dalí," *Oeuvres complètes*, 2:307–9.

40. Salvador Dalí, "Poema agafat al vol, no taquigràficament," *Art* (Lleida), No. 0 (1934): 6.

41. André Breton, *Entretiens (1913–1952)*, interviews with André Parinaud (Paris: Gallimard, 1969), 162.

42. Many if not all of the illustrations are reproduced in Abadie et al., *Salvador Dalí retrospective 1920–1980*, 334–39. See also Renée Riese Hubert, *Surrealism and the Book* (Berkeley: University of California Press, 1988), 205–19.

43. Ades, *Dalí*, 148.

44. Nandor Fodor and Frank Gaynor, eds., *Freud: Dictionary of Psychoanalysis* (Greenwich, Conn.: Fawcett, n. d.), 113–14.

45. Isidore Ducasse, *Les Chants de Maldoror* in *Oeuvres complètes*, ed. Maurice Saillet (Paris: Livre de Poche, 1963), 322.

46. Breton, *Oeuvres complètes*, 2:140.

47. Sigmund Freud, *The Interpretation of Dreams*, tr. James Strachey (New York: Avon, 1965), 391.

48. Salvador Dalí, "Objets surréalistes," *Le Surréalisme au Service de la Révolution*, No. 3 (December 1931): 16.

49. Salvador Dalí, "L'Ane pourri," *Le Surréalisme au Service de la Révolution*, no. 1 (July 1930): 9.

50. On multistable imagery and the "Duck-Rabbit" connundrum see W. J. T. Mitchell, *Picture Theory* (Chicago: University of Chicago Press, 1994), 45–57.

CHAPTER 6: THE SPANISH EXPERIENCE

1. See C. B. Morris, *This Loving Darkness: The Cinema and Spanish Writers, 1920–1936* (Oxford: Oxford University Press, 1980).

2. Virginia Higginbotham, "Lorca's Apprenticeship in Surrealism," *Romanic Review* 61, no. 2 (April 1970): 112.

3. Rafael Utrera, *García Lorca y el cinema* (Seville: EDISUR, 1982), 49. For a general survey, see Uta Feltan, "La Réception de Buster Keaton dans le surréalisme espagnol," *Mélusine*, no. 24 (2004): 171–81.

4. Marie Laffranque, "Pour l'étude de Federico García Lorca: bases chronologiques," *Bulletin Hispanique* 65 (1963): 341.

5. In addition to the works cited in the first three notes see Rupert C. Allen, "A Commentary on Lorca's *El paseo de Buster Keaton*," *Hispanófila* 16, no. 3 (1973): 23–35; Robert G. Havard, "Lorca's Buster Keaton," *Bulletin of Hispanic Studies* 54,

no. 1 (January 1977): 13–20; and Havard, *From Romanticism to Surrealism: Seven Spanish Poets* (Totowa, New Jersey: Barnes and Noble, 1988), 220–27; Gwynne Edwards, *Lorca: The Theatre Beneath the Sand* (London: Boyars, 1980), 48–50; and Carlos Jerez-Farran. "García Lorca y El Paseo de Buster Keaton: Alegoria del Amor Homosexual," *Romanic Review* 88, no. 4 (November 1977): 629–55.

6. Morris, *This Loving Darkness: The Cinema and Spanish Writers, 1920–1936*, 139.

7. Letter from Federico García Lorca to Guillermo de Torre, *Obras completas*, ed. Arturo del Hoyo, 10th ed. (Madrid: Aguilar, 1965), 1630. See Allen, "A Commentary on Lorca's *El paseo de Buster Keaton*."

8. Havard, "Lorca's Buster Keaton," 13–14.

9. Higginbotham, "Lorca's Apprenticeship in Surrealism," 113.

10. Utrera, *García Lorca y el cinema*, 52.

11. Havard, "Lorca's Buster Keaton," 17.

12. Higginbotham, "Lorca's Apprenticeship in Surrealism," 112.

13. Havard, "Lorca's Buster Keaton," 15.

14. Morris, *This Loving Darkness*, 135. A wooden bicycle with no pedals appears briefly in *Our Hospitality* (1923).

15. Edwards, *Lorca: The Theatre Beneath the Sand*, 49.

16. Havard, "Lorca's Buster Keaton,"17.

17. Ibid.

18. Ibid.,15–16 and Allen, "A Commentary on Lorca's *El paseo de Buster Keaton*," 31.

19. Havard, "Lorca's Buster Keaton," 18.

20. Julio Huélamo Kosma, "Lorca y los limites del teatro la surrealista" in *El teatro en España entre la tradición y la vanguardia, 1918–1939*, ed. Dru Dougherty and María Francisca Vilches de Frutos, 211 (Madrid: Tabapress, 1992).

21. Morris, *This Loving Darkness*, 139.

22. Higginbotham, "Lorca's Apprenticeship in Surrealism," 122.

23. Havard, *From Romanticism to Surrealism*, 242.

24. Some, but not all, of the poems were eventually collected in his *Poesías completas* (Buenos Aires: Losada, 1961). For a more authoritative edition, see *Sobre los ángeles. Yo era un tonto y lo que he visto me ha hecho dos tontos*, ed. C. B. Morris. 5th ed. (Madrid: Catedra, 1992).

25. C. B. Morris, *A Generation of Spanish Poets 1920–1936* Cambridge, England: Cambridge University Press, 1969), 107.

26. Anthony L. Geist, "Mecánica, amor, poesía: discurso e ideología en *Yo era un tonto y lo que he visto me ha hecho dos tontos*," *Insula*, no. 515 (November 1989): 10.

27. Carlos Alberto Pérez, "Rafael Alberti: sobre los tontos, *Revista Hispánica Moderna* 32, nos. 3–4 (July–October 1966), 210.

28. Morris, *This Loving Darkness*, 97. For an excellent overview, see C. Brian Morris, "Rafael Alberti y el cine" in *Rafael Alberti y Marí Teresa León cumplen cien años*, ed. Julio Neira (Santander: Caja Cantabria, 2004), 51–68.

29. Ibid., 92 and 80.

30. Geist, "Mecánica, amor, poesía," 10.

31. Edgar O'Hara, "Exercises in the Dark: Rafael Alberti's Cinema Poems," in *The Spanish Avant-Garde*, ed. Derek Harris, 167 (Manchester: Manchester University Press, 1995).

32. Pérez, "Rafael Alberti: sobre los tontos," 211.

33. Larry Edwards, *Buster: A Legend in Laughter* (Bradenton, Florida: McGuinn and McGuire, 1995), 71.

34. Pérez, "Rafael Alberti: sobre los tontos," 209 n. 14.

35. Higginbotham, "Lorca's Apprenticeship in Surrealism," 122.

36. Eric Proll, "The Surrealist Element in Rafael Alberti," *Bulletin of Spanish Studies*, Vol. XVIII (1941). Repr. in Victor García de la Concha, ed., *El surrealismo* (Madrid: Taurus, 1982), 217.

37. Morris, *A Generation of Spanish Poets 1920–1936*, 108.

38. O'Hara, "Exercises in the Dark: Rafael Alberti's Cinema Poems," 172.

39. Ibid., 173.

40. Daniel Moews, *Keaton: The Silent Features Close Up* (Berkeley: University of California Press, 1977), 164 and 169.

41. Morris, *This Loving Darkness*, 100.

42. See for example J. C. Cooper, *An Illustrated Encyclopaedia of Traditional Symbols* (London: Thames and Hudson, 1978).

43. Moews, *Keaton: The Silent Features Close Up*, 160.

44. Ibid., 286.

45. Pérez, "Rafael Alberti: sobre los tontos," 213.

46. Geist, "Mecánica, amor, poesía," 10.

47. Morris, *This Loving Darkness*, 100.

48. Moews, *Keaton: The Silent Features Close Up*, 164.

49. Jim Kline, *The Complete Films of Buster Keaton* (New York: Citadel, 1993), 108.

50. Morris describes the other occasion in *Sobre los ángeles. Yo era un tonto y lo que he visto me ha hecho dos tontos*, 172 n. 52.

Chapter 7: The Canary Islands

1. C. B. Morris, *Surrealism and Spain 1920–1936* (Cambridge, England: Cambridge University Press, 1972), 19.

2. "11º. Manifiesto de G. A.," *Gaceta de Arte*, no. 22 (December 1933): 3.

3. Morris, *Surrealism and Spain 1920–1936*, 19.

4. Domingo López Torres , "Surrealismo y revolución," *Gaceta de Arte*, No. 9 (October 1932), 2. Repr. in *Obras completas*, ed. C. B. Morris and Andrés Sánchez Robayna, 133–35 (Santa Cruz de Tenerife: Aula de Cultura, 1993).

5. Domingo López Torres, "Picasso: cubismo," *Gaceta de Arte*, no. 7 (August 1932). Repr. in *Obras completas*, 131–32.

6. Vicente Aleixandre, "Picasso" in *Obras completas* (Madrid: Aguilar, 1968), 967–69. Rafael Alberti, "Picasso" in *Poesías completas* (Buenos Aires: Losada, 1961), 700–703.

7. "Une Anatomie: dessins de Picasso," *Minotaure*, No. 1 (February 15, 1933): 33–37.

8. José María de la Rosa, "Ante la 'Anatomia' de Picasso" in *Facción española surrealista de Tenerife*, ed. Domingo Pérez Minik, 172–74 (Barcelona: Tusquets, 1975).

9. Roland Penrose, *Picasso: His Life and Work* (New York: Harper and Row, 1973), 276.

10. André Breton and Paul Eluard, *Dictionnaire abrégé du surréalisme* in André Breton, *Oeuvres complètes*, ed. Marguerite Bonnet et. al. (Paris: Gallimard/Pléiade, 1992), 2:832.

11. Pedro García Cabrera, *Obras completas*, ed. Sebastian de la Nuez et al. (n.p.: Consejería de Cultura y Deportes del Gobierno Autónomo de Canarias, 1987), 2:163.

CHAPTER 8: ARGENTINA AND PERU

1. See for example Willard Bohn, *Apollinaire and the International Avant-Garde* (Albany: State University of New York Press, 1997), chapters 7 and 8.

2. Aldo Pellegrini, *Antología de la poesía viva latinoamericana* (Barcelona: Seix Barral, 1966), 9. See Robert Ponge, "Notes pour une histoire du surréalisme en Amérique hispanique des années 20 aux années 50," *Mélusine*, no. 24 (2004), 315–32.

3. Jean de Milleret, *Entretiens avec Jorge Luis Borges* (Paris: Belfond, 1967), 23. See also Kira Poblete Araya, "El surrealismo argentino y su praxis," in *Las vanguardias literarias en Argentina, Uruguay y Paraguay*, ed. Carlos García and Dieter Reichardt (Frankfurt: Vervuert and Madrid: Iberoamericana, 2004), 233–41.

4. Letter from Aldo Pellegrini to Stefan Baciu, quoted in Baciu, *Antología de la poesía surrealista latinoamericana*, 76 (Mexico City: Mortiz 1974).

5. Aldo Pellegrini, *La valija de fuego* (Buenos Aires: Americalee, 1952), 31.

6. Enrique Anderson-Imbert, *Spanish-American Literature: A History* (Detroit: Wayne State University Press, 1969), 2:617.

7. Cited by Margo Glantz in her preface to *Enrique Molina* (Mexico City: UNAM, n.d.), 5.

8. Ibid., 3.

9. J. C. Cooper, *An Illustrated Encyclopaedia of Traditional Symbols* (London: Thames and Hudson, 1978), 182.

10. Danubio Torres Fierro, "Un poeta en la intemperie: entrevista a Enrique Molina" in Enrique Molina, *Obra completa* (Buenos Aires: Corregidor, 1984), 1:347.

11. Baciu, *Antología de la poesía surrealista latinoamericana*, 111.

12. Anderson-Imbert, *Spanish-American Literature: A History*, 2:600.

13. André Breton et al., "Recherches expérimentales," *Le Surréalisme au Service de la Révolution*, no. 6 (May 15, 1933): 11, 13, and 15; *La Mobilisation contre la guerre n'est pas la paix* (July 1932), repr. in *Tracts surréalistes et déclarations collectives*, ed. José Pierre (Paris: Terrain Vague, 1991).

14. César Moro, *Los anteojos de azufre*, ed. André Coyné (Lima: Torres Aguirre, 1956), 32. For the text that Moro contributed to the catalogue of the Exposición Internacional del Surrealismo (Mexico City 1940), see 29–31.

15. André Breton, *Oeuvres complètes*, ed. Marguerite Bonnet et al. (Paris: Gallimard/Pléiade, 1992), 2:68–70.

16. André Breton, "La Lampe dans l'horloge" (1948) in *La Clé des champs* (Paris: Pauvert, 1967), 187.

17. Breton, *Oeuvres complètes*, 2:1828–29.

18. Anderson-Imbert, *Spanish-American Literature: A History*, 2:601.

19. Emilio Adolfo Westphalen, "Poetas en la Lima de los años treinta" in *Otra imagen deleznable*... (Mexico City: Fondo de Cultura Económica, 1980), 117–18.

20. The epigraph is the last line of a poem entitled "Sur la route qui monte et descend," published in *Le Revolver à cheveux blancs* (*The White-Haired Revolver*) in 1932. See Breton, *Oeuvres complètes*, 2:70.

21. Baciu, *Antología de la poesía surrealista latinoamericana*, 114–15.

22. The poem was eventually reprinted in *Otra imagen deleznable*... (1980). C. B. Morris conjectures in *Surrealism and Spain, 1920–1936* (Cambridge, England: Cambridge University Press, 1972) that Aleixandre may have borrowed his title in turn from a book by Louis Aragon (59).

23. Westphalen, "Poetas en la Lima de los años treinta," 119. He is quoting the French critic Jean Cohen.

24. André Coyné, *César Moro* (n.p.: n.p., 1956?), 12.

25. Ibid, 15.

CHAPTER 9: CHILE AND MEXICO

1. Stefan Baciu, *Antología de la poesía surrealista latinoamericana* (Mexico City: Mortiz, 1974), 86.

2. Teófilo Cid, "Poesía, revolución" in *Defensa de la poesía* by Braulio Arenas, Teófilo Cid, and Enrique Gómez-Correa (Santiago de Chile: Mandrágora, 1939), n. p.

3. Enrique Anderson-Imbert, *Spanish-American Literature: A History* (Detroit: Wayne State University Press, 1969), 2:705 and 706.

4. Stefan Baciu, "Enrique Gómez-Correa, poeta de la violencia" in Enrique Gómez-Correa, *Poesía explosiva (1935–1973)* (Santiago de Chile: Aire Libre, 1973), 10.

5. Jorge Cáceres, "Max Ernst" in Braulio Arenas, Enrique Gómez-Correa, and Jorge Cáceres, *El AGC de la Mandrágora* (Santiago de Chile: Mandrágora, 1957), 91–92.

6. André Breton, "Avis au lecteur pour 'La Femme 100 têtes' de Max Ernst," *Oeuvres complètes*, ed. Marguerite Bonnet et al. (Paris: Gallimard/Pléiade, 1992), 2:306.

7. Max Ernst, "Les Mystères de la forêt," *Minotaure*, no. 5 (May 1934): 6.

8. Breton, "Max Ernst," *Oeuvres complètes*, 1:246.

9. André Breton, *Le Surréalisme et la peinture*, 2nd rev. ed. (Paris: Gallimard, 1965), 64.

10. Jorge Cáceres, *Textos inéditos* (Toronto: Oasis, 1979), 44. "Douanier Rousseau" may be found on 55–56.

11. Paul Klee, "Creative Credo" in *Theories of Modern Art: A Source Book by Artists and Critics*, ed. Herschel B. Chipp et al. (Berkeley: University of California Press, 1968), 182.

12. Herbert Read, *A Concise History of Modern Painting*, rev. ed. (London: Thames and Hudson, 1968), 186.

13. Breton, *Oeuvres complètes* 1:331–32.

14. Derek Harris, *Metal Butterflies and Poisonous Lights: The Language of Surrealism in Lorca, Alberti, Cernuda, and Aleixandre* (Arncroach, Scotland: La Sirena, 1998), 64.

15. Robert Goldwater, *Primitivism in Modern Art*, rev. ed. (Cambridge, Mass.: Belknap, 1986), 181.

16. Pierre Courthion, *Henri Rousseau: Paintings* (London: Eyre Methuen, n.d.), unpaginated.

17. Breton, *Le Surréalisme et la peinture*, 368.

18. Courthion, *Henri Rousseau: Paintings*, unpaginated.

19. Quoted in *Henri Rousseau* (New York: Museum of Modern Art, 1985), 166.

20. Baciu, *Antología de la poesía surrealista latinoamericana*, 87.

21. The portrait, which Magritte sent to him four years earlier, is reproduced in Braulio Arenas and Enrique Gomez-Correa, *El AGC de la Mandrágora* (Santiago de Chile: Mandrágora, 1957). Letter from René Magritte to Enrique Gómez-Correa dated June 4, 1953, Getty Research Institute for the History of Art and the Humanities, Los Angeles.

22. Sarane Alexandrian, *Surrealist Art* (London: Thames and Hudson, 1970), 119–20.

23. Breton, *Le Surréalisme et la peinture*, 402.

24. Magritte seems to have sent him twelve color postcards—probably among those printed by Berger in Brussels. No such book is listed in André Blavier's splendid bibliography in Patrick Waldberg's *René Magritte* (Brussels: De Rache, 1965).

25. Alexandrian, *Surrealist Art*, 123.

26. René Magritte, *Ecrits complets*, ed. André Blavier (Paris: Flammarion, 1979), 565.

27. Ibid.

28. Ibid., 261.

29. Suzi Gablik, *Magritte* (New York: Thames and Hudson, 1991), 80.

30. Breton, *Le Surréalisme et la peinture*, 72.

31. Gablik, *Magritte*, 80–82.

32. Breton, *Le Surréalisme et la peinture*, 403.

33. Baciu, *Antología de la poesía surrealista latinoamericana*, 13.

34. Anderson-Imbert, *Spanish-American Literature: A History*, 2:691 and 693.

35. Cited in Baciu, *Antología de la poesía surrealista latino-americana*, 106.

36. André Breton, *Entretiens (1913–1952)*, ed. André Parinaud, rev. ed. (Paris: Gallimard, 1969), 291 and 207 respectively.

37. *El soñado mundo de Rauschenberg* (Mexico City: Museo Rufino Tamayo, April 17-June 23, l985), 6–7. The poem is dated February 25, 1985. *For Octavio Paz* is reproduced in Octavio Paz, *Obras completas*, 2nd ed. (Mexico City: Fondo de Cultura Económica, 1994), 6: opposite 37.

38. Paz, *Obras completas*, 288.

39. Ibid., 89. See, for example, two interviews with Rauschenberg reprinted in *Readings in American Art 1900–1975*, ed. Barbara Rose, 2nd ed. (New York: Praeger, 1975), 149–50.

40. See, for example, Gablik, *Magritte*, 77–83.

41. Donald Barthelme, "Being Bad" in *Robert Rauschenberg, Work from Four Series: A Sesquicentennial Exhibition* (Houston: Contemporary Arts Museum, 1985), 9.

42. J. C. Cooper, *An Illustrated Encyclopaedia of Traditional Symbols* (London: Thames and Hudson, 1978), 124.

43. Walter Hopps, "Rauschenberg's Art of Fusion" in *Robert Rauschenberg: A Retrospective*, ed. Walter Hopps et al. (New York: Guggenheim, 1997), 20.

44. Linda L. Cathcart, "Robert Rauschenberg: Work From Four Series" in *Robert Rauschenberg, Work from Four Series: A Sesquicentennial Exhibition,* 12.

45. Ibid., 10.

CODA

1. Roman Jakobson, "Two Aspects of Language and Two Types of Aphasic Disturbances" in *Fundamentals of Language,* ed. Roman Jakobson and Morris Halle, 2nd ed. (The Hague: Mouton, 1971),69–96. This essay has had an extraordinary influence on scholars working in widely different areas over the years. See Willard Bohn, "Roman Jakobson's Theory of Metaphor and Metonymy: An Annotated Bibliography," *Style,* 18, no. 4 (fall 1984): 534–50.

2. Willard Bohn, *The Rise of Surrealism: Cubism, Dada, and the Pursuit of the Marvelous* (Albany: SUNY Press, 2002), 141–70.

3. Barbara Johnson, *A World of Difference* (Baltimore: Johns Hopkins University Press, 1987), 155–57.

Bibliography

Abadie, Daniel, et al., eds. *Salvador Dalí retrospective 1920-1980.* 2nd ed. Paris: Musée National d'Art Moderne, 1980.

Adamowicz, Elza. *Ceci n'est pas un tableau: les écrits surréalistes sur l'art.* Paris: L'Age d'Homme, 2004.

Ades, Dawn. *Dada and Surrealism.* Woodbury, New York: Barron's, 1978.

———. *Dalí.* London: Thames and Hudson, 1982.

Alberti, Rafael. *Poesías completas.* Buenos Aires: Losada, 1961.

———. *Sobre los ángeles. Yo era un tonto y lo que he visto me ha hecho dos tontos.* 5th ed. Ed. C. B. Morris. Madrid: Catedra, 1992.

Aleixandre, Vicente. *Obras completas.* Madrid: Aguilar, 1968.

Alexandre, Maxime, Louis Aragon, et al. "Hands Off Love." *Transition,* 1927.

Alexandrian, Sarane. *Surrealist Art.* London: Thames and Hudson, 1970. Reprint New York: Thames and Hudson, 1985.

Allen, Rupert C. "A Commentary on Lorca's *El paseo de Buster Keaton.*" In *Hispanófila* 16, no. 3 (1973).

Anderson-Imbert, Enrique. *Spanish-American Literature: A History.* Vol. 2. Detroit: Wayne State University Press, 1969.

Apollinaire; Guillaume. *Oeuvres en prose complètes.* Edited by Michel Décaudin and Pierre Caizergues. 3 vols. Paris: Gallimard/Pléiade, 1977–93.

———. *Oeuvres Poétiques.* Edited by Marcel Adéma and Michel Décaudin. Paris: Gallimard/Pléiade, 1965.

Aragon, Louis. Review of *Calligrammes* by Guillaume Apollinaire. *Europe* 44, nos. 451–52 (November–December 1966): 53–55.

———. Review of *Calligrammes* by Guillaume Apollinaire. *L'Esprit Nouveau* 1, no. 1 (October 1920): 103–7.

———. Review of *Calligrammes* by Guillaume Apollinaire. *SIC,* no. 31 (October 1918): 235.

Aragon parle avec Dominique Arban. Paris: Seghers, 1968.

Arenas, Braulio, Teófilo Cid, and Enrique Gómez-Correa. *Defensa de la poesía.* Santiago de Chile: Mandrágora, 1939.

Arenas, Braulio, and Enrique Gómez-Correa, *El AGC de la Mandrágora.* Santiago de Chile: Mandrágora, 1957.

Baciu, Stefan. *Antología de la poesía surrealista latinoamericana.* Mexico City: Mortiz., 1974.

————. "Enrique Gómez-Correa, poeta de la violencia." In *Poesía explosiva (1935–1973)*. By Enrique Gómez-Correa. Santiago de Chile: Aire Libre, 1973.

Balakian, Anna. *André Breton: Magus of Surrealism*. New York: Oxford University Press, 1971.

————. "Art Criticism as Poetry." In *Celebrating Comparativism*. Edited by Katalin Kürtösi and József Pál. Szeged: Gold, 1994.

————. "Breton in the Light of Apollinaire." In *About French Poetry from "Dada" to "Tel Quel": Text and Theory*. Edited by Mary Ann Caws. Detroit: Wayne State University Press, 1974.

————. "From *Poisson soluble* to *Constellations*: Breton's Trajectory for Surrealism." *Twentieth Century Literature*, 21, no. 1 (February 1975): 48–58.

————. *Surrealism, the Road to the Absolute*. Rev. ed. Chicago: University of Chicago Press, 1986.

Barthelme, Donald. "Being Bad." In *Robert Rauschenberg, Work from Four Series: A Sesquicentennial Exhibition*. Houston: Contemporary Arts Museum, 1985.

Baudelaire, Charles. *Curiosités esthétiques, L'Art romantique et autres oeuvres critiques*. Ed. Henri Lemaitre. Paris: Garnier, 1962.

Bohn, Willard. *The Aesthetics of Visual Poetry, 1914–1928*. Cambridge, England: Cambridge University Press, 1986. Reprint, University of Chicago Press, 1993.

————. *Apollinaire and the International Avant-Garde*. Albany: State University of New York Press, 1997.

————. *Apollinaire, Visual Poetry, and Art Criticism*. Lewisburg: Bucknell University Press, 1993.

————. "Mirroring Miró: J. V. Foix and the Surrealist Adventure." In *The Surrealist Adventure in Spain*. Ed. C. Brian Morris. Ottawa: Dovehouse, 1990.

————. *Modern Visual Poetry*. Newark, Delaware: University of Delaware Press, 1999.

————. *The Rise of Surrealism: Cubism, Dada, and the Pursuit of the Marvelous*. Albany: SUNY Press, 2002.

————. "Semiosis and Intertextuality in Breton's 'Femme et Oiseau.'" *Romanic Review* 74, no. 4 (November 1985), 415–28.

Boisson, Madeleine. *Apollinaire et les mythologies antiques*. Fasano: Schena and Paris: Nizet, 1989.

Bonnet, Marguerite. "Aux sources du surréalisme: place d'Apollinaire." *Revue des Lettres Modernes*, nos. 104–7 (1964): 38–74.

————. "Lettres d'Apollinaire à André Breton." *Revue des Lettres Modernes*, nos. 104–7 (1964): 13–37.

Breton, André. *Entretiens (1913–1952)*. Edited by André Parinaud. Rev. ed. Paris: Gallimard, 1969.

————. *La Clé des champs*. Paris: Pauvert, 1967.

————. *Le Surréalisme et la peinture*. 2nd rev. ed. Paris: Gallimard, 1965.

————. *Oeuvres complètes*. Ed. Marguerite Bonnet et al. 2 vols. Paris: Gallimard/Pléiade, 1988 and 1992.

————. *"Signe ascendant" suivi de "Fata Morgana"*. Paris: Gallimard, 1968.

————. *Yves Tanguy*. New York: Pierre Matisse, 1941.

Breton, André, et al. *La Mobilisation contre la guerre n'est pas la paix.* July 1932. Reprinted in *Tracts surréalistes et déclarations collectives.* Edited by José Pierre. Paris: Terrain Vague, 1991.

———. *Violette Nozières.* 1933. Reprinted, Paris: Terrain Vague, 1991.

Breton, André, and Paul Eluard. *Dictionnaire abrégé du surréalisme.* In André Breton, *Oeuvres complètes.* Vol. 11. Edited by Marguerite Bonnet et al. Paris: Gallimard/ Pléiade, 1992.

Breton, André, Jindrich Heisler, and Benjamin Péret. *Toyen.* Paris: Sokolova, 1953.

Breunig, L. C. "Les Phares d'Apollinaire." *Cahiers du Musée National d'Art Moderne.* no. 6 (1981): 62–69.

———. "Préface." *Chroniques d'art (1902–1918).* By Guillaume Apollinaire. Paris: Gallimard, 1960.

Breunig, L. C., and J.- Cl. Chevalier. "Introduction." In *Méditations esthétiques: les peintres cubistes.* By Guillaume Apollinaire. Paris: Hermann, 1965.

Cáceres, Jorge. *Textos inéditos.* Toronto: Oasis, 1979.

Cathcart, Linda L. "Robert Rauschenberg: Work From Four Series." In *Robert Rauschenberg, Work from Four Series: A Sesquicentennial Exhibition.* Houston: Contemporary Arts Museum, 1985.

Cauvin, Jean-Pierre. "Introduction: The Poethics of André Breton." In *Poems of André Breton: A Bilingual Anthology.* Ed. Jean-Pierre Cauvin and Mary Ann Caws. Austin: University of Texas Press, 1982.

Caws, Mary Ann. *The Art of Interference: Stressed Readings in Verbal and Visual Texts.* Princeton: Princeton University Press, 1989.

———. *The Poetry of Dada and Surrealism.* Princeton: Princeton University Press, 1970.

Chadwick, Whitney. *Women Artists and the Surrealist Movement.* Boston: Little, Brown, 1985.

Chaplin, Charles. *My Autobiography.* New York: Simon and Schuster, 1964.

Chénieux-Gendron, Jacqueline. *Le Surréalisme.* Paris: Presses Universitaires de France, 1984.

Chevalier, Jean-Claude. "La Poésie d'Apollinaire et le calembour." *Europe* 44, nos. 451–52 (November–December 1966).

Cid, Teófilo. "Poesía, revolución." In *Defensa de la poesía.* By Braulio Arenas, Teófilo Cid, and Enrique Gómez-Correa. Santiago de Chile: Mandrágora, 1939.

Clüver, Claus. "On Intersemiotic Transposition." *Poetics Today* 10, No. 1 (spring 1989): 55–90.

Cocteau, Jean. *Nouveau Théâtre de poche.* Monaco: Rocher, 1960.

———. *Poésie critique.* Ed. Henri Parisot. Paris: Quatre-Vents, 1945.

Cooper, J. C. *An Illustrated Encyclopaedia of Traditional Symbols.* London: Thames and Hudson, 1978.

Courthion, Pierre. *Henri Rousseau: Paintings.* London: Eyre Methuen, n.d.

Coyné, André. *César Moro.* N.p.: N. p., 1956?

Dalí joven (1918–1930). Madrid: Museo Nacional Centro de Arte Reina Sofía, 1994.

Dalí, Salvador. *L'alliberament dels dits: obra catalana completa.* Ed. Fèlix Fanés. Barcelona: Quaderns Crema, 1995.

———. "L'Ane pourri." *Le Surréalisme au Service de la Révolution,* no. 1 (July 1930): 9.

———. "Objets surréalistes." *Le Surréalisme au Service de la Révolution,* no. 3 (December 1931): 16–17.

Debreuille, Jean-Yves. "Deux Poèmes d'Eluard: 'Giorgio de Chirico' et 'Joan Miró.'" *Littérales: art et littérature.* Ed. Jacques Horriez. Paris: Belles Lettres, 1994.

Décaudin, Michel. "Le Travail du peintre ou le poète, la peinture et la musique." *Europe,* no. 525 (1972): 101–6.

Ducasse, Isidore. *Oeuvres complètes.* Ed. Maurice Saillet. Paris: Librairie Générale Française, 1963.

Duhamel, Georges. Review of *Alcools* by Guillaume Apollinaire. *Mercure de France* 103, no. 294 (June 1913): 800–801.

Edgar Jené. Paris: Galerie La Dragonne (Nina Dausset), December 2–21, 1948.

Edgar Jené, Rosa und Heinrich Loew: dokument einer Freundschaft. Mainz: Mittelrheinisches Landesmuseum, 1984.

Edgar Jené: Werke von 1928–1974. Saarbrucken: Saarland-Museum, 1974.

Edwards, Gwynne. *Lorca: The Theatre Beneath the Sand.* London: Boyars, 1980.

Edwards, Larry. *Buster: A Legend in Laughter.* Bradenton, Fla.: McGuinn and McGuire, 1995.

El soñado mundo de Rauschenberg. Mexico City: Museo Rufino Tamayo, April 17–June 23, 1985.

Eluard, Paul. *Oeuvres complètes.* Ed. Marcelle Dumas and Lucien Scheler. 2 vols. Paris: Gallimard/Pléiade, 1968.

Ernst, Max. "Les Mystères de la forêt." *Minotaure,* no. 5 (May 1934): 6–7.

Esteban, Manuel A. "Eluard et Miró." *Chimères* (fall 1974): 15-29.

Felten, Uta. "La Réception de Buster Keaton dans le surréalisme espagnol." *Mélusine,* no. 24 (2004): 171–81.

Fenoli, Marc. *Le Palais du facteur Cheval.* Grenoble: Glénat, 1990.

Finkelstein, Haim. *Salvador Dalí's Art and Writing, 1927–1942: The Metamorphosis of Narcissus.* Cambridge, England: Cambridge University Press, 1966.

Fodor, Nandor, and Frank Gaynor, eds. *Freud: Dictionary of Psychoanalysis.* Greenwich, Connecticut: Fawcett, n.d.

Foix, J. V. *Obra poètica.* Ed. J. VallcorbaPlana. Barcelona: Quaderns Crema, 1983.

Freud, Sigmund. *The Complete Psychological Works.* Edited by James Strachey et al. London: Hogarth and the Instutute of Psycho-Analysis, 1955.

———. *The Interpretation of Dreams.* Translated by James Strachey. New York: Avon, 1965.

Gablik, Suzi. *Magritte.* New York: Thames and Hudson, 1991.

García Cabrera, Pedro. *Obras completas.* Edited by Sebastian de la Nuez et al. 2 vols. n.p.: Consejería de Cultura y Deportes del Gobierno Autónomo de las Canarias, 1987.

García de Carpi, Lucía. *La pintura surrealista española (1924–1936)*. Madrid: Istmo, 1986.

García Lorca, Federico. *Obras completas*. Edited by Arturo del Hoyo. 10th ed. Madrid: Aguilar, 1965.

Gasch, Sebastià. "Salvador Dalí." *L'Amic de les Arts*, no. 11 (February 28, 1927): 16.

———. "Vers la supressió de l'art." *L'Amic de les Arts*, no. 31 (1929): 2–3.

Gateau, Jean-Charles. *Paul Eluard et la peinture surréaliste (1910–1939)*. Geneva: Droz, 1982.

Geist, Anthony L. "Mecánica, amor, poesía: discurso e ideología en *Yo era un tonto y lo que he visto me ha hecho dos tontos*." *Insula*, no. 515 (November 1989): 10–11.

Glantz, Margo. Preface to *Enrique Molina*. Mexico City: UNAM, n. d.,: 3–6.

Goldwater, Robert. *Primitivism in Modern Art*. Rev. ed. Cambridge, Massachusetts: Belknap, 1986.

Gombrich, E. H. *Meditations on a Hobby Horse and Other Essays on the Theory of Art*. 4th ed. Chicago: University of Chicago Press, 1985.

Greene, Robert W. "Spiritual Quest and Scriptural Inquiry: Pierre Jean Jouve's Art Criticism." *Conjunctions: Verbal-Visual Relations*. Edited Laurie Edson. San Diego: San Diego State University Press, 1996.

Greet, Anne Hyde. "Paul Eluard's Early Poems for Painters." *Forum for Modern Language Studies* 9, no. 1 (January 1973): 86–102.

Harris, Derek. *Metal Butterflies and Poisonous Lights: The Language of Surrealism in Lorca, Alberti, Cernuda, and Aleixandre*. Arncroach, Scotland: La Sirena, 1998.

Havard, Robert G. *From Romanticism to Surrealism: Seven Spanish Poets*. Totowa, New Jersey: Barnes and Noble, 1988.

———. "Lorca's Buster Keaton." *Bulletin of Hispanic Studies* 54, no. 1 (January 1977): 13–20.

Heffernan, James A. W. *Museum of Words: The Poetics of Ekphrasis from Homer to Ashberry*. Chicago: University of Chicago Press, 1993.

Heliodoro Valle, Rafael. "Dialogo con André Breton." *Universidad* (Mexico), June 22, 1938.

Henri Rousseau. New York: Museum of Modern Art, 1985.

Higginbotham, Virginia. "Lorca's Apprenticeship in Surrealism." *Romanic Review* 61, no. 2 (April 1970): 109–22.

Hopps, Walter. "Rauschenberg's Art of Fusion." In *Robert Rauschenberg: A Retrospective*. Ed. Walter Hopps et al. New York: Guggenheim, 1997.

Hubert, Etienne-Alain. "Rivalise donc poète avec les étiquettes des parfumeurs." *Revue des Lettres Modernes*, no. 677–81 (1983): 179–81.

Hubert, Renée Riese. "La Critique d'art surréaliste: création et tradition." *Cahiers de l'Association Internationale des Etudes Françaises*, no. 37 (May 1985): 213–27.

———. *Magnifying Mirrors: Women, Surrealism, and Partnership*. Lincoln: University of Nebraska Press, 1994.

———. *Surrealism and the Book*. Berkeley: University of California Press, 1988.

Huélamo Kosma, Julio. "Lorca y los limites del teatro surrealista." In *El teatro en

España entre la tradición y la vanguardia, 1918–1939. Edited by Dru Dougherty and María Francisca Vilches de Frutos. Madrid: Tabapress, 1992.

Huff, Theodore. *The Early Work of Charles Chaplin.* New York: Gordon, 1978.

Jakobson, Roman. "Two Aspects of Language and Two Types of Aphasic Disturbances." *Fundamentals of Language.* By Roman Jakobson and Morris Halle. 2nd ed. The Hague: Mouton, 1971.

Jardí, Enric. *Els moviments d'avantguarda a Barcelona.* Barcelona: Cotal, 1983.

Jean, André. *Le Palais idéal du facteur Cheval à Hauterives (Drôme).* N.p.: n.p., 1937.

Jené, Edgar. *Wasserfarben.* Worms am Rhein: Werner, 1989.

———. *Zeichnungen.* Worms am Rhein: Werner, 1988.

Jerez-Farran, Carlos. "García Lorca y El Paseo de Buster Keaton: Alegoria del Amor Homosexual." *Romanic Review* 88, no. 4 (November 1997): 629–55.

Johann Heinrich Füssli. Geneva: Cailler, 1942.

Johnson, Barbara. *A World of Difference.* Baltimore: Johns Hopkins University Press, 1987.

Jouve, Jean-Pierre et al. *Le Palais idéal du facteur Cheval: quand le songe devient la réalité.* Paris: Moniteur, 1981.

Kamin, Dan. *Charlie Chaplin's One-Man Show.* Metuchen, New Jersey: Scarecrow, 1984.

Klee, Paul. "Creative Credo." In *Theories of Modern Art: A Source Book by Artists and Critics.* Ed. Herschel B. Chipp et al. Berkeley: University of California Press, 1968.

Kline, Jim. *The Complete Films of Buster Keaton.* New York: Citadel, 1993.

Laffranque, Marie. "Pour l'étude de Federico García Lorca: bases chronologiques." *Bulletin Hispanique* 65 (1963): 333–77.

Las vanguardias en Cataluña 1906–1939. Barcelona: Fundació Caixa de Catalunya, 1992.

Les Sept Epées hors du fourreau. Paris: Galerie Furstenberg, April 30–May 17, 1958.

López Torres, Domingo. *Obras completas.* Edited by C. B. Morris and Andrés Sánchez Robayna. Santa Cruz de Tenerife: Aula de Cultura, 1993.

Magritte, René. *Ecrits complets.* Edited by André Blavier. Paris: Flammarion, 1979.

———. Letter to Enrique Gómez-Correa, June 4, 1953. Getty Research Institute for the History of Art and the Humanities, Los Angeles, California.

Mallarmé, Stéphane. *Oeuvres complètes.* Edited Henri Mondor and G. Jean-Aubry. Paris: Gallimard/Pléiade, 1959.

Matthews, J. H. "André Breton and Joan Miró: *Constellations.*" *Symposium* 34, no. 4 (winter 1980): 353–76.

———. *André Breton: Sketch for an Early Portrait.* Amsterdam and Philadelphia: Benjamins, 1986.

———. "Apollinaire devant les surréalistes." *Revue des Lettres Modernes,* nos. 104–7 (1964): 75–85.

———. *Surrealist Poetry in France.* Syracuse, New York: Syracuse University Press, 1969.

McDonald, Gerald. *The Picture History of Charlie Chaplin.* N. p.: Nostalgia Press, n.d.

Millan, Gordon. *Mallarmé: A Throw of the Dice: The Life of Stéphane Mallarmé.* London: Secker and Warburg, 1994.

Milleret, Jean de. *Entretiens avec Jorge Luis Borges.* Paris: Belfond, 1967.

Mitchell, Robert T., and Herbert S. Zim. *Butterflies and Moths: A Guide to the More Common American Species.* Rev. ed. New York: Golden, 1987.

Mitchell, W. J. T. *Picture Theory.* Chicago: University of Chicago Press, 1994.

Moews, Daniel. *Keaton: The Silent Features Close Up.* Berkeley: University of California Press, 1977.

Moro, César. *Los anteojos de azufre.* Edited by André Coyné. Lima: Torres Aguirre, 1956.

Morris, C. B. *A Generation of Spanish Poets 1920–1936.* Cambridge, England: Cambridge University Press, 1969.

———. *Surrealism and Spain 1920–1936.* Cambridge, England: Cambridge University Press, 1972.

———. *This Loving Darkness: The Cinema and Spanish Writers, 1920–1936.* Oxford: Oxford University Press, 1980.

Morris, C. Brian. "Rafael Alberti y el cine." *Rafael Alberti y María Teresa León cumplen cien años.* Edited by Julio Neira. Santander: Caja Cantabria, 2004, 51–68.

Nadeau, Maurice. *The History of Surrealism.* Translated by Richard Howard. New York: Collier, 1965.

Navarri, Roger. "Critique synthétique, critique surréaliste: aperçus sur la critique poétique." *Revue d'Histoire Littéraire de la France* 78, no. 2 (March–April 1978): 216–30.

O'Hara, Edgar. "Exercises in the Dark: Rafael Alberti's Cinema Poems." In *The Spanish Avant-Garde.* Edited by Derek Harris. Manchester: Manchester University Press, 1995.

"11º. Manifiesto de G. A." *Gaceta de Arte,* no. 22 (December 1933): 3.

Parcerisas, Pilar, and Montse Badia, eds. *Miró-Dalmau-Gasch: l'aventura per l'art modern, 1918–1937.* Barcelona: Centre d'Art Santa Mònica, 1993.

Paz, Octavio. *Obras completas.* 2nd ed. 11 vols. Mexico City: Fondo de Cultura Económica, 1994.

Pellegrini, Aldo. *Antología de la poesía viva latinoamericana.* Barcelona: Seix Barral, 1966.

———. *La valija de fuego.* Buenos Aires: Americalee, 1952.

Penrose, Roland. *Picasso, His Life and Work.* New York: Harper and Row, 1973.

Péret, Benjamin. *Oeuvres complètes.* 7 vols. Paris: Corti, 1992.

Pérez, Carlos Alberto. "Rafael Alberti: sobre los tontos." *Revista Hispánica Moderna,* Vol. XXXII, Nos. 3–4 (July–October 1966): 206–16.

Pérez Minik, Domingo. *Facción española surrealista de Tenerife.* Barcelona: Tusquets, 1975.

Pérez-Jorba, J. "Pensées à coupe-papier." *SIC,* nos. 40–41 (February 28–March 15, 1919): 314.

Perloff, Marjorie. *The Futurist Moment: Avant-Garde, Avant Guerre, and the Language of Rupture.* Chicago: University of Chicago Press, 1986.

————. *Radical Artifice: Writing Poetry in the Age of Media.* Chicago: University of Chicago Press, 1991.

————. *Wittgenstein's Ladder: Poetic Language and the Strangeness of the Ordinary.* Chicago: University of Chicago Press, 1996.

Picasso, Pablo. "Une Anatomie." *Minotaure,* no. 1 (February 15, 1933): 33–37.

Pierre, José. *An Illustrated Dictionary of Surrealism.* Translated by W. J. Strachan. New York: Barron's, n.d.

Poblete Araya, Kira. "El surrealisimo argentino y su praxis." *Las vanguardias literalias en Argentina, Uruguay y Parauary.* Edited by Carlos García and Dieter Reichardt (Frankfurt: Vervuert and Madrid: Iberoamericana, 2004), 233–42.

Ponge, Robert. "Notes pour une histoire du surréalisme en Amérique hispanique des années 20 aux années 50." *Mélusine,* no. 24 (2004): 315–32.

Proll, Eric. "The Surrealist Element in Rafael Alberti." *Bulletin of Spanish Studies* 8 (1941). Reprinted in Victor García de la Concha, ed., *El surrealismo.* Madrid: Taurus, 1982.

Raillard, Georges. "Breton en regard de Miró: 'Constellations.'" *Littérature,* no. 17 (1975): 3–13.

————. "Comment Breton s'approprie les *Constellations* de Miró." *Poésie et peinture du symbolisme au surréalisme en France et en Pologne.* Edited by Elzbieta Grabska. Warsaw: University of Warsaw, 1973.

Read, Herbert. *A Concise History of Modern Painting.* Rev. ed. London: Thames and Hudson, 1968.

Reverdy, Pierre. *La Peau de l'homme.* Paris: Nouvelle Revue Française, 1926.

————. *Les Epaves du ciel.* Paris: Nouvelle Revue Française, 1924.

————. *Plupart du temps.* Paris: Gallimard, 1945.

Riffaterre, Michael. "Ekphrasis lyrique." *Pleine Marge,* no. 13 (June 1991): 133–49.

————. *Semiotics of Poetry.* Bloomington: Indiana University Press, 1978.

Rose, Barbara, ed. *Readings in American Art 1900–1975.* 2nd ed. New York: Praeger, 1975.

Running, Thorpe. *The Critical Poem: Borges, Paz, and Other Language-Centered Poets in Latin America.* Lewisburg: Bucknell University Press, 1996.

Sadoul, Georges. *Vie de Charlot: Charles Spencer Chaplin, ses films et son temps.* Paris: L'herminier, 1978.

Sánchez Rodríguez, Alfonso. "Los poemas del primer Dalí (1927-1929)." *Insula* 115, no. 44 (November 1989): 5, 7.

Sandbank, Shimon. "Poetic Speech and the Silence of Art." *Comparative Literature* 46, no. 3 (summer 1994): 225–39.

Santos Torroella, Rafael, ed. *Salvador Dalí escribe a Federico García Lorca. Poesía,* nos. 27–28 (April 1987).

Saurat, Denis. *Victor Hugo et les dieux du peuple.* Paris: Vieux Colombier, 1948.

Sobrer, Josep Miquel. *Catalonia, A Self-Portrait.* Bloomington: Indiana University Press, 1992.

Stammelman, Richard. "'La Courbe sans fin du désir': les *Constellations* de Joan Miró et André Breton." *L'Herne,* no. 72 (Paris: L'Herne, 1998): 313–27.

Todd, Ruthven. *Tracks in the Snow: Studies in English Science and Art.* London: Grey Walls, 1946.

Torres Fierro, Danubio. "Un poeta en la intemperie: entrevista a Enrique Molina." In Enrique Molina, *Obra completa.* Vol. 1. Buenos Aires: Corregidor, 1984.

Tzara, Tristan. *Oeuvres complètes.* 6 vols. Edited by Henri Béhar. Paris: Flammarion, 1975.

Utrera, Rafael. *García Lorca y el cinema.* Seville: EDISUR, 1982.

Varga, A. Kibédi. "Criteria for Describing Word-and-Image Relations." *Poetics Today* 10, no. 1 (spring 1989): 31–53.

Waldberg, Patrick. *René Magritte.* Brussels: De Rache, 1965.

Walters, Lori. "'Giorgio de Chirico': le poème et le peintre." *Neophilologus* 63, no. 2 (April 1979): 212–19.

Weisstein, Ulrich. "Literature and the Visual Arts." In *Interrelations of Literature.* Edited by Jean-Pierre Barricelli and Joseph Gibaldi. New York: MLA, 1982.

Westphalen, Emilio Adolfo. *Otra imagen deleznable . . .* Mexico City: Fondo de Cultura Económica, 1980.

Index